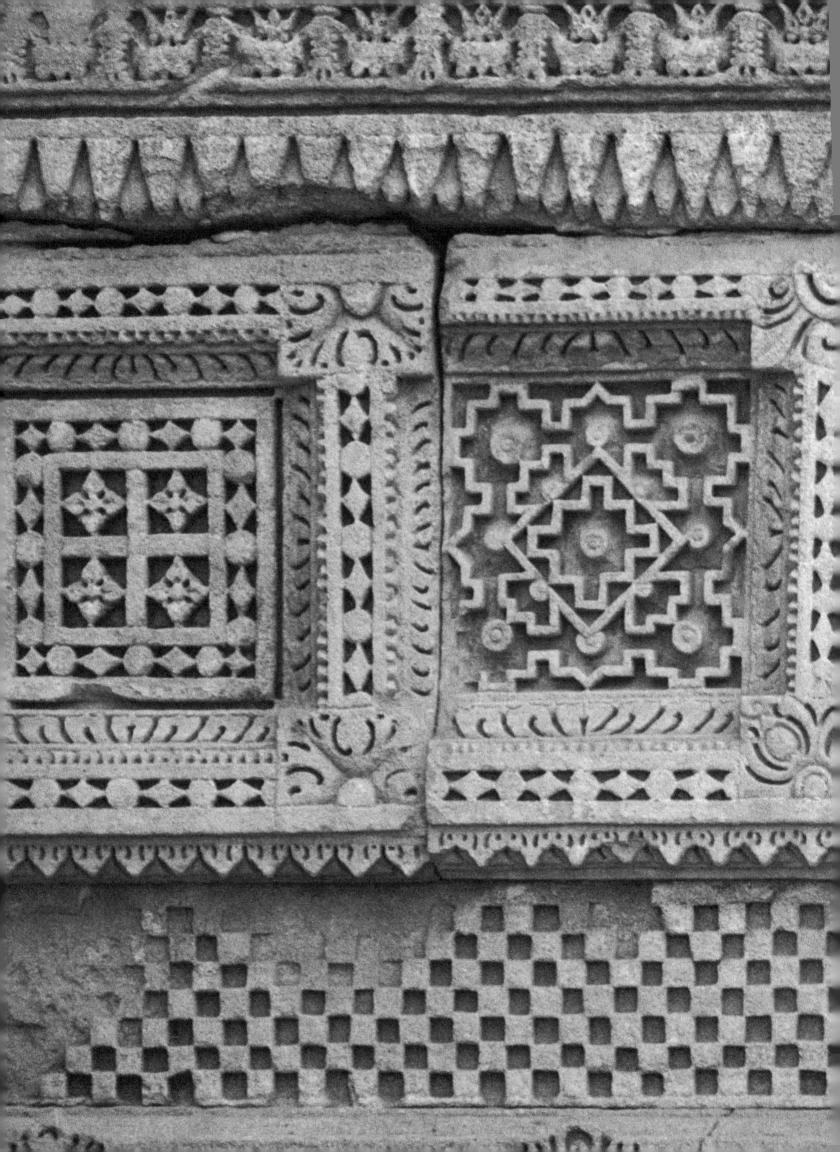

Gods,
Guardians,
and
Lovers

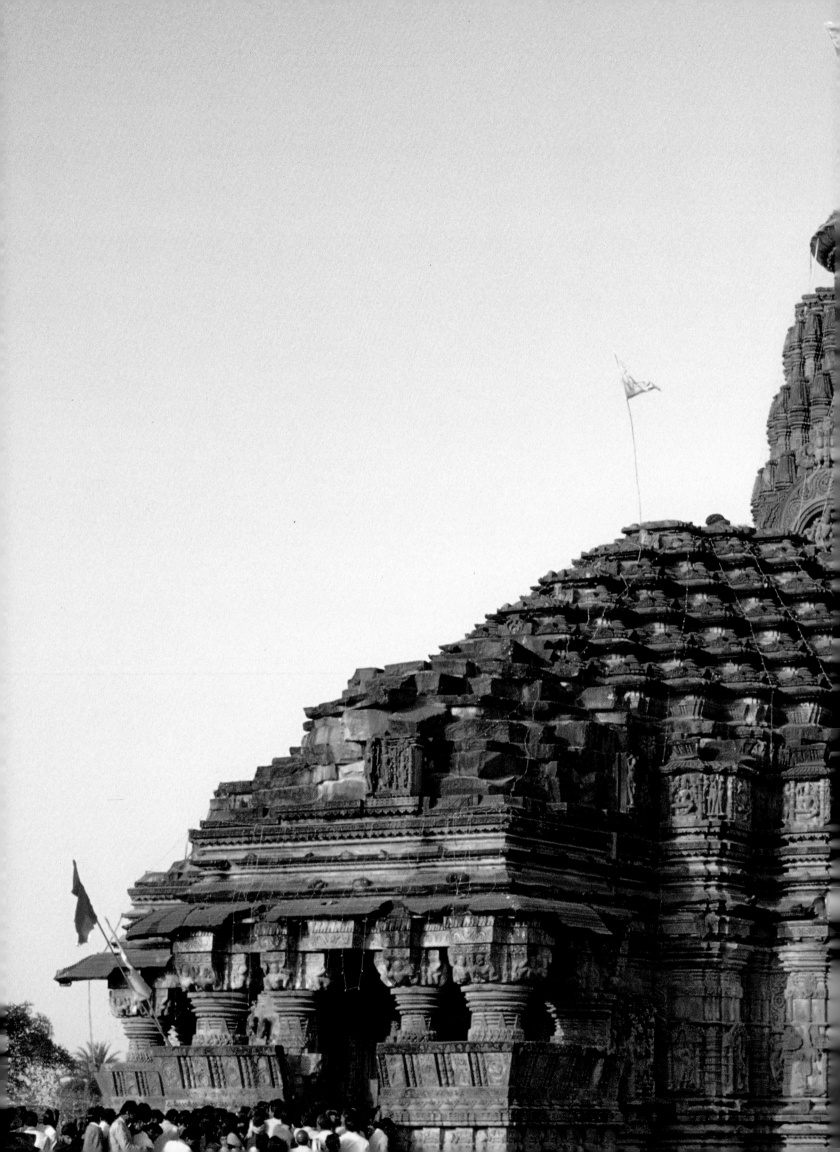

Gods, Guardians, and Lovers

Temple Sculptures from North India
A.D. 700 – 1200

Edited by
Vishakha N. Desai
Darielle Mason

The Asia Society Galleries, New York
in association with
Mapin Publishing Pvt. Ltd., Ahmedabad

Published on the occasion of
Gods, Guardians, and Lovers:
Temple Sculptures from North India, A.D. 700–1200
an exhibition organized by
The Asia Society Galleries, New York
March 31–August 15, 1993 and at
The Nelson-Atkins Museum of Art, Kansas City, Missouri
October 10 – November 28, 1993

The Asia Society Galleries, New York
Vishakha N. Desai, Director

Acting Publications Coordinator: Merantine Hens-Nolan
Publications Assistant: Alexandra Johnson
Editors: Patricia Emerson
 Elisabeth Gleason Humez

First published in the United States of America in 1993 by
Grantha Corporation
80 Cliffedgeway, Middletown, New Jersey 07701
in association with
The Asia Society Galleries
725 Park Avenue, New York, NY 10021-5088

Simultaneously published in all other countries by
Mapin Publishing Pvt. Ltd.
Chidambaram, Ahmedabad 380 013 India

Distributors:
North America
University of Washington Press
P. O. Box 50096, Seattle, Washington 98145-5096

United Kingdom and Europe
Gazelle Book Services Limited
Falcon House, Queen Square, Lancaster LAL 1RN, England

Rest of the world:
Mapin Publishing Pvt. Ltd.
Chidambaram, Ahmedabad 380 013 India

ISBN: 0-944142-92-3 (Grantha)
ISBN: 8-185822-10-7 (Mapin)
ISBN: 0-295972-56-4 (U.W. Press)
ISBN: 0-87848-075-7 (TASG)
Library of Congress Catalog Card Number: 92-076089

Designed by Paulomi Shah Madhvani/Mapin Studio
Typeset in Bembo by Akar Typographics Pvt. Ltd., Ahmedabad
Printed and bound by Tien Wah Press, Singapore

Pronunciation Key

a	as in m**i**ca, r**u**ral
ā	as in t**a**r, f**a**ther
i	as in f**i**ll, l**i**ly
ī	as in pol**i**ce
ṛi	approximately as in me**rri**ly
ñ	approximately as in si**n**ge
ṇ	approximately as in **n**o**n**e
ś/ṣ	as in **s**ure

Source: Monier-Williams, M. *A Sanskrit-English Dictionary.*
Delhi: Motilal Banarsidass, 1974 (1899).

Cover illustrations
Front:
Celestial Woman Undressed by a Monkey (No. 13);
The Nelson-Atkins Museum of Art, Kansas City,
Missouri.

Back:
Royal Couple, from base molding of temple at
Abaneri, Uttar Pradesh, about A.D. 800–825.

Endpapers:
Exterior wall (detail), Queen's step well (Rāṇi ki Vāv),
Patan, Gujarat, about A.D. 1060.

Pages 2–3:
View from the northeast of Śiva temple, Udayeśvara,
Udayapur, Madhya Pradesh, about A.D. 1080.

Page 5:
Gaṇeśa (No. 16); The Asia Society, New York.

Pages 6–7:
Exterior wall (detail), Sūrya temple, Osian, Rajasthan,
about A.D. 700–725.

Contents

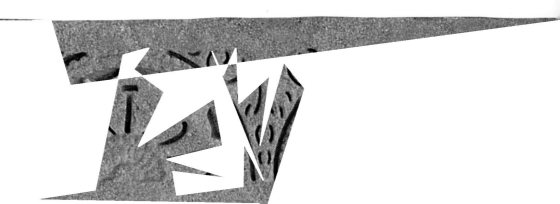

Funding Acknowledgements

The Asia Society Galleries gratefully acknowledges the generous support of the following funders for the exhibition, catalogue, and related programs:

National Endowment for the Humanities
National Endowment for the Arts

Air India
Indo-U.S. Subcommission on Education and Culture
Lisina and Frank Hoch
Leon and Cynthia Polsky
The Starr Foundation
Arthur Ross Foundation
Friends of The Asia Society Galleries

This catalogue is published with the assistance of the Getty Grant Program.

Lenders to the Exhibition

James W. and Marilynn Alsdorf Collection, Chicago
Amber Archeological Museum
The Art Institute of Chicago
Ashmolean Museum, Oxford
The Asia Society, New York
Asian Art Museum of San Francisco
The Trustees of the British Museum
The Brooklyn Museum
Central Archeological Museum, Gwalior
Amita and Purnendu Chatterjee
Cincinnati Art Museum
Durgawati Museum, Jabalpur
The Cleveland Museum of Art
The Dayton Art Institute
The Denver Art Museum
Berthe and John Ford Collection
Government Museum, Mathura
Mr. and Mrs. Nathan L. Halpern
Indian Museum, Calcutta
Kannauj Archeological Museum
Kota Archeological Museum
Los Angeles County Museum of Art
The Metropolitan Museum of Art
Museum of Fine Arts, Boston
Museum Rietberg Zürich
National Museum of American Art, Smithsonian Institution
National Museum, New Delhi
The Nelson-Atkins Museum of Art, Kansas City, Missouri
Philadelphia Museum of Art
Prabhas Patan Museum, Veraval
Pritzker Family Collection
Private Collections
Royal Ontario Museum
Frank C. Russek Collection/Novel Art
Shri Sadu Shantiprasad Jain Art Museum, Khajurāho
The San Antonio Art Museum
Seattle Art Museum
Mr. and Mrs. Joel Shapiro
Dorothy and Richard Sherwood
Mr. and Mrs. Stanley Snider Collection
State Museum, Dhubela
Virginia Museum of Fine Arts, Richmond
Victoria and Albert Museum
Doris Wiener

Preface

Gods, Guardians, and Lovers: Temple Sculptures from North India, A.D. 700–1200 has been in the making since 1988, when I was at the Museum of Fine Arts, Boston. It began with a very simple, and perhaps somewhat naive assumption that these so-called medieval sculptures had not yet received the kind of serious and multidisciplinary attention that they deserved. As a museum curator specializing in Indian painting, I was continually surprised and slightly frustrated by the idea that many of these sculptures, which originated in a geographic area wider than Europe during a period spanning more than five hundred years, could not be dated more precisely than within two to three hundred years. Although the proper iconographic identification for many of the figures could be made, generally very little information about their original architectural context or suggested location on a temple wall was available. Clearly, a scholarly examination of these sculptures was long overdue.

As a museum educator and professor of Asian art, I also was particularly aware of the alternating sense of bafflement and intense curiosity felt by many museum visitors when confronted with the multiarmed gods and goddesses and sensually elegant celestial females—hallmarks of the period—so often exhibited. It could be argued that these sculptures, many of which are "medieval" north Indian, typify the average museum visitor's conceptions about Indian art. If the project were to serve as a catalyst to the development of a fresh, comprehensive, scholarly approach to the study of north Indian "medieval" sculpture, it would have to be done in a way that would be useful to both the specialist and the nonspecialist.

It was clear at the outset that the geographic and chronological scope of the project had to be delineated. The geographic span of the exhibition—from north of the Narmadā River in central India to the western part of Uttar Pradesh through all of Rajasthan and Gujarat (see pages 16–17)—made art-historical sense. The sculptures from this broadly defined area share some formal characteristics. These commonalities are due to a number of interrelated factors, ranging from shared architectural forms and intraregional political connections to possible migrations of crafts guilds in search of suitable patronage. As stated by Professor Chattopadhyaya, the broad northern-southern division of the subcontinent at the Narmadā River and Vindhya Mountains has been acknowledged even in the literature of the period. The more problematic geographic boundaries of this exhibition are in the eastern and northern areas. One could argue for the inclusion of some parts of easternmost and northernmost Uttar Pradesh and for southeastern Madhya Pradesh. However, from a visual standpoint, the outlying regions have highly pronounced localized forms that are not shared by mainstream north Indian medieval areas as defined here. In addition, such outer areas fall outside the domain of cross-cultural and political interaction that characterized the ancient subregions discussed in Darielle Mason's catalogue entries.

Although the chronological parameters of this exhibition are similarly broad by art-historical standards, they are carefully considered. Initially our intention was to begin the exhibition with images dating from about A.D. 550. But as we began to develop the conceptual basis for the exhibition and recognized that among the most salient features of these sculptures is their architectural function and placement in a temple, it became clear that we should move our terminus post quem date to around A.D. 700. Sculptures from A.D. 550 to about 700 can be considered transitional in that they gradually change from being individual relief forms to what Michael Meister has described as architectural "fragments from a divine cosmology." There is no question that from A.D. 700 onward, sculpture

became architecturally oriented. Also, there is a great deal more information available from this period about architectural placement than there is from prior periods.

The date A.D. 1200 as the terminus ante quem is based equally on art-historical and historical grounds. As described in Michael Willis's essay on patronage, the increasing Muslim invasions from the northwest put temples at risk. Large temples continued to be built but not with the same frequency. Political and historical factors made it difficult for the royalty and elite of northern India to continue to patronize temple construction with the same degree of verve, commitment, and investment. With temples that were built after 1200, such as the complex at Rāṇakpur in Rajasthan, emphasis shifted from the carving to the articulation of grand spaces. Thus, it could be said that after about 1200 there is a significant dearth of well-carved sculptures.

The title of the exhibition, Gods, Guardians, and Lovers: Temple Sculptures from North India, A.D. 700–1200, is intended to suggest both the complexity of diverse forms one finds on a medieval north Indian temple as well as a fluid functional relationship between different types of forms. Many of the Hindu gods, depending on their architectural placement, can function as guardian deities and, of course, many of them are seen as divine couples or celestial lovers. Similarly, some of the semidivine loving figures (mithuna) are seen as propitious and protective figures, alternating with such obviously protective figures as the zoomorphic vyālas.

The first part of the title, Gods, Guardians, and Lovers, as Michael Meister's essay aptly elucidates, is also intended to suggest both the plethora of forms that grace temple walls and interiors and "to make visible a single reality." The second part of the title makes it clear that these sculptures were integral parts of religious edifices. Clearly, temples were carefully created to suggest a cosmological unit and function as a social and a religious center for the worshiper. The two parts of the title were also chosen to deliberately suggest a sense of dynamism between two diverse approaches to the material—to study them as individual, aesthetic objects in a narrowly defined art-historical sense and to place them in a more comprehensive architectural, religious, and cultural context.

As anyone who has worked with this material knows, there is a great deal of choice available in organizing an exhibition such as this. Thousands of temples and related religious structures were created throughout the region and many were profusely decorated with sculptures. Only a small portion of the temples survive intact, but loose sculptures can be found all over the world. The selection process for the exhibition was governed by a number of factors, ranging from quality, condition, and availability of objects to our desire to present diversity in terms of both iconography and original architectural context. In other words, our goal has been to combine the traditional museological preference for the presentation of the "finest" available objects with an explication of their architectural and cosmological role within larger structures and symbolic systems. The selection of objects reflects this duality, which is not mutually exclusive.

Undoubtedly, this has not been an easy task. Such a multidisciplinary approach to Indian art remains rudimentary. This catalogue and exhibition, therefore, are intended to pave the way for future multidisciplinary projects. The Asia Society Galleries is pleased to present this path-breaking exhibition of Indian sculpture and share it with The Nelson-Atkins Museum of Art in Kansas City, Missouri. We hope that the exhibition and catalogue will open up new ways of appreciating and understanding north Indian medieval sculpture.

Vishakha N. Desai
Director, The Asia Society Galleries

Acknowledgements

Gods, Guardians, and Lovers has been a collaborative project on many levels. My initial concept, developed while I was at the Museum of Fine Arts, Boston, very quickly became enriched through discussion with many colleagues, especially Michael Meister and Darielle Mason. Both have become active collaborators—with Michael as one of the advisory consultants and Darielle as a research associate in the planning stages and ultimately as an equal partner. Michael has been a sounding board not only for broad conceptual questions but also for such technical considerations as the title of the show and visual order of the images. Darielle has been involved in every aspect of the exhibition, from writing catalogue entries and working on the entire manuscript to developing the installation plans with me. When I assumed the position of Director of The Asia Society Galleries, it was clear that I would have to eventually give up some of my curatorial duties. Darielle has taken up that burden.

Among the most pleasurable experiences I had during the planning phase of this exhibition were the extensive field trips through remote areas of Rajasthan, Gujarat, and Madhya Pradesh that I was able to share with Michael and Darielle during the past four years. As a painting specialist, my own exploration of north Indian medieval sculpture had initially been limited to acquisition, research, and museum presentation. It is doubtful that I could have developed or carried out such a comprehensive approach to the material without Michael's advice and Darielle's support. These trips were greatly facilitated by the Archaeological Survey of India offices in Delhi, Gujarat, and Rajasthan.

Other colleagues who have helped a great deal in defining my ideas about this exhibition are the scholars with whom I have consulted for several years. Donald Stadtner, a member of the original team of advisors, not only lent his unstinting enthusiasm and support but was also on the lookout for interesting objects and unusual inscriptions. Unfortunately, Don was unable to participate in the project after December 1991, but I am delighted that Michael Willis was able to step in at a relatively late date and contribute his essay on royal patronage. His study of temple construction and inscriptions has been important in the examination of these objects.

Professor Chattopadhyaya, a leading scholar of medieval Indian history, has been enthusiastic about the project and has helped in numerous ways. He has provided the historical framework for the show and understands the value of monuments and objects as primary sources of information. Professor Chattopadhyaya was also instrumental in leading us to the filmmakers who provided us with the marvelous footage of ritual festivals at the great medieval temple of Udayeśvara. I would also like to thank Professor Romila Thapar for early discussions on the historical framework of the show and for her suggestion to include Professor Chattopadhyaya as a contributor.

One of the challenges of organizing a multidisciplinary project such as this has been to locate scholars from the related fields of cultural and religious history. We were very fortunate to have Phyllis Granoff as our medieval religion scholar. Her interest in art, her commitment to the exploration of the experiential aspects of medieval Indian religiosity, and her insistence on keeping the poetic voices of medieval writers intact have been invaluable in shaping the religious context of the works in the show.

Additionally, I have benefited a great deal from discussions with numerous colleagues in the United States and India. Early conversations with Paul Mattick, Jr., resulted in a clearer articulation of the relationship between the original

context for the works of art and their recontextualization as museum objects. Joanna Williams, Susan Huntington, and Walter Spink have been supportive of the project in various ways, including writing support letters for funding requests.

As mentioned before, the exhibition was conceived while I was at the Museum of Fine Arts, Boston, and a number of colleagues had been involved. I would like to acknowledge Alan Shestack, Director of the Museum, and Wu Tung, Curator of the Asiatic Department, for their early support of the exhibition and for sparing Darielle Mason, who is now at the Museum of Fine Arts, to work on the project. The staff members of the Asiatic, Education, and Development departments were all very helpful in the planning phase of the exhibition. Tom Wong and the Design Department of the Museum of Fine Arts have been instrumental in conceiving the installation plan for the exhibition. I am delighted that Tom Wong has continued as the designer of the exhibition at The Asia Society Galleries and has adroitly accommodated my wish that these objects be placed at the level at which they were intended to be seen.

When I joined The Asia Society Galleries, it was clear that being a director while maintaining the curatorship of this project would be difficult. This exhibition would not have been possible without the support and hard work of the dedicated Galleries staff. Denise Leidy has been involved with the curatorial and design aspects of the exhibition. Amy McEwen has coordinated complex shipping arrangements, and Richard Pegg has maintained the status of all loans and assisted with registrarial and installation details. As usual, Mirza Burgos has not only kept up with the frantic pace of this project but also with all the other aspects of my directorial duties. Becky Mikalson began the complex process of publication of this catalogue, which was ably carried to fruition by Merantine Hens-Nolan and Alexandra Johnson. I would also like to acknowledge Kathleen Treat, Kathryn Selig, and Nicole Hsu for preparation of the manuscript. Special thanks go to our editors Patricia Emerson and Elisabeth Gleason Humez for performing miracles in a very short period of time. It has also been a pleasure to work with Bipin Shah of Mapin Publishing. He has made it possible for this catalogue to reach a worldwide audience.

There are several other members of The Asia Society staff who have worked on diverse aspects of the exhibition. Nicolas Schidlovsky helped with fund-raising; Janet Gilman and Heather Steliga Chen developed the publicity; and Nancy Blume coordinated educational activities. Our colleagues in the Performances, Films, and Lectures Department, Rhoda Grauer and Linden Chubin, developed public programs relevant to the exhibition. Marshall Bouton, Executive Vice President of The Asia Society, who has continually worked to heighten awareness of Indian culture in the United States, has nurtured the project with his customary attention to detail.

It has been a pleasure to share the exhibition and to collaborate with my colleagues at The Nelson-Atkins Museum, Kansas City, Missouri. Marc Wilson, Director and Chief Curator of Asian Art, and Dorothy Fickle, Associate Curator for Indian and Southeast Asian Art, were immediately receptive to the exhibition when we first approached them almost four years ago. As the dates for the exhibition were changed and delayed, they remained patient and committed. I am grateful for their continuing support.

Any major exhibition is possible only with support from a wide range of institutional and private lenders. I would particularly like to acknowledge the following individuals: James N. Wood, Yutaka Mino, The Art Institute of Chicago; Andrew Topsfield, Ashmolean Museum, Oxford; Rand Castile, Terese Tse Bartholomew, Asian Art Museum of San Francisco; J. R. Knox, Sir David Wilson, The British Museum; Robert T. Buck, Amy Poster, The Brooklyn Museum; Millard F. Rogers, Jr., Ellen Avril, Cincinnati Art Museum; Evan H. Turner, Stanislaw Czuma, The Cleveland Museum of Art; Clarence W. Kelley, The Dayton Art Institute; Lewis Sharp, Ronald Y. Otsuka, The Denver Art Museum; Earl A. Powell III, Pratapaditya Pal, Janice Leoshko, Los Angeles County Museum of Art; Philippe de Montebello, Martin Lerner, Stephen

Kossack, The Metropolitan Museum of Art; Elizabeth Broun, National Museum of American Art, Smithsonian Institution; Milo Beach, The Arthur M. Sackler Gallery; Anne d'Harnoncourt, Stella Kramrisch, Nancy D. Baxter, Philadelphia Museum of Art; Eberhard Fischer, Museum Rietberg Zürich; T. Cuyler Young, Barbara Stephen, Royal Ontario Museum; James Godfried, The San Antonio Art Museum; Jay Gates, William J. Rathbun, Michael Knight, Seattle Art Museum; Katherine C. Lee, Joseph M. Dye, Virginia Museum of Fine Arts, Richmond; and John Guy, Deborah Swallow, Victoria and Albert Museum.

I would also like to acknowledge the collectors who agreed to part with their pieces for the exhibition: Marilynn Alsdorf, Amita and Purnendu Chatterjee, Berthe and John Ford, Mr. and Mrs. Nathan L. Halpern, Tom and Margo Pritzker, Frank C. Russek, Mr. and Mrs. Joel Shapiro, Dee and Richard Sherwood, Marianne and Stanley Snider, Doris Wiener, and two lenders who wish to remain anonymous. Others who have been helpful are Carlton Rochelle of Sotheby's (New York) and Jane Thurston-Hoskins of Spink & Son, Ltd., London. Patrick George provided the drawings for the catalogue and the exhibition and Joseph Ascherl was the mapmaker.

In India I received invaluable help from the National Museum, New Delhi, staff, especially Dr. R. C. Sharma and Mr. L. A. Narain, in coordinating all of the Indian loans. My sincere thanks to them and to all colleagues at the lending museums in India for sharing these important sculptures with the people of New York and Kansas City. Bhaskor Ghose, Joint Secretary of Culture for the Government of India, has provided unflagging support and has helped in obvious and subtle ways to facilitate the loan process. I should also acknowledge the timely and enthusiastic support of The American Institute of Indian Studies in New Delhi and Varanasi.

It is doubtful that this exhibition could have been realized without generous funding. The Indo-U.S. Subcommission on Education and Culture supported my research trips to India. I would especially like to thank Ted M. G. Tanen and Reba Perez for their continued and enthusiastic help. The National Endowment for the Humanities provided generous planning and implementation grants and showed enormous patience when we encountered delays. The National Endowment for the Arts and the Getty Trust have provided additional funds for the exhibition and the accompanying catalogue. Air India has helped us immensely with the transport of Indian loans and international travel. Mr. and Mrs. Leon Polsky, in their customary fashion, have generously supported the lecture series in conjunction with the exhibition. The ongoing support from The Starr Foundation, the Arthur Ross Foundation, and the Friends of The Asia Society Galleries for our exhibition program is gratefully acknowledged.

Last, but not least, I would like to express my deep gratitude to Robert Oxnam, President Emeritus of The Asia Society, who has not only believed in the project but has endured my hectic schedule of the past several months.

Vishakha N. Desai
Director, The Asia Society Galleries

In addition to the above-mentioned individuals and institutions, I would like to thank those in India who not only facilitated my research but also acted as gracious hosts to make my time there a constant delight. First among these are the Vyas and Vasant families of Ahmedabad—my family in India. The American Institute of Indian Studies in Delhi, under Dr. Pradeep Mehendiratta, provided both financial and administrative support for my dissertation research, which laid the groundwork for much of this exhibition and catalogue. My academic advisor in India, Dr. Shridhar Andhare, Director of the Lalbhai Dalpatbhai Museum in Ahmedabad, was a constant source of encouragement and good advice, and the staffs of both the Lalbhai Dalpatbhai Museum and Institute of Indology have been wonderful. The staffs of the Departments of Archaeology in Rajasthan, Madhya Pradesh, and particularly Gujarat have provided invaluable assistance over the years. I am grateful to M. A. Dhaky at the American Institute of Indian Studies Center for Art and Architecture in Varanasi as intellectual exemplar and for the resources that he and the staff of the Center so diligently assembled. The extraordinary photographic archive produced by the Center and reproduced at the University of Pennsylvania was the single most important tool for determining the region and chronology of loose objects. Without it this catalogue would have been impossible.

I thank Miss Kanta Bhatia, South Asia Bibliographer at Penn, who ably administers the archive as well as other crucial library resources, and the members of the History of Art Department for their unflagging support. I am indebted to my fellow Penn students, Mr. Ajay Sinha and Ms. Katherine Hacker, for the many probing conversations—both in the classroom and coffee shop.

Mr. Wu Tung and the staff of the Asiatic Department at the Museum of Fine Arts, Boston, have not only tolerated my absences but have been a source of constant encouragement. To Dr. Michael Meister—academic advisor, mentor, and friend—the debt is clear. And to Dr. Vishakha Desai, who not only conceived of this exhibition and made it a reality, but also allowed me to participate so thoroughly, thanks! Finally I thank my family in Rhode Island and New York, *ad aeternum.*

Darielle Mason
Asiatic Department, Museum of Fine Arts, Boston

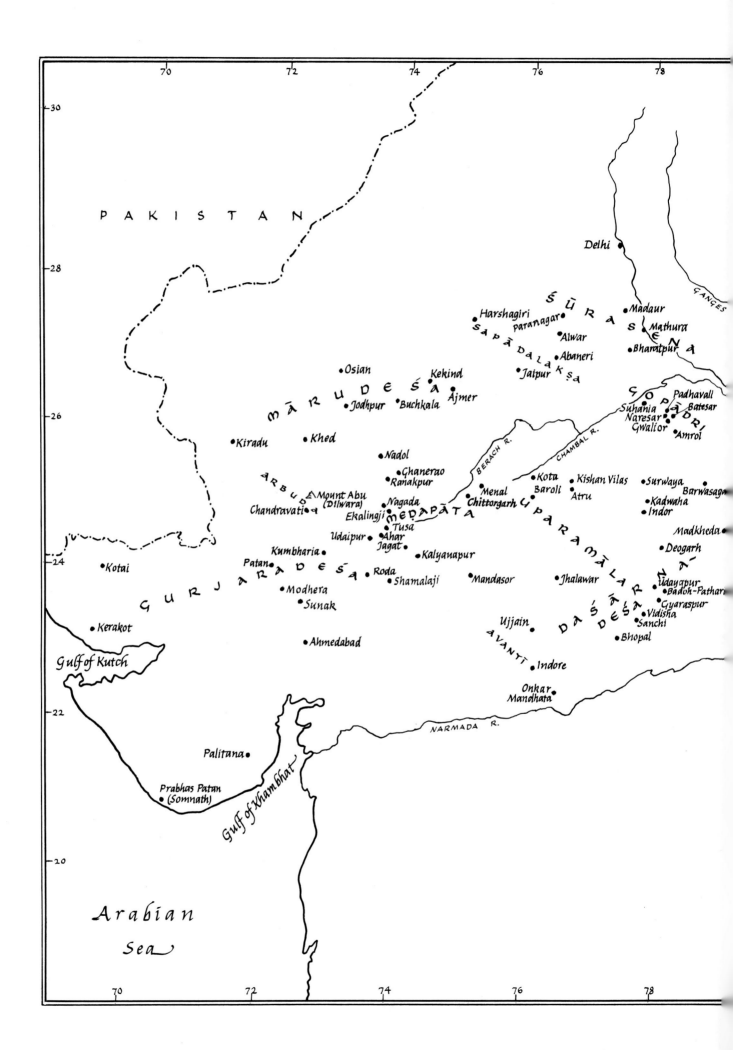

PAKISTAN

GANGES

Delhi

ŚŪRASENA

Harshagiri
paranagar
Madaur
Mathura
Alwar
SAPĀDALAKṢA
Abaneri
Bharatpur
Jaipur

Osian
Kekind
Ajmer

GOPĀDRI
Padhavali
Batesar
Suhania
Naresar
Gwalior
Amrol

MĀRUDEŚA

Jodhpur
Buchkala

Kiradu
Khed

Nadol

Ghanerao
Ranakpur

BERACH R.
CHAMBAL R.

Kota
Kishan Vilas
Surwaya
Barwasagar

ARBUDA
Mount Abu
(Dilwara)
Nagada
Menal
Baroli
Atru
Kadwaha
Indor

Chandravati
Ekalingji
MEDAPĀTA
Chittorgarh
UPARAMĀLA
Madkheda

Tusa
Udaipur
Ahar
Jagat
Kalyanapur
Deogarh

Kumbharia
Roda
DAŚARNA
Udayapur
Badoh-Pathari

Patan
GURJARADEŚA
Shamalaji
Mandasor
Jhalawar
Gyaraspur

Modhera
Vidisha
Sanchi

Sunak
Ujjain
Bhopal

Kotai
AVANTI
Ahmedabad
Indore

Kerakot

Gulf of Kutch

Onkar
Mandhata

NARMADA R.

Palitana

Prabhas Patan
(Somnath)

Gulf of Khambhat

Arabian
Sea

16

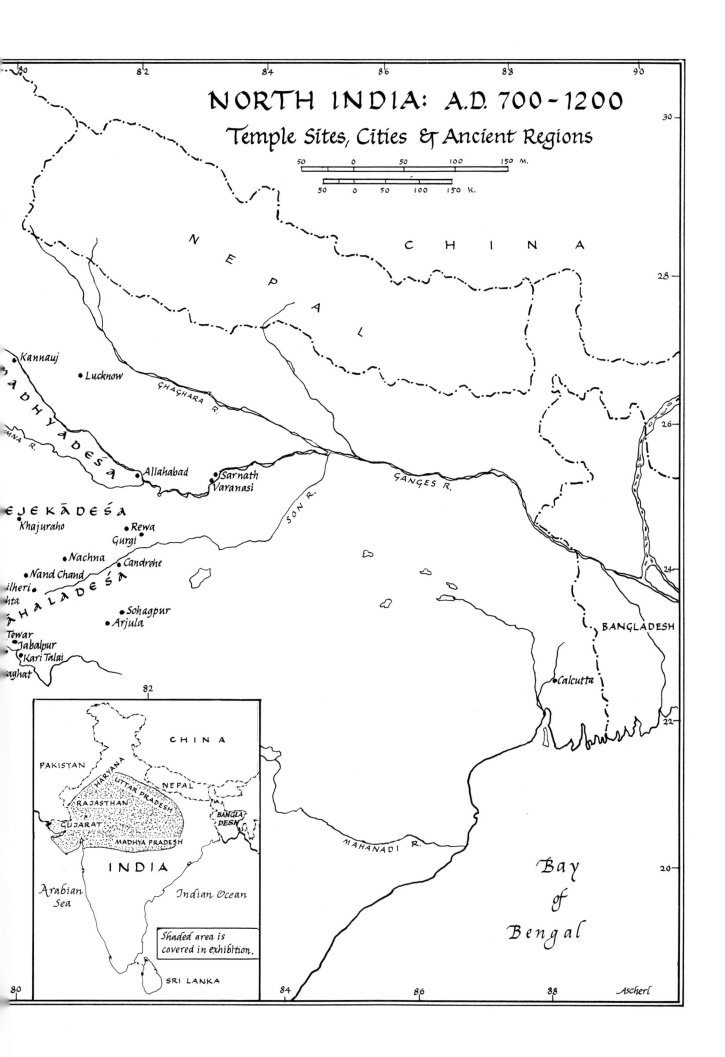

NORTH INDIA: A.D. 700–1200
Temple Sites, Cities & Ancient Regions

50 0 50 100 150 M.

50 0 50 100 150 K.

N E P A L

C H I N A

Kannauj

Lucknow

MADHYADEŚA

GHAGHARA R.

MNA R.

Allahabad

Sarnath
Varanasi

GANGES R.

SON R.

EJEKĀDEŚA

Khajuraho

Rewa
Gurgi

Nachna

Candrehe

Nand Chand

ilheri

ḥta

ĀHALADEŚA

Sohagpur

Arjula

Tewar
Jabalpur

Kari Talai

aghat

BANGLADESH

Calcutta

CHINA

PAKISTAN

HARYANA

UTTAR PRADESH

NEPAL

RAJASTHAN

BANGLA-
DESH

GUJARAT

MADHYA PRADESH

INDIA

Arabian
Sea

Indian Ocean

*Shaded area is
covered in exhibition.*

SRI LANKA

MAHANADI R.

Bay
of
Bengal

Ascherl

17

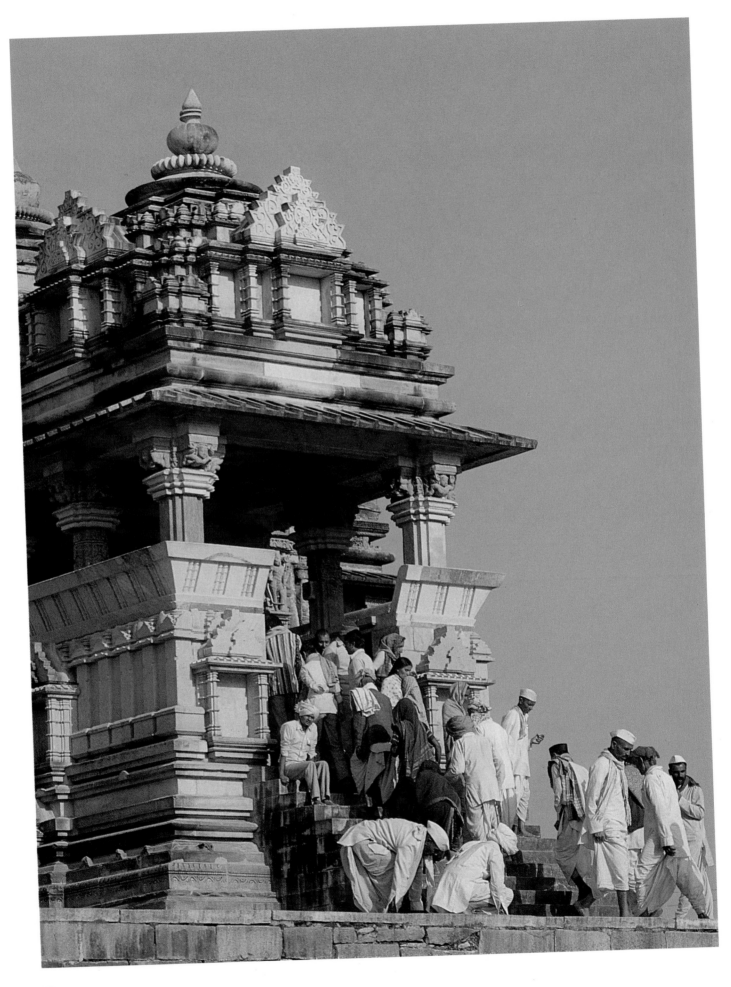

Beyond the Temple Walls
The Scholarly Fate of North Indian Sculpture, A.D. 700–1200

Vishakha N. Desai

For a worshiper in India, the temples, along with the images on their walls and in their interiors, regardless of their scale or age, articulate the spirit of the enshrined deity in the sanctum in prescribed ritual ways. Ascending the steps (Fig. 1) and walking through an archway, the worshiper enters the sacred interior space (*maṇḍapa*) and begins the personalized veneration of the central deity in the innermost, darkest part of the temple, the "womb chamber" (*garbhagṛha*). By performing some of the ritual activities—ringing the bell; chanting; offering flowers, food, and milk; or lighting the lamps—the worshiper enlivens the spirit of god and hopes to forge an active personal relationship with the central deity. A *darśan* of the deity—to see him and to be seen by him—remains one of the fundamental principles of Hindu worship to this day (see Fig. 2).[1]

Another important ritual for the worshiper is the circumambulation of the temple exterior, an act through which one experiences some of the broader conceptual and architectural meanings of the temple and the role of the plethora of sculptures that grace its exterior (see Fig. 3). Even a casual, nonworshiping visitor is struck by the elaborate arrangement of sculptures on temple exteriors and their less profuse presence in the darker inner halls. While one may not grasp all of the cosmological meanings, iconographic orders, or aesthetic subtleties of the forms, many of these characteristics are foregrounded by the very placement of the sculptures.

In direct contrast to this experience of temple sculptures in situ, are the instances in which a visitor encounters the same forms as individual entities in a museum. He or she is baffled by the complex iconography as well as the figures' exaggerated limbs and contorted positions that defy the laws of human anatomy. Many forms of art become decontextualized in the museum setting. However, when viewed discretely, temple sculpture from north India, dating from about A.D. 700 to 1200 (often referred to as the "medieval" period), suffers most gravely.[2] This is due to the fact that, to a greater degree than almost any other type, this type of sculpture was designed as an integral part of an architectural whole, to be seen and understood as a component performing a cosmological function, enabling one to visualize the "manifested multiplicity" of the divine (see Fig. 4).[3]

Indeed, it is difficult to do justice to these elaborate carvings of divine, semidivine, human, and natural forms when seen in isolation. How do we bring the context of the whole to bear on the part that we see in a museum setting? How do we develop a methodology for the study of such sculptures that can take into account their original placement and function in the temple architecture as well as their enormous visual and stylistic diversity? These are difficult but answerable questions. The fact that they are rarely raised is reflective of the dearth of comprehensive scholarship on the subject.

Fig. 1
Worshipers at the entrance of Kandariyā Mahādeva temple, Khajurāho, Madhya Pradesh, about A.D. 1025–50.

The general tendency to view these sculptures as inferior to and less worthy of serious study than those that predate them is deeply rooted in the scholarship of Indian art. As suggested by Professor Chattopadhyaya's essay, the relative lack of interest in the art and culture of early medieval north India is by no means an isolated phenomenon. It is well matched by a similar disdain for the historical developments of the period.[4] Beginning with the earliest nineteenth-century scholarly literature on Indian art,[5] it is evident that sculpture on the whole was considered less important than architecture, and within that hierarchy, sculpture dating from the sixth century onward was not even worthy of much discussion.[6] The earliest writers on the subject, from James Fergusson and Alexander Cunningham to James Burgess, were all Englishmen with the sensibilities of the Victorian age who belonged to what can be characterized as the "archaeological group."[7] Although sufficiently enlightened to look at the architectural wonders of the early Buddhist tradition, they were unable to appreciate the unabashed sensuality and iconographic complexity of the medieval sculptural forms that seemed to be completely antithetical to the prevalent neoclassical Western sensibilities of balance, harmony, and representational order. In fact, writers such as Burgess and Cousens, generally quite interested in Indian architecture, casually referred to the medieval representations of gods as "monstrous shapes."[8]

This nineteenth-century neoclassical prejudice against later sculptural forms is abundantly clear in the often quoted remarks of John Ruskin, made in his "Two Paths" lectures in 1859.

> It is quite true that [the] art of India is delicate and refined. But it has one curious character distinguishing it from all other art of equal merit in design—*it never represents a natural fact*. It either forms its compositions out of meaningless fragments of colour and flowings of line; or if it represents any living creature, it represents that creature under some distorted and monstrous form. To all the facts and forms of nature, it willfully and resolutely opposes itself; it will not draw a man, but an eight-armed monster.[9]

Even George Birdwood, who was generally very appreciative of the contributions made by Indian artisans, showed discomfort with temple sculpture in statements such as the following: "The monstrous shapes of the *purāṇic* deities are unsuitable for the higher forms of artistic representations."[10]

The English scholars writing about Indian architecture in the nineteenth century could express enthusiasm for such deceptively simple forms as the *stūpa* or the early caves not only because these forms were quite distinct from Western architectural tradition but also because certain elements—such as the nave in the shrine halls (*caitya*) of the cave temples—appeared to exhibit some degree of Western influence or connection. The sculpture, on the other hand, in its persistent representation of the human body, invited direct comparison with the prevailing neoclassical tradition. Yet, Indian sculptures, especially those dating from the seventh century on, could not be more different from their neoclassical counterparts. Thus, on formal and aesthetic grounds, medieval sculpture from north India could not possibly have been appreciated by the early Western writers who sought to compare the best of Indian art with classical art or to attribute such qualities to the influence of Western art.

Several other tendencies of these early scholars also proved to be detrimental to the study of medieval temple sculpture. One was based on a rather curious "theory of decay," which postulated that early Indian art emerged as a full-blown form that immediately went into a steady decline. Within this view, the treatment of volume in the early sculpture was equated with "natural" and "real" and was accordingly judged "better." The articulation of the relationship between different parts of the body in a "naturalistic" manner was preferred to the more abstract rendition of body parts in the later sculpture. As stated by Ludwig Bachhofer in his study of early Indian sculpture, "It is the capacity to conceive the body as something organically grown, as a totality, which distinguishes the early Indian art

Fig. 2
Worship in the inner sanctum of Śiva temple (Yoginī temple complex), Bherāghāt, Madhya Pradesh, 11th century.

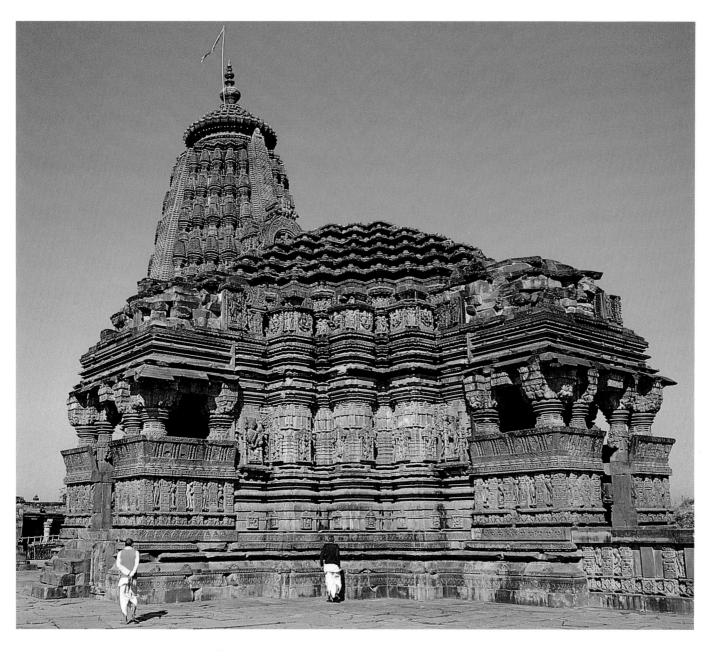

from that of the later centuries."[11] Since this was completely contrary to the principles on which the medieval Indian sculptures were created, it is quite natural that they would be ignored or condemned by the early scholars.

The tendency to compare Indian sculpture with Western sculpture and to value those styles that suggested Western influence over Indian norms also precluded any serious consideration of later Indian sculpture in the early decades of this century. Thus, the preference for the Gandhara style of Buddhist art from the second and third centuries, because of its close relationship to the Greco-Roman world at the beginning of the Christian era, is clearly visible in the writing of the period. This preoccupation with possible Western influence is so palpable that at times scholars begin to look for Western connections if they like a particular style, the rationale being that if something good was being done in India at all, it must have been due to foreign influence.

Yet another characteristic of early twentieth-century scholarship was to study the sculpture simultaneously as a representation of Indian life and as the symbol of eternal reality or truth, expressing an unbroken tradition. According to this romantic and exoticizing view of Indian art, it was felt that "the European method of artistic exegesis, applied to India, will only provide more material for museums, the hobbies of the collector, and for dealers in antiquities."[12] The

Fig. 3 *above*
Udayeśvara temple, Udayapur, Madhya Pradesh, about A.D. 1080.

Following pages
Fig. 4
The exterior wall of Ambikāmātā (Devī) temple, Jagat, Rajasthan, about A.D. 961.

21

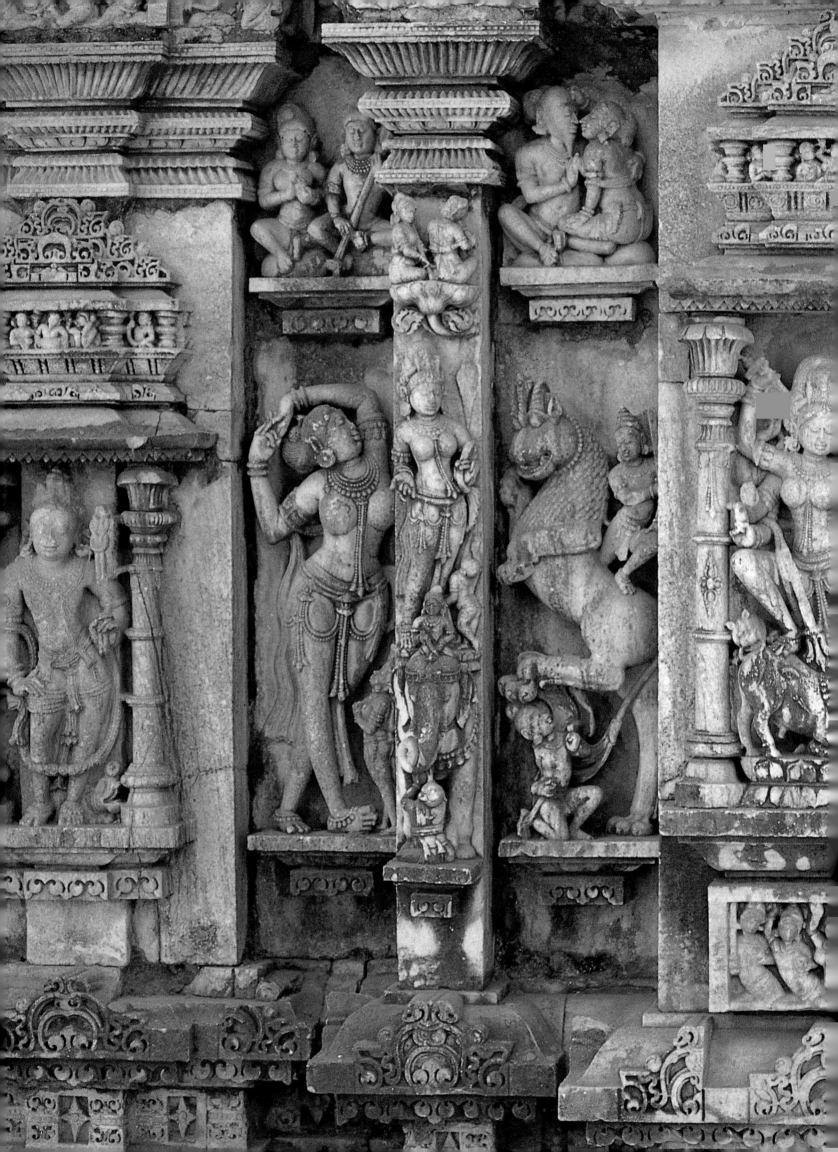

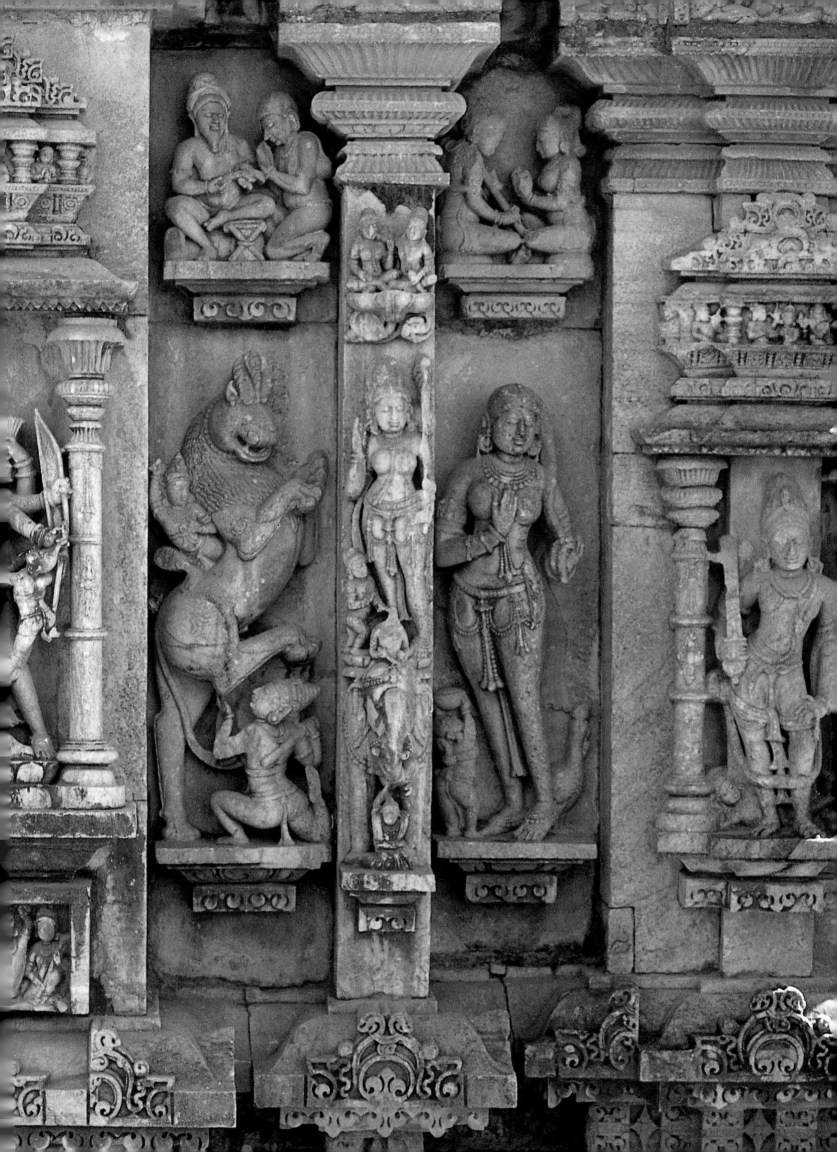

proponents of this view rejected the tendency to develop a chronological classification of sculptural styles on the grounds that such periodization of art is inextricably linked with the market value of the given object and therefore morally corrupt. Such early aversion to studying the changing qualities in Indian art has also hobbled the historical study of sculptural forms from the later periods. This romantic resistance to historical study of Indian sculpture was part of a larger, fairly prevalent attitude in the early decades of this century that emphasized the idealistic—and essentially symbolic and transcendental—nature of Indian art and served to criticize the prevailing Victorian prejudice (as exemplified by Ruskin) against it. But even this group of scholars, in its search for the perfect visualization of the divine essence, did not see much value in later sculpture. E. B. Havell can be seen as the leading representative of this group. As early as 1908, he vexed eloquently about the essential qualities of Indian art in his *Indian Sculpture and Painting*.

> Indian art is essentially idealistic, mystic, and transcendental. . . . [It] appeals more to the imagination and strives to realize the spirituality and abstraction of a supra-terrestrial sphere.[13]

In this context, Havell's preference was for such earlier abstracted sculptures as those at Sanchi. He even lamented the "decline" of Indian sculpture as perceived in the seated sculpture of the Buddha from Sarnath, now universally acknowledged as one of the masterpieces of Indian sculpture from the Gupta period in the fifth century. He described it as an example of "weak sculpture" because of its artistic tendency "to render the ideal beauty of the perfect Yogi with the poverty of plastic technique" that showed "flabbiness of surface modelling and bad articulation of the joints."[14] Havell and some of his contemporaries such as Bachhofer saw the sculptures of the tenth and eleventh centuries as forms in which sensualism was forever divorced from spiritualism and therefore not worthy of serious consideration.[15]

Ananda K. Coomaraswamy can be characterized as the most distinguished leader of the scholars who eloquently promoted the idealistic and essentially religious basis of Indian art. As Partha Mitter has perceptively argued, it was Coomaraswamy and his contemporaries who first provided the insight that Indian art could not be properly appreciated within the categories defined by Western art, especially those governed by Renaissance taste.[16] At the same time, by promoting an essentialist or idealist viewpoint in contrast to the prevailing Western notions of art, even Coomaraswamy, who was more than capable of judging and analyzing art-historical developments, by and large shied away from articulating fully the rationale for changes in Indian art forms. In his major survey, *History of Indian and Indonesian Art,* Coomaraswamy barely discussed the development of north Indian medieval temple architecture and hardly mentioned the sculptural tradition of the period, even though he acknowledged that the period was the "culminating age of Hindu civilization."[17]

Stella Kramrisch, through her seminal publication, *The Hindu Temple,* was one of the first scholars to address in detail the development of north Indian temple forms and their relationship to sculptural styles.[18] She argued perceptively that the visual basis for most Indian temples was sculptural rather than architectural. When structural and architectural problems were being solved, sculptural effects were uppermost on the minds of the builders. Her most important contribution to the study of north Indian sculpture is her clear articulation of the close relationship between architectural developments and sculptural forms and her observation that medieval sculptures need to be looked at from the perspective of architectural logic rather than as individual units. While she discussed some of the textual sources for the iconographic program of the temple structures and emphasized the architectural context of isolated sculptures, on the whole, her penchant for the spiritual and philosophical dimensions of the temple forms overpowers her brief discussion of stylistic or historical developments. In this sense, Kramrisch is closely related to the "transcendental" group of scholars that included Coomaraswamy.

One of the direct results of the search for the eternal essence of Indian art was advancement in the field of iconographic studies of Indian sculpture. In this arena, more often than not, Indian scholars distinguished themselves by their careful research of Indian texts. However, even such mammoth iconographic works as the volumes by Gopinatha Rao did not entail the study of the actual forms or their historicity. Unfortunately, the few historical studies of specific iconographic forms that were conducted by scholars, such as Jouveau-Dubreuil and J. N. Banerjea, did not focus on the images in the northern-central regions of India, leaving the sculptures under consideration in this exhibition completely out of the scope of their work.[19]

In the last thirty years, a great deal of new work has been done on Indian sculpture; yet north Indian temple sculpture, from one of the most prolific periods of production, has not received a great deal of attention from scholars. While some of the reasons for this apparent neglect can be traced back to the foundations of the late nineteenth- and early twentieth-century methodology outlined above, there are also other factors that have impeded the cause of comprehensive scholarship of medieval Indian sculpture. One of the reasons for this lack is the unfortunate division in contemporary scholarship between architecture and sculpture. While many art historians in the academy study specific temple sites and the evolution of architectural forms in north India, the general tendency is to avoid dealing with related loose sculptures that might be found in public and private collections. As a result, we know much more about the art-historical developments of such temple parts as the superstructure (*śikhara*) than we do about the sculptural programs of north Indian temples. On the other hand, the study of isolated medieval sculptures usually takes the form of exhibition or permanent collection catalogues, which emphasize formal changes and iconographic meanings of Indian sculpture but avoid the issue of architectural context.[20] This tendency to deal with medieval sculptures as individual works of art in the Western post-Renaissance sense, rather than as elements of a singular whole, namely the temple itself, has resulted in another problem. By avoiding the issue of original architectural and geographic context, museum curators and exhibition organizers have not made use of the rich abundance of materials in situ, resulting in a relatively poor chronological and regional classification of the individual sculptures. Even in the general publications on Indian art or on Indian sculpture in particular, the preference continues to be for the earlier periods, its culmination point being the Gupta-period sculpture in the fifth and sixth centuries. This bias is clearly evident in the first edition of the widely distributed survey book *The Art and Architecture of India* by Benjamin Rowland.[21] Although five sections and nineteen chapters are devoted to India, only one chapter addresses the architecture of the medieval period, which encompassed more than seven hundred years, and scant mention is made of the period's sculptures. In the new, enlarged edition of the survey, entitled *The Art and Architecture of the Indian Subcontinent* and authored by J. C. Harle, this obvious omission is corrected by including a detailed discussion of post-Gupta architecture and sculpture in one chapter and of the later, medieval period in another. However, the greater emphasis continues to be placed on such architectural developments as the *śikhara,* the ground plan, and the outer walls. The sculpture is discussed in a somewhat disparaging tone, as demonstrated by the sentence that ends the discussion of post-Gupta sculpture of the ninth and tenth centuries. "Beautifully integrated, eminently sculptural, unmannered though they are, we miss the Gupta magic, its naturalism, and even its mannerisms."[22] (see Fig. 5)

Another recent survey, *The Art of Ancient India* by Susan Huntington, also attempts to redress earlier neglect by devoting several chapters to the region and period. Huntington very carefully avoids making value judgments about later sculptures while making clear that they are quite different from the earlier material in both form and intent. Thus, she describes the sculptures on the Kandariyā Mahādeva temple at Khajurāho in the following manner.

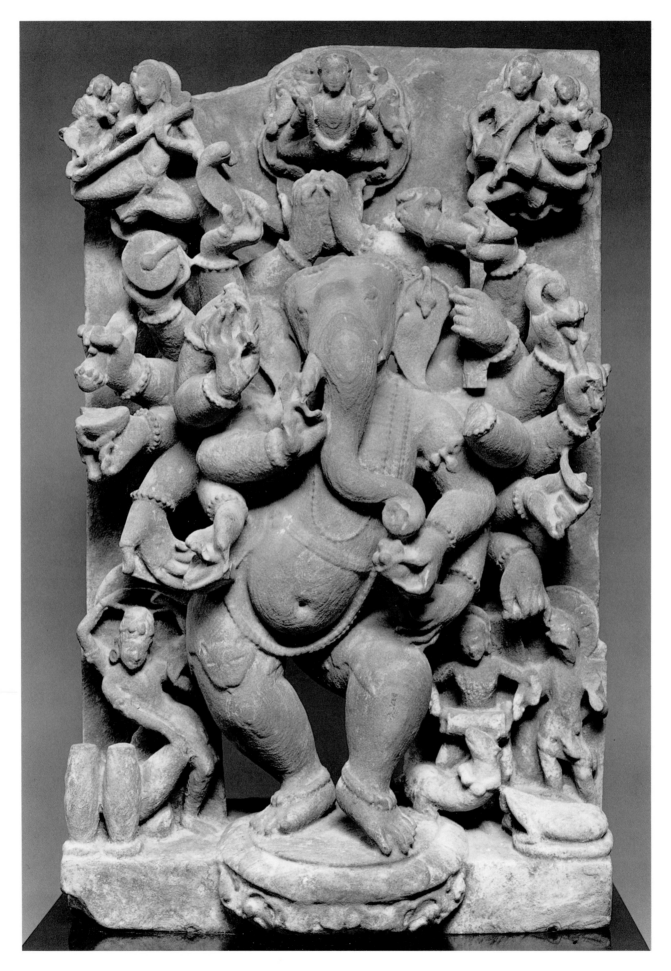

Over six hundred sculptures on the exterior and two hundred on the interior adorn the structure, and, indeed, the carved pantheon that inhabits the walls of the monument represents the culmination of a trend in Hindu temple art that is traceable from the Gupta period. Sculpture now dominates the architectural form, so that even though the carvings are strictly relegated to precise locations on the monument, the effect of the sculpture is more overwhelming than that of the architectural forms themselves. Posed in accentuated postures, twisting and turning in space, these figures embody the movement and dynamism merely hinted at in the repose and introspection of Gupta-period carvings. The hardening of facial features, elaboration of detailing of jewelry and headdresses, and deeper carving than was visible in [earlier] Gurjara–Pratīhāra monuments here reaches its final form.[23]

While Huntington also discusses a number of individual examples, they often remain isolated. Indeed, it is difficult to comprehensively delineate the development of sculptural styles as they relate to architectural forms in a specific region or time frame in such a broad survey. This may be partially due to the above-mentioned tendency of Western art-historical scholarship to separate the study of architecture from that of sculpture, especially for post-Renaissance periods. It could be argued that in keeping with the development of art history as a discipline, which, until recently, focused primarily on the study of form and style, there has been a steady focus on those Indian sculptures that can be studied as individual, singular objects. Clearly, the Gupta-period sculptures fit this concept more neatly than any other group, and thus continue to be judged as the highest form of aesthetic expression in India (see Fig. 6).

The fact that there are numerous publications on fourth- and fifth-century Gupta art whereas no publication exclusively treats north Indian medieval sculpture in any depth reflects the prevailing notion that the latter need not be the subject of serious study.[24] Almost all of the books on Gupta art emphasize that the art of the period was a culmination of all the artistic processes that came before it, and that it determined the development of Indian art and culture for succeeding centuries. Identifying the Gupta age with the classical phase in Western art, many scholars consider the former as a golden age of Indian art and culture, leading to such statements as the following: "The Gupta age represents the classic phase of Indian civilization in so far as it inspired to create a perfect, unsurpassable style of life."[25] The acknowledged beauty and sensual spirituality of Gupta sculpture notwithstanding, it is fair to say that the sculptural tradition from the post-Gupta period has suffered from the weight of the international reputation of its predecessor. Indeed, it is very difficult to establish a functional conceptual framework for the study of later sculpture when almost every scholar continues to write about Gupta material in the tradition so well articulated by Ananda Coomaraswamy.

> With a new beauty of definition it establishes the classical phase of Indian art, at once serene and energetic, spiritual and voluptuous. The formulae of Indian taste are now definitely crystallized and universally accepted; iconographic types and compositions, still variable in the Kuṣāṇa period, are now standardized in forms whose influence extended far beyond the Ganges valley, and of which the influence was felt, not only throughout India and Sri Lanka, but far beyond the confines of India proper, surviving to the present day.[26]

It is interesting to note that much of what we call Gupta art was actually created in the second half of the fifth century, a period of definite decline for the Gupta rulers whose principal reign came to an end in A.D. 467. This desire to associate an artistic style with an imperial age, even when the two do not coincide, can be directly connected with historians' tendency toward defining historical and cultural developments in imperial and dynastic terms and

Fig. 5
Twenty-armed Gaṇeśa (No. 17).

27

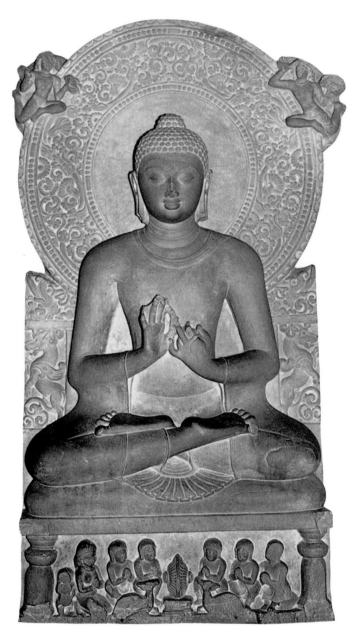

characterizing periods following great empires exclusively within a framework of decay and factionalized regionalism.[27] One exception to this general categorization of medieval northern Indian art, particularly sculpture, is the suggestion by Joanna Williams in her conclusion to *The Art of Gupta India* that the changes seen in the post-Gupta or early medieval-period art were not simply a decline in quality or craftsmanship, but were deliberate and reflective of the change in the very conception of the role of art.

> Thus architecture became more complex and coherent as a religious experience, and sculpture was integrated into that larger purpose. This new role led to the patterning of detail, linking different parts of the temple's decor. It also led to the depiction of less credible human anatomy, the creation of less self-sufficient sculptural compositions and the organization of imagery in more inclusive iconographic programs.[28]

Professor Williams further argues that if Gupta art has remained aesthetically attractive to Western audiences, it is precisely because there is a greater aesthetic basis for this particular style of art in India. In contrast, the religious, ritualistic, and architectural function of a temple in early medieval India determined the

Fig. 6
Seated Buddha, Sarnath, Uttar Pradesh, late 5th century. (Sarnath Museum)

aesthetic quality of the sculpture to a much greater extent than was apparent in Gupta India. To put it another way, when Indian sculpture is viewed in isolation and not in situ, north Indian medieval sculpture is bound to suffer in our estimation precisely because the traditional museological approach to this material diminishes the very essence of its existence—to function as an integral part of a more comprehensive spatial experience and cosmological system.

This presents an interesting dilemma for the organization of this exhibition. Ideally, these sculptures should never have been separated from their original edifices since that would be the most appropriate way to appreciate and understand them. But the reality is something quite different. Many of the temple and religious structures from whence these images came have been destroyed by battles and the ravages of time. Some images have long been divested of their original architectural context, and others may have been removed more recently. Whether it is appropriate or not, these sculptures can now be seen only as singular entities and are appreciated as individual works of art by private collectors and museum visitors alike. In other words, as articulated by a number of scholars in recent years, these decontextualized sculptures have acquired the new aesthetic aura essential to their present reality.[29] Depending on one's political and philosophical bias regarding notions of "universal aesthetics," one could argue that these two "realities" of medieval sculpture—past contexts and current re-presentations—are mutually exclusive and cannot be explored simultaneously. But, as Irene Winter states, if we claim that one of the most fundamental reasons for the existence of an art museum is to understand other cultures through art forms, then it is imperative that both the aesthetic reality of an art object as well as its original meaning and function be properly articulated in the institutional setting.[30] Indeed, one of the challenges for exhibitions such as this is to sustain the tension between the individuality of the object in a museum context and its role as a referent to a grander, architecturally and cosmologically oriented whole.

Both the exhibition installation and the catalogue are organized with this duality of intention. In the exhibition the objects are arranged within broad categories that suggest their original location and function in a temple. Thus, images that were intended for particular placement on temple exteriors are grouped in the first section, which consists of sculptures from the outer walls of north Indian medieval temples. Sculptures made for the interior of temple halls (*maṇḍapa*) and inner shrine doors constitute the middle section. The last section is reserved for the images that may have been placed as singular objects of worship in the inner sanctum (*garbhagṛha*). Of course, one of the difficulties in such an arrangement is the fact that it is not always possible to ascertain original architectural location of objects that have been separated from their edifices, and it is likely that some sculptures in the present exhibition are not placed appropriately. Nonetheless, such an arrangement emphasizes the fragmentary nature of the sculptures and suggests larger architectural and spatial associations. To the extent possible, the sculptures are exhibited at a height indicative of their original placement in an architectural setting. Hopefully, this departure from the usual museum practice of displaying works of art at eye level will not only heighten the viewer's awareness of the original function of the objects but also allows the objects to be viewed from the vantage point for which they were created. One of the reasons that north Indian medieval sculptures often fail to be appreciated in a museum setting is that many were created for specific locations in a temple, and their forms were appropriately compensated to be viewed properly from a particular point. The exaggerated limbs or awkwardly twisting forms of some figures, for example, have a very different impact when they are viewed from their original vantage. Thus, liberating the north Indian sculptures from the "tyranny" of eye-level viewing is also to allow the aesthetic essence of the singular objects to come through properly, while providing a sense of their original location.

On the other hand, the inclusion of photographs, architectural drawings, and an audiovisual presentation of temple worship is intended to subvert the singularity of the sculptures as museum objects and remind the viewer that the

fragments merely provide a clue to the architectural and cosmological whole.

In the catalogue, these two ideas—that the sculptures need to be scrutinized more closely as individual objects and as parts of a greater whole—are further developed in the essays by Darielle Mason and Michael Meister. Mason focuses on the more precise methodology for the stylistic and regional understanding of the development of north Indian medieval sculpture and its placement within the temple structure. As a complement to Mason's discussion of individual objects, Meister discusses the cosmological significance of north Indian temple forms and places the understanding of the sculptures within the larger architectural and philosophical framework.

It is hoped that the combination of the stylistic analysis of selected north Indian medieval sculptures and the discussion of their original placement and function will greatly advance scholarship. The next task, as mentioned by Partha Mitter in *Much Maligned Monsters,* is to go beyond the metaphysical and spiritual generalizations that infused the scholarship of the earlier generation and find fresh, new ways to look at religious, cultural, and social contexts of Indian art in human and concrete terms.[31] In keeping with this objective, the essays by Chattopadhyaya, Granoff, and Willis are intended to provide a broader multidisciplinary perspective to the study of temple sites as political, religious, and social centers in medieval northern India. Professor Chattopadhyaya gives a vivid sense of the fluctuating patterns of regional powers, their relationship to their spiritual mentors, and their need for legitimation of newly acquired power in the form of temple building. Professor Willis further discusses the nature of different levels of patronage of temple sites, and Professor Granoff provides a rare glimpse into the multifaceted experience of religion as described in contemporary religious literature. In doing this, she simultaneously goes beyond the metaphysical generalizations about the spiritual basis of Indian art and complements our conceptual understanding of the medieval temple's architectural form and sculptural decoration.

Needless to say, this is an ambitious task—to look at north Indian temple sculptures from both microscopic and macroscopic perspectives, to study them as objects with a complex stylistic and chronological framework, to view them as fragments of a cosmological whole as articulated in a temple structure, and ultimately to understand them from a more comprehensive historical and cultural perspective. It is hoped that this multilayered approach to the study of north Indian sculpture, while not providing all the answers, will at least serve as a solid foundation for future scholarship on the subject.

1. For a very clear and in-depth analysis of the concept of *darśan,* see Diana L. Eck, *Darśan, Seeing the Divine Image in India* (Chambersburg, PA: Anima Publications, 1981).

2. The term *medieval* is generally applied to this period because it is seen as the one following the "classical" period of the Gupta dynasty. As pointed out by Professor Chattopadhyaya in his essay, the appellation is often seen in inferior terms. Ironically, for the temple sculptures presently under discussion, the term *medieval* is architecturally quite relevant. Like the sculptures in medieval churches of Europe, Indian sculptures were integral parts of their architectural location.

3. The term *manifested multiplicity* is used and discussed in depth by A. K. Coomaraswamy in his essay, "An Indian Temple: The Kandariyā Mahadeo," first published in *Art in America,* vol. 35 (1947), reprinted in *Traditional Art and Symbolism: Coomaraswamy, 1. Selected Papers,* Roger Lipsey, ed. (Princeton, NJ: Princeton University Press, 1977), p. 10.

4. See the essay by B. D. Chattopadhyaya.

5. For a detailed discussion of the history of Western reaction to Indian art from the sixteenth century through the early twentieth century, see Partha Mitter, *Much Maligned Monsters: History of European Reactions to Indian Art* (Oxford: Clarendon Press, 1977).

6. For a detailed discussion on the historiography of Indian art, see Pramod Chandra, *On the Study of Indian Art* (Cambridge and London: Harvard University Press, 1983).

7. Mitter characterizes the early group of art historians as "archaeological" and "transcendental." See Mitter, op. cit., p. 256.

8. J. Burgess and H. Cousens, *Architectural Antiquities of Northern Gujarat* (London: T. Rubner & Co., Ltd., 1903), p. 31.

9. As quoted in Mitter, op. cit., p. 245, and G. H. R. Tillotson, *The Tradition of Indian Architecture* (New Haven, CT: Yale University Press, 1989), p. 36.

10. Tillotson, op. cit., p. 38.

11. Ibid., p. ix.

12. E. B. Havell, *Indian Sculpture and Painting* (London: John Murray, 1908), p. 41.

13. Ibid., p. 10.

14. Ibid., p. 28.

15. Ludwig Bachhofer, *Early Indian Sculpture,* 2 vols. (New York: Pegasus Press, 1929 reprint, 2 vols. in 1, New York: Hacker Art Books, 1972), p. vii.

16. Mitter, op. cit., pp. 278–80.

17. Ananda K. Coomaraswamy, *History of Indian and Indonesian Art*, reprint (New York: Dover Publications, 1965), pp. 105–09.

18. Stella Kramrisch, *The Hindu Temple,* 2 vols. (Calcutta: University of Calcutta, 1946).

19. For a detailed iconographic discussion of Indian sculptures, particularly from southern and eastern India, see Gopinatha T. A. Rao, *Elements of Hindu Iconography,* reprint (New Delhi: Motilal Banarsidass, 1968); and J. N. Banerjea, *The Development of Hindu Iconography*, 2d ed. (Calcutta: University of Calcutta, 1956).

20. Among the more recent publications on Indian sculpture are those by Stella Kramrisch, *Manifestations of Shiva* (Philadelphia: Philadelphia Museum of Art, 1981); Pramod Chandra, *Sculpture of India 3000 B.C.–1300 A.D.* (Washington, D.C.: National Gallery of Art, 1985); and Pratapaditya Pal, *Indian Sculpture,* vol. 2 (Los Angeles: Los Angeles County Museum of Art and Berkeley: University of California Press, 1988). It could be argued that one of the reasons for the neglect of architectural context of sculptures is to avoid the uneasy discussion about how the sculptures may have been removed from their original location.

21. Benjamin Rowland, *The Art and Architecture of India: Buddhist, Hindu, Jain* (Harmondsworth, Middlesex: Penguin, 1970) (paperback ed.).

22. J. C. Harle, *The Art and Architecture of the Indian Subcontinent* (Harmondsworth, Middlesex: Penguin, 1986), p. 157.

23. Susan Huntington, *The Art of Ancient India* (New York: Weatherhill, 1985), p. 479.

24. Among the books published on Gupta art in the last fifteen years are: Pratapaditya Pal, *The Ideal Image: The Gupta Sculptural Tradition and Its Influence* (New York: The Asia Society, in association with John Weatherhill, 1978); J. C. Harle, *Gupta Sculpture: Indian Sculpture of the Fourth to Sixth Centuries A.D.* (Oxford: Clarendon Press, 1974); and Joanna G. Williams, *The Art of Gupta India: Empire and Province* (Princeton, NJ: Princeton University Press, 1982).

25. H. Goetz, "The Gupta School" in *The Encyclopedia of World Art*, Massimo Palloting, ed., vol. 7 (New York: McGraw-Hill, 1959), quoted in Harle, op. cit., p. 8.

26. Ananda K. Coomaraswamy, *History of Indian and Southeast Asian Art*, as quoted in Pal, *The Ideal Image*, p. 13.

27. This is further elaborated by Professor Chattopadhyaya in his essay.

28. Williams, op. cit., p. 175.

29. For a more detailed discussion of the changing contexts of non-Western works of art, see Irene Winter, "Change in the American Art Museum: The Art Historian's Voice," in *Different Voices: A Social, Cultural, and Historical Framework for Change in the American Art Museum*, Marcia Tucker, ed. (New York: Association of Art Museum Directors, 1992); and Clifford Geertz, *The Predicament of Culture: Twentieth-Century Ethnography, Literature, and Art* (Cambridge: Harvard University Press, 1987).

30. Winter, op. cit., p. 39.

31. Mitter, op. cit., p. 286.

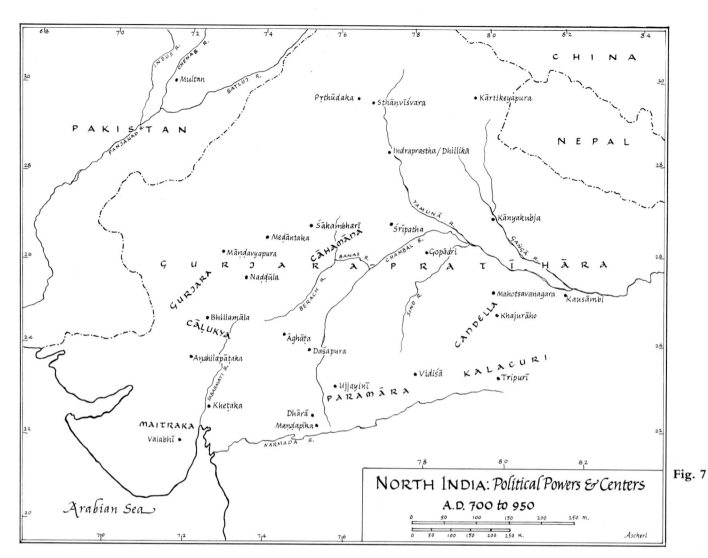

Fig. 7

NORTH INDIA: *Political Powers & Centers*
A.D. 700 to 950

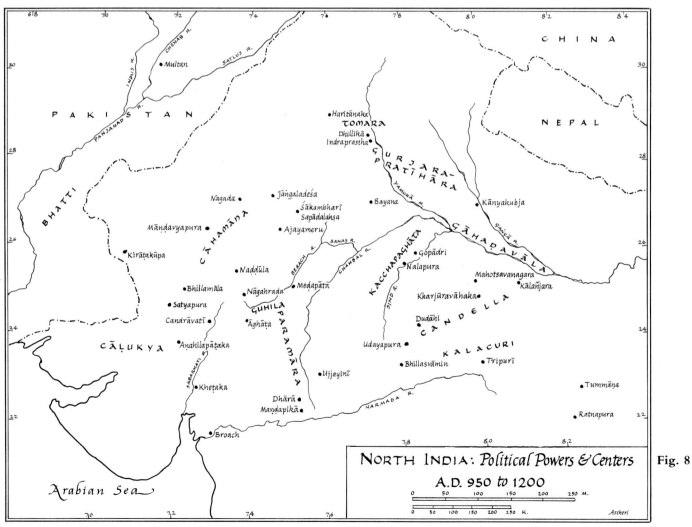

Fig. 8

NORTH INDIA: *Political Powers & Centers*
A.D. 950 to 1200

Historiography, History, and Religious Centers
Early Medieval North India, circa A.D. 700–1200

B. D. Chattopadhyaya

Historical Writings and the Image of Early Medieval North India

The bias with which north India between A.D. 700 and 1200 (see Figs. 7, 8) is generally viewed, both by writers and consumers of history, has been systematically perpetuated throughout the construction of its past and continues to cloud even the most recent accounts (Fig. 7). The portrayal of India's past, which began in the period of colonial domination, has had European history as a constant frame of reference. Whether in a colonial or Indian nationalist historiographic venue, contrivances are implicit in the use of such terms as *classical* or *feudal*. In organizing their data, either at the level of pan-Indian or regional history, historians have looked for periods that may be labelled "classical" and with which other phases of history may be contrasted.[1]

The image of the period A.D. 700 to 1200 has suffered equally through sharply contrasted historical approaches for several reasons. One is the tendency to equate the geographic boundary of India, even in an early context, with a single political entity, thereby viewing periods of extensive territoriality as high historic watermarks. By contrast, periods with comparatively minor states fail to fit the standard. For example, the period of the Maurya empire (late fourth to early second century B.C.) is often characterized as having been territorially extensive and centralized. The period that followed was marked by numerous autonomous centers of power. Consequently, despite a radically different characterization in recent times, the latter is often viewed as a "dark" period. Similarly, the period of Gupta rule (from the beginning of the fourth to the middle of the sixth century) is seen as a resurgence. Samudragupta, an early Gupta ruler who carved out a large territorial kingdom by doing away with a number of small political entities, has been hailed as an "Indian Napoleon."[2] This period is generally considered to be India's "golden" or "classical" age.[3] This characterization encompasses all aspects of early Indian culture as well.

Thus, for both imperialist and nationalist historians, the tendency has been to view post-Gupta society and culture as a deviation from the classical norm. It is often remarked that the fine elements of classical culture thinned out gradually and assumed decadent and purely regional shapes in later centuries.[4] It is not surprising, then, that the study of art and architecture from this period should suffer the same fate.

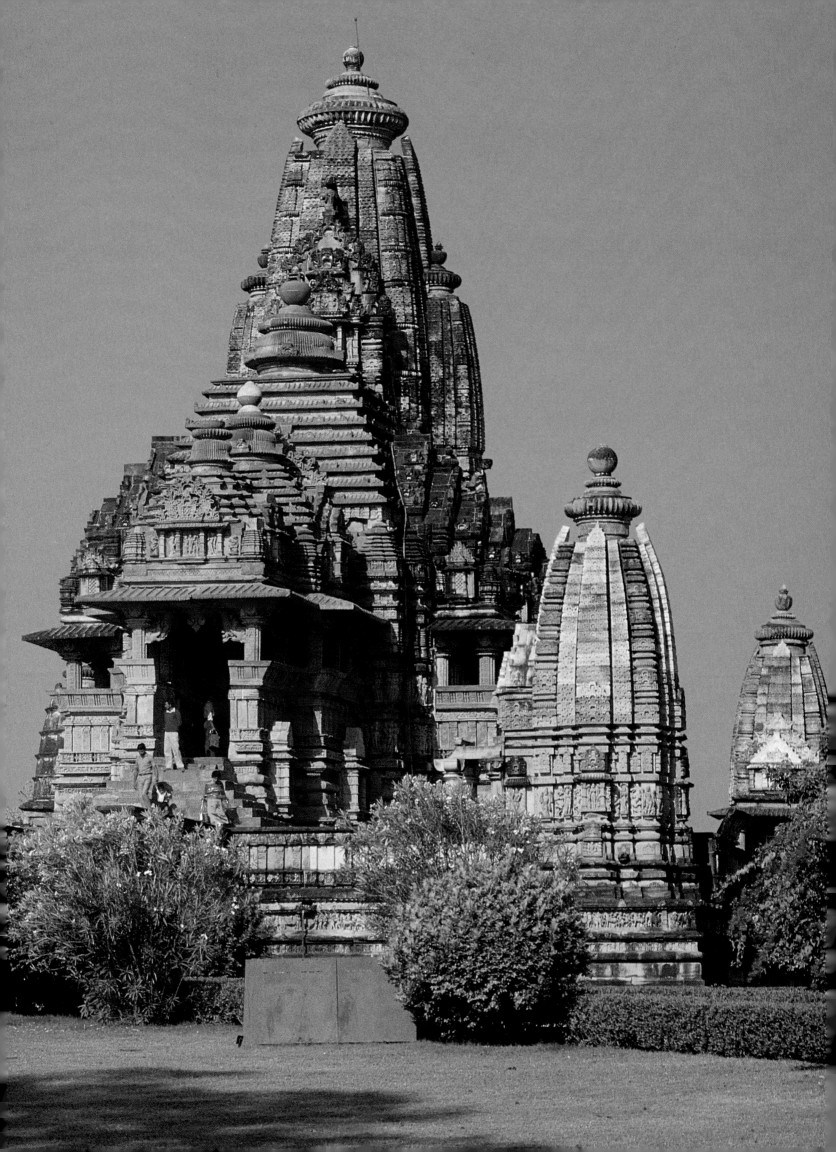

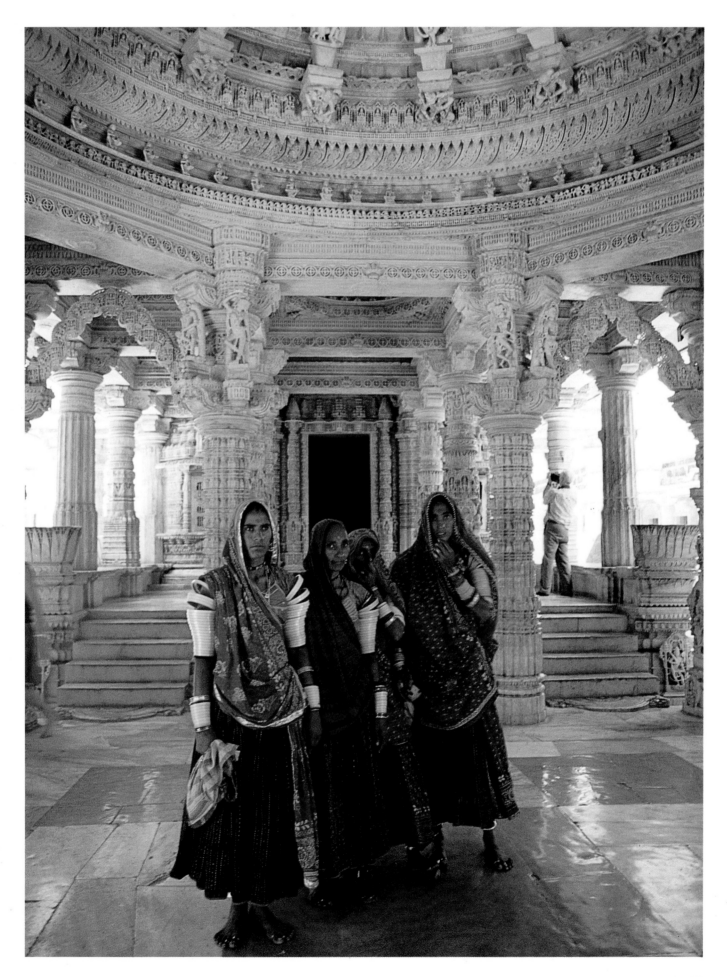

This view has acquired new dimensions in recent historical writings that posit the crystallization of a "feudal" society in early medieval India.[5] The imaging of this society closely approximates that of western Europe following the fall of Rome. On the Indian political scene, barbarians, such as the Hūṇas, make their appearance. The political map of the post-Gupta and particularly post-Harṣa period shows an abundance of mostly local kingdoms strewn throughout the subcontinent. In these highly hierarchic kingdoms, the monarch wielded only nominal power. The vassals of the king (mahāsāmantas), (sāmantas), and others down the scale exercised the actual power.[6]

Feudal social formation, of course, envisages a much more widely significant range of social change. It is stressed that prefeudal society was open, urbanized, and cosmopolitan. From the Gupta period onward, there was a shift toward a closed society and economy. Early Indian urban civilization, which reached its zenith during the Śaka-Kuṣāṇa period (from the first century B.C. to the third century A.D.) and displayed networks of wide-ranging territorial and intercivilizational contact, is seen to have declined from the Gupta period onward. Thus, the post-Gupta period supposedly saw increasing ruralization, the total localization of artisanal products, and the deterioration of the mercantile community.[7] The emphasis on the shift from urban to rural is reflected in the nature of early medieval culture as well. The typical urbanite of the "classical" age was the affluent city dweller (nāgaraka), whose refined culture is held up as a model to be emulated in Vātsyāyana's Kāmasūtra, a treatise not only on physical love but on cultured lifestyle as well.[8] By contrast, the elite of early medieval India had essentially rural bases and a radically different cultural orientation. Deprived of an urban milieu and patronage from a cross section of society, art activities came to depend essentially on the patronage of the rural aristocracy, thereby becoming increasingly localized and regionalized. The decadence of Hindu society in its "feudal" period comes through quite strongly in the assessment made by K. M. Panikkar almost four decades ago.

> Another problem that faces the student is the decadence which seems to have overtaken Hindu society in the period between the [eighth] and the [twelfth] centuries. That there has been a marked decadence over large areas *is well attested by facts.* Our architecture, literature, scientific thought, and all other spheres of activity proclaim loudly not only a decay of taste and interest, but a change of attitude which is truly remarkable. From the simple beginnings of the early temple pictures on the Bhārhut railings to the more elaborate structure of the extant temples of the Gupta period we have a natural development of considerable significance, vigorous and artistic but without any touch of sensuality. But in the [ninth] and [tenth] centuries, Hindu temple architecture in [north] India is overloaded with sculptures the beauty of which should not obscure the sensuality and often the obscenity of the themes portrayed. The Khajurāho and Orissa temples for all their magnificence testify to a *degeneration of the Hindu mind.* . . (italics added).[9]

The above quote is intended to show how closely a general notion, articulated by a historian four decades ago, approximates the perspective of many art historians who view early medieval art as "feudal," created through the patronage deriving from the royal court and related institutions, the major concerns of which were "war and sex."[10]

The above sweeping assessment of early medieval society and culture is, on many counts, inadequate particularly because it does not offer a clear explanation of how Indian society and culture came to acquire certain characteristics in the "postclassical" phase. Admittedly, the society that created Bhārhut, Sanchi, Amarāvatī, Mathura, Kārle, and Sarnath was vastly different from that which created such temple sites as Khajurāho (Fig. 9), Modherā, Dilwārā, Osian, and Udayeśvara. However, without a proper understanding of the processes of social

Previous pages
Fig. 9 *left*
Lakṣmaṇa temple complex, Khajurāho, Madhya Pradesh, about A.D. 954–55.

Fig. 10 *right*
Interior of Vimalā Vasāhi temple, Dilwārā, Mount Ābū, Rajasthan, 12th century.

transformation, it would be difficult indeed to locate and decode the meanings of the period's cultural products.

Geographic Space, Historic Processes, and the Political and Cultural Dimensions of Early Medieval North India

To think of geographical and political boundaries as static would be anachronistic, particularly in the context of early India. It is therefore necessary to discuss the way this region was contemporaneously perceived. Schemes of regional divisions define north India in various terms. Since early times, a broad division existed between north (*uttarāpatha*) and south (*dakṣiṇāpatha*) that was aimed at differentiating the region north of the Vindhyas from that to their south; however, neither was homogenous.[11] While the names of the early historical regions (*janapadas*), such as Kośala (northeast Uttar Pradesh), Magadha (south Bihar), Kaliṅga (Orissa), and so forth, were used in later times, new *janapada* names, which suggest a crystallization of a stable sociopolitical order in a region, or more appropriately, a subregion, kept appearing in the records. For example, new *janapadas* like Gauḍa and Kāmarūpa in eastern India or Ḍāhala in central India started appearing regularly in records from the Gupta period onward.[12] Later names such as Gurjaratrā, signifying the region associated with the Gurjaras in western India; Sapādalakṣa, the territory of the Cāhamānas; Meḍapāta, the territory of the Guhilas; and Jejākabhukti (Bundelkhand), the territory of the Candellas,[13] are all indicative of the process of geographic-historic transformation (see Fig. 8).

Whether *janapadas* corresponded to the domain of a ruling lineage or other regional factors, they were distinct from the geographic category of the forest region, (*aṭavi*) or (*araṇya*). The *janapada* and the *aṭavi/araṇya* represented two distinct cultural patterns. This distinction is elucidated in the *Harṣacarita*, a literary version of the biography of King Harṣavardhana (606–647), written by Bāṇabhaṭṭa, his contemporary. The celebrated author informally describes the different cultural characteristics of the geographic space of his time. Bāṇabhaṭṭa's Śrīkaṇṭha *janapada* (in modern Haryana), location of Harṣa's early capital Thanesar, was a well-irrigated, settled agricultural region that produced a variety of crops. In contrast, the Vindhyas—the archetypal forest region—were the habitat of hunters and more rudimentary agriculturists. This image of the forest region, home to such tribes as the Bhils, the Śabaras, the Pulindas, and the Niṣādas, continued to figure in later texts like the *Kathāsaritsāgara*.[14]

Two clarifying qualifications must be made to this distinction. First, the forest regions, along with regions peripheral to settled agriculture, were being transformed on a significant scale. Second, within the settled *janapadas,* space was also differentiated to allow for a wide variety of habitats, including small villages, larger settlement units, and big cities. Space was constantly being transformed, and the emergence of the pattern of early medieval society and culture was closely interwoven with this process. Geographic transformation indicated cultural and social direction.[15]

The core element of this transformation was the appearance of state society in areas that had long been peripheral. For example, while edicts of the Mauryan emperor Aśoka refer to the people of the *aṭavi*,[16] there had emerged, in the same location, a number of forest-kingdoms (*āṭavika-rājyas*) during the Gupta period.[17] From the Gupta period onward, epigraphic documents that pertain to new kingdoms emanate from such regions as Bastar in Madhya Pradesh and Koraput in Orissa.[18] Even today these locations are considered remote. The transformation of peripheral spaces into local, royal domains was sometimes the result of territorial expansion. There are many references to monarchical expeditions undertaken against such tribal groups as the Śabaras, Pulindas, Bhillas (Bhils) or Ābhīras.[19] Usually, however, the transformation came from within the peripheral society, resulting from regular interaction with the society in which the state system had evolved previously. In other words, most local kingdoms emerged out of what

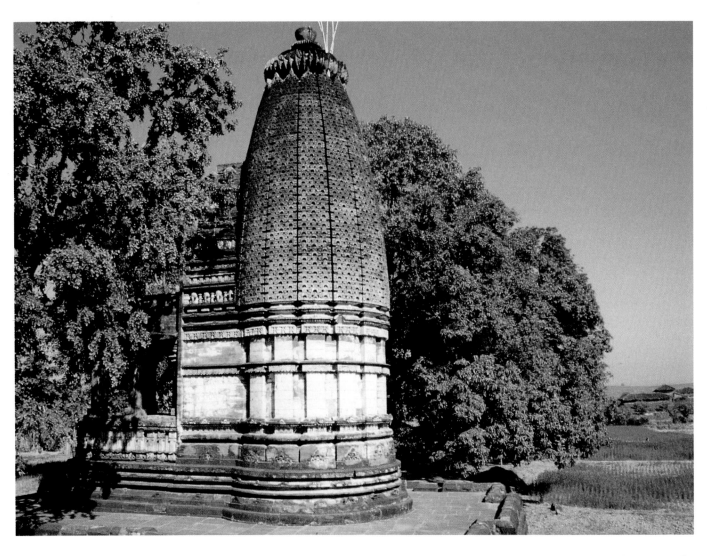

Fig. 11
Śiva temple, Candrehe, Madhya
Pradesh, before A.D. 973.

had originally been bases of tribal society and not through the breaking up of a given state structure. Thus it is significant that the early medieval Candella rulers of Jejākabhukti, patrons of the magnificent clusters of temples at Khajurāho in Madhya Pradesh, are believed to have come from the ethnic group of the Gonds of central India.[20]

In many ways, the origin of the Rajputs illustrates the major historical processes, essentially derived from cultural elements present in "classical" society, involved in reshaping that society. The period between the seventh and twelfth centuries witnessed a gradual rise in a number of new royal lineages in Rajasthan, Gujarat, Madhya Pradesh, and Uttar Pradesh that came to constitute a sociopolitical category known as "Rajput." Among these lineages were the Pratīhāras of Rajasthan, Uttar Pradesh, and adjacent areas; the Guhilas and the Cāhamānas of Rajasthan; the Cālukyas or the Solaṅkis of Gujarat and Rajasthan; and the Paramāras of Madhya Pradesh and Rajasthan. Others who also claimed to be Rajputs included the Candellas of Bundelkhand and the Gāhaḍavālas who ruled in the upper and middle Ganges valley between the eleventh and thirteenth centuries. The groups that claimed, at different points of time, to be Rajputs were of disparate origin, and the category exemplified the many channels through which an upwardly mobile social group could enhance its status. Disparate groups were brought together by a number of factors, including the acquisition of political power over roughly definable territories; the domination of economic resources, basically secured through shared control of land and trade routes; the large-scale construction of forts for military and economic purposes; and a gradually expanding interlineal social and cultural network.[21]

Another significant historical process revealed by the appearance of the Rajputs relates to the ideology of the period and directly impacts the patronage of temples in the region. The most significant ideological dimension from contemporaneous records is the legitimation of temporal power. State formation, among the Rajputs and in general, was invariably linked with the practice of grants of land to Brāhmaṇas, temples, Buddhist monasteries (*vihāras*), and Brāhmaṇic monasteries (*maṭhas*). Such grants, which reinforced the nexus between royal power and sacred authority, were undoubtedly on the increase in the early medieval period. Royal power, usually having emerged from obscure origins, required legitimacy, which it procured by extending worldly patronage to the highest caste, Brāhmaṇa *varṇa*. This priestly caste monopolized sacred knowledge and the sacred centers, and, in turn, assigned respectable ancestry to new kings.

The rulers, essentially from tribal backgrounds, could thus claim Kṣatriya origin and trace descent, as did some Rajputs, from such mythical lines as solar lineage (*Sūryavaṁśa*) or lunar lineage (*Candravaṁśa*). New myths could be created or old myths modified to provide an emergent group with status and cohesion.[22] For example, the myth of origin from the fire pit (*agnikula*), used by several Rajput clans to explain their genealogy, was first used by the Paramāras of Malwa in an inscription of the eleventh century at Udayeśvara temple in Madhya Pradesh (Fig. 3).

> . . . a hero who had sprung from the fire-altar of Vasishṭha on the Mount Arbuda (Ābū) slew the enemies and brought back the cow of the sage which Viśvāmitra had taken away and was, in reward of this deed, given the name of Paramāra ("slayer of the foes") by Vasishṭha, who also blessed him with kingship.[23]

Fig. 12
Mālādevī temple, near Gyaraspur, Madhya Pradesh, about A.D. 850–75.

Incidentally, the same epigraph, while eulogizing the achievements of Paramāra ruler Bhoja, records that he "covered the world all around with temples, dedicated to Kedāra, Rāmeśvara, Somanātha, Suṇḍīra, Kāla, Anala, and Rudra"—different manifestations of Śiva.[24] The essence of royal power and the luster of a Kṣatriya could also be bestowed by a preceptor (ācārya) or a guru. For example, a thirteenth-century epigraph eulogizes Pāśupata ācārya Hāritarāśi by attributing to him the rise of the Rajput Guhila lineage of Mewar in the following terms.

> Assuredly from Brahmā-like Hārita (Hāritarāśi-sage) Bāppaka obtained, in the shape of an anklet, the lustre of a Kṣatriya and gave the sage his own devotion, his own brāhmaṇical lustre. Thus even till now, the descendants of that line shine on this earth, like Kṣatriyahood in human form.[25]

The Candellas of Bundelkhand, the builders of Khajurāho (Fig. 9), also traced their sacred ancestry from sage Candrâtreya, who in turn, descended from mythical sacred personalities, Marīcī and Atri.[26] The need to link one's royal origins to religious and divine forces clearly led to the extraordinary temple building of this period.

The emergence of ruling lineages of diverse origins exemplifies one dimension of the formation of early medieval society. Other groups represent the same historical processes operating in different regional contexts. One distinct social group noted in records dating from the Gupta period onward was the Kāyasthas (drawn from the ranks of scribes, accountants, and so on), who crystallized into distinct north Indian subcastes and became closely associated with new royal courts.[27] As a literate elite group, the Kāyasthas projected their own lineage in modest imitation of royal genealogies. Equally significant was the emergence of merchant families, often of distinct merchant lineages, particularly in western India. These merchant lineages figure in the early medieval epigraphic records of the region. Among the most frequent references are those to the Dharkaṭas, Oswals, Śrīmālīs, and Prāgvaṭas.[28] The merchant lineages, many of which were of Jaina affiliation, also emulated royalty in accounting for their ancestry. It is clear that these subgroups were important patrons of temples from the innumerable references to them in inscriptions of such temple clusters as Osian and Dilwārā (Fig. 10).[29] There are many references to the Dharkaṭa Jāti (caste merchants) in the inscriptions at the temple cluster at Osian. Vāstupāla and Tejahpāla, perhaps the two most illustrious merchant personalities of early medieval India, were descended from the Prāgvaṭa lineage, were high-ranking officials of the rulers of Gujarat, and were associated with the construction of the Jaina temples at Arbudagiri or Mount Ābū and at Girnar.[30]

Records from other regions like Uttar Pradesh and Madhya Pradesh generally refer to the śreṇī (a term taken to denote a merchant or artisanal guild). North Indian guilds of the early medieval period were quite different from the big merchant associations like the Ayyavole 500 or the Maṇigrāmam of contemporaneous Deccan and south India. They were more like castes pursuing particular professions; however, they also were associated with important political and urban centers. A very significant piece of information is contained in a set of epigraphic records (A.D. 867–904) of the Gurjara-Pratīhāra period from the city of Tattānandapura,[31] which was located near Bulandshahr in Uttar Pradesh. They refer to substantial donations made to the temple of a female deity, Kāñcanaśrīdevī, by the local community of goldsmiths. Obviously, the community had acquired sufficient wealth and status to name a deity accordingly. (Kāñcana means "gold.") The social groups of early medieval India thus ranged from rulers claiming universal monarch (cakravarti) status to subordinates of various ranks as mahāsāmanta, mahāmāṇḍalika, sāmanta, māṇḍalika, to regional or subregional castes (jātis), encompassing severely oppressed communities that included the untouchables. The historical processes that gave rise to such a hierarchic, complex social structure also created a very complex cultural-ideological milieu.

In the context of the resultant diverse pattern of patronage of religious establishments, two aspects of this dimension of early medieval society need to be highlighted. First, the process of local state formation, which has been identified in this essay as the major process through which "classical" India changed to early medieval India, resulted in the incorporation of many local cults into what is generally understood as *purāṇic* Hinduism.[32] This process may explain how purely local cults and deities came to be regarded as manifestations of such deities as Śiva, Pārvatī, or Viṣṇu, who all symbolized supraregional Hinduism. This may also tell us why Tāntric practices, which were essentially esoteric, came to permeate not only Hinduism but also the erstwhile heterodox systems like Buddhism and Jainism.[33] At one level of Hinduism as well as in other systems, there was tremendous opposition to Tāntrism and such nonconformist sects as the Kaulas and Kāpālikas.[34] At another level, however, there were elements that came to permeate different sects and rituals. A curious convergence of emotional devotion (*bhakti*) and adherence to primordial Tantra is recognizable in all major religious systems of the period.

The presence of common elements in the midst of diverse religious practices can also be seen in the second major area of the cultural-ideological dimension of the period. This is reflected in the growth of the institution of the *ācārya* or *guru*, the central figure in the *maṭha*, which often in combination with the temple constituted the sacred complex in a mundane landscape.[35] Royalty almost invariably subscribed to Brāhmaṇic ideology; *deva-dvija-guru-pūjā*,[36] or the worship (*pūjā*) of the deity (*deva*), the Brāhmaṇa (*dvija*), and the preceptor (*guru*), was expected. Elsewhere, there could often be opposition to the authority of the Brāhmaṇa and the ideology of *varṇa*, but *bhakti*, which reflected the bond between an individual and his deity, was universal, and initiation into the correct path was conducted by the *ācārya* or *guru*. The growth of Hindu *maṭhas* in the "postclassical" period (which somewhat paralleled the Buddhist and Jaina monastic orders), particularly among the Śaiva sects, was of momentous significance. Apart from being geographically widespread and close to temporal power, the *maṭha* centers evolved a system of succession of *ācāryas*, who figure in epigraphic records in terms akin to genealogies of royal families. The *maṭhas* functioned as dissemination centers and networks of sectarian and philosophical traditions. Their growing importance in early medieval society is attested by the fact that in the kingdom of the Kalacuris of Tripurī (near Jabalpur in Madhya Pradesh) alone, Śaiva temples and *maṭhas* controlled by the Śaiva Mattamayūra sect were created at Gurgī, Masaun, Chandrehe (Fig. 11), Bilhari, Bherāghāt, and other places.[37]

Religious Centers: Spatial Contexts and Social Linkages

Religious centers—the major loci for ritual and other activity, including architecture, art, dance, and music—were, in keeping with the cultural-ideological complexity of the period, also of diverse type.[38] However, it was the temples which (among a variety of religious centers) had become the common structural features along the continuum of geographical space. A modest temple structure might be erected in the density of a forest or in a hamlet. The range of spatial contexts of temples would further encompass villages and urban centers of various dimensions. In such places as Osian in Rajasthan, Bhuvaneśvara in Orissa and Paṭṭadakal and Aihole in north Karnataka, temples dominated and constituted a sacred landscape. It can be assumed that when a shrine to a deity called "Dweller of the Forest" (*araṇyavāsinī*) was put up by a guild in south Rajasthan in the seventh century,[39] it was located far from a settled area.[40] One can contrast this with the evidence from a major urban center of the Gurjara-Pratīhāra period, located, in all likelihood, in the Lalitpur district of Uttar Pradesh. The set of epigraphic records related to this urban center called Sīyaḍoṇipaṭṭana range in date from 907 to 967 and show that temples, of different sectarian affiliations, were an

integral part of what appears to have been a rather spacious commercial-manufacturing and residential center. There were temples dedicated to deities called Nārāyaṇabhaṭṭāraka ("aspect of Viṣṇu"), Śivabhaṭṭāraka ("aspect of Śiva"), Bhaillasvāmi, Sīgākīyadeva, and so on.[41] It is unlikely that at Śīyaḍoṇipaṭṭana, or other settlements of this kind, sacred space was exclusive and separated from commercial and residential space. The admixture of different types of space in areas of settlement suggests a close physical proximity between deities and their devotees.

This was, however, not the only pattern. As previously mentioned, major temple structures with subsidiary structures or clusters of temples constituting a sacred landscape could also be segregated from mundane space. Remote pilgrimage centers (tīrthas) required that devotees cover wide stretches of inhospitable terrain in order to achieve closeness to a deity (see Fig. 12). Nevertheless, in order to understand how crucial the temple had become in the practice of everyday religion (even when all sections of society did not have access), it is necessary to keep in mind the varieties of spatial contexts in which it figured.

The linkages that the temple represented were many. These linkages were made possible at one level by the nonexclusivity of sacred space—a feature demonstrated by the fact that at any particular settlement or site, structures with different sectarian affiliations could coexist. This was also made possible by cases in which a deity of Brāhmaṇic affiliation could assume Jaina characteristics. The Osian complex in Rajasthan bears evidence to both conditions. Temples dedicated to deities of different sectarian affiliation coexist at this center. Further, Saccikādevī (popularly known as Saciyā Mātā and regarded as the titular deity of the Oswal community) occupied a prominent place at Osian (Fig. 13) and existed alongside her Brāhmaṇic prototype Mahiṣāsuramardinī.[42] Such centers could thus enlarge the network of linkages among communities and forge a considerable measure of social integration.

Linkages mediated through temples operated at other levels as well. The early medieval period saw the emergence of royal cult centers in different parts of India. The royal cult center, like monarchical power representing integration of different political segments into a state structure, could represent integration of local cults and their centers. The symbiotic relationship between a monarch and what grew to be a royal cult center (and the growing perception of this relationship as perhaps the foremost cultural symbol of a region) is well illustrated by the cult of the Śaiva deity Ekaliṅga, the patron deity of the Guhila rulers of Mewar. [43] This relationship was forged over centuries by the Pāśupata Śaivas who were in control of the shrine of Ekaliṅga.[44] The Guhila rulers also functioned as the chief officers (diwāns) of Ekaliṅga, the deity being the sovereign of the realm.

In addition to the symbolic significance that was attached to major centers like the royal cult center, the regular social linkages of a center's network were contingent upon the way in which resources were provided to it by various elite groups. This point can be illustrated by citing evidence for two centers, one from the kingdom of the Kalacuris of Tripurī and the other from that of the Nadol Cāhamānas of the Marwar region in Rajasthan. The Kalacuri record, which dates to the close of the tenth century, comes from Bilhari. Beginning with an invocation to Śiva, one part of the inscription records the gifts of at least nine villages to different Śaiva ācāryas bestowed by a Kalacuri queen, Nohalā, who was related paternally to Cālukya rulers.[45] The final part of the record specifies a number of levies that were imposed on different items of merchandise at the marketplace (pattanamaṇḍapikā) at Bilhari. The levies were resources allocated to a maṭha called Nohaleśvara (after Queen Nohalā) and presided over by a Śaiva ācārya Aghoraśiva. They were imposed on such items as salt, products from oil presses, betel nuts, black pepper, dried ginger, and so on. They were also imposed on horses and elephants, suggesting the presence of long-distance, specialized merchants at the marketplace.

The evidence for a temple and monastery center in the kingdom of the Nadol Cāhamānas is available from a set of twelfth-century copper plates from

Fig. 13
Entrance to Saciyā Mātā temple, Osian, Rajasthan, 11th century, with later additions.

Nanana in eastern Marwar.[46] The records refer to a central deity called Tripuruṣa and a *maṭha*. They also mention other deities named after the members of the royal family and enshrined in the temple complex. The Nanana plates thus appear to pertain to what eventually became a royal cult center, although it may not have existed as one beyond the twelfth or thirteenth century and was by no means comparable to major centers like Puruṣottama-Jagannātha in Orissa or Ekaliṅga in Rajasthan. The significant information derived from details in the plates relates to the way allocated resources created the center's economic and social network.[47] At least two deities enshrined in the complex received grants of villages; so did the head of the monastery (*maṭhapati*). Temple girls, musicians, and others providing different types of services to the complex received shares of produce earmarked for the purpose from villages. The resources were often redistributed and reallocated among those for whom the temple complex was the nucleus of daily activity. The Nanana plates refer to individual cultivators (as well as families of cultivators) being given to the temple complex not only by members of the royal family but by private donors as well. The Bilhari record and the Nanana plates are only two documents from among thousands. Many provide greater details and clearer indications that temple centers did not exist apart from other social institutions. They existed through a network of linkages that held together the fabric of early medieval society.

The major features of early medieval society appear to be dissimilar to what constituted Indian society and culture down to the period of the Guptas. Even so, characterizing this society as being "degenerate" or in direct opposition to early society does not offer an adequate understanding of it. That understanding has to be derived by making reference to the historical processes that went into the making of early medieval society and the manner in which cultural institutions, practices, and symbols of the period are intelligible in regional contexts as well as at a pan-Indian level. The rapid growth in the number and networks of temple centers, whose origins certainly date to pre-Gupta times, become understandable when we begin to appreciate how closely they were linked, as were gifts and land grants to Brāhmins (*brahmadeyas* and *agrahāras*) with the formation of subregional and regional kingdoms and their legitimation, consolidation of their resource bases, and the forging of linkages for social integration across communities.

1. For the use of the term *classical* in the context of Indian history, which extends to the characterization of Indian art as well, the best example would be *The Classical Age*, which is the third volume in the series *History and Culture of the Indian People,* R. C. Majumdar et al., eds. (Bombay: Bharatiya Vidya Bhavan, 2d impression, 1962). The term *feudal* has also been variously used in the Indian context; relevant references can be found in H. Mukhia, "Was There Feudalism in Indian History?" *The Journal of Peasant Studies,* vol. 8, no. 3 (1981), pp. 273–310; D. N. Jha, "Editor's Introduction" in D. N. Jha, ed., *Feudal Social Formation in Early India* (Delhi: Chanakya Publications, 1987); B. D. Chattopadhyaya, "Political Processes and Structure of Polity in Early Medieval India: Problems of Perspective," Presidential Address, Ancient India Section, Indian History Congress (44th session, Burdwan, 1983). It must be pointed out that writings on India's past do not consistently suggest comparability between Indian and European history. In fact, the two interrelated notions that strongly influence Western perspectives on India and that sharply differentiate between Occidental and Asian history are those of "Oriental despotism" and "unchanging East." For relevant discussions, see B. O'Leary, *The Asiatic Mode of Production: Oriental Despotism, Historical Materialism and Indian History* (Oxford: Blackwell Ltd., 1989); R. Inden, *Imagining India* (Oxford: Blackwell Ltd., 1990), chapters 4 and 5; R. Thapar, "Interpretations of Ancient Indian History" in *Ancient Indian Social History: Some Interpretations* (Delhi: Orient Longman, 1978), pp. 1–25.

2. V. A. Smith, *Early History of India, From 600 B.C. to the Muhammadan Conquest, Including the Invasion of Alexander the Great,* 4th ed., revised by S. M. Edwardes (Oxford: Oxford University Press, 1924), p. 306.

3. In addition to Majumdar, op. cit., read the remark by K. K. Dasgupta: "Indeed,

the advent of the Guptas on the political stage ushered in an epoch which has rightly been called the 'Golden Age' or the 'Classical Period' of Indian history. . . . " "Preface" in R. C. Majumdar and K. K. Dasgupta, eds., *A Comprehensive History of India*, vol. 3, pt. 1 (A.D. 300–985) (Delhi: Peoples Publishing House, 1981).

4. For the articulation of this approach see Niharranjan Ray, "The Medieval Factor in Indian History," General President's Address, Indian History Congress (29th session, Patiala, 1967). Niharranjan Ray, in his introductory paragraph reviewing the sculptural art of the early medieval period, comments, "The eighth and ninth centuries saw the consolidation of that process of conscious regionalism that had made itself felt already in the seventh century. For a whole millennium, roughly from about the third century B.C. to about the seventh century A.D., Indian art admits, despite local variations due to local tastes and visions, of a common denominator at each different stage of evolution and fulfillment. . . . The *classical* tradition of an all-India art lingers for one or two centuries, but the regional spirit gets the better of the Indian." R. C. Majumdar and A. D. Pusalker, eds., *The Struggle for Empire* (vol. 5 of *The History and Culture of the Indian People*) (Bombay: Bharatiya Vidya Bhavan, 1957), pp. 640–41. Compare these remarks with a more recent statement by Devangana Desai, "Sculptural motifs were thoroughly subordinated to the regional architectural pattern. . . regional patterns had conditioned its (the erotic motifs) depiction in medieval art," "Art under Feudalism in India (c. A.D. 500–1300)," *The Indian Historical Review*, vol. 1, no. 1 (1974), pp. 10–17. These comments are indeed telling, but they do not tell us about the historical processes leading to regionalization of cultures; this is primarily because Indian culture was assumed to be initially homogenous in nationalist historiography.

5. The major works that posit "feudal formation" in the Indian context are: D. D. Kosambi, *An Introduction to the Study of Indian History* (Bombay: Popular Book Depot, 1956); R. S. Sharma, *Indian Feudalism, c. 300–1200* (Calcutta: Calcutta University, 1965); B. N. S. Yadava, *Society and Culture in Northern India in the Twelfth Century* (Allahabad: Central Book Depot, 1973).

6. The hierarchic range is often demonstrated by citing a normative text on art, the *Aparājitapṛcchā*, written during the rule of the Cāḷukyas of Gujarat in the twelfth century. One section of the text is concerned with the types of residences to be constructed for different tiers of landed aristocracy and specifies such ranks as: *daṇḍanāyaka, maṇḍaleśa, māṇḍalika, mahāsāmanta, sāmanta, laghusāmanta, caturaṁśika* and *rājaputra*. For relevant discussions see R. S. Sharma, *Social Changes in Early Medieval India (circa A.D. 500–1200)* (Delhi: Peoples Publishing House, 1969); B. N. S. Yadava, op. cit., p. 149; R. Inden, "Hierarchies of Kings in Early Medieval India," *Contributions to Indian Sociology*, New Series, vol. 15 (1981), pp. 99–125.

7. A recent detailed statement of this position is found in R. S. Sharma, *Urban Decay in India (c. 300–c. 1000)* (Delhi: Munshiram Manoharlal Publishers Pvt. Ltd., 1987).

8. See translation of the text by S. C. Upadhyaya (Bombay: 1963).

9. K. M. Panikkar, "Presidential Address," Indian History Congress (18th session Calcutta, 1955), p. 17.

10. This approach, based on a substantial body of empirical evidence, is most forcefully articulated in Devangana Desai, op. cit.; Idem, *Erotic Sculpture of India: A Socio-cultural Study* (New Delhi: Tata-McGraw-Hill Ltd., 1975); Idem, "Social Dimensions of Art in Early India," Presidential Address, Ancient India Section, Indian History Congress (50th session Gorakhpur, 1989).

11. B. D. Chattopadhyaya, *A Survey of the Historical Geography of Ancient India* (Calcutta: Manisha Granthalaya, 1984).

12. Reference to Kāmarūpa is found in the Allahabad Praśāsti of the early Gupta period, D. C. Sircar, *Select Inscriptions Bearing on Indian History and Civilization*, vol. 1 (Calcutta: University of Calcutta, 1965), p. 265; *Ḍabhālā-rājya* (same as Ḍāhala), which was one of the eighteen *āṭavika-rājyas* or "forest kingdoms," is mentioned in a record of 529 from Khoh in Madhya Pradesh, Ibid., p. 395. Gauḍa was the kingdom of Śaśāṅka, a contemporary of Harṣa, in the seventh century; R. C. Majumdar, *The Classical Age*, pp. 77–78.

13. For regions of western India see D. Sharma, general editor, *Rajasthan Through the Ages*, vol. 1 (*From the Earliest Times to 1316*) (Bikaner: Rajasthan State Archives, 1966), pp. 11–19; for Jejākabhukti see S. K. Mitra, *The Early Rulers of Khajurāho*, 2d rev. ed. (Delhi: Motilal Banarsidass, 1977), pp. 1–11; P. K. Bhattacharya, *Historical Geography of Madhya Pradesh from Early Records* (Delhi: Motilal Banarsidass, 1977), pp. 135–39.

14. For relevant discussion see B. D. Chattopadhyaya, *Aspects of Rural Settlements and Rural Society in Early Medieval India* (Calcutta: K. P. Bagchi & Co., 1990), chapter 1.

15. This was so because transformation of a forest region or an area of tribal habitat would imply the beginning of stratified

45

society, dominance of *varṇa* ideology, heterogeneity of social groups, and many-stranded religious beliefs and practices. For these implications see B. D. Chattopadhyaya, *Aspects of Rural Settlements and Rural Society in Early Medieval India*; also "The Making of Early Medieval India" (forthcoming).

16. References to forest regions (*aṭavī*) are found in different versions of Major Rock Edict 13 of Aśoka in a context that suggests the forest people did not reconcile to the penetration of Mauryan imperial power into their region; for the text of the edict see D. C. Sircar, op. cit., pp. 34–37.

17. D. C. Sircar, op. cit., p. 395.

18. For example, the Nalas who were certainly associated with Koraput and Bastar from the first half of the sixth century; R. C. Majumdar, *The Classical Age*, pp. 188–90. The spate in the emergence of local ruling lineages in Gupta and post-Gupta times is underlined in J. G. De Casparis, "Inscriptions and South Asian Dynastic Tradition," in *Tradition and Politics in South Asia*, R. J. Moore, ed. (New Delhi: Vikas Publishing House Pvt. Ltd., 1979); B. D. Chattopadhyaya, "Political Processes and Structure of Polity in Early Medieval India"; R. S. Sharma, *Urban Decay in India*, chapter 10.

19. F. Kielhorn, "Two Chandella Inscriptions from Ajaygadh," *Epigraphia Indica*, vol. 1 (Reprint, New Delhi: Archaeological Survey of India, 1971), p. 337; Munshi Deviprasad, "Ghaṭayālā Inscription of the Pratīhāra Kakkuka," *Journal of the Royal Asiatic Society* (1895), pp. 513–21; D. R. Bhandarkar, "Ghaṭayālā Inscriptions of Kakkuka: Saṁvat 918," *Epigraphia Indica*, vol. 9. Reprint (New Delhi: Archaeological Survey of India, 1981), pp. 277–81.

20. For a discussion of different theories on the origin of the Candellas, see chapter 17 ("Origin of the Chandellas") in J. N. Asopa, *Origin of the Rajputs* (Delhi-Varanasi-Calcutta: Bharatiya Publishing House, 1976), pp. 208–17. Asopa, of course, traces their descent from an old Brāhmaṇa ruling lineage. See S. K. Mitra, op. cit., chapter 2.

21. For an analysis of different dimensions of the process see B. D. Chattopadhyaya, "Origin of the Rajputs: The Political, Economic and Social Processes in Early Medieval Rajasthan," *The Indian Historical Review*, vol. 3, no. 1 (1976), pp. 59–83.

22. For the unusual origin myth that traces the ancestry of some local kingdoms through the protection given to a child by mice, see Romila Thapar, "The Mouse in the Ancestry," in *Amritadhara* (Professor R. N. Dandekar Felicitation Volume), S. D. Joshi, ed. (New Delhi:

Ajanta Books International, 1984), pp. 429–30.

23. H. V. Trivedi, *Inscriptions of the Paramāras, Chandellas, Kachchhapaghātas and Two Minor Dynasties* (*Corpus Inscriptionum Indicarum*, vol. 7, pt. 2) (New Delhi: Archaeological Survey of India, 1978), p. 76.

24. Ibid, p. 79.

25. *A Collection of Prākrit and Sanskrit Inscriptions* (Bhavnagar Archaeological Department, n.d.), p. 89.

26. F. Kielhorn, "Inscriptions from Khajurāho," *Epigraphia Indica*, vol. 1, p. 130.

27. See Chitrarekha Gupta, "The Writers' Class of Ancient India—A Case Study in Social Mobility," *The Indian Economic and Social History Review*, vol. 2, no. 2 (1983), pp. 191–204. Ancestries of modern Kāyastha castes like the Nigamas, Śrīvāstavas, and Māthuras may be traced to early medieval records from Madhya Pradesh, Uttar Pradesh, and Rajasthan in the period with which the present essay is concerned.

28. B. D. Chattopadhyaya, "Markets and Merchants in Early Medieval Rajasthan," *Social Science Probings*, vol. 2, no. 4 (1985), pp. 413–40; V. K. Jain, *Trade and Traders in Western India (A.D. 1000–1300)* (New Delhi: Munshiram Manoharlal Publishers Pvt. Ltd., 1990), chapter 9.

29. Devendra Handa, *Osian: History, Archaeology, Art and Architecture* (Delhi: Sundeep Prakashan, 1984), chapter 6.

30. V. K. Jain, op. cit., pp. 245–49.

31. D. R. Sahni, "Ahar Stone Inscription," *Epigraphia Indica*, vol. 19 (1927–28), Reprint (New Delhi: Archaeological Survey of India, 1983), pp. 52–62.

32. For further information on this subject, see the essay by Phyllis Granoff.

33. S. B. Dasgupta, *An Introduction to Tāntric Buddhism*, 3d ed. (Calcutta: University of Calcutta, 1974). For Tāntric elements in Jainism, see R. N. Nandi, *Religious Institutions and Cults in the Deccan* (Delhi: Motilal Banarsidass, 1973), chapters 9 and 10; R. B. P. Prasad, *Jainism in Early Medieval Karnataka (c. A.D. 500–1200)* (New Delhi: Motilal Banarsidass, 1975), chapter 3.

34. *Prabodhacandrodaya of Kṛṣṇamiśra*, Sanskrit text with English translation by S. K. Nambiar (Delhi: Motilal Banarsidass, 1971). The allegorical play *Prabodhacandrodaya*, written by Kṛṣṇa Miśra and staged at the court of a Candella ruler, is evidence of acrimony that certainly existed among followers of different sects in early medieval India.

35. Sergio Meliton Carrasco Alvarez, "Brāhmaṇical Monastic Institutions in Early Medieval North India: Studies in

Their Doctrinal and Sectarian Background, Patronage and Spatial Distribution," Ph.D. Dissertation, Centre for Historical Studies, Jawaharlal Nehru University, New Delhi, 1990.

36. See D. N. Jha, "State and Economy in Early Medieval Himalayan Kingdom of Chamba," (paper presented at the 52d session of the Indian History Congress).

37. V. V. Mirashi, *Inscriptions of the Kalachuri-Chedi Era* (*Corpus Inscriptionum Indicarum*, vol. 4, pt. 1) (Ootacamund: Department of Archaeology, India, 1955), CLI.

38. Debala Mitra, *Buddhist Monuments* (Calcutta: Sahitya Sansad, 1971), pp. 85–89, 225–32, 240–46. One must keep in mind the fact that although by now Buddhism had lost its dominance and its distinct identity, major Buddhist centers like Nālandā, Vikramaśilā, Somapura Vihāra, Ratnagiri, and Mainamati, all of which reveal massive structural and sculptural activities, continued to exist until the close of the early medieval period.

39. The shrine (*devakula*) of Araṇyavāsinī, the "forest deity," was established at Araṇyakūpagiri; R. R. Halder, "Samoli Inscription of the Time of Siladitya; [Vikrama-Saṁvat] 703," *Epigraphia Indica*, vol. 20 (1929–30), Reprint (New Delhi: Archaeological Survey of India, 1983), pp. 97–99.

40. F. Kielhorn, "Khalimpur Plate of Dharmapāladeva," *Epigraphia Indica*, vol. 4. (1896–97), Reprint (New Delhi: Archaeological Survey of India, 1979), pp. 243–54. Similarly, when Dharmapāla, Pāla ruler of eastern India in the late eighth to early ninth century, was making a grant of villages for a deity, a small temple shrine (*devakulikā*) for Goddess Kādambarī—probably a local goddess absorbed into an ever-expanding Brāhmaṇic pantheon—was mentioned as a boundary mark of one of the villages.

41. F. Kielhorn, "Siyadoni Stone Inscription," *Epigraphia Indica*, vol. 1 Reprint (New Delhi: Archaeological Survey of India), pp. 126–79. The evidence of this inscription has been analyzed in some detail in B. D. Chattopadhyaya, "Trade and Urban Centers in Early Medieval North India," *The Indian Historical Review*, vol. 1, no. 2 (1974), pp. 203–19.

42. Devendra Handa, op. cit., pp. 14–17, 52–55.

43. A. Eschmann, H. Kulke and G. C. Tripathi, *The Cult of Jagannāth and the Regional Tradition of Orissa* (Delhi: Manohar Publications, 1978). According to the cult of Puruṣottama–Jagannātha of Orissa, the deity became the ruler of the region and the monarch his representative.

44. For a recent study of the relationship between the Guhilas, the Lakulīśa Pāśupatas and the shrine of Ekaliṅga, see Nandini Sinha, "Guhila Lineages and the Emergence of State in Early Medieval Mewar," M. Phil. Dissertation, Centre for Historical Studies, Jawaharlal Nehru University, New Delhi, 1988.

45. V. V. Mirashi, op. cit., pp. 204–24.

46. D. C. Sircar, "Stray Plates from Nanana," *Epigraphia Indica*, vol. 33, pp. 238-46; S. Sankaranarayan, "Nanana Copperplates of the Time of Kumārapāla and Ālhaṇa," *Epigraphia Indica*, vol. 39, pt. 1, pp. 17–26.

47. For detailed analysis of the Nanana plates from this perspective, see B. D. Chattopadhyaya, *Aspects of Rural Settlements and Rural Society in Early Medieval India*, chapter 3.

...सर्वाॐ...भमाला...

श्रीसाधिकावकरिस्तिगुरुमें

सवारितावरितः...हिदांतों...

दशिरसलाद्यानिब्रह्मणिसाव

कृतिः भगवान्पुराणमंदिरह

वतावुद्धः प्रलीसवितसक्रमग

ल्ज्ञानसमाःहारइउकृतसुकृत

नरमीसमावरणश्रीनिर्यांकातिर

...शागाद्धनंःपद्मोद्धिवलसहु

...निर्यकाश्मिवसज्ञानारुःप्रतन

कृतमंगलगणपिरीदनत्शाकेता

मस्पुनाद्यानाद्याशाकृतवासमंःकु

कनोदवरतीश्ज्ञानरत्नकाशसग्रास

नाःसहतिटंनपारगलतावद्यग्रामाः

दाशग्यातामगागाविशहकादिरमददगा

नागादलानाबीरवापरसमग्रातमतोकाल

श्रीरागताःकोनिकटश्रीराक्मिनोटमणिनार

क्सागिवितावरतनाउकृतमाशारद्वनिवंरगानाः

व्रात्तःपागिगेग्यात्रुभरत्तिरेभाधशासत्कृगार

१श्राद्धिलगातारत्तविप्रमुखाश्री

Religious and Royal Patronage in North India

Michael D. Willis

The building of temples was a leading concern of the Indian people between the eighth and thirteenth centuries. This is shown not only by the surviving monuments but by numerous inscriptions recording the construction and endowment of temples. This epigraphic information is particularly critical because no archival material from before the thirteenth century has been preserved. Despite the importance of temple building to Indian society and the fact that inscriptions are, for the most part, documents of religious giving, the subject of patronage has not been systematically explored.[1]

Direct evidence for patronage first appears in northern India during the third century B.C., and gifts to temples, particularly in the south, have continued to the present day. In order to facilitate detailed examination, the present exhibition focuses on north India between A.D. 700 and 1200, a period during which temples were constructed in considerable numbers and ornamented with an abundance of sculpture. In many cases these temples were also provided with inscriptions that record the names of donors and details about the temple's property. While north India is a vast area with a corresponding number of inscriptions, a narrower geographical horizon would not yield a representative sample, precluding a balanced evaluation of the data found in individual records. Similarly, our time frame spans several centuries. Because standardized formulae dominate epigraphic records, only a broad chronological cross section can illustrate changes in the anatomy of religious giving.

Inscriptions and the Nature of Religious Gifts

Inscriptions from north India between the eighth and thirteenth centuries vary considerably. However, two basic types were predominant: (a) land grants on copper plates and (b) eulogistic and commemorative inscriptions on stone tablets or pillars. Copper-plate inscriptions usually recorded a king's donation of villages or tax-free agricultural land (*agrahāra*) to members of the priestly class.[2] The revenue from a village supported a particular Brāhmin and was thus seen as rewarding and perpetuating sacred knowledge. Apparently the plates were held by the recipients (rather like a deed) and often have been discovered near the villages to which they refer. Stone inscriptions, in contrast, were commonly associated with the foundation of temples. Hundreds of stone inscriptions have been preserved; some remain near temple entrances as originally intended, while others have been recovered from ruins and are held in museum collections (see Fig. 14).

Both stone and copper-plate inscriptions were normally written in Sanskrit verse and open with an invocation to a deity such as Śiva or Viṣṇu. This might be followed by an account of the presiding monarch. Many verses praising the king and his ancestors were often included. If the king was not the donor, then the royal eulogy was followed by an account of the donor and his family, followed by a description of the building or grant. In the case of buildings, gifts for the temple's maintenance are often detailed. These gifts could consist of villages,

Fig. 14

Estampage of an inscription from Central Archeological Museum, Gwalior, recording the establishment of a Śiva temple in about the 12th century.

49

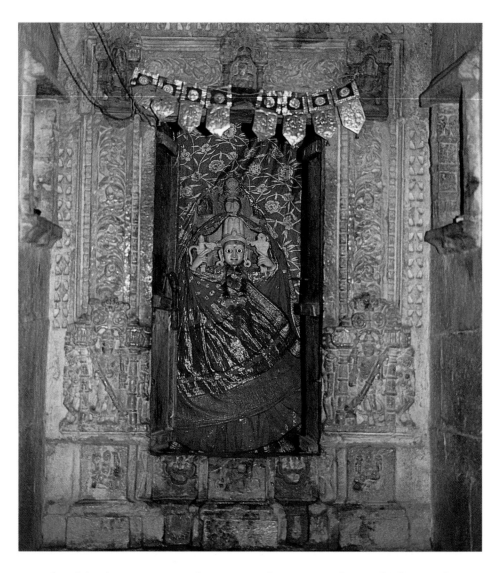

agricultural land, or commercial property, the revenue from which served as an endowment. An inscription's closing statement often expresses the hope that the temple might long endure and that the endowment might not be disturbed. Assorted facts could then follow, such as the date, the names of the architect (*sūtradhāra*), the poet who composed the inscription, the individual who transcribed it, and the engraver. While copper plates and commemorative stone tablets are the most common sort of record, other epigraphic sources occasionally provide information about patronage. Pilgrim inscriptions recount visits to holy places and give an indication of the significance of certain shrines. Memorial inscriptions provide an account of departed relatives or warriors who died in battle and sometimes mention endowments to support the bereaved. Cultic inscriptions furnish the pious texts or ritual formulae considered appropriate for a particular place.[3]

Despite standard content and phraseology, each inscription is unique. Just as north Indian temples have a generic similarity but are distinct, each donor emerges from the epigraphic record as an individual with particular motivations for building a shrine or making a donation. Likewise, each sacred place had its own special history and reservoir of endowments. These endowments, because of their economic value, were given exact descriptions. An exemplary inscription from Ahar records a number of transactions in favor of the Goddess Kāñcanaśrīdevī.[4] In one case, individuals arranged for rent revenue to be directed to the temple; in another, a community council (*mahājana*) donated long-term leases on commercial enclosures (*āvārī*). These properties are described with legal precision and their revenues were placed under the control of a managing board or committee (*goṣṭhī*).

Fig. 15
Worship of the Goddess (Devī) in the inner sanctum, Durgā temple (with later additions), near Udaipur, Rajasthan, 12th century.

Endowments like those documented by the Ahar inscription were made in substantial numbers before the thirteenth century and were considered the personal property of the god or goddess enshrined in the building. These deities were not abstract symbols but concrete personalities with clearly defined legal rights to donated property. A temple was thus a complex institution consisting of one or more gods and a number of social groups who managed the temple's property and controlled worship. Making a gift to a temple, or more correctly to the god in a temple, was seen as a meritorious act in which all could participate according to their means. Gifts were made by all sorts of people but most commonly by the ruling nobility. Aside from making gifts, it was incumbent upon rulers to provide a stable environment in which religion could flourish. This meant, in practical terms, the maintenance of established preferments and the protection of temple property from abuse and encroachment. As a consequence, temples came to control an increasing amount of property revenue. Temples also accumulated important fixed assets such as jewels, bullion, and miscellaneous paraphernalia, including image frames, thrones, parasols, crowns, and vestments for the deity (see Fig. 15). Temple property could also include ritual implements such as bells, lamps, censers and palanquins or temple carts for parading the divinity on festival days.

The end of temple wealth and social prominence was heralded by the violent incursions of Maḥmūd of Ghazna in the early eleventh century. Celebrated religious centers such as Mathura and Somanātha were ransacked, and temple treasuries were looted, with much booty being removed to Afghanistan.[5] With the establishment of the Mu'izzi Sultanate at Delhi in the closing years of the twelfth century, the power and influence of the indigenous ruling elite that had built and endowed temples was increasingly circumscribed. Temple building declined precipitously, the remaining vestiges being all but swept away by the expansionist policies of the Tughluq dynasty in the fourteenth century. The old temples that survived this cataclysm now stand as hollow shells in secluded spots, their property and revenue sequestered, their rites in abeyance, and their names lost to memory (see Fig. 16). It is from the particular facts provided by inscriptions that a history of religious giving can be constructed and it is against these facts that the architectural and sculptural residue of the temple tradition must be measured.

Religious Giving and Temple Patronage

A history of patronage between circa A.D. 700 and 1200 has not been written for a variety of reasons, the most salient being that epigraphic records, like most legal documents, use standard formulae that *prima facie* offer little to the historian. The description of temples and religious gifts changed little after the seventh century and this repetitiveness was coupled with the use of stock descriptive phrases that are of little concrete value. For example, a great many temples are described as having spires "as high as Mount Kailāsa." In contrast, the factual data provided by inscriptions (such as donors' names and the conditions surrounding an endowment) are so particular that the information is seldom repeated in other records. Furthermore, many of the temples described, especially those from before the tenth century, are either ruined or unidentifiable. As a result, it is impossible to transform the myriad facts into a connected narrative. While a comprehensive history cannot be rendered, a modest survey of patronage is nonetheless feasible. With numerous individual inscriptions it is possible to present a cross section of temple building and religious giving. Although this approach has the disadvantage of representing patronage as a static phenomenon, it can be justified due to the extremely conservative nature of Indian society, the concepts of innovation and progress having virtually no place in intellectual life before the thirteenth century.[6] A synchronic description is thus appropriate, provided it is tempered with instances of change. Our survey might be criticized as burdened with excessive detail. In fact the details given are only a fraction of what

has been preserved. These details not only illustrate the character of inscriptions but highlight the information that ancient patrons deemed worthy of record.

Noble Patronage

After the seventh century, north India was seldom ruled by a single power. Major kings and dynasties emerged only rarely from a matrix of competing clans and principalities. The history of these political entities is not well understood, but surviving inscriptions indicate that religious institutions were vigorously supported by all members of the ruling elite. The first major king to appear after the death of Harṣavardhana (A.D. 606–47) was Yaśovarman of Kannauj (ca. A.D. 720–50). Yaśovarman's ancestry is not directly known, but he may have come from a Mauryan clan that controlled Mathura in the late seventh and early eighth centuries.[7] Although a powerful ruler, little archaeological material can be connected with Yaśovarman. Vākpati's *Gauḍavaho* states that Yaśovarman built a temple at Hariścandranagarī (Ayodhya).[8] The only other indication of Yaśo-varman's architectural activities is given in an inscription from Ghosrāwā that mentions a location called Yaśovarmapuravihāra, apparently a monastery in the Rājgir hills.[9] Yaśovarman's successor Āma (ca. A.D. 750–75) is credited with building a temple to Mahāvīra, founder of Jainism, at Gwalior (ancient Gopādri, Gopagiri).[10]

This evidence indicates that the kings who ruled the Gangetic heartland in the eighth century had an active interest in constructing temples. More information is forthcoming about contemporary princes in Rajasthan. An illuminating example of such patronage is provided by the inscription from Kanswa near Kotah that recorded the establishment of a temple by one Śivagaṇa, son of King (*nṛpa*) Saṃkuka, an ally of King Dhavala.[11] Dhavala belonged to one of the Mauryan clans that prevailed in many parts of north India during the eighth century. Śivagaṇa built a temple (*bhāvana*) of Parameśvara in the hermitage of Kaṇva (modern Kanswa).[12] Two villages were given as a perpetual endowment for maintenance, lights, incense, and other accoutrements of worship. The conclusion includes the customary prayer that the *kīrti* (fame of the builder and thus also the building) might long endure, the purpose of this temple (to augment merit and fame), the date, the name of the poet Devata, and the names of others, including Naṇṇaka, the *sūtradhāra*. That this sort of patronage continued in later times and was not restricted to deities such as Viṣṇu and Śiva is evidenced by the archaeological material discovered at Ghaṭiyālā, a site northwest of Jodhpur. A ruined Jaina temple bears a Prākrit inscription that states it was erected by Kakkuka, a ruler of Pratīhāra lineage, in [Vikrama] year 918 (A.D. 861–62). Beginning with a genealogy of Kakkuka, the record states that in order to increase his fame the ruler founded a market (*haṭṭa*) and established two pillars, one at Maḍḍodara (modern Mandor) and the other at Rohinsakūpa (modern Ghaṭiyālā).[13] Though inscribed during the reign of Mihira Bhoja (ca. A.D. 836–85), a celebrated Pratīhāra monarch, the inscription does not mention his name. The genealogy indicates that Kakkuka was related in some way to the imperial Pratīhāras and that occasionally the two branches of the family may have been in conflict.[14]

The pillar mentioned in the Ghaṭiyālā inscription stands near the ruined Jaina temple and is locally known as Khakhu-devalam. On the shaft are three ninth-century inscriptions. The inscription on the east side, in Sanskrit prose, gives the genealogy of Kakkuka and again records that he set up two pillars, built a *haṭṭa*, and established a community (*mahājana*). The inscription on the west side records that the area was originally inhabited by Ābhīras until Kakkuka routed them and built a market with lovely streets and houses and induced a *mahājana* of Brāhmins and other reputable people to live there.[15]

The degree to which epigraphic records focus on matters of local concern is further illustrated by an inscription of the Guhila prince Bālāditya from Chātsu.[16] This gives a long account of the achievements of the Guhilas in the service of their Pratīhāra overlords (even though the Pratīhāras are barely mentioned). The

inscription's main purpose was to record that Bālāditya married Raṭṭavā and that after her death he erected a temple (*prāsāda*) of Murāri (Viṣṇu) in commemoration. An inscription from Rajor cites another commemorative temple.[17] A prince named Mathanadeva granted a village to a Śiva temple to maintain rituals. The temple was named the Lacchukeśvara Mahādeva after Mathana's mother Lacchukā. The naming of temples after a donor or an esteemed person is a long-established practice. It is known from at least the fifth century and continues today.[18]

The predominantly local focus of inscriptions necessitates a brief consideration of Indian polity between the eighth and thirteenth centuries. Historians have traditionally emphasized major dynasties and assumed that they were responsible for organizing a powerful and centralized administrative structure. The lesser nobility functioned as feudatories, their main significance being that they either supported or opposed the dominant power. This approach has produced a number of important works, some of which are now classics of Indian historical writing.[19] While such histories are useful and easily updated when new discoveries are made, they do not provide an entirely satisfactory account of events in relation to internal political arrangements and the constitution of power. This has prompted a number of scholars to probe into the structure of several Indian kingdoms. Burton Stein, using the Cōḷas of Tamil Nadu as his example, has proposed that the kingdom was a decentralized "segmental state" and that the king was an almost entirely symbolic figure.[20] Power rested not in the hands of a centralized government, but in what Stein calls "ethnoagrarian microregions." Ronald Inden, using the Rāṣṭrakūṭa dynasty of the Deccan as his starting point, has argued that the king was important, but that his power was continually constituted, contested, and remade. The business of "imperial formation" took place, according to Inden, in an environment of shifting human agencies.[21] Finally, Nicholas Dirks, working mainly with much later dynasties in south India, has described how "large kingdoms" and "little kingdoms" coexisted and were interdependent.[22] Authority was shared and could thus fluctuate between kingdoms, transforming a small kingdom into a large one. While none of these

Fig. 16
General view of the tank and ruined temples at Batesar, Madhya Pradesh, 8th century, with later additions.

models can be regarded as directly applicable to north India, they nevertheless alert us to the complexity of the political situation and help explain the predominantly local focus we have seen in individual inscriptions. Perhaps one of the most important records illustrating the weakness of the centralized model is the inscription of King Parabāla on the pillar at Badoh, which states that he built a temple of Śauri (Viṣṇu) and that he caused this Garuḍa-bannered pillar (*garuḍadhvaja*) to be set up before the temple.[23] In verse 27 we have an eloquent description of the pillar (Fig. 17).

> Repeatedly deliberating whether this is Viṣṇu's foot making three
> strides, or the body of Sthāṇu shaped like a post, or
> Śeṣa pulled out of a hole in the ground by the enemy of the serpent
> king, the gods on viewing it find that it is really a
> Pillar of pure stone, proclaiming the glory of King Parabāla.[24]

This pillar and the adjacent ruined temple are important in the history of architecture, there being few securely dated monuments of the period.[25] However, the position of Parabāla, and consequently the dynastic affiliation of the physical remains, constitute a challenge to the centralized model of kingship. Parabāla is usually described as an ally of the Rāṣṭrakūṭas of Malkhed (ancient Mānyakheṭa) because the record states that he was of Rāṣṭrakūṭa lineage. Consequently his title *kṣmāpāla* ("protector of the earth," i.e., "king") has been translated as "governor." Some key facts stated by the inscription have been ignored. First, one of his forebears gained control of Lāṭa (coastal Gujarat), having defeated the Karṇāṭas (a common name for the Rāṣṭrakūṭas in northern epigraphs). This makes it virtually impossible for Parabāla to have been an ally of the Rāṣṭrakūṭas in the Deccan. Second, princes claiming Rāṣṭrakūṭa lineage are occasionally encountered in north India but they have no connection with their famous namesakes.[26] Nor can Parabāla be claimed as a Pratīhāra ally. His father, Karkarāja, put Nāgabhaṭṭa II (ca. A.D. 810–33) to flight and invaded his home. Parabāla and his line must therefore be seen as independent and ninth-century north India more politically diverse than previously supposed.

An examination of the composition of the nobility brings forward the issue of gender and India's long tradition of women's patronage of temples. According to the early ninth-century inscription from Buchkalā, for example, a temple (*devagṛha*) was founded by Queen (*rājñī*) Jayāvalī, daughter of Jajjaka, himself the son of the Pratīhāra prince Bāpuka.[27] A slightly older epigraph from Kāmān (ancient Kāmyaka) gives the genealogy of a local Śūrasena dynasty and mentions that one Vacchikā, the wife of Durgādaman, built a temple to Viṣṇu.[28] The dynasty is otherwise unknown, but the record has been dated to the eighth or ninth century on the basis of its style.[29]

Further insight into the ruling class is provided by stelae that bear reliefs depicting noble individuals. A votive slab from Sāgar showing a prince with members of his family is of historic value.[30] Presumably set up in a temple built by the donor, the slab is comparable to a later relief in the Gupteśvar temple at Mohangarh (Fig. 18). That these were freestanding stelae is shown by the long inscription on the reverse of the Mohangarh slab.[31] The memorials that record the death of warriors and occasionally the self-immolation (*satī*) of their widows also sometimes provide information regarding temple patronage, especially through their placement in temple complexes.

Patronage of Officers and Subjects

Like the nobility, officers and subjects supported religious institutions. A useful example of this level of patronage is found at Gwalior. Two inscriptions on the Caturbhuj temple (Fig. 19) state that it was established by Alla, the warden (*koṭṭapāla*) of Gwalior fort in the last quarter of the ninth century.[32] Alla was the son of Vāillabhaṭṭa, who had come from Lāṭa where he had served as a frontier commander (*maryādādharya*) under the Pratīhāra king Rāmabhadra (ca. A.D. 833–36). Alla succeeded to this post and was subsequently appointed to

Fig. 17
Pillar known as "Bhīmgaja," Badoh, Madhya Pradesh, dated Vikrama year 917 (A.D. 861).

Gwalior by Mihira Bhoja. In this position, Alla must have been a respected member of the Pratīhāra nobility, for Gwalior fortress was an important location for the rulers—it guarded the territory between Kālinjar and Chittaur and was integral to their campaigns against the Rāṣṭrakūṭas to the south. After assuming his post at Gwalior, Alla built the Caturbhuj temple of Viṣṇu for the increase of his and his wife's merit, "a receptacle of his fame, cut by the chisel and marked with his name." The temple is described as a single piece of rock (*ekaśile . . . bhavane*) and a "great ship for crossing the ocean of existences." The temple was known as Vaillabhaṭṭasvāmin in honor of Alla's father. Alla also built a second temple dedicated to the goddess that has not survived. Endowments were lavished on both buildings by various sections of the community and the city council made a grant on behalf of the entire town.

The Caturbhuj temple inscriptions also provide an unusually thorough eulogy of the Pratīhāra dynasty. More typical is an inscription made during Yaśovarman's reign describing how his officer Bālāditya built a temple of the Buddha at Nālanda and how it was endowed by Malada, the son of Yaśovarman's minister.[33] Virtually no information is given, however, about the ruling monarch. The same situation is found in the copper plates from Una.[34] These were issued by Bālavarman and his son Avanivarman Yoga of the Cāḷukya family; they record the gift of villages to a temple of the sun god called Taruṇādityadeva. They mention that the Pratīhāra monarch Mahendrapāla I (ca. A.D. 885–910) conferred the title of the "five great sounds" (*pañcamahāśabda*) on Bālavarman and that the gifts were sanctioned by a frontier-guardian (*antapāla*) named Dhīika. This Dhīika appears to have been a representative of Mahendrapāla's court. Despite these imperial connections, a royal genealogy is not given and all the details focus on matters of immediate local importance. The same situation is found in the plates from Haddala.[35] Citing the example of the nobility, we can conclude that officers enjoyed considerable autonomy, giving only brief acknowledgement of their sovereign when issuing such documents regarding their temple patronage.

The wives of important officers were also active patrons. An image of Śiva and Pārvatī from Gwalior carries an inscription stating that it was commissioned by Rjjūkā, the wife of Śrī Rudra, a Pratīhāra feudatory.[36] Another inscription, of unknown provenance but now in Udaipur, records the activities of Yaśomatī, who built a temple of Viṣṇu. She was the wife of Varāhasiṁha, a commander in the service of the Guhila prince Aparājita.[37] Though separated by two centuries, both the Caturbhuj and Udaipur inscriptions describe temples as a means of crossing over this world—a reminder of how little inscriptions and their contents changed with the passage of time.

Patronage of Persons without Title

The foregoing examples are fairly simple in that they represent donors constructing individual temples or making individual grants. Religious centers of importance, however, often attracted an extended series of temples and endowments. This led to complicated inscriptions recording numerous gifts by a range of individuals over a span of time. Such collective records are known from Kāmān, Ahar, Partābgarh and Siron.[38] The Siron inscription lists a number of grants by persons without title—an appropriate bridge to the most common level of patronage.[39] Temple gifts at this level often consisted of plots of land, the rents from which were intended to benefit a particular god. However, land was not the only source of temple revenue. This is shown by an inscription at Delhi dating to Mihira Bhoja's time, which records the gift of rent money from a house for lamps, sandal paste, flowers, and worship at a particular shrine.[40] Similar, but somewhat unusual, is a monthly gift of wine for the worship of Viṣṇu (probably in the Tāntric fashion).[41] A number of records show that some kind of taxing was used to support temples. An inscription from Pehowa (ancient Pṛthūdaka) recounts how a group of horse traders imposed certain taxes upon themselves and upon their customers and the way in which the proceeds were to be distributed to certain temples in fixed proportions.[42]

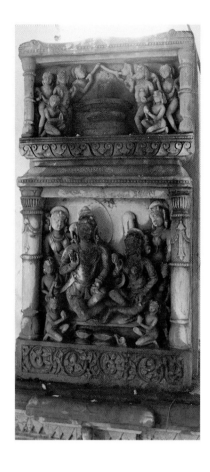

Fig. 18
Memorial stele, Gupteśvar temple, Mohangarh, Madhya Pradesh, early 10th century.

Individuals without title not only endowed temples but also constructed them. This is shown by a second inscription from Pehowa recording that three brothers built a temple (*āyatana*) of Viṣṇu.[43] Each brother's contribution to the work is described as follows.

> In the middle it was made by Gogga, the back by Pūrṇarāja,
> The front by Devarāja, for destroying the cloud of intense ignorance.[44]

Common devotion did not always express itself as a complete monument. A pillar at Deogarh dated [Vikrama] year 919 (A.D. 862) is one of a pair at the site that seem to have been parts of a gate or gate house of the main temple.[45] The inscription explicitly states that "this pillar" was set up "near the temple of Śāntinātha (*śrī śāntyāyata[na] [saṁ]nidhe*)" by Śrī Deva, a disciple of Kamaladeva, suggesting that the gate may have been the collective gift of several individuals.[46] Places like Deogarh and Gwalior Fort, which had an established reputation, were naturally subject to embellishment. At Gwalior, other embellishments such as small shrines, niches, *liṅgas*, and Jaina images were provided well into the sixteenth century.

Apart from epigraphic documentation of this type, many sites possess material indicative of common patronage, although personal details are often lacking due to the absence of inscriptions. The collection of shrines located at Batesar, near the village of Pāroli (ancient Paḍhāvali), is a noteworthy example.[47] A Śiva temple was built near the tank at Batesar toward the end of the eighth century and a complex of small shrines subsequently developed in the immediate neighborhood (Fig. 16). No record states who commissioned these shrines, but more recent sites explain them. For example, an analogous temple city evolved at Soṇagir (ancient Suvarṇagiri) during the last two centuries, each addition being a product of the individual devotion and means of its patron. The miniature monolithic temples found at many places in north India are of the same character. Such shrines, including the example from Gwalior in the exhibition (see No. 1), were bona fide temples and represent what a person of humble means could add to a sacred site for his own religious merit.

That grants to religious establishments by ordinary people were growing in number after the seventh century is evidenced by the increasing mention of the administrative boards or committees (*goṣṭhīs*) that were set up to manage endowments. These boards ensured that the funds were directed to the stipulated purpose. The wealth of temples from minor grants was considerable and the *goṣṭhīs* supervised significant investments and expenditures. These involved repairs to temples and at times the construction, so some account of these boards is necessary for a complete picture of temple patronage. A good indication of how boards were formed is given by the Kāmān inscription, dated Harṣa year 263 (A.D. 869).[48] This begins by naming the board members (*goṣṭhīka*) and recording that three brothers built a tank (*vāpī*) and a temple (*maṭha*) and further arranged for *piṇḍa* rites, the offerings to deceased parents. The brothers then formed part of the board that was set up to manage the shrine and the offerings. A second Kāmān inscription, carrying various dates between Harṣa year 180 and 279 (A.D. 786 and 885), mentions a variety of gifts to different gods, the most important of which was Śiva as Kāmyakeśvara. Several of these grants were instituted or managed by board members.[49] The Pehowa inscription recording how some horse dealers distributed income to various shrines ends with an exhortation to the board members to manage the grants in accordance with the terms set down.[50]

Royal Patronage in the Age of Pratīhāra Supremacy

Among the competing principalities of the eighth century were the Gurjara-Pratīhāras, a clan whose power was centered in the Māru country of Rajasthan. During the reign of Nāgabhaṭṭa II, the Pratīhāras were able to assert control over most of the ruling families in northern India. An important step in

the expansion of their power, celebrated in Pratīhāra-period inscriptions, was the capture of Kānyakubja (modern Kannauj), the imperial capital of the Gangetic heartland. A considerable number of Pratīhāra inscriptions survive, some of which have been mentioned. These provide sufficient documentation to allow a tentative reconstruction of imperial patronage during the ninth and tenth centuries. The largest corpus of imperial Pratīhāra records are copper plates recording gifts of villages to Brāhmins.[51] In several cases kings made grants for the religious merit of their parents—a long-standing practice.[52] These records contain royal genealogies and references to the deities that were the object of each monarch's special devotion. An imperial gift to a temple is also recorded in the stone inscription from Partābgarh. Mahendrapāla II (ca. A.D. 943–46) granted a village to Vaṭayakṣiṇidevī, a goddess whose shrine was under the care of the monastery (maṭha) of Haryṛṣīśvara.[53] Records such as these demonstrate that the imperial Pratīhāras were active patrons of both Brāhmins and notable temples. However, no epigraphs state that the Pratīhāras supported the actual construction of temples. The only evidence for imperial building activity is an inscription found at Sāgar Tāl, a large tank on the outskirts of Gwalior.[54] The epigraph opens with an invocation to Viṣṇu and a verse in his praise, followed by a twenty-four-verse account of the Pratīhāra family and their noble achievements. The actual object of the inscription, mentioned in verse 26, is that the Pratīhāra king Mihira Bhoja erected a city for his seraglio in the name of Viṣṇu.

> To increase the fame and merit of his queens,
> The king built a harem city in Viṣṇu's name.[55]

The inscription closes with a prayer for the longevity of this noble building (āryakīrti) and mentions the poet Bālāditya. The crucial phrase is antaḥpurapuraṁ. The word antaḥpura is well known from inscriptions and its interpretation in this context as "royal harem" or "seraglio" is not contentious.[56] The word pura means "city" or "fort," and taking the whole as a karmadhārāya compound we can render it "a city for the royal harem" or "palace complex."[57] This complex is unknown because the site of Sāgar Tāl, where the inscription was discovered in 1896, has only one battered ninth-century fragment. It served as the wall section of a small shrine that stood beside the tank. The tank itself was rebuilt in Mughal times. At or before that period, Sāgar Tāl's original function as a palace site was transformed and it became part of the necropolis of Islamic Gwalior.

Further evidence of royal patronage is provided by the Caturbhuj temple inscription at Gwalior. As mentioned before, the primary purpose of the inscription was to record the establishment of a temple by a man named Alla, warden of Gwalior fort.[58] It also states that the temple was built "on the descent of the roadway of Śrī Bhojadeva (śrībhojadevapratolyavatare)," referring to the steep road cut into the east face of Gopādri that was made, or substantially expanded, by Mihira Bhoja. The road originally consisted of a series of wide steps, some of which are still visible beside the gravel and paving stones laid in the mid-nineteenth century to facilitate vehicular traffic.[59]

The phrase "on the descent of Bhoja's road" suggests that the roadway led to a building of note. Examination of the fifteenth-century building that now crowns the fort shows that Bhoja's road led to a ninth-century palace. Some sumptuously carved pilasters belonging to the original structure were reused when the Elephant Gate was reconstructed (Fig. 20). From the description of Ibn Baṭṭūṭa, who visited Gwalior in the fourteenth century before the reconstruction began, we know that a life-sized image of an elephant and mahout stood outside the entrance.[60] All that remains of the spectacular structure are the reused pilasters and, on the south side of the entrance, about forty courses of ashlar relieved by a number of cornices (kapotas). A unique double-lion capital, now in the National Museum of India, was found near Trikonia Tāl on the fort and may have crowned a pilaster in the Pratīhāra palace complex.[61] These remains are of considerable importance, there being little known about palace architecture before the Islamic conquest. Further information on early secular architecture is provided

Fig. 19
Caturbhuj temple, Gwalior, Madhya Pradesh, dated Vikrama year 932 (A.D. 875–76).

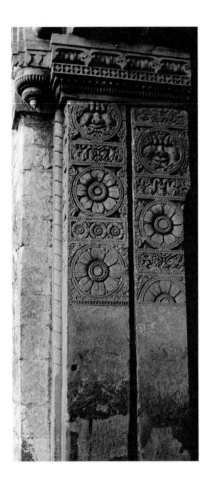

by the Sola Khambi at Badoh.[62] Built on a knoll overlooking a lake, the structure apparently served as a pleasure pavilion. It consists of an open pillared hall conforming to the type placed before temples; no inscriptions pertain to the structure, but it may be dated architecturally to about the tenth century.

Our overview of ninth- and tenth-century inscriptions suggests that the Pratīhāra monarchs, while active in providing land grants, were not involved in commissioning temples or images. This is supported by the inscription of Bāuka, a prince of Mandor (ancient Māṇḍavyapura), dated Vikrama year 894 (A.D. 837–38), which gives a long account of Bāuka's family and culminates with a ghoulish description of his victory in a battle.[63]

> Verily when Bāuka danced in the battlefield,
> putting down his feet on the very entrails and corpses,
> His frightened enemies, like antelope, became ever so quiet
> with the strain *tiṣṭha, tiṣṭha*. This was strange indeed! [64]

The celebration of this victory and the praise of Bāuka's lineage is the sole purpose of the inscription; no temple was built and no grant of villages made. Bāuka was a Pratīhāra prince but did not belong to the main imperial line. During the setbacks which marked the reign of Rāmabhadra (ca. A.D. 833–36), Bāuka asserted independence and laid claim to the full range of kingly titles. Though his political ambitions were soon suppressed by Mihira Bhoja, Bāuka's inscription is imperial in aspiration and general character.[65] Records of this type were probably once common in the capital at Kannauj before that city was completely destroyed in the eleventh and twelfth centuries. The fairly wide use of these purely laudatory inscriptions is evidenced by a eulogy (*praśasti*) of the Rāṣṭrakūṭa monarch Kṛṣṇa III (ca. A.D. 939–67). This inscription has no purpose but the valorization of the king.[66] Its political overtones are evident both from the use of the Kannada language and its location at Jura in the Ḍāhala country, an area traditionally under the sway of northern rulers.

The noninvolvement of the imperial Pratīhāras in temple building can be understood in various ways. The elaborate Vedic rituals, such as the horse sacrifice (*aśvamedha*) and royal consecration (*rājasūya*), crucial to early Indian kingship, represent the most ancient aspect of the situation. These rites, frequently performed in India during the two centuries before and after Christ, were seen as propelling the king into a heavenly sphere and infusing him with divine power, simultaneously giving him a mandate and placing him above numerous sects and classes of society. Ritual performance was therefore the primary and most appropriate focus of royal patronage and made kings dependent on Brāhmins because only they were qualified to carry out the rites. Brāhmins consequently had to be supported through village grants and other gifts. Royal sponsorship of Vedic ritual declined after the fifth century and regal patronage of temples and images clearly emerged under Harṣavardhana and his contemporaries in Tamil Nadu and the Deccan.[67] In northern India this innovation proved to be short-lived. Inscriptions show that the Pratīhāras stood aloof from temple building. While Vedic performances were not reinstated, grants to Brāhmins continued, suggesting that preservation of Vedic knowledge through recitation (*svādhyāya*) was valued apart from its application to specific rituals (*prayoga*).[68] However, the Vedas and attendant Śrauta rituals had declined in importance and had ceased to impinge on day-to-day affairs, beyond their theoretic value as the source of tradition and the basis of cosmogonic and social order.

The reluctance of the imperial Pratīhāras to become involved in temple building can be attributed to other factors as well. As mentioned earlier, a deity could receive and hold gifts as a bona fide legal entity. A different relationship was created, however, when a ruler actually constructed a shrine and thus established a divine personality. The relationship between such shrines and the ruling clan could be extended to the point where the deity was seen as the true ruler and the prince merely a minister or representative of the god. One of the best known instances of this is the Lakulīśa temple at Ekalingji, which contains the patron-deity of the

Guhilas of Medapāta (modern Mewar).[69] Such temples can be called clan shrines and were associated with particular warrior families over generations.

While the complete subordination of a king to a god was not elaborated in epigraphic records until well after the disintegration of Pratīhāra power, close ties between temples and their founders are indicated by the above-cited practice of naming divinities after specific individuals. Building a temple was thus a meritorious deed that tangibly linked an individual and his clan to a particular place, especially those founded by members of the ruling elite. It was precisely this localization of power and particularization of identity that the imperial Pratīhāras sought to avoid. They belonged to a recognized clan yet claimed hegemony over all their contemporaries; temple building and its inevitable ties would only impede their efforts to control the nobility of north India, a nobility that had a sufficient history of factionalism and violent competition.

This interpretation could be subverted by excavations at Kannauj and the discovery of inscriptions showing that the Pratīhāras built temples in the capital. However, information buttressing our conclusion is provided by the Cambay plates, which were issued by the Rāṣṭrakūṭa dynasty, the Pratīhāra's most bitter and long-standing foes.[70] One of the events recorded in the Cambay plates is a raid led by Indra III against north India in the early tenth century. Indra's rampage northward is celebrated in the following verse.

> After the courtyard of the temple of Kālapriya was knocked
> askew by the strokes of his rutting tuskers,
> His steeds crossed the bottomless Yamunā, which rivals the sea,
> and he completely devastated the hostile city of Mahodaya,
> Which even today is renowned among men by the name Kuśasthala.[71]

The temple of Kālapriya was located at Kālpī near the Yamunā River.[72] Mahodaya was, of course, the capital city of Kannauj. While the temple at Kālpī was singled out for destructive attention, there seem to have been no temples at Kannauj meriting similar treatment. If the Pratīhāras had a temple in the capital surely the Rāṣṭrakūṭas would have destroyed it and taken special delight in recording its desecration. Not only are the Cambay plates silent in this regard, but the Sanjān, Rādhanpura and Waṇi plates, in recording earlier defeats of the Pratīhāras, do not mention the destruction of temples. Instead they state that the Pratīhāra king was forced to ritually attend upon his Rāṣṭrakūṭa rival.[73] That no account of temple destruction is found suggests once again that the Pratīhāras were not involved in temple building.

Dynastic Temples After the Disintegration of Pratīhāra Hegemony

During the first half of the tenth century Mahendrapāla II and Devapāla (ca. A.D. 948–59) maintained the Pratīhāras as a power in the Gangetic plain, but succession problems and Rāṣṭrakūṭa incursions prompted the development of strong regional dynasties throughout northern India.[74] Most of these regional dynasties fostered temple building on an unprecedented scale and this exhibition includes some especially impressive pieces from the ruins of these monuments. This later period is also rich in epigraphic records that shed considerable light on patronage after the disintegration of Pratīhāra power.

The Candellas are perhaps the most well-known regional dynasty due to the number of temples surviving at Khajurāho (ancient Khajūravāhaka). The Candellas first appeared as a notable power when Harṣadeva supported Mahīpāla (ca. A.D. 912–43) in his successful bid for the Pratīhāra throne.[75] Yaśovarman (ca. A.D. 925–54) raised the prestige of the Candellas by taking Kālinjar, an important fortress and center of military power. The same trends are augured by the inscription on the Sās Bahu temple at Gwalior. This records that the

Kacchapaghāta prince Vajradāman (ca. A.D. 975–1000) "put down the rising power of the ruler of Gadhinagara [Kannauj] and his proclamation drum . . . resounded on the fort of Gopādri."[76] In the Malāva region, the Paramāra prince Vairisimha seems to have ruled Dhārā as a feudatory of the Rāṣṭrakūṭas.[77] Vairisimha's son Harṣa Sīyaka rebelled and defeated the Rāṣṭrakūṭa Khoṭṭiga (A.D. 967–72), devastating Mānyakheṭa in the process.[78] Vākpati Muñja, son of Harṣa Sīyaka, issued a charter from Ujjayinī in A.D. 974–75 and subsequent Paramāras ruled over Malwa for more than a century.[79] In Rajasthan, the imperial Pratīhāras were able to maintain some tributaries, but their relative decline is documented by inscriptions from Rajor, Bayānā, Harasnāth and Garh.[80]

No abrupt changes are found in temple patronage with the rise of these regional dynasties. However, there were subtle shifts in emphasis and a clarification of the ties between kings and the temples they supported. The inscriptions and monuments at Khajurāho are perhaps the most dramatic illustration of this. The Lakṣmaṇa temple inscription is symptomatic of the building activities of the Candella kings.[81] It enters into some unusual detail, describing how Yaśovarman forced the Pratīhāra king Devapāla to surrender an ancient and celebrated metal image of Vaikuṇṭha. This image was set up in the Lakṣmaṇa temple, a building expressly constructed by Yaśovarman for the purpose.[82] At the close of the inscription, there is a brief reference to Vināyakapāla, the Pratīhāra monarch. While this passing nod maintains the fiction that the Candellas were tributaries of the Pratīhāras, they soon set aside their token homage. The Viśvanātha temple inscription of Vikrama year 1059 (A.D. 1002–03) omits any mention of an overlord.

Most of the Khajurāho inscriptions, despite their large size, have been shifted from their original position. An effort to protect the archaeological remains has resulted in some of the tablets being placed in temples to which they have no historical connection. In the Sās Bahu temple at Gwalior, however, the dedicatory inscription is still beside the main entrance as originally intended and is carefully incised with over one hundred verses giving a history of the Kacchapaghāta dynasty. The temple was founded by Padmapāla and completed by his successor Mahīpāla.[83] As at Khajurāho, direct links are made between the temple and the dynasty, in this case reinforced by the building's dedication to Padmanātha (Viṣṇu) in honor of Padmapāla.

Among the most fascinating inscriptions of this period is one from the ruined Śiva temple on a hill called Harsha or Uchāpahar, not far from Sikar in Rajasthan. Some sculptures from this site have been included in this exhibition. The superlative quality of these sculptures is matched by the historic significance of the inscription, which states that a series of additions and endowments were made to the temple by a line of Cāhamāna princes and their supporters.[84] It also contains elaborate references to the temple complex. For example, verse 12 of the inscription describes the main shrine.

> Glory to this mansion of holy Harṣadeva! It is auspicious for the expanse
> of its superlative halls which are radiant like eggs of gold; it is
> Pleasing like Pāṇḍu's mighty sons for the rows of shrines at its edge;
> It is comparable to the pinnacle of Mount Meru, and it is
> Pleasant for the skillfully carved bull at the entrance gate and for its
> endowment of manifold objects of enjoyment.[85]

From the perspective of patronage, the central point revealed by the inscription is that a Cāhamāna clan had this temple as its family shrine. Construction was initiated in the mid-tenth century by Simharāja who provided the necessary funds and "on Śiva's dwelling he set a golden [man] like the full moon, his own glorious form made manifest."[86] The custodians of this shrine were a line of Śaiva ascetics or ācāryas who supervised the building of the temple and its surrounding wells, courts, and gardens. The ascetic Bhāvarakta Allaṭa began the work and it was finished after his death by Bhāvadyota. These ascetics did not

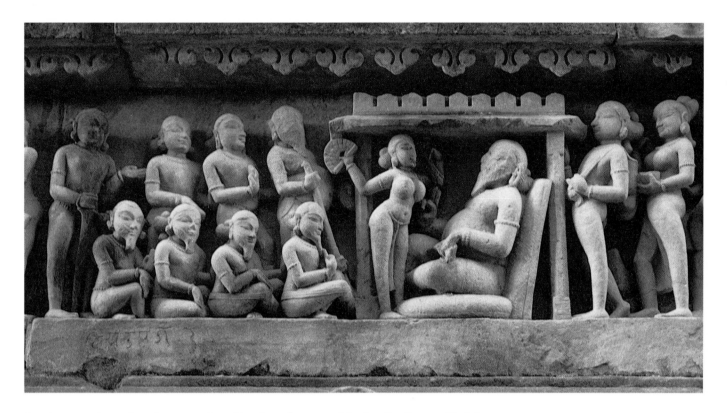

do the actual work, of course, but hired craftsmen with the funds provided by their patrons. The architect's name is given as Caṇḍaśiva, son of Vīrabhadra; the temple was completed in Vikrama year 1013 (A.D. 956–57). The mention of ascetics introduces an important element of temple life. While the cults represented by these individuals were quite ancient, it is only in the tenth and eleventh centuries that their history and social position emerges with any degree of clarity. That ascetic orders were well established in northern India by the eighth century is shown by a number of records, a good example being the Indragarh inscription of Vikrama year 767 (A.D. 710–11).[87] Two ascetics named Vinītarāśi and Dāṇarāśi of the Pāśupata sect are its central figures. The record states that Dāṇarāśi was responsible for making a temple (*mandira*) of Svayambhorlokanātha (Śiva). The inscription does not specify what sort of relationship existed between Dāṇarāśi and Naṇṇappa, a ruler whose exploits are praised at some length. One would suspect that Naṇṇappa was a patron, but this is not actually stated, a circumstance that is not unusual. However, an inscription from Rannod shows how ascetics might establish a relationship with a prince and subsequently become sponsors of architectural projects.[88] This record explicitly states that a king named Avantivarman was desirous of being instructed in Śaiva doctrine and so resolved to bring Purandara to his country. Purandara belonged to a respected line of teachers known from several sources.[89] The saint eventually initiated Avantivarman and then founded a monastery (*maṭha*) in the king's city. About one hundred years after Purandara's passing, a master named Vyomaśiva took charge of the establishment. He restored the building and constructed a tank and temple. The tank and adjacent monastery are still extant at Rannod (ancient Araṇipadra). The inscription is not dated but likely belongs to late tenth or early eleventh century. That Śaiva cults enjoyed wide currency is indicated not only by the preponderance of dedications in favor of Śiva, but by incidental depictions of Śaiva ascetics on temples. Several examples are found at Khajurāho, one of the most detailed being on the Lakṣmaṇa temple (Fig. 21). This relief shows a master seated in a small pavilion; in front of him is a female attendant and a row of four bearded disciples. To the left is a doorkeeper with a sword who appears to be introducing three individuals.[90]

 Close ties could be established between ascetics as depicted in the Khajurāho relief and princes and, in turn, could lead to the construction of temples and

Fig. 21
Relief in the temple platform showing a Śaiva ācārya with disciples and attendants, Lakṣmaṇa temple, Khajurāho, Madhya Pradesh, datable to Vikrama year 1011 (A.D. 954–55).

monasteries. In some cases, the temples became closely associated with the dynasty, the ascetics becoming royal intimates and enjoying, albeit indirectly, the revenue belonging to the god. The relationship was beneficial to all concerned. The ascetics established and controlled the temple, but the dedication was made in the royal patron's name. A link between the god and king was thus forged through the application of the ascetic's sacred knowledge. From this the king received legitimacy and the *ācārya* support for his order. The tangible product was a temple that advertised the power of the dynasty and its associations with a particular manifestation of the godhead.[91]

These arrangements were substantially different from the old Vedic scheme of kingship. Up to the fifth century, Śrauta rituals propelled the king upward into contact with the divine, from whence he returned infused with power and a mandate to rule. After the abeyance of royal sacrifices, power was seen as flowing down from the divine through whole or partial incarnation (in the case of Viṣṇu) or manifestation (in the case of Śiva). Kings no longer reached up through sacrificial effort but sought to associate themselves with the sacred as it was known and revealed in this world. Rulers devoted to Viṣṇu saw themselves as participating in the descent of the divine through noble deeds and an august lineage that recapitulated the god's incarnation into the world for the maintenance of universal order. Rulers devoted to Śiva identified their personalities with the infinite power of the supreme lord that eternally pervades the whole creation. Given that nobles had long built temples and that inscriptions display remarkable continuity in organization and poetic style, it seems likely that these connections were always inherent, if not openly articulated. They become clear after the mid-tenth century due to the decline of the Pratīhāras and the increasingly unstable condition of north India. Regional princes made free use of imperial titles and competed vigorously with each other in the arts of peace and war. Yet, however powerful some of these princes became, no ruler was able to claim paramount status. In the absence of a recognized imperial center, there was no impetus to return to the detached role once played by the Pratīhāra monarchs. Regional princes, unlike the Pratīhāras, maintained and amplified their programs of temple construction. In the competitive climate that prevailed, the small temples of earlier days gave way to projects of unprecedented size and elaboration. The passing of the Pratīhāras in the later part of the tenth century thus inaugurated an era in which temple building, typically on a vast scale, became one of the central acts of Indian kingship. This pattern of patronage prevailed until the establishment of the Islamic Sultanate in the closing decades of the twelfth century.

1. A general introduction will be found in Willis, "India, XI. Patronage, 1. architecture and sculpture," in *The Dictionary of Art*, J. S. Turner, ed. (London: Macmillan, forthcoming).

2. The term is spelled *āgara* or *agrahāra*, the latter being an early form; see K. V. Ramesh and S. P. Tewari, *A Copper-Plate Hoard of the Gupta Period from Bagh, Madhya Pradesh* (Delhi: 1990), p. xi.

3. One such inscription is discussed in Phyllis Granoff's essay.

4. *Epigraphia Indica*, vol. 19 (1927–28), pp. 52–65. (*Epigraphia Indica* is hereafter cited as *EI*.) Ahar is located in District Bulandshahr, Uttar Pradesh; the inscription is now in the State Museum, Lucknow.

5. Excavations at Ghazna have uncovered a variety of Indian items, among them Brāhmaṇic stone images that were set up in the palace as souvenirs of the conquest.

6. Sheldon Pollock, "The Theory of Practice and the Practice of Theory in Indian Intellectual History," *Journal of the American Oriental Society*, vol. 105 (1985), pp. 499–519 and Pollock, "Mīmāṁsā and the Problem of History in Traditional India," *JAOS*, vol. 109 (1989), pp. 603–10.

7. *EI*, vol. 32 (1957–58), pp. 207–12; S. M. Mishra, *Yaśovarman of Kanauj* (Delhi: Abhinav, 1977).

8. Vākpati, The *Gauḍavaho: A Historical Poem in Prākrit*, Shankar Pandurang Pandit, ed. (Bombay: Government Central Book Depot, 1887), verses 507–08; the construction was said to have been completed in a single day (*surāpasāo pahuṇā ekkeṇa diṇeṇanimmavio*).

9. *Indian Antiquary*, vol. 19 (1890), p. 310; the inscription dates to the ninth or tenth

century. (*Indian Antiquary* is hereafter cited as *IA*.)

10. Prabhācandrācārya, *Prabhāvakacarita*, Jina Vijaya Muni, ed. (Ahmedabad, 1940), p. 94 (verses 139–40) and Rājaśekharasūri, *Prabandhakośa*, Jina Vijaya Muni, ed. (Santiniketan, 1935), pp. 28–29.

11. *IA*, vol. 19 (1890), pp. 55–62. This record is dated Mālava year 795 (A.D. 738–39). The complexity of calendars and eras in India often excludes exact Gregorian equivalents even when the day and month are recorded in the inscription. For the present purpose, equivalents have been approximately calculated and thus typically span two Gregorian years. In some cases, however, there is sufficient information about the procedure used to record a date to enable provision of an exact equivalent. For an introduction to Indian calendars, see A. Basham, *The Wonder That Was India* (London: Fontana, 1971), Appendix III.

12. Read *Kanaswa* or *Kamsuvan* as "Kanswa," Survey of India Map 45 D.16.5. Elaborate synonyms being typical of these epigraphs, the temple is also described as a *mandira* of Dhūrjaṭi.

13. Munshi Deviprasād [and F. Keilhorn], "Ghaṭayālā Inscription of the Pratīhāra Kakkuka of [Vikrama] Saṁvat 918," *Journal of the Royal Asiatic Society* (1895), pp. 513–21.

14. As evidenced by Bāuka, *EI*, vol. 18 (1925–26), pp. 87–99, also discussed below.

15. *Progress Report of the Archaeological Survey of India, Western Circle* (1906–07), pp. 34–35.

16. *EI*, vol. 12 (1913–14), pp. 10–17. The inscription likely dates to the tenth century.

17. *EI*, vol. 3 (1894–95), pp. 263–67. The inscription was found in the ruins of a temple called Nīlakaṇṭha Mahādeva in Pāranagar, south of Rajor; it is dated Vikrama year 1016 (A.D. 960).

18. The Karmḍaṇḍ inscription of Gupta year 117 (A.D. 436–37) records the setting up of a *liṅga* by Pṛthivīṣena and then naming it Pṛthivīśvara. Ram Swaroop Mishra, *Supplement to Fleet's Corpus Inscriptionum Indicarum, Vol. III 1888, Inscriptions of the Early Gupta Kings and Their Successors* (Varanasi: Benares Hindu University, 1971), number 19.

19. K. A. Nilakanta Sastri, *The Cōḷas* (Madras: Madras University, 1955); A. S. Altekar, *The Rashtrakutas and Their Times* (Poona: Oriental Series, 1934); R. S. Tripathi, *History of Kanauj* (Benares: Indian Book Shop, 1937).

20. Burton Stein, *Peasant State and Society in Medieval South India* (Oxford: Oxford University Press, 1980).

21. Ronald Inden, *Imagining India* (Oxford: Basil Blackwell, 1990).

22. Nicholas B. Dirks, *The Hollow Crown: Ethnohistory of an Indian Kingdom* (Cambridge: Harvard University Press, 1988).

23. *EI*, vol. 9 (1907–08), pp. 248–56.

24. *Viṣṇoh kim caraṇastrivikramakṛteḥ stambhākṛtervvā vapuḥ sthāṇorbhūvira[rā]tphaṇindra ripunā śeṣothavā proddhṛtaḥ/ itthaṁ bhūri vi[cāra]yadbhiramarairālokya nī[ści]yate stambhaḥ śuddhaśilamāyah Parabāla [kṣmā]pāla kīrttipradaḥ//*

25. R. D. Trivedi, *Temples of the Pratīhāra Period in Central India* (Delhi: Archaeological Survey of India, 1990), plates 131–32.

26. *EI*, vol. 32 (1957–58), pp. 112–17. Cāḷukya princes are likewise found, but they are unrelated to the Cāḷukyas of Vātāpi; see *EI*, vol. 9 (1907–08), pp. 1–10.

27. *EI*, vol. 9 (1907–08), pp. 198–200. M. A. Dhaky, "The Genesis and Development of Māru-Gurjara Temple Architecture," in *Studies in Indian Temple Architecture*, Pramod Chandra, ed. (New Delhi: American Institute of Indian Studies, 1975), plates 63–64.

28. *IA*, vol. 10 (1881), pp. 34–36. The inscription is damaged and consequently all details of this foundation are not clear.

29. *EI*, vol. 36 (1965–66), p 32.

30. Illustrated in Donald M. Stadtner, "The Śaṅkaragaṇa Panel in the Sāgar University Art Museum," in *Indian Epigraphy: Its Bearing on the History of Art*, F. M. Asher and G. S. Gai, eds. (New Delhi: American Institute of Asian Studies), pp. 165–68; also in Stadtner, "Nand Chand and a Central Indian Regional Style," *Artibus Asiae*, vol. 43 (1981–82), fig. 6.

31. This inscription, datable to the early tenth century and probably critical for late Pratīhāra and early Candella history, has not been published.

32. *EI*, vol. 1 (1889–92), pp. 154–62. One inscription is over the lintel, the second on the wall of the cella.

33. *EI*, vol. 20 (1929–30), pp. 37–46; the temple has not survived. Buddhist foundations were not unusual in the eighth century as shown by an inscription from Shergarh (District Kotah), *IA*, vol. 14 (1885), pp. 45–48.

34. *EI*, vol. 9 (1907–08), pp. 1–10. The Una plates are dated Valabhī year 574 and [Vikrama or Śaka] year 956.

35. *IA*, vol. 12 (1883), pp. 190–95.

36. Richard Salomon and Michael Willis, "A Ninth-Century Umāmaheśvara Image," *Artibus Asiae*, vol. 50 (1990), pp. 148–55.

37. *EI*, vol. 4 (1895–97), pp. 29–32.

38. *EI*, vol. 36 (1965–66), pp. 52–53; *EI*, vol. 10 (1927–28), pp. 52–62; *EI*, vol. 14 (1917–18), pp. 176–88; *EI*, vol. 1

(1889–92), pp. 162–79.

39. The adjective *common* is undesirably amorphous but it is forced upon us by the paucity of information about the humbler levels of Indian society during this period.

40. *Annual Report on the Workings of the Rajputana Museum, Ajmer for the Year Ending 31st March 1924* (Simla: Government of India Press, 1924), p. 3; also see *EI*, vol. 19 (1927–28), p. 54, n. 1.

41. *EI*, vol. 36 (1965–66), pp. 49–52. The inscription is dated Harṣa year 182 (A.D. 788) and comes from Tasai near Alwar.

42. *EI*, vol. 1 (1889–92), pp. 184–90 and 162–79.

43. *EI*, vol. 1 (1889–92), pp. 242–50.

44. *Goggena kāritaṁ madhye Pūrṇarājena pṛṣṭhaḥ / purato Devarājena ghanāndhatamasacchide.//*

45. *EI*, vol. 4 (1895–97), pp. 309–10. The date corresponds to 10 September 862.

46. Illustrated in Trivedi, *Temples of the Pratīhāra Period*, plates 83–84.

47. The ancient name is provided by an eighth-century hero stone in the Central Archeological Museum, Gwalior; illustrated in J. C. Harle, "An Early Indian Hero-stone and a Possible Western Source," *Journal of the Royal Asiatic Society* (1970), pp. 162–64, plate II(b). I am grateful to Richard Salomon for providing a reading of this inscription from my estampage.

48. *EI*, vol. 36 (1965–66), pp. 52–53; this inscription is fragmentary.

49. *EI*, vol. 24 (1937–38), pp. 329–36; further comments in *EI*, vol. 36 (1965–66), pp. 52–53.

50. *EI*, vol. 1 (1889–92), pp. 184–90.

51. *EI*, vol. 5 (1898–99), pp. 208–13; *EI*, vol. 19 (1927–28), pp. 15–19; *IA*, vol. 15 (1886), pp. 105–13.

52. *IA*, vol. 15 (1886), pp. 105–13 and 138–41; *EI*, vol. 14 (1917–18), pp. 176–88.

53. *EI*, vol. 14 (1917–18), pp. 176–88. This inscription was found in the platform of a well and is now in Ajmer; it carries two dates, Vikrama year 999 (A.D. 942–43) and Vikrama year 1003 (A.D. 946–47).

54. *EI*, vol. 17 (1925–26), pp. 99–114; D. C. Sircar, *Select Inscriptions Bearing on Indian History and Civilization, 2* vols. (Calcutta: University of Calcutta, 1965; Delhi: Motilal Banarsidass, 1983), pp. 242–46, plate XVII.

55. *rājñā ṭena svadevīnāṁ yaśaḥ puṇyābhivṛdhhaye / antaḥpurapuraṁ namnā vyadhāyi narakadviṣaḥ//*.

56. D. C. Sircar, *Indian Epigraphical Glossary* (Delhi: Motilal Banarsidass, 1966), s.v. *antaḥpura.*

57. H. D. Sankalia is mistaken in thinking the inscription records the foundation of a temple, "Gurjara-Pratīhāra Monuments: Study in Regional and Dynastic Distribution of North Indian Monuments," *Bulletin of the Deccan College Research Institute*, vol. 4 (1942–43), p. 150.

58. *EI*, vol. 1 (1889–92), pp. 154–62.

59. *Archaeological Survey of India Report 2* (1864–65), p. 337.

60. Mahdi Husain, *The Reḥla of Ibn Baṭṭūṭa (India, Maladive Islands and Ceylon) Translation and Commentary* (Baroda: Oriental Institute, 1953), pp. 45 and 163. The palace remains were first published in Willis, "An Eighth-Century Miḥrāb in Gwalior," *Artibus Asiae*, vol. 46 (1985), pp. 227–46.

61. J. B. Keith, *Preservation of National Monuments; Gwalior Fortress* (Calcutta: Superintendent of Government Printing, 1883), p. 75, records that the capital was found at Trikonia Tāl, Gwalior. Illustrated in Department of Archaeology, Gwalior State, *A Guide to the Archaeological Museum at Gwalior* (Gwalior, [193–?]), plate vii; Pramod Chandra, *The Sculpture of India, 3000 B.C. to 1300 A.D.* (Washington, D.C.: National Gallery of Art, 1952), p. 209.

62. D. R. Patil, *The Cultural Heritage of Madhya Bharat* (Gwalior: Department of Archaeology, Madhya Bharat Government, 1952), p. 110.

63. *EI*, vol. 17 (1925–26), pp. 87–99. The inscription was recovered from Jodhpur; though belonging to the ninth century it refers to events and building activities from as early as ca. A.D. 600.

64. *nanu sama[ra]dharāyāṁ Bāuke ṇṛtyamāne śavatanuśakalāntreṣveva vinyastapādē / śamamiva hi gātās te tiṣṭhatiṣṭheti gītād bhayagatanṛk[u]raṅgāścittram etat tadāsīt.//*

The words *tiṣṭha, tiṣṭha* capture, in an onomatopoeic sense, the sound of dancing through corpses and entrails oozing with blood. Such descriptive passages are not uncommon in epigraphic accounts of war.

65. The reassertion of imperial Pratīhāra power in the region is evidenced by the Siwāh plate that records that Bhoja reinstated a grant of Vatsarāja, which was in abeyance; *EI*, vol. 5 (1898–99), pp. 208–13. Though called the Daulatpurā plate, it was in fact recovered at the village of Sewa or Siwāh, Survey of India Map 45.I.11.7.

66. *EI*, vol. 19 (1927–28), pp. 287–90.

67. Michael Rabe, "Royal Portraits and Personified Attributes of Kingship at Mamallapuram," *Journal of the Academy of Art and Architecture, Mysore*, vol. 1 (1991), pp. 1–4.

68. Louis Renou, "The Vedic Schools and the Epigraphy," in *Siddha Bharati*, 2 vols., Vishva Bandhu, ed. (Hoshiarpur: Veshvarananda Vedic Research Institute, 1950), vol. 2, pp. 214–21.

69. The temple is dated to A.D. 961; R. C. Agrawala, "Inscriptions from Jagat, Rajasthan," *Journal of the Oriental Institute, Baroda*, vol. 14 (1965), pp. 75–78; Agrawala, "Unpublished Temples of Rajasthan," *Ars Asiatiques*, vol. 11 (1965), pp. 53–72.

70. *EI*, vol. 7 (1902–03), p. 43.

71. *yanmādyaddvipadantaghatavisamam kālapriyaprāṅgaṇaṁ tīṛṇā yatturagair agādhayamunā sindhu-pratisparddhinī / yenedaṁ hi mahodayārinagaraṁ ṇirmūlam unmūlitaṁ nāmnādyāpi janaiḥ kuśasthalam iti khyātiṁ parāṁ nīyate//.*

72. V.V. Mirashi, "Three Ancient and Famous Temples of the Sun," *Purāṇa*, vol. 8 (1966), pp. 38–51; D.C. Sircar, *Studies in the Geography of Ancient and Medieval India* (Delhi: Motilal Banarsidass, 1971), pp. 301–07.

73. *EI*, vol. 18 (1925–26), pp. 243 (verse 9); *EI*, vol. 6 (1900–01), p. 243 (verse 8); *IA*, vol. 11 (1882), p. 157.

74. See R. C. Majumdar, ed., *The History and Culture of the Indian People: The Age of Imperial Kanauj* (Bombay: Bharat Vidya Bhavan, 1955), p. 37, for the complexities of imperial succession after Mahendrapāla II.

75. *EI*, vol. 1 (1889–92), p. 122 (line 10). The inscription was found near the Vāmana temple, Khajurāho. For more general information, see R. K. Dikshit, *The Candellas of Jejākabhukti* (Delhi: Motilal Banarsidass, 1977).

76. *IA*, vol. 15 (1886), pp. 33–46; the record is dated Vikrama year 1150 (A.D. 1093–94). For a recent account of the dynasty's history, see Harihar Nivās Dvivedī, "Gopakṣetra ke kacchapaghāta," in *Gvaliyar darśan* (Gwalior: Gwalior Research Institute, 1980), pp. 186–216.

77. *Annual Report on Indian Epigraphy* (1957–58), p. 2.

78. *EI*, vols. 19–23 (1927–36), Appendix, number 64; *EI*, vol. 1 (1889–92), p. 137 (verse 12). For literary references to the devastation of Mānyakheṭa, see Hem Chandra Ray, *The Dynastic History of Northern India*, 2 vols. (Calcutta: University of Calcutta, 1931–36), vol. 2, pp. 850–51.

79. *EI*, vols. 19–23 (1927–36), Appendix, number 84.

80. *EI*, vol. 3 (1894–95), pp. 263–67; *EI*, vol. 22 (1933), pp. 120–27; *EI*, vol. 2 (1892–94), pp. 116–30; *EI*, vol. 39 (1972), pp. 189–98, the last giving a fresh summary of the problems of late Pratīhāra history.

81. *EI*, vol. 1 (1889–92), pp. 122–35. The inscription, dated Vikrama year 1011 (A.D. 954–55), was found "amongst the ruins at the base of the temple known as Lakshmaṇ̄ji" at Khajurāho.

82. The theme of objects looted by Indian kings was explored by Richard Davis, "Indian Art Objects as Loot," read at the Annual Meeting of the American Committee of South Asian Art (Richmond, Virginia) 29 April 1988. S. Huntington, *The Art of Ancient India* (New York: Weatherhill, 1985), p. 469, suggests the main image in the Lakṣmaṇa temple is a tenth-century replacement of the metal Vaikuṇṭha; in fact the current image dates to the eleventh century.

83. *IA*, vol. 15 (1886), pp. 33–46. The date given is Vikrama year 1150 (A.D. 1093–94).

84. *EI*, vol. 2 (1892–94), pp. 116–130.

85. *[eta]t svarṇṇāṇḍakāṁtipravaratama mahāmandapābhogabhadraṁ prāṁtaprāsādamālāviracitavikaṭāpāṇḍu-putrābhirāmam / meroḥ sṛṅgopamānaṁ sughaṭitavvṛṣasattoraṇadvāraramyaṁ nānāsadbhogayuktaṁ jayatī bhagavato harṣadevasya [harmmyam] //.*

86. *haimamāropitaṁ yena śivasyabhavanopari / pūrṇṇacandropamaṁ svīyaṁ mūrttaṁ ya[ś] [piṁ?]ḍakam.* The description is somewhat opaque, but I would take *haima* ("golden") to mean *haimapuruṣa* or *hiraṇyapuruṣa*, the "golden man" that often holds a temple's crowning flagstaff. Surviving examples are of stone, but this description suggests they could be gilt or made completely of metal. The donor is apparently being identified with this figure near the summit of the spire. Epigraphic descriptions of temple buildings (among them *EI*, vol. 39 [1972], pp. 189–98, and *EI*, vol. 41 [1975–76], pp. 49–57) merit comprehensive study. An important instance of the use of this material is M. A. Dhaky, *The Indian Temple Forms in Karṇāṭa Inscriptions and Architecture* (Delhi: Abhinav, 1977).

87. *EI*, vol. 32 (1957–58), pp. 112–17. The inscription is in the Central Museum, Indore.

88. *EI*, vol. 1 (1889–92), pp. 351–61.

89. Mirashi, "Gwalior Museum Stone Inscription of Pataṅgaśambhu," *Journal of the Madhya Pradesh Itihas Parishad*, vol. 4 (1962), pp. 3–12; also see *IA*, vol. 12 (1883), pp. 190–95 (copper-plate grant recording the gift of a village to Śrī Maheśvarācārya of the glorious Āmardaka tradition, *śrīmadāmarddakasantāna*). Elsewhere I have suggested that Āmardaka is represented by the modern Amrol; see "Introduction to the Historical Geography of Gopakṣetra, Daśārṇa and Jejākadeśa," *Bulletin of the School of Oriental and African Studies*, vol. 51 (1988), pp. 273–78.

90. The doctrines and practices of some of the Śaiva cults are summarized by Pramod Chandra, "The Kaula–Kapalika Cults at Khajurāho," *Lalit Kalā*, vols. 1–2 (1955–56), pp. 98–107.

91. These circumstances neither prevailed in all temples nor applied to all ascetic orders; see *Progress Report of the Archaeological Survey of India, Northern Circle* (1905–06), p. 14; *IA*, vol. 16 (1887), pp. 173–75.

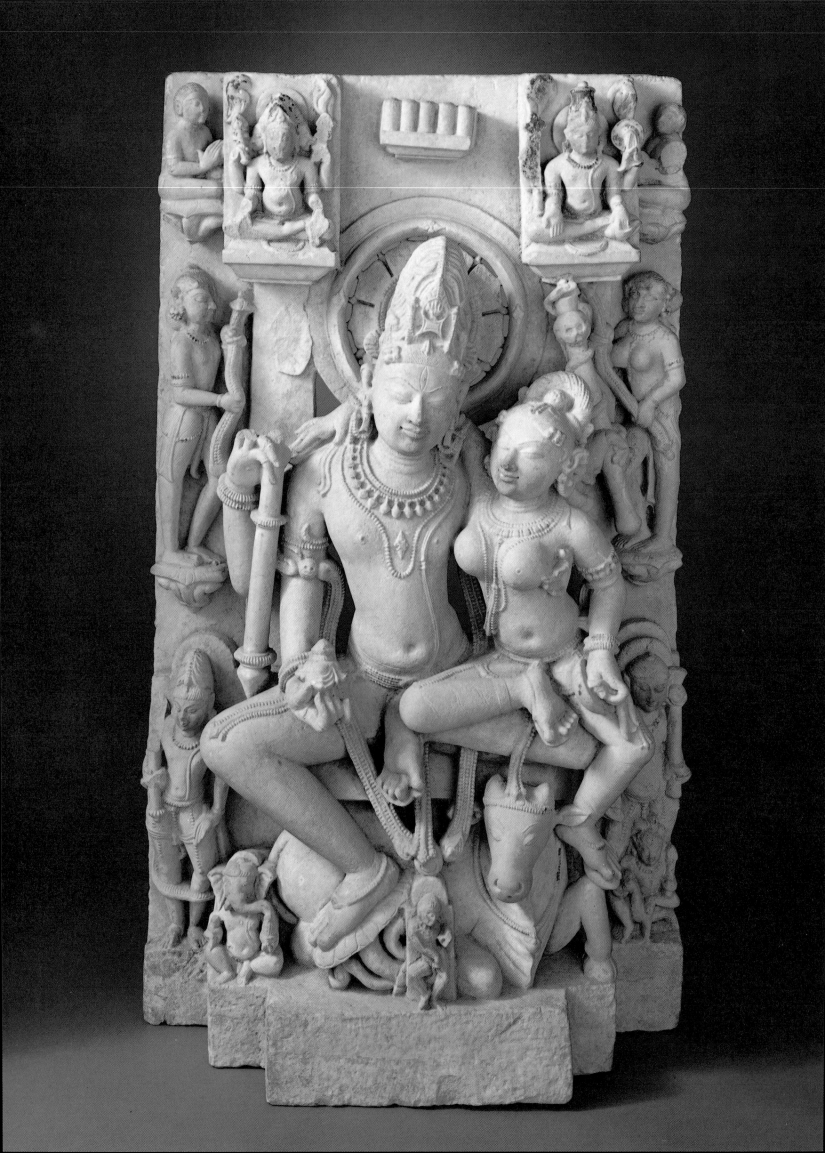

Halāyudha's Prism

The Experience of Religion in Medieval Hymns and Stories

Phyllis Granoff

The period covered by this exhibition (A.D. 700 to 1200) was one of great creativity, producing works of art that ranged from elaborately sculpted temples to intricately composed poems. We are extremely fortunate in having at our disposal a rich and diverse body of medieval literature to which we may turn to facilitate our understanding of the religious, philosophical, and emotional context of the individual visual works represented here. This essay draws primarily on two types of medieval religious writing—hymns and stories.

The hymns were written as independent compositions, while the stories were included in encyclopedic collections known as *purāṇas*. A typical *purāṇa* might include myths about the many Hindu gods and goddesses, accounts of the origin of the universe, instructions for the proper performance of rituals, and summaries of current knowledge on subjects as diverse as grammar and the care of elephants and horses. The *purāṇas* were not written at a single time nor by a single hand. They have been notoriously difficult to date, and some of the stories used in this essay belong to a period that slightly postdates the exhibition. Nonetheless they typify medieval Indian attitudes toward temple worship. The hymns can be more precisely dated; they belong to the tenth and eleventh centuries. Both the hymns and the stories were originally written in Sanskrit, long considered the most appropriate vehicle for religious and philosophical instruction and the language favored by scholars and poets of the royal courts.

To the extent possible, the original author will be allowed to speak for himself (albeit in translation). A panoply of sources has been deliberately included in order to demonstrate that, despite the approach taken in many textbooks, medieval Indian religious experience cannot really be defined as one thing or another. Medieval worshipers had many different ways in which they approached and conceptualized the divine. Therefore, many different voices will be heard.

The first voice belongs to the tenth-century poet Halāyudha, who wrote a remarkable hymn to Śiva. Halāyudha's poem is a good opening because it brings together, in one act of writing, many of the different understandings of worship and God that existed in medieval India. In his fervent devotion, Halāyudha worships at once the God of the philosophers—abstract and beyond the normal range of conceptual thought—and the God of the *purāṇic* stories—human, subject to passion and anger, the God whose many exploits were recorded on the walls of medieval temples. In pouring out his emotions to both an abstract deity and a very personal god, Halāyudha vividly illustrates the mystery and complexity of perceptions of the divine in medieval India.

Halāyudha's Hymn to Śiva

The One God Śiva, whose very form is pure knowledge, along with His Goddess, surpasses all else. All of this world in all its manifold

Fig. 22
Śiva-Pārvatī (No. 25).

splendor—earth, heaven, and the netherworld—is a manifestation of Their joint power. I bow before that divine couple [see Fig. 22], who are ever united, never apart, ever eternal and unchanging, the source from which the origin of the universe proceeds. (3)

O Śiva, I long to sing of Your boundless glory, and yet my mind stops short, knowing only a fraction of what there is to know.

O Three-eyed Lord, though I know all too well my limits, my deep feelings of devotion urge me on to commit this rash act and sing this hymn. (5)

O Śiva! Even the Gods Brahmā and Viṣṇu could not find words to describe Your true form, which is beyond the range of normal speech and thought.

O Granter of Wishes! So that is why in my devotion to You I worship with my words this lower form of Yours, in which You are the Beloved of Pārvatī, the Daughter of the Mountain Himālaya. (7)

In this endless cycle of rebirths, it is difficult just to be born as a human being.

Only someone who has accumulated great merit over many past lives finds You; the masses worship other gods.

O Destroyer of the God of Love, many may climb the magic mountain Rohaṇa, which is studded with jewels; but only one will actually find a diamond while the others will be satisfied with worthless glimmering crystals of quartz. (10)

Jains and Buddhists, surrendering themselves to the Jina or the Buddha, in truth worship You.

And You grant them their heart's desires as well You should. After all, does not the cool water that exhausted travelers drink quench their thirst, whatever they imagine it to be in their delirium? (11)

The Sun and the planets follow their courses;

Time passes, measured in days, nights, fortnights, months, and seasons.

None of this would be possible without You as the active agent of change.

Whose else is the power to move the heavenly bodies and measure out time? (12)

O Three-eyed One! You have burned the God of Love with the fire of Your glance, that God of Love whose might had burned the three worlds—earth, heaven, and the netherworld.

And in doing so You only did what was right.

For those who would cause others pain must in the end suffer the anger of those who are their overlords. (16)

You are the sole refuge of those who are blighted by poverty and tormented by misfortune;

Of those whom enemies besiege and of those who are the victims of their own foolishness;

Of all of those who are sorely troubled by grief and misery, You are the sole refuge, as water is for the thirsty. (18)

O God Who Bears the Crescent Moon in His Locks!

All that follows is worthless if one does not worship Your feet: a noble birth, mature knowledge of the scriptures, a tendency to perform pious acts, expertise in philosophy, cultivated and well-adorned speech, great wealth, a healthy and a sound body. (19)

As soon as he is reborn in heaven, rays of light emanating from the crowns of Brahmā and the other gods will restore the natural ruddiness to the calloused feet of Your devotee who got those callouses from running here and there to gather flowers for Your worship. (20)

Once they are reborn in heaven as the leaders of the gods, Your devotees will anoint their hands with the sandal paste that they rub off from the breasts of heavenly damsels; for those are the very hands that had once been smeared with wet cow dung as they cleansed the house that held your image. (21)

It is truly a wonder; I have never heard tell of or seen anything like it before.

Tell me, O Lord, for I am curious.

How is it that a single flower placed in devotion at Your feet at once produces billions of fruits, whatever the devotee desires? (23)

O Three-eyed Lord! To the person who offers You a lamp that rends the darkness of Your temple with blazing light, You in turn give that light of knowledge that needs no further illumination and that splits the dense darkness of delusion in the night of terrifying illusion. (27)

You wear a garland of skulls, live in the cremation grounds, and adorn Yourself with ashes.

Your friends are ghosts and goblins; You beg for Your food.

What of it?

For someone whose power over all things has reached the highest limit, stones and gold—indeed all physical objects—are equally unimportant. (31)

In Benaras there is a divine light that is Śiva. It is like a mirror that reflects everything in the universe.

Those who abandon their bodies to that refulgence become one with You, just as single lamps merge into one great light. (39)

There is a *liṅga* of light that is visible in the sky above Śrīparvata, of golden radiance, a marvel in all the world. Those who have done great acts of merit in their past lives see it and, freed from the bondage of rebirth through Your compassion, become Your eternal companions. (40)

O Śiva! Some visualize You in the innermost recesses of their hearts by projecting images onto You—that most subtle light of knowledge.

And they become one with You as those projected images are removed, just as the ether in a pot merges with the great ether when the pot is broken, leaving no confining surface to mark off the unbroken space. (44)

I worship You as my very own soul, as the light of knowledge, self-radiant, in need of no other source of illumination in the three worlds, and beyond the touch of material qualities; I worship You as that One real in which everything in the universe is revealed, as in a shining mirror, to those whose thoughts are rigorously controlled and who are engaged in meditation. (48)

O Granter of Boons! Some know You as their innermost soul, pure bliss, and supreme consciousness, from which has vanished that illusory sense of difference that lies behind our perceptions of different objects in our world. Abandoning all passions, even as they live out their lives, they are free from the strong chains of illusion that once bound them and have achieved final release. (52)

If the state of Oneness with You that comes from destroying bondage is final release, then O Śiva, what good is that to me? I would rather fall into the darkest well.

May You always be my Lord and I always be Your servant.

That is best.

Servants should never strive to attain the state of their masters. (57)

Halāyudha's hymn consists of seventy-one verses, many of which repeat or elaborate upon similar ideas. These excerpts represent all of the basic themes that

are present in the poem. The poem has been preserved not in manuscript, as was customary, but in stone. In A.D. 1063, approximately one hundred years after Halāyudha wrote this hymn, a man named Gandhadhvaja had it carved onto the southern wall of the *ardhamaṇḍapa* of the temple to Śiva at Māndhātā, a small village on the banks of the Narmadā River in central India. Gandhadhvaja tells us what motivated this pious act; he says quite simply that he did it for his own welfare, and though the inscription is partially effaced, we may surmise that he was at the same time acting on the instructions of his religious guide, a Śaiva ascetic, whose spiritual lineage he also relates in some detail.[1]

Halāyudha's hymn is not the only hymn that was carved onto a temple wall; other temples of the period bear hymns on their walls.[2] It seems likely that the emotions and ideas that we might discern in these hymns also motivated many of the people who worshiped at those temples. We may look through the hymn as through a multifaceted prism to try to catch a glimpse of some of the many aspects of medieval Indian religiosity.

Halāyudha begins his hymn with two benedictory verses to Śiva's children (not translated). The first is to Gaṇeśa, the Elephant-headed God, and the second is to Skanda, the God of War. This follows the common medieval Indian practice of beginning any literary composition with benedictory verses in order to ensure its success.

It is with verse 3 that the hymn to Śiva properly starts. In this verse our attention is drawn to two facets of Halāyudha's God and to two closely interrelated ways of approaching God in medieval India. In this verse Halāyudha's God is above all the God of the philosopher, whose real form is self-refulgent knowledge. This God is the highest soul, which from the time of the Upaniṣads had been defined as perfect knowledge and bliss.[3] In keeping with one interpretation of Upaniṣadic teaching, a subsequent verse will tell us that this Highest Soul is in reality identical to our individual soul; it is also knowable through direct intuition, gained in part through meditative practices (44, 48, and 52).[4] As the Highest Soul, Śiva is without physical form and qualities, and to know Him we must reject the visible world as an illusion and turn inward, away from external forms of worship. The final goal of this philosopher's quest is release from the cycle of rebirth, unity with Śiva (52).

At the same time Halāyudha tells us that his Śiva is also the Beloved of Pārvatī, Daughter of the Himālaya Mountain, ever conjoined with his spouse. It is in this more concrete form, as we are told a few verses later, that the philosopher's God becomes accessible to the devotee (7). As the beloved of Pārvatī, Śiva enacts his many exploits that were celebrated in the stories of the *purāṇas* and inspired many of the different iconographic forms of Śiva familiar to medieval sculpture.[5]

The Śiva of the *purāṇas* is atypical in appearance and somewhat antisocial. He lives in the burial ground, wears garlands of snakes, smears his body with ashes, and sports the crescent moon in the tangle of his ascetic locks. In several verses our poet seeks to justify his God's unconventional behavior and unusual appearance (15, 16, 31, and 35). The *purāṇic* Śiva also burned the God of Love (16). His main function in the *purāṇic* group of three major gods, which includes Brahmā as creator and Viṣṇu as preserver, was to destroy the universe when one world cycle was complete (4). Śiva as destroyer is also equated with time, the great destroyer (12). This Śiva is a significant presence in Halāyudha's hymn, and the *purāṇic* stories aid our quest to understand medieval Indian religion.

However, if we are to gain a more complete understanding of the God of this hymn, we must focus not only on what Halāyudha says of that God, but also pay some heed to what the poet says of himself. In the opening verses, Halāyudha does glorify his God, but once he has generally defined the God to be praised as both the Highest Soul of the philosophical texts and the spouse of Pārvatī of the mythological works, he quickly turns to a self-characterization, emphasizing his own unworthiness (5 and 6). Śiva is not only the Highest Soul, Lord of the World, Destroyer of the Universe, Prime Mover of Creation; he is also the gentle savior of his most abject and unworthy devotee, who submits to him in moments

of fervent prayer. This is a theme that will recur in several later verses (8, 11, and 57). Furthermore, the devotee who is absorbed in such an awareness of his own insignificance yearns for a distinctive religious goal. The philosopher aims to become one with Śiva and to put a stop to the cycle of rebirth. By contrast, the humble devotee finds such desires sacrilegious and longs instead for perpetual rebirth and servitude (57).

Halāyudha as humble devotee approaches his God first and foremost with prayer. He says again and again that it is only his intense love of God that has prompted him to sing his song of praise; the hymn is his act of worship. But Halāyudha's Śiva also accepts other forms of worship. Śiva is not only the God of the philosopher, the hero of the *purāṇic* story, and the savior of the humble devotee; He is also a real physical presence, the visible God for whom the temple is built and to whom worship is offered.[6]

As the Lord of the temple, the God takes on concrete physical form, sometimes anthropomorphic, sometimes as the *liṅga,* often (as the stories tell us) in response to the needs of a particular devotee. Halāyudha mentions two famous manifestations of Śiva, one in Benaras (39) and one on Śrīparvata in south India (40). Increasingly in medieval India the divine presence in a particular temple and geographic location becomes the focus of a local cult and the occasion for many local stories.[7] The medieval corpus of *purāṇas* was greatly increased by the appearance of new texts that dealt with local gods and local temples. These texts, called *māhātmyas* or *sthala purāṇas*, sometimes circulated as independent texts; more frequently they were simply tacked on to existing *purāṇas.* They were written in the style of the earlier *purāṇas* but differ from them in their distinctly local flavor. *Sthala purāṇas* deal with the origins of a particular local manifestation of Viṣṇu, Śiva, or a goddess. They make use of earlier *purāṇic* stories to describe the sanctity of a specific site.[8]

In addition, the God in the temple was often named after the donor, and sometimes the temple served as a funerary monument, strengthening the connection of the temple with a particular local site and specific events.[9] In the case of Śiva, there developed a cult of the *jyotirliṅga,* particularly sacred *liṅgas* at various sites of pilgrimage, and stories were told to explain the origins of these pillars of flame. The *Śivapurāṇa* contains a substantial section on the *jyotirliṅga,* and it is worth noting that the language of the stories leaves no doubt about the fact that Śiva comes down to earth as the *liṅga* in concrete physical form (see Fig. 23).[10] We should be careful not to regard the *liṅga* in the Śiva temple or the anthropomorphic image of Viṣṇu, for that matter, as an abstract symbol. The God in the temple, unlike the abstract God of the philosophers, is a real person with legal rights, and it is to that God that wealthy and poor alike made their gifts. Moreover, that God could be identified with earthly donors or with those in whose memory the temple was built.

Many medieval stories and inscriptions describe the lavish gifts that could be made, particularly by kings. In fact, the very act of building a temple was considered an act of giving through which the builder of the temple provided the God a home. Temple building became the paradigmatic act of royal piety in medieval India. Controlling access to the temple and its rituals was also an important means of political control.[11]

Daily worship in the temple included a number of offerings, usually grouped into sixteen major types.[12] Halāyudha mentions the offering of flowers, lamps, garlands, and hymns of praise (20, 21, 23, and 27) (see Fig. 24). The marvelous fruits of such worship included a sojourn in heaven with divine pleasures, sensual delights, and a position of power among the gods. This is in contrast to both the release of the philosopher and the eternal servitude of the abject devotee that were achieved outside the structure of temple ritual.

Halāyudha's Śiva reflects the diverse nature of medieval Indian religiosity—He is at once abstract and anthropomorphic; He is one with the individual soul and He is ever distinct from the individual soul. Halāyudha's devotee also embodies many devotees and displays many different forms of

devotion and the various possible attitudes of a temple visitor in medieval north India. We see the devotee as a philosopher, who projects in his mind image after image of the God only to erase these images to arrive at bare reality. This devotee longs for a mystical awareness of his oneness with God and an end to the cycle of rebirth. We also meet the devotee as a humble servant, who prays and pleads with God to rescue him, to allow him to be reborn again and again as the servant of God. Finally, we see the devotee as a temple donor and worshiper, who makes offerings to God and hopes to be rewarded with rebirth in heaven. The poem makes abundantly clear that we must not focus on any one of these points, on any one side of the prism, to the exclusion of any other. He prays to Śiva at once as Supreme Consciousness and Bliss known to yogins in meditation, as Prime Mover of the universe beyond name and form, as resident God of the temple fixed in time and space and possessing concrete shape, and as personal deity and savior of the poor. In doing so he tells us unambiguously that as we glance through any side of the prism, we must keep in mind that the vista revealed is only part of a dynamic and active whole. There is no conflict between these different points of view, and in any given act of devotion the medieval poet honored his God in each of these many understandings.

Therefore, there are many directions in which we might orient our further quest to understand the religious background of the pieces of sculpture and architectural fragments in this exhibition. We might, for example, focus on the philosophical verses that tell of the essential unity between all individual souls and God. Indeed, the period covered by this exhibition was the most prolific in the entire history of Indian philosophy. Like Halāyudha, many medieval philosophers wrote deeply personal devotional hymns in addition to their abstruse speculative works. There is no question that their yearnings were important expressions of devotion.

We might alternatively focus on the poet's fervent avowal of his own unworthiness and his deepest desire for any rebirth, even the most humble, in which he can continue his devotion to God. Like many of his contemporaries, Halāyudha was affected by growing devotional movements, some of which would ultimately reject both philosophical speculation and temple ritual as paths to God. Much of the literature of these burgeoning movements was written in vernacular languages and sung in popular folk tunes, often stressing the importance of personal, private religious vision, with the religious teacher as the ultimate source of authority, supplanting the Sanskrit scholastic text. These religious movements were also highly influenced by Tāntric religion, which stressed personal transmission of the teachings and often repudiated traditionally sanctioned piety.[13]

The third lens is represented by those verses in which Halāyudha describes his God as the God of the temple and the *purāṇic* stories. Only one of Halāyudha's concerns—the merits that were said to have been gained by temple worship—will be the focus of the balance of this essay. By extension this will include an exploration of what might have brought men and women to the temples.

What follows are translations of several sections from the *purāṇas* that extol worship and relate miracles that occurred as a result. Halāyudha's hymn has shown that the God of the temple dominates only one plane on the prism. *Purāṇic* stories corroborate what may be surmised from the hymn by providing counterstories that either question the efficacy of the rituals or sarcastically attack the very institution of temple worship. Two subsequent stories make this clear, and the essay will speculate as to the reasons that they seek to undermine what other texts so fulsomely praise. It should be kept in mind that all of these stories, both those in support of and those against temple worship, are "miracle stories" that tend to the extreme; nonetheless, they also tell simple truths. Finally, some verses of a Jain poem help round out the picture by presenting some of the less religious reasons that people came to the temple—the thrill of the crowds, the excitement of watching a new play, and the aesthetic pleasure afforded by the structure and its elaborate sculpture.

The Glories of Worship: The *Viṣṇudharmottarapurāṇa* and the *Dvārakāmāhātmya* of the *Skandapurāṇa*

The *Viṣṇudharmottarapurāṇa* is said to have been composed sometime before A.D. 1000, probably in South Kashmir.[14] The first half of the text contains a number of stories that extol the worship of Viṣṇu. Viṣṇu, Śiva, and various forms of a female deity (usually associated with Śiva) were the most popular gods in medieval Hinduism. The majority of *purāṇas* deal with one of these three deities, and the splendid temples that were built during the period from 800 to 1200 were mostly dedicated to Śiva, Viṣṇu, or the goddess Durgā. A few temples were dedicated to Sūrya, the Sun God, and to Brahmā, the *purāṇic* deity associated with creation. Medieval literature contains numerous references to temples to minor deities, often called *yakṣas*, and to shrines to the God of Love, Kāma. The absence of any major temple to either Kāma or any of the *yakṣas*, however, leads to the suspicion that, at least during this period, shrines to these gods may have been made out of perishable materials and were much more modest than the temples to Viṣṇu, Śiva, or Durgā.

A survey of inscriptions associated with medieval temples leads to the general conclusion that most temples were royal donations.[15] Inscriptions also indicate that temples were dedicated at times in the calendar year that were traditionally associated with ritual activities, for example, the solstices, equinoxes, and eclipses of the sun or moon. These are the same days on which grants of land were most often made by kings to Brāhmins and on which the *purāṇas* particularly praise ritual bathing and offerings at pilgrimage sites. The dedication of temples was incorporated into the ritual calendar as one more type of offering or gift, or *dāna*, and dedications were made on the days traditionally considered most efficacious for ritual giving.[16]

Temple worship was not entirely a matter for kings and ministers. In fact, texts like the *Viṣṇudharmottarapurāṇa* that describe the merits of temple worship make it a point to show how even the lowliest groups of people and even animals benefited from simple acts of piety.

These stories often reflect both the growing importance of the temple and a desire on the part of certain groups to increase the prestige of temple worship and define strict sets of rules for the way in which that worship was to be practiced. The *Viṣṇudharmottarapurāṇa* reflects the influence of the Pāñcarātra, a medieval school of Vaiṣṇava thought that, among other contributions, codified the rules for temple worship. Parallel groups existed among Śaiva worshipers.

Pāñcarātra texts and Śaiva *āgamas* are both addressed to professional ritual specialists, priests who tended the images in temples and who came to form a dominant special-interest group. These priests eventually sought to regulate and define the way in which worship was performed. Their own status in the community was initially problematic. In contrast to the Brāhmin ritual specialist who assisted at every other religious function, the temple priest was considered of low status and his craft was vilified in strictly orthodox Brāhmaṇic circles. This was not the only direction from which criticism came; there were countermovements that reacted strongly to the prescribed rituals of these priests, while generally supporting the practice of worshiping images in temples.

The *Viṣṇudharmottarapurāṇa* seems a good place to begin our investigation into medieval attitudes toward temple worship for it reflects the "orthodox" viewpoint of the ritual specialists associated with temple practice. The first story, chapter 167 of part I, tells of the unusual benefits that one can expect from making a gift of an oil lamp to a temple of Viṣṇu. Oil lamps were used in worship, and the gift of an oil lamp to the God was itself a part of the worship ceremony (see Fig. 25). The story is told by the sage Mārkaṇḍeya to a King Vajra.

> Mārkaṇḍeya said, "O King, the wise men tell this story of times long past that illustrates just what Latikā gained from giving a lamp to a temple. There was a king named Citraratha in the country

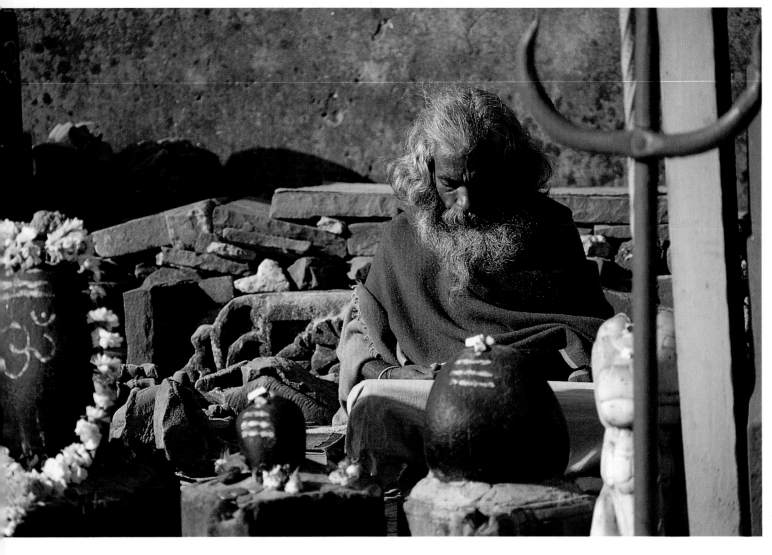

Fig. 23
Worship of the *liṅgas*, 11th-century
Śiva temple (Yoginī temple
complex), Bherāghāt, Madhya
Pradesh.

Opposite page
Fig. 24
Worship of the *liṅga*, Mahākāla
temple, Ujjain, Madhya Pradesh.

of Vidarbha. He had one hundred and fifteen sons and one
daughter—Latikā. Her father gave her to Cārudharmin, king of
Kāśī. Now Cārudharmin had three hundred wives and Latikā
became the chief queen among them. O Best of Kings, Slayer of
Enemies! In the temple to Viṣṇu, there blazed, day and night, a
thousand lamps that she had donated. In the dark fortnight of the
month of Aśvin and the bright half of the month of Kārttika,
Latikā's lamps blazed far above all the others. On every evening at
those times of the year, Latikā was busy sending lamps to the homes
of the Brāhmins. And at those particular times, O Yādava, she
busied herself seeing that lamps were placed on the crossroads and
the city streets, in temples, before sacred trees, in places where
people gathered to chat and enjoy themselves, on mountain peaks
and banks of rivers, and by the side of drinking wells.

"Now one day, her co-wives, impressed by what she had been
doing, asked her this, 'O pretty Latikā, you are always so busy
bringing lamps to the temple of Viṣṇu that you have no time for any
other pious act. Tell us why, O Latikā, for we are very eager to
know. Surely you must have heard that great merit is to be gained
by donating lamps.'

"Latikā told them, 'I am not at all a jealous woman, nor am I
under the sway of evil emotions. And you have always shown me
proper respect, for we are all equally devoted to our husband. We
all have the same interest and so listen carefully as I explain how I

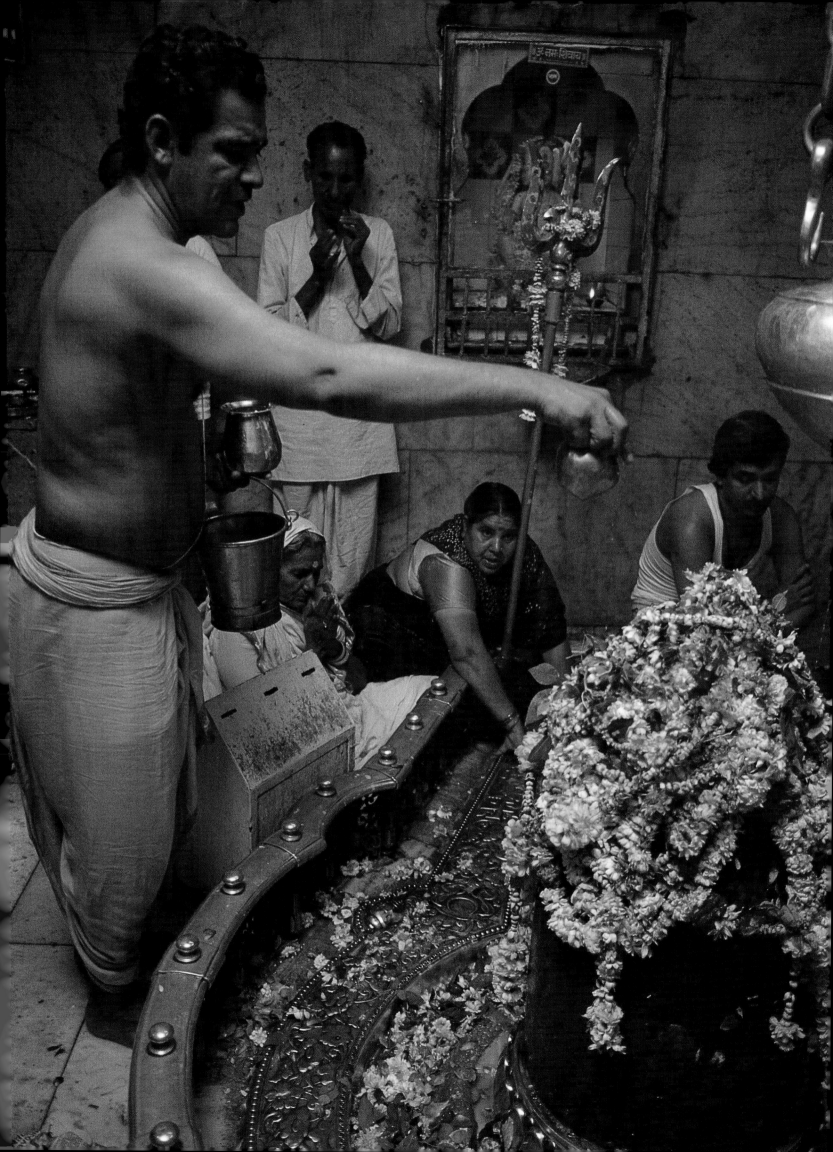

continue to reap the fruit of the act of donating a lamp. The beloved wife of Śiva, named Umā, the daughter of the king of mountains, was brought to earth as the best of rivers, Devikā, in the country of the Madras. The Brāhmins bid her to come there as that river out of compassion for humankind. There is an area of four furlongs on both banks of that river where the water is considered to be most holy, including within itself all the holy water of every sacred spot on earth. Mortals who die in those waters gain the highest rebirth; even thinking about, longing for, or just seeing that river destroys all sin. A man who bathes in that water just once becomes part of Śiva's divine host. That sacred place is known as Nṛsiṃha tīrtha and it destroys all sin; it is called Nṛsiṃha tīrtha since once, long, long ago, Viṣṇu in his man-lion incarnation, Viṣṇu Nṛsiṃha, bathed there.

"'Now once upon a time a King Sauvīra had a priest named Maitreya. Maitreya built a temple to Viṣṇu at that sacred site on the river and that Brāhmin worshiped Viṣṇu there every day, offering flowers and incense to Viṣṇu, cleansing and anointing the temple, and offering gifts of lamps and other things necessary for worship. Now once during the month of Kārttika, he gave many lamps that burned all night long in front of the image until they were almost burned out. At that time I was a mouse living in the temple. O Lovely Ladies, I took it into my head to steal the wick from one of those lamps. I did indeed make off with a wick, and just as I grabbed the wick, a cat let out a huge meow. I fled in terror of the cat. As I ran away with the wick, it so happened that I moved the lamp in such a way that it blazed and burned brightly in the temple again, just as brightly as it had when it was newly lit. When I died I was reborn as the daughter of the king of Vidarbha, who became the chief queen of the King Cārudharmin. I have the gift of remembering my past births. Lovely Ladies, this is the great power of giving a lamp during the month of Kārttika; this is my great reward from the lamp in the temple of Viṣṇu. If you are not jealous of me, heed my words and always make gifts of lamps to the temple. See the fruit that I got from unintentionally moving the lamp and making it burn brightly in that temple of Viṣṇu. And that is why, day and night, I am busy giving lamps to the temple of Viṣṇu, for the fruits of such a gift made with full knowledge of the act must be great indeed.'"

Mārkaṇḍeya said, "When they had been told this story, her co-wives all became devoted to the pious act of giving lamps to the temple of Viṣṇu, God of Gods. And in time, when they died they accompanied their husband, the king, to the heaven of Viṣṇu. And Latikā, as lovely as a lotus blossom, enjoyed many divine pleasures with her husband, the king, in that heaven. Because she had given all those lamps during her lifetime she was able to remain in heaven forever, never having to suffer the pain of falling from heaven into a lower state.'"

This next story, chapter 170 of the *Viṣṇudharmottarapurāṇa*, describes what results from cleaning the temple and smearing its walls and floor with cow dung as a kind of whitewash.

Mārkaṇḍeya said, "The wise men tell this story of times long past to illustrate the fruit of whitewashing the temple walls and floor. There was a certain poor and unfortunate low-caste fellow who took to trade with what little money he had left. When even those meager funds were exhausted, O Best of Kings, he became a farmer, and when he failed in that endeavor he became a servant and waited upon many a master. Failing to get anything from that as

well, he betook himself to the banks of the River Sindhu, which is considered to be the seventh branch of the holy River Ganges, O Best of Men. The cool, pure water of the Sindhu gives heaven as its reward; Brāhmins, practicing austerities, gain rebirth in heaven from bathing there.

"There was on the banks of the Sindhu an image of Viṣṇu in the boar incarnation [Fig. 26] that had been consecrated by the sages of old. Our low-caste fellow went as far as that image and lived there as a monk, begging for his food. He stayed there with his dutiful wife and devoted himself to the pious act of whitewashing the temple walls and floor. Now it so happened that at that same point in time the King Citravāhana, king of Sauvīra, came to that temple wishing to see that image of Viṣṇu in his boar incarnation. The king, along with his wife, bathed in the River Sindhu and worshiped Viṣṇu, the Lord of the World. When he had finished, the king and his wife went back whence they had come.

"That low-caste fellow with his wife saw the great splendor and riches of the king. He conceived a strong desire to become a king, and as fate would have it, his time was over and he died. His wife fetched wood from the forest and built a funeral pyre; she then mounted the pyre and joined her low-caste husband in death. That pious low-caste fellow and his wife went from this world right to heaven, all as a result of his meritorious deed of whitewashing the temple.

"Now at that very point in time a King Yuvanāśva worshiped Viṣṇu with special observances in order to obtain a son. At the end of those observances he had a dream in which Viṣṇu said to him, 'Go to the sage Bhārgava Cyavana. You will get your son from him.'

"Yuvanāśva, having been given these instructions by Viṣṇu in his dream, went on foot to the hermitage of the sage Cyavana. He paid homage to Cyavana, who in turn honored the king. And that best of kings told Cyavana about both his observances and dream. The great ascetic then summoned all the sages and, unbeknownst to the king, prepared and put into a pot some consecrated water that would ensure him a son.

"That night, the king was seized with a sudden thirst. The sages were asleep all around him, and he said, 'O Brāhmins, I am terribly thirsty. Give me some water.' But fate had ordained that none of the sages were to hear his words. So the king, oppressed by thirst, came to drink that water that would ensure him a son, and when he had drunk the water he fell fast asleep.

"When the sages awoke the next morning and could not find the pot of water, they asked each other, 'What has happened to the pot of water that would guarantee the king a son?' At that the King of Kings spoke up, 'I drank the water and threw the pot away.' The sages then said, 'Surely you have only done what fate ordained for you. Your wife was to have drunk that water and then given birth to your son. That was the purpose of the consecrated water, O King. But fool that you are, you have gone and drunk that water yourself. And so you will have to bear your own son in your own loins. You will not die from this unusual pregnancy because we Brāhmins grant you that as a boon.'

"After he heard these words, the king honored the Brāhmins and went home. A child, ruddy like the rising sun, was born from the king, bursting forth from his loins. It was that low-caste fellow I told you about, who had fallen from heaven. As soon as he was born, Indra, the King of Gods, stuck his finger in the baby's mouth,

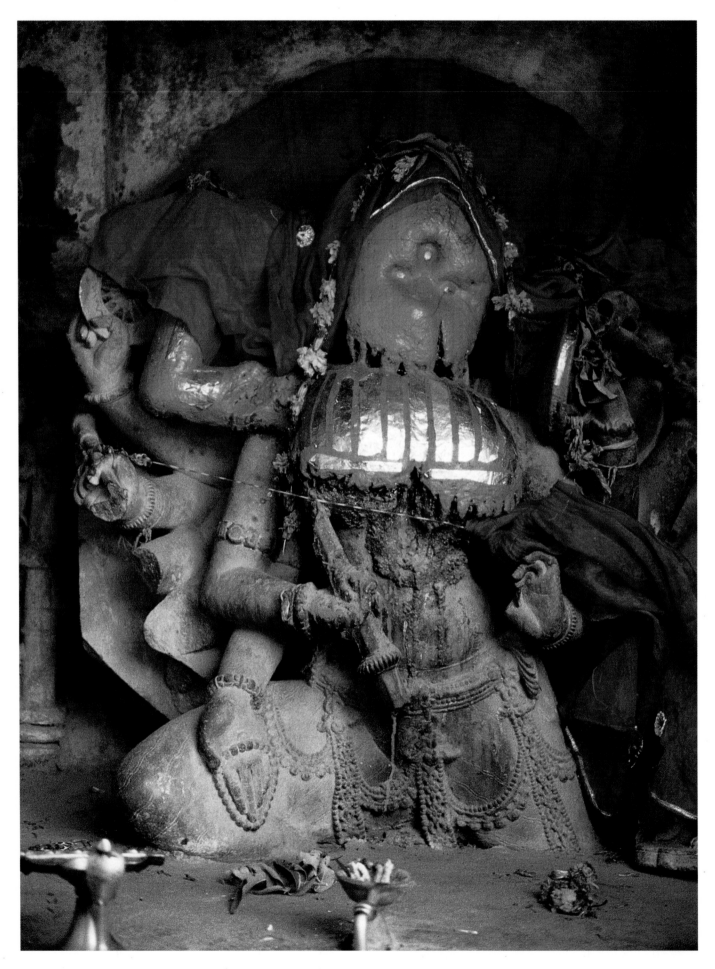

and suddenly the baby was a baby no more. Indra also touched the loins of the king; at that touch the King Yuvanāśva was healed and his wound vanished. Indra named the child Māndhātā, and so he became known in the world. That name was chosen because the child sucked Indra's finger as soon as he was born, and *Māndhātā* means "suck me." And Viṣṇu himself entered into that child with his fiery presence.

"Now the woman who had been the wife of that low-caste man in a former birth also fell from heaven and became the daughter of Bhīmavega, king of Kāśī. Her name was Prabhāvatī, and she was lovely, in fact the most beautiful woman in all the world. Yuvanāśva chose her as a bride for Māndhātā, for she was endowed with every auspicious mark. And King Citravāhana gave her to Māndhātā. She was his only wife and was extremely beautiful; in the full bloom of youth and handsome in form, she was dearer to him than his own life. Yuvanāśva, having made their wedding, crowned his son as king of Ayodhya and went to the forest to practice austerities. From the forest he went to heaven. Māndhātā, now king and proud of his skill at arms, within the space of one short week, single-handedly conquered the three worlds—heaven, earth, and the netherworld. The magic wheel that preceded his military march, preparing the conquest, was unchallenged in the netherworld, in heaven, on mountains, and at sea. He became the emperor of the whole universe, and he was a just lord, a pious devotee of Viṣṇu. He ruled the world for ten aeons. They say that the kingdom of Yuvanāśva extended over the entire world—everywhere the sun's rays shone. And so that low-caste fellow became a great king, who defeated all of his enemies, just from having whitewashed the walls and floor of the temple in his former life. And his wife became again his wife and the foremost of women."

These stories agree in granting to the most lowly the highest benefits from acts of worship. The story of the mouse who becomes a princess goes even further than the story of the low-caste beggar in saying that an inadvertent and unintentional act of worship can still yield a marvelous result. In both stories the ritual act is simple and does not involve great expense; the mouse obviously had nothing to spend, and the low-caste worshiper was penniless when he carried out his pious act of whitewashing the temple walls.

But the *purāṇas* do not always describe a simple mode of worship accessible to all. Although this might have been the preferred ritual of miracle stories, they were not the only medium through which medieval Hindu authors glorified temple worship. *Purāṇas* often simply catalogued the wonderful results that accrued from each step of ritual worship. In doing so they often compared the worship of a god with the ancient Vedic sacrifices, particularly the costly horse sacrifice (*aśvamedha*), that only a king might perform. To valorize image worship, these texts proclaim that the merit to be gained from one small act of worship is greater than that to be had from countless sacrifices. But the parallel to the Vedic sacrifice goes deeper than the fact that the sacrifice serves as an obvious point of comparison for a meritorious deed. Like the Vedic sacrifice, temple worship could also be a costly and splendid affair, with gifts ranging from simple wildflowers to gold and jewels. The following verses from the *Dvārakāmāhātmya* are a glorification of Dvārakā, the city associated with Kṛṣṇa's reign. The *Dvārakāmāhātmya* is included in the *Skandapurāṇa*, *Prabhāsakhaṇḍa*, and these sections are from chapter 23.[17]

Those men who pour milk over the head of Kṛṣṇa, with each and every drop of milk that falls, reap the merit that is to be had from

Fig. 25
Worship of the Goddess (Devī), a 10th-century image, with lamps in the foreground, Harshagiri, Rajasthan.

one hundred performances of the horse sacrifice. (14)

He who dries Kṛṣṇa's wet body after a bath with a cloth is cleansed of ten thousand sins. (18)

He who, having bathed the Lord, then places a flower garland on Him, will gain billions of gold coins for each blossom on the garland. (19)

He who blows a conch shell as the God is being bathed is reborn in heaven for a vast length of time. (20)

The Lord is pleased with every possible hymn of praise sung during His bath and grants the singer all his desires. (23)

Still greater is the merit of one who recites the Vedas during the God's bath; indeed, his merit is so great that an ordinary mortal can never know its extent, O Lord of Men! (24)

The same is true of the one who dances before Kṛṣṇa during His bath or sings or recites hymns of praise. (25)

He who shouts, "Glory! Glory!" as the God is being bathed; dances, sings, and claps his hands; gesticulates, laughs, and chatters never again has to pass from a mother's womb. (26–27)

He who recites the virtues of Kṛṣṇa during the God's bath never lies upside down in his mother's womb again, O King of Men. (28)

He who rubs the body of Kṛṣṇa with fragrant unguents, saffron mixed with sandalwood and aloe, camphor and musk, sojourns with his ancestors for an aeon in Viṣṇu's paradise. (29)

Those who spend all that they can to adorn the God of Gods with unsurpassed shining ornaments of gold and magnificent ornaments made from jewels gain a fruit so great that none but Viṣṇu even knows what it is, not the other gods, Brahmā and Śiva, nor the sages of old. (32–34)

Those who worship the Lord of the World, Kṛṣṇa, who removes all the sin of this degenerate age, with basil and Ketaki leaves, with jasmine and many other local flowers, gain the fruit of a kingly sacrifice for each flower that is offered, O King. (34–35)

Those who burn incense of black aloe and camphor in front of Kṛṣṇa in this wicked and degenerate age become equal to Kṛṣṇa. (47)

O King, he who gives a lamp to Kṛṣṇa erases his own sin and goes to the heaven that is radiant like fire. (49)

He who daily places a row of lamps at the door of the temple of Kṛṣṇa becomes the ruler of all seven continents, one after the other. (50)

He who offers Kṛṣṇa fruit achieves the fruits of his own desires for aeons to come. (52)

He who erects a flag over the temple to Kṛṣṇa goes to the heaven of Brahmā where he sports with the God Brahmā. (61)

He who decorates the courtyard of the temple with colorful auspicious designs enjoys pleasures galore in the three worlds of heaven, earth, and the netherworld. (62)

He who paints the temple of the God of Gods dwells in Śiva's heaven for as long as the oceans endure. (64)

He who worships Kṛṣṇa by waving blazing lamps over His head later rejoices in His company. (69)

These verses single out for praise ritual offerings that have become standard in temple worship, some of them potentially simple, for example, the offerings of incense, flowers, and food. But in other verses from this same section of the *māhātmya*, not all of which are translated here, we hear of more lavish offerings of jewels and gold, of flags that crown the temple, of canopies and umbrellas over the God's head. There is no question that the medieval worship service was an elaborate multisensory experience, with song and dance, recitations of sacred texts and prayers, with splashing milk poured over the god, and fragrant incense burned

Fig. 26
Viṣṇu in his boar incarnation (Varāha) (No. 71).

before him. While it is true that no two texts will detail every step of worship in the same way, there was a generally accepted procedure that began with bathing the god and involved offerings of food, clothes, lamps, and incense.

The worship ceremony of the *purāṇas* in fact could also be an occasion for displays of wealth. Like the Vedic sacrifices before it and the extravagant gifts that some *purāṇas* urged people to give to Brāhmins, the *purāṇic* rituals ran the risk of becoming a form of worship that only the wealthy could afford. The next set of stories are a reaction against the bustling service the *Dvārakāmāhātmya* extols and call for simpler and more accessible acts of worship. In contrast to the miracle stories of the *Viṣṇudharmottarapurāṇa*, these stories go beyond suggesting forms of worship in which even poor people could participate. They offer an alternative to the ritual that the priests organized in the temple and can be seen as a reaction against not only the expense of temple offerings but also against the perceived elitist, regimented orientation of temple worship. Temple worship came to be increasingly controlled by the priests who tended the images and its rules came to be rigidly codified in a growing body of literature that included some of the *purāṇas* and the various ritual manuals of the Vaiṣṇava and Śaiva schools.

The Reaction Against Temple Ritual: The *Skanda* and *Padmapurāṇas*

One section from the *Sābhramatīmāhātmya* of the *Padmapurāṇa, uttarakhaṇḍa* (chapter 144, verses 20 to 83) advocates an alternative type of worship, which could be practiced outside of the temple.[18] There is virtually nothing known about this section of the *Padmapurāṇa* beyond the obvious fact that it deals with a river in Gujarat. The text often mentions holy sites that have been destroyed and images that are buried, reflecting Muslim iconoclasm in the region.[19] The story is told by Śiva (who is also a major character) to his wife, Pārvatī. He thus appears as narrator and actor and is also given many names.[20]

A second "reformist" story, from the *Tāpī Khaṇḍa* of the *Skandapurāṇa*, likewise speaks of holy sites buried under sand and lying desolate. It is also from Gujarat and has been characterized as a caste *purāṇa*, describing the origins of the Nagar Brāhmins.[21] Chapter 78 goes even further than the story from the *Padmapurāṇa* in questioning the orthodox temple ritual and asks whether it is even desirable to have such powerful rituals.

From the *Padmapurāṇa*:

> Śiva said, "O Queen of the Gods! Listen to what happened long ago. There was a man of the Vaiśya caste named Nandin who lived in the village of Indragrāma. He was always absorbed in meditation on Śiva. There was a *liṅga* named Dhavala in a penance grove. Every morning Nandin, devoted to Śiva, would rise early and worship that *liṅga* with all his heart. He worshiped the *liṅga* with flowers, exactly as the ritual texts prescribed.
>
> "Now one day an aboriginal hunter in pursuit of his prey, addicted to the vice of harming living beings, wicked, and of evil conduct, was killing creature after creature along the banks of the Sābhramatī River, which were home to many living beings. It so chanced that the tribal hunter, intent upon harming living beings, in the course of his travels came to that place where the *liṅga* was being worshiped. He saw that *liṅga*, known as Lord Dhavala, noted far and wide for its miraculous powers, and worshiped with various kinds of flowers and fruits. He threw his arms around that *liṅga* and then went to the banks of the Sābhramatī and took a gulp of water. With his mouth full of water and the flesh of a deer dangling from one hand, he grabbed some *bilva* leaves with his free hand to offer to the *liṅga* in worship. He rushed back and tendered his offerings; and as

Following pages
Fig. 27
Female ceiling figures, Vimalā Vasāhi temple, Dilwārā, Mount Ābū, Rajasthan, 12th century.

he did so he scattered far and wide those flowers that had previously been offered. He spat out the water in his mouth to bathe the *liṅga*, using one hand to lay down the *bilva* leaves as his offering. With his other hand he offered to the *liṅga* the flesh of the deer, and as he prostrated himself before the *liṅga* he made the following earnest vow in his mind: From this day forward I shall worship this *liṅga* with all my might; O Śiva, you are my Lord and master and I am your devoted servant. Having made this vow, the hunter went back to his home.

"When morning came Nandin went to the temple and saw everything that the hunter had done. He saw the mess around the *liṅga* and those impure substances left in the presence of Śiva. His flowers had been scattered far and wide by that wicked and violent hunter. Nandin was puzzled and thought, What strange things are happening to me today! Surely these things are happening to hinder my worship of Śiva, despite my devotion. They must be a sign that I have suffered a great reversal of fate. So he thought, again and again; and having cleansed the *liṅga*, Nandin went back home.

Now the priest who advised and assisted Nandin in his worship of Śiva noticed that he seemed distracted and asked him, 'Why do you seem so distracted?' Nandin said, 'Today I saw some impure things in the presence of Śiva and I do not know who defiled the God and why.'

At that the priest said, 'The person who disturbed your offering of flowers is surely an idiot, a perfect fool, who cannot tell right from wrong. My Lord, do not give this a moment's further thought; tomorrow morning let us go together to the temple to see what is happening. I shall punish that wicked person.' "

Śiva said, "And Nandin, having heard those words, spent the night at home, his mind in turmoil. At daybreak he summoned the priest and together with that great soul he went to the temple of Śiva. He washed the *liṅga* and performed his worship, covering it with jewels and offering it the five pure substances—milk, butter, curds, honey, and sugar. He did this along with many Brāhmins. Then he spent two full watches of the day there singing songs of praise to Śiva.

"But then the hunter came upon the scene, ugly and terrifying like the God of Death, and indeed named Mahākāla, God of Death; strong, dark-skinned, menacing, and mighty, bearing his bow in his hand. When Nandin saw the hunter, he was struck with fear and fled. The priest, too, was terrified as soon as he saw the hunter, who removed the offerings that had just been made and offered instead *bilva* leaves and flesh. The hunter prostrated himself before the *liṅga* and then rose and went home.

"After witnessing these unprecedented acts, Nandin and the priest thought for a long time. Being perplexed, the priest summoned a number of Brāhmins, all learned in the scriptures of the Vedas, and told them exactly what the aboriginal hunter had done. 'O Brāhmins! Tell me what I should do now.' he said to them. They all got together and pondered the matter, seeking the answer in the texts on ritual, and then they said the following to Nandin, who had no idea what to do.

"The Brāhmins said, 'There is no question that these acts threaten to destroy the God; moreover it will not be easy to keep them from happening again. So take this *liṅga*, O Best of the Vaiśyas, and keep it safely in your own home.' "

Śiva said, "Nandin thought that was a good solution and so he uprooted the *liṅga*, took it home, and washed it carefully, according

to the rituals prescribed in the texts. He made it a base of gold, adorned with the leaves of the plaintain, and he worshiped the *liṅga* with many offerings.

"The next day the aboriginal hunter returned to the temple of Śiva, and, looking everywhere, could not find a trace of the *liṅga*. He broke his silence and suddenly cried out with these words, 'Hey, Śiva! Where have you gone? Show yourself to me right this very minute. If you do not show yourself to me I shall kill myself. Hey, Śiva! Lord of the World! Destroyer of the Three Cities of the Demons! Śaṅkara! Hey, Rudra! Hey, Mahādeva! Show yourself to me now!' "

Śiva continued, "In this way the hunter castigated Śiva with words that were meant to please the God as they upbraided Him. As he spoke these words he took his sword and cut his own belly, slapping his forearms loudly and crying in anger, 'Hey, Śiva, show yourself to me! Where do you think you've gone, leaving me behind?'

"And with these words, the hunter pulled out his own entrails and cut off his own flesh and threw it all with his own hand into the hole where the *liṅga* had been. Pure in heart, he then immersed himself in the River Sābhramatī. He quickly brought water from the river and *bilva* leaves and, prostrating himself on the ground, worshiped the *liṅga* as he had promised.

"As the hunter was absorbed in meditation, Śiva actually appeared to him, along with his divine host. Śiva was white like camphor and radiant; he held a skull as his begging bowl and bore the crescent moon in his matted ascetic locks. Śiva took him by the hand and comforted him with these words, 'Hero! Greatly Wise One! Surely you are my true devotee, O Noble Man! Ask of me a boon, devoted servant! Ask of me whatever you desire!' "

Śiva said, "When Śiva said these words to the hunter Mahākāla, he was filled with joy and overcome by the greatest feelings of reverence. He prostrated himself on the ground. He then said to Śiva, 'I do not desire any boon from you. I am your servant, O Rudra, and you are my master. Of that there is no doubt. Let this wonderful state persist in every succeeding birth that I experience. You are my mother, father, friend, and companion. You are my teacher; you are the supreme sacred words by which you are always to be known.' "

Mahādeva said, "Hearing those words of the hunter, which were without any desire for worldly personal gain, Śiva gave to him the boon of becoming the chief among His attendants, the keeper of the gate to His abode. The world then resounded with the sound of Śiva's drum, the beating of other drums, and the sound of conches. Drums beat everywhere, small drums and large drums, by the thousands. Nandin heard their sound and was astonished. He quickly made his way to that penance grove where Śiva now stood with his divine host. Nandin saw the hunter, approached him, and still amazed, spoke these words in praise of his great act of meditation. 'You have brought Śiva here in person. Surely you are the greatest devotee. I have come here as your servant. Please tell that to Śiva.'

"When he heard these words the hunter quickly took Nandin by the hand and led him to Śiva. Śiva smiled and said to the hunter, 'Tell me, whom have you brought here, among my divine host?'

"The hunter said, 'He is one of your devotees and was ever intent on worshiping you, every day, with all kinds of offerings of various kinds of jewels, gemstones, and flowers. There is no question that he has offered you his life and his wealth. Here is

Nandin, My Lord, O You Who Are Ever Kind to Your Devotees!'

"Mahādeva said, 'I know who Nandin is; he is a merchant by trade. You are my devotee, Mahākāla, you are my friend, O Noble One! Those who are without any hidden motive, without guile, they are the ones I love; they are my best devotees and the most excellent of men.' "

Mahādeva said, "Śiva accepted both Nandin and the hunter as chief members of his divine host. Numerous and glorious heavenly chariots appeared, and in that way that best of Vaiśyas, Nandin, was saved by that glorious hunter."

Like the stories from the *Viṣṇudharmottarapurāṇa*, this is a miracle story that praises worship of a god in his temple. However, it differs by conveying unambiguously the considerable debate over the established temple ritual in medieval India. The contrast between the worship of the hunter and the worship of Nandin, the Vaiśya, is explicitly said to hinge on the fact that Nandin worships Śiva according to the prescribed ritual texts, under the guidance of a priest and along with Brāhmins, while the hunter is oblivious to the niceties of ritual prescriptions. Nandin's offerings are, in fact, the very offerings the *Dvārakā-māhātmya* praises: jewels, flowers, fruits, the five proper pure substances of milk, curds, butter, honey, and sugar.

In Indian story literature the aboriginal hunter is the ultimate Other, who stands outside the pale of civilization and does not participate in any way in the rituals of normative Hinduism. He is violent and sinful, and everything he does is the direct antithesis of what normative Hinduism regards as pure. He spits on the *liṅga* to bathe it. There is nothing more polluting than food or drink that has touched someone's saliva, and the saliva of an outcaste aboriginal would be the most polluting substance of all. The hunter offers the *liṅga* freshly killed meat, whereas the normative texts all prescribe vegetarian offerings of flowers and fruit. The story openly mocks normative Hinduism's preoccupation with matters of ritual purity, for to prevent what he and the Brāhmins regard as a defiling of the *liṅga*, Nandin is ready to commit the far greater sin of uprooting it. The hunter, ignorant of ritual purity, establishes a direct relationship with Śiva by his more radical act of devotion: He offers Śiva his own body in the ultimate act of sacrifice. It is this act of devotion that Śiva prefers to Nandin's obsessive concern with the rules and regulations in the ritual handbooks of the priests. In the end, although Nandin and the hunter both go to heaven, clearly it was only through the intervention of the hunter that the merchant was saved.

The next story presents, with biting humor, a more radical challenge to the institution of temples and the belief in the efficacy of images. It is told by a bard to some Brāhmins.

The *Tāpī Khaṇḍa* of the *Skandapurāṇa*, chapter 78, verses 3–53:

The bard said, "O Best of Brāhmins! Let me tell you about the miracle that happened long ago in the temple of the Four-headed God, Brahmā. There was a certain woman of loose morals, a Brāhmin, who used to go there with her lover, Devadatta, and make love with him. Her husband, her mother, and her other relatives never suspected her, and so in the dark half of the fortnight, when the moon was waning, happy as anything, she would go there with her lover. O Brāhmins, now it so happened that one time someone saw her there with her paramour and told her husband. He was furious, of course, and accused her in the harshest terms—he even went so far as to beat her. But she was utterly shameless, as women are wont to be, and with tears in her eyes, humbly folding her hands in submission, she said these words to him, 'Why do you take the word of some scoundrel and beat me cruelly, though I am free from blame? My Lord, I throw myself on your mercy and bow before

your feet. I shall take some oath, or drink poison, or enter the fire, just so that I may somehow convince you I am pure.'

"At this, the Brāhmin told her, 'If you are free from sin, then take a divine oath in front of all the Brāhmins.' She agreed at once, bold as she was, and so that good woman made a divine oath to undergo an ordeal by fire, exactly as the texts prescribe it. She was shown to be pure and sinless in front of all her relatives and the other Brāhmins; she who had openly sinned was proclaimed to be pure before the gods and her elders. At that everyone praised her chastity and rebuked her husband in the strongest terms. 'See how wicked this lowliest of the Brāhmins is, how evil! For he has dared falsely to insult his faithful and loyal wife.'

"O Best of Brāhmins, in this way that man was roundly condemned by everyone, and in his misery, he got mad at the God of Fire, who had attested to his wife's chastity. He made up his mind to curse the God of Fire, so grieved was he. And so again and again he spoke terrible and cruel words, upbraiding the God of Fire. 'I saw her with my own eyes, lying with her lover! O Fire! Why did you not burn to ashes that sinful woman? Now let there be no doubt. I shall curse you with a terrible curse, for you have done an evil thing in giving false witness.' "

The bard said, "When the God of Fire heard what the angry Brāhmin said, he was terrified, and with his hands folded in reverence, humbly implored him, 'It is not my fault that your beloved was not burned to ashes, even though she had greatly sinned. Listen clearly to what I say. It is true that she has had a lover for a long time and that today you caught her in the act. But I could not burn her to ashes because she has become purified of her sin. Now listen intently, for I shall tell you how she has become pure. There is an image of Brahmā with Śiva on his head in that temple where she made love to her lover. She had her fun with her lover, and then she looked up at that image of Brahmā with Śiva on his head. Afterwards she washed her body in the water of the tank in front of the image. That is how that lady with her beguiling smile, though she had sinned, came to be purified. In that same temple long, long ago, Brahmā himself, the Grandfather of the World, was purified after he had sinned by looking with lust on the face of Satī, Śiva's wife. So I have not done anything wrong, not in the slightest, O Best of Brāhmins! It all happened because of the marvelous power of that image of Brahmā with Śiva on his head and the miraculous power of the water in that tank. And now you must take your wife, pure as she is, free from sin, and return home with her, O Best of Brāhmins! I speak the truth!'

"The Brāhmin said, 'O Fire! I shall not take her home with me even if she has been purified, for I have seen her making love to her lover with my very own eyes.'

"After he said these words, that pious Brāhmin left his wife and went home alone. Everyone else went home, too. The wife, for her part, was mightily pleased with herself, even after she had been abandoned by her husband, for she had now come to know of the miraculous powers of that temple by listening to the God of Fire. She indulged herself totally in sexual delights with that lover of hers right in that temple, and she always remembered to bathe afterwards in the water of that tank. In time other women who had been chaste, moral, and faithful to their husbands only out of fear of some terrible retribution in the next life began to come from far and wide to that temple in which there was that image of Brahmā with Śiva on his head. There they held a veritable orgy, after which they all

bathed in the tank that destroyed their sin, and were likewise freed from sin by gazing on the image of Brahmā with Śiva on his head. So it came to be that the very idea of a woman's being faithful to her husband vanished, and men were no longer faithful to their wives. Whenever a man saw a beautiful woman, even if she was of good family, he would happily lead her off to that temple and enjoy her there, O Best of Brāhmins. And whenever a woman spied a man that caught her fancy she would take him to that temple and have a veritable orgy there with him. Neither man nor woman would be stained by any sin for what they had done, because of the miraculous powers of that place.

"In time Viduratha became king of the region known as Ānarta and gradually grew old. He had a beautiful young wife, whom he held as dear to him as his own life, though he was in his dotage. But she did not love the king, for he was old and feeble; and so she would go to that temple and make love to any man she desired. The king found out and was furious; he hastened to that lovely spot. He filled the tank of water with mounds of dust and razed the temple. He then uttered these terrible words, 'Whoever shall dig out this tank that I have filled with dust or rebuild this temple will take upon himself all the sins of adultery committed here by men and women, blinded by their lust.'"

The bard said, "After the king had uttered these words he took his wife and went home, pleased with what he had done. Now that king knew well that his wife was disgusted by him and was in love with another man, so he guarded her jealously and never trusted her for a moment. One day that lovely damsel concealed a weapon in her long tresses and went to his bed to kill him. She jested with him as a warrior's wife might do with her lord and made love to him in every conceivable position. And then that beloved of the king, knowing that he was fast asleep, removed the weapon from her locks and, without an ounce of compassion, took his life. Thus did the king of Ānarta reap the fruit of destroying that fine holy site, a terrible act indeed that the whole world had condemned."

The *Tāpī Khaṇḍa* of the *Skandapurāṇa* is an unusual text and has a leitmotif of destruction of holy sites that produce miracles that negate normal morality. The story of the temple of the fornicators is only one of these unusual accounts, and it is important to bear in mind the larger context that speaks of the ultimately harmful effects of all medieval religious ritual associated with temples and pilgrimage sites for which *purāṇic* texts made their extravagant claims. Like the *Sābhramatīmāhātmya's* preoccupation with the destruction of temples and pilgrimage places, this text may also reflect Hindu reactions to Muslim attacks on Hindu holy sites. Beyond the surface, these stories may represent not so much a direct challenge to current religious practices as an attempt to vest responsibility for external threats to established religious sites firmly within the Hindu community, thereby reducing their traumatic effect.[22]

At the same time, it is possible to see a number of direct reactions to the cult of images in temples. The story raises a fundamental objection to the worship of images in temples by stating graphically that the extreme emphasis on ritual activity and images ignores much that is esteemed in the domain of religion: a cultivation of ethical ideals and internal standards. The merits of a holy site were often underlined by associating the site with a primeval miraculous act, usually the removal of some heinous sin committed by a god. The holy site Puṣkara in Rajasthan, for example, is praised in a medieval ballad by asserting that it was there that the God Yama was cleansed of the sin of incestuous longing for his sister, and the God of Fire himself was freed from the sin of adultery.[23] The above story provides a warning about the consequences of allowing miraculous powers to go unchecked and alludes to the possibility that worship in the temple could be

for very limited, selfish, and worldly ends. Texts like the *Dvārakāmāhātmya* had promised wealth and rebirth in heaven or lordship to the worshiper, themselves worldly gains in contrast to the freedom from rebirth desired by the philosopher. This story humorously suggests that there was another deeply secular context to temple worship in medieval India. In fact, the medieval poets who celebrated the glories of particular temples were often equally mindful of their aesthetic qualities and the sensuous beauty of their carvings.

The Experience of the Temple: A Medieval Poet Speaks

While all of the above material comes from Hindu texts, other religious groups in medieval India also built temples and worshiped images. While little remains of medieval Buddhist temples outside of eastern India for the period in question, we do have many Jain temples and images that attest to the popularity of temple worship among the Śvetāmbara Jains throughout much of north India. A number of sculptures in this exhibition are known to be from Jain temples. Since many of the secondary figures on exterior walls of both Jain and Hindu temples can be identical, more sculptures might be from Jain temples than are documented. Jainism was particularly strong in Gujarat and Rajasthan, and the king of Gujarat, Kumārapāla, whose reign began in A.D. 1142, is said by the Jains to have converted from Śaivism to Jainism under the tutelage of the monk Hemacandra.[24] One of the Jain temples Kumārapāla built in his capital city was called the Kumārapālavihāra. The temple no longer stands, but we have a vivid description of it by the monk Rāmacandrāgani, a disciple of Hemacandra. Rāmacandrāgani wrote just over a hundred verses in praise of the temple. His poem came to be known as the "Hundred Verses on King Kumārapāla's Temple," the *Kumāravihāraśataka*.[25] The following excerpts provide a glimpse of some of the aesthetic and sensory pleasures the temple offered as well as the sense of wonder it aroused in its many visitors.

> There young children gazed in awe at the hall where the monks delivered their sermons, for they could not understand how the delicate pillars, ensheathed in plaintain leaves, could possibly support the great weight of the building. (42)
>
> There young couples, feeling great desire for each other, were too shy to touch one another with so many others present. Instead they experienced vicarious pleasure as they watched themselves reflected on the shining crystal pillars, where their mirror images embraced and entwined. (65)
>
> There, in that temple made of dark stone, lovely women had to feel their way, able to step quickly only at the door frames, which were made of glittering sunstone that threw off light; they smiled upon seeing the female bracket figures [see Fig. 27] and felt fear at the sight of the lions adorning the thrones of the main images; they were wearied by the crush of worshipers and felt a tingle of pleasure as they brushed against the bodies of their husbands; they danced to the sound of the drums and all in all were a delight to the young gallants who watched them. (68)
>
> In that temple people were always present; faithful Jains came simply as a pious act; those who were seriously ill came out of a desire for a cure; artists came to admire the skill and workmanship; ugly men and women came out of a desire to become beautiful; those who had lost their wealth came out of a desire for money; some who loved music came to hear the singing, and servants came because they wanted to become masters. (71)
>
> There, in that temple, people jostled against each other, and as they rubbed chests, sparkling jewels fell from their long pearl

necklaces. The floor became studded with these gems and pearls as if with tiny stones, and as they tried to step over them so as not to hurt their feet, people seemed to break into dance with every single step. (82)

There a mortal seemed instantly to be turned into a god by the power of the Jina. For like the gods, who do not blink and whose feet do not touch the ground, one visitor gazed unblinkingly at the marvelous sight before him, while his body was held aloft by the crush of the crowd. His feet did not even touch the earth as he went from one end of the courtyard to the other. (96)

The deer-eyed women who passed by struggled to count the temple's flags, their staffs gilded with pure gold. And as they tried to look higher and higher, the pots that they were carrying on their heads fell, to the great merriment of the young men gathered in the bazaar. (98)

Outside the temple on the street, people craned their necks to stare fixedly at the beauty of this structure [see Fig. 29], which reached into the sky; not watching where they were going, they banged into each other and grew so angry that fights and quarrels arose all around. (99)

There, in that temple, on festival days when the crowd blocked their way, the cries of the elderly made everyone feel compassion for them as they implored, "Brother! Take me up front and give me a glimpse of the lotus face of Lord Pārśvanātha, who grants all wishes." (107)

There, in that temple, people experienced a strange desire to renounce further pleasures of the senses; their ears were filled with the singing; their eyes were intent upon the marvelous dancing, and all they could smell was the fragrant water that was being used to bathe the main image. So satiated, they no longer yearned for any other objects of the senses. (109)

There the hall of paintings single-handedly awakened astonishment in the mind of every visitor: It amazed the children with pictures of monsters; the traveling merchants with pictures of elephants, monkeys, camels, and conveyances; the faithful with pictures of the exploits of the gods; the wives of the kings with depictions of the harems of famous queens of old; the dancers and actors with pictures of dances and dramas; and the heroes with depictions of the cosmic battles between the gods and the demons. (110)

There, in that temple, the statue of a lady who struggled to hold fast to her girdle as a monkey untied its knot [Fig. 28] made young gallants feel desire and confirmed the steadfast in their rejection of sensual delights; it disgusted the pious and made old ladies feel embarrassed; while it made young men laugh and young girls wonder. (112)

Fig. 28
Monkey untying the girdle of a celestial beauty, from the exterior wall of the subsidiary shrine on Saciyā Mātā Hill, Osian, Rajasthan, 11th century.

Opposite page
Fig. 29
Visitors at Sās Bahu temple complex, Nagda, Rajasthan, 11th–12th century.

1. I am using primarily the text of the inscription that is published by Dr. A. C. Mittal, *The Inscriptions of the Imperial Paramāras (800 A.D. to 1320 A.D.)* (Ahmedabad: L. D. Institute, Series 73, 1979), pp. 322–39, with a Hindi translation. I have also referred to the text that was edited in the *Epigraphia Indica,* vol. 25, 1939–1940, by Professor P. P. Subrahmanya Sastri, entry no. 17, pp. 173–83. Following the entry is a brief essay on the hymn by N. P. Chakravarti, pp. 183–86.

2. See Mittal, op. cit., inscription number 36, in which another Paramāra-period temple is said to have been inscribed with hymns.

3. See, for example, *Bṛhadāraṇyaka Upaniṣad,* 4.5.

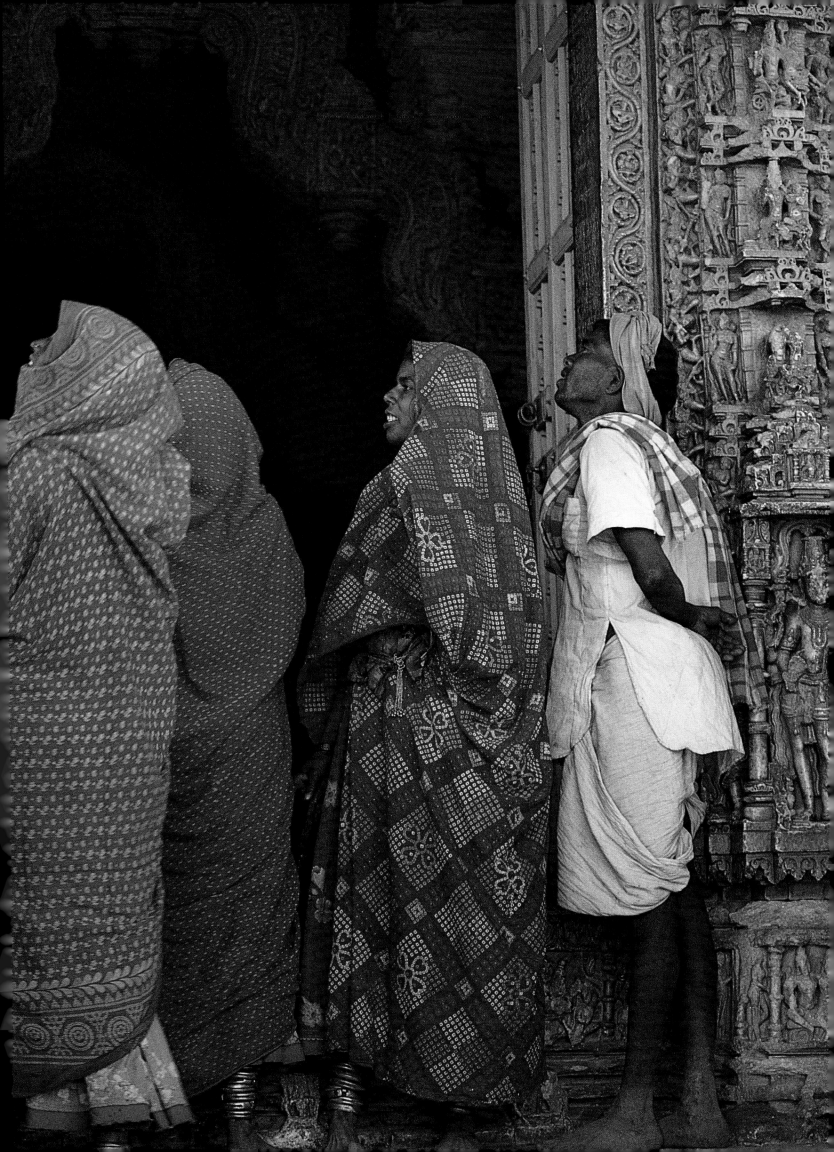

4. A convenient exposition of the Advaita interpretation of the identity of the individual soul and the highest soul may be found in Sengaku Mayeda's introduction to his translation of Śaṅkara's *Upadeśasāhasrī, A Thousand Teachings* (Tokyo: University of Tokyo Press, 1979).

5. A convenient reference work on the *purāṇas* is Ludo Rocher, *The Purāṇas,* in the series *A History of Indian Literature,* vol. 2, fas. 3 (Wiesbaden: Otto Harrassowitz, 1986).

6. In a recent article entitled "The Buddha as Owner of Property and Permanent Resident in Medieval Indian Monasteries," published in *Journal of Indian Philosophy,* vol. 18 (1990), Gregory Schopen strongly and convincingly argues against our interpreting the presence of the Buddha in a symbolic fashion and for our attempting to understand what the language of the inscriptions makes obvious: that the Buddha was regarded as a real physical presence in the monastery. See also Arjun Appadurai, "The Status of Brāhman Priests in Hindu India," *South Asian Anthropologist* (1983), pp. 43–56; Gunthur-Dietz Sontheimer, "Religious Endowments in India and the Juristic Personality of Hindu Deities," in *Zeitschrift für vergleichende Rechtswissenschaft einschliessende ethnologisce Rechtswissenschaft,* vol. 67 (1965), pp. 44–100; Heinrich von Steitencron, "Orthodox Attitudes Towards Temple Service and Image Worship in Ancient India," *Central Asiatic Journal,* vol. 21 (1971), pp. 126–38. The *Śivapurāṇa,* which devotes considerable attention to describing the origin of the *jyotirliṅgas,* makes clear in its language that the *liṅga* is not a symbolic presence but a corporeal incarnation of the god, just as are other, anthropomorphic manifestations like Kirātārjunīya, the hunter who fought with Arjuna. *Śatarudrīyasaṃhitā,* chapter 42.

7. For further information on localization of deities and temple patronage, please see the essay by Michael Willis.

8. There is not much scholarship on the various *māhātmyas.* Hans Bakker's book *Ayodhyā* (Groningen: Egbert Forsten, 1986) deals with the *māhātmya* sections on Ayodhya; A. W. Entwistle, *Braj: Centre of Krishna Pilgrimage,* (Groningen: Egbert Fortsen, 1987), deals with Braj. Hermann Kulke's *The Cidambara-māhātmya* (Weisbaden: Otto Harrassowitz, 1970) was the first major study of any *sthala purāṇa,* and remains one of the best. Friedhelm Hardy, "Ideology and Cultural Contexts of the Śrīvaiṣṇava Temple" in *The Indian Economic and Social History Review,* vol. 14 no. 1 (1972), pp. 119–51, discusses some of the *māhātmya* texts associated with Śrī Vaiṣṇava temples in south India. I have

studied some of the stories in the *Tāpī Khaṇḍa* of the *Skandapurāṇa* in a paper, "When Miracles Become Too Many: Stories of the Destruction of Holy Sites in the *Tāpī Khaṇḍa of the Skandapurāṇa,*" delivered at the annual meeting of the Association for Asian Studies, 1991, and to be published in the *Annals of the Bhandarkar Oriental Research Institute,* vol. 72, 1991.

9. For references to naming the god after a particular donor, please see the essays by B. D. Chattopadhyaya and Michael Willis. See also Richard Kennedy, "The King in Early South India as Chieftain and Emperor," *Indian Historical Review,* vol. 3 (1976), pp. 1–15. Jain sources also mention temples erected to commemorate the memory of the deceased. The *Prabandhakośa* of Rājaśekhara in the biography of Vāstupāla and Tejaḥpāla describes how the two ministers built their famous temple at Mount Ābū, the Luṇigavasāhi, in memory of their brother. The temple bears his name. In addition, when Vāstupāla himself died, Tejaḥpāla built a temple for him, called the "Svargārohana Prāsāda," "The Temple That Was the Stairway to Heaven." *Prabandhakośa,* Jina Vijaya Muni, ed., Singhi Jain Series, vol. 1 (1935), Santiniketan: Singhi Jaina Pīṭha, pp. 121–29. I have made a study of the relationship between temple worship and the cult of the dead in Jainism in a recent paper, "Worship as Commemoration: Pilgrimage, Death and Dying in Medieval Jainism," written for the Association for the Study of Popular Religion, to be delivered at the Association of Medieval Scholars in Kalamazoo, Michigan.

10. I have in mind the language of the *Śivapurāṇa,* for example, in the story on the origins of the Nāgeśaliṅga, where we are told that the *liṅga* is "*śambhuḥ svalīlāttavigraha,*" "Śiva, who through his own divine play has taken on physical form." This is verse 14, chapter 30 of the *Koṭirudrasaṃhitā.*

11. See Hermann Kulke's article, "Kṣetra and Kṣatra: The Cult of Jagannātha of Puri and the 'Royal Letters' of the Rajas of Khurda," in *The Sacred Centre as the Focus of Political Interest,* Hans Bakker, ed., (Groningen: Egbert Forsten, 1992), pp. 131–43. For further discussion of royal patronage of temples, see Michael Willis's essay.

12. Hans Bakker, in his study of the texts related to Ayodhya has a detailed discussion of the worship of images according to some of the *purāṇic* texts on this site. See *Ayodhyā,* pt. I, op. cit., pp. 100ff.

13. This point is also emphasized by B. D. Chattopadhyaya. A typical text might be the *Haripāṭh of Dnyāṇdeva,* with its denial of the importance of scriptural study and

external acts of worship and its emphasis on personal experience. The text is translated into French with an introduction by Charlotte Vaudeville, *L' Invocation: Le Haripāṭh de Dnyāndeva,* (Paris: Publications de l'Ecole Francaise d' Extreme Orient, vol. 73, 1969).

14. Rocher, op. cit, p. 252.

15. For further information on royal patronage of temples in north India, please refer to the essay by Michael Willis.

16. The *Ekāmrapurāṇa,* which describes the temples of Bhuvaneśvara in Orissa, is explicit about temple building as a form of *dāna* as are medieval digests on ritual. See chapter 49, verses 17 and 29 of the *Ekāmrapurāṇa,* edited by Dr. U. N. Dhal (Delhi: Nag Publishers, 1986). The *Ekāmrapurāṇa* belongs to a subgenre of *purāṇic* writing, the *sthala purāṇas.* For details on these texts see note 7.

17. Like the *Viṣṇudharmottarapurāṇa,* the *Dvārakāmāhātmya* shows Pāñcarātra influence, although it is probably considerably later in date. For some comment on the text see Françoise Mallison, "Development of Early Krishnaism in Gujarat: Viṣṇu-Raṇchod-Kṛṣṇa," in Monika Thiel-Horstmann, ed., *Bhakti in Current Research, 1979–1982* (Berlin: Dietrich Reiner Verlag, 1983), pp. 245–57. For both the *Dvārakāmāhātmya* and the *Viṣṇudharmottarapurāṇa,* I am using the editions from Nag Publishers in Delhi.

18. I am using the Ānandāśrama edition, 1894.

19. This interpretation is discussed in my paper cited earlier on the *Tāpī Khaṇḍa* of the *Skandapurāṇa.*

20. I have taken the liberty in my translation of reducing the number of different names and substituting for an alternate name the more familiar "Śiva" when I suspected that the different names might be confusing.

21. See Rocher, op. cit., p. 233. For further discussion of genealogies of different subcastes in the medieval period, see the essay by B. D. Chattopadhyaya.

22. This is my argument in the paper I have cited in note 8.

23. The *Pṛthivīrājavijayamahākāvya* of the twelfth century, S. D. Belvakar, ed. (Calcutta: The Asiatic Society, 1914), chapter 1, p. 28.

24. A good source of information about traditional Jain accounts of the life and conversion of Kumārapāla is Georg Bühler's *The Life of Hemacandrācārya,* translated from German into English by Manilal Patel in the Singhi Jain Series, no. 11 (Santiniketan: Singhi Jaina Jnanapitha, 1936).

25. The text is published from the Jaina Ātmānanda Sabhā in Bhavnagar, 1909.

Fragments from a Divine Cosmology
Unfolding Forms on India's Temple Walls

Michael W. Meister

The Indian temple can be said to begin with a "singularity," in the phrase used by Stephen Hawking from today's theory of quantum physics: "a point in space-time at which the space-time curvature becomes infinite."[1] The reality of man's universe emerges from this infinitely intertwined cosmic fabric in India's myths of origin, a fabric closely resembling what the great scholar of India's architecture, Stella Kramrisch,[2] has called the "Uncreate."[3]

She defined this as the eternal "ground and antithesis of creation," always parallel to and in opposition with the charnel ground of the material world's cycles of creation and dissolution. In the beginning, as recorded by one famous passage from India's earliest speculative text, the Ṛg Veda:

> Then there was nothing that is, nothing that is not. There was no air then, no heavens beyond the air. What covered it over? Where was it? Who kept it? . . .

> But who really knows, who can say where it all came from, how creation came about. The gods themselves are after creation; who knows really where it all came from?

> Where Creation came from, whether it was made or not, only He knows who looks over it from highest heaven, unless even he does not know.[4]

The purpose of this essay is to provide a brief history of the evolution of the north Indian temple's forms; of the application of figural imagery to the temple; and to explain the links between the temple's geometry, imagery, and the role it played in Indian society as a model of cosmic order and origination. It is only within such a context that India's exceptional temple sculpture can be appreciated and understood.

Creation

Vedic India had honored natural forces by name but not primarily in a personified form. Indra, for example, as rain cloud "Lord of Heaven," or later Skanda, as "War Lord," represented nature's potency much more than either of them yet had developed personalized myths.

In much of India's early speculation, cosmic creation was thought to have spread from a moment of origin—called variously a point (*bindu*), seed (*bīja*), or egg (*aṇḍa*) (see Fig. 30) —in the cardinal directions. The universe thus was said to have taken the form of a square, oriented and stabilized by cardinal faces; its surface—the earth—was the altar on which the first sacrificial offering was enacted (see Fig. 31).[5]

Both this mythical act and the structure of cosmic order have been represented in ritual and architectural texts by a square diagram called the "*vāstupuruṣamaṇḍala*" (*vāstu*–"building"; *puruṣa*—"man"; *maṇḍala*—"diagram") presenting the figure of a "dæmon" pinned as sacrifice to the earth by a series of divine entities distributed within a grid of usually sixty-four or eighty-one squares (Fig. 32).[6] Such a mapping of the cosmogonic myth was first determined in the early centuries B.C. as part of the ritual used to construct open-air brick altars. From at least the fourth or fifth century A.D., however, it was adapted by architects as a means by which to lay out temples and to locate them ritually (see Fig. 33).[7]

The plans of many of the early temples surviving in north India take the form of a square (or rather—extending the plane of the cosmos toward the apex and nadir—that of a cube). Among the earliest of these, the small stone temple on the hill at Sanchi in central India (ca. A.D. 400–415) consists only of a cubical sanctum and a shallow portico to shelter the approaching worshiper (Fig. 34).[8]

The earliest surviving text to describe the temple's constructing diagram, the *Bṛhatsaṃhitā*, was written in the early sixth century A.D. when such temples, in brick or stone, had only begun to be built.[9] At the center of this grid, the *vāstupuruṣamaṇḍala*, as described in the *Bṛhatsaṃhitā*, was a place for the all-pervading, formless, divine entity called *brahman* (see Fig. 33).[10] Around the periphery of the grid were placed "pinning divinities" (*padadevatās*), referring to that much earlier myth in which pinning down the flayed skin of a dæmon who threatened creation had become the world's first act of sacrifice and salvation. The dæmon, through his role in the sacrifice, was transformed into the guardian spirit of the ritual site (the "*vāstupuruṣa*," also called Vāstoṣpati) and thus also of creation and of all subsequent architectural construction.[11]

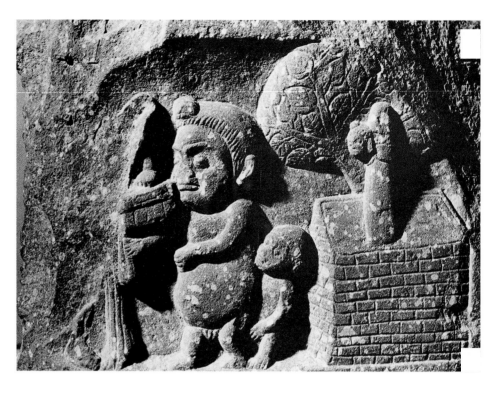

In the *Bṛhatsaṃhitā*, the width of the inner space of a temple was prescribed to be twice the thickness of the walls. Thus, if the temple's construction was based on a sixty-four square grid, the sanctum's "womb chamber" (*garbhagṛha*) took up sixteen squares. Of these, the central four squares constituted the "place for *brahman*" (*brahmasthāna*). This massive density of walls was produced by utilizing the grid's defined proportions and gave protection to the temple's generative center, where, through an act called *darśan*, divinity could be "seen" by the worshiper, as if foaming into existence.[12] This mental vision was produced by the use of a central cult image (*mūrti*) and by the sound and incense of ritual (see Fig. 35). Each of these—including both the image and temple—was only a tool (*yantra*) applied to heighten the mind of the worshiper toward ultimate transcendence.

Time

To a Hindu, the cycles of time are maintained by daily rites, whether at home, on a riverbank, or in a temple. By building a temple, the patron and priest re-enacted the first cosmogonic moment (as if by watching Carl Sagan we could re-enact our universe's first ten-thousandth of a second) and provided the worshiper a model by which to explain the abundance and proliferation of creatures within this universe. This abundance itself became a primary motive (as well as motif) for the temple's elaborate decoration (see Fig. 36).

The primitive mythical forces represented by the building diagram's peripheral "pinning divinities" had, by the time temple building first began in the fourth century A.D., become associated with the twenty-eight astral markers of the lunar calendar (marking days of a lunar month) and ultimately with the astrological emblems of a solar zodiac. This made the temple an active chronogram (time marker) as well as static cosmogram (space marker).[13]

The architects of some temples began to give expression to this time function by using a rotating plan with angled buttresses in both cardinal and subcardinal positions. Such a "stellate" temple's highly faceted walls, much like those of a fortress, both reflected and protected the inner divinity (see Figs. 37, 38).[14]

Around such a temple's chronomic and iconic pulsation, the more irregular rhythms of a human and agricultural ritual calendar were carried out.[15]

Fig. 31
Relief showing Kuṣāṇa-period altar, Mathura, Uttar Pradesh, about 2d century. (State Museum, Lucknow)

Fig. 32 *above*
Ritual diagram (*vāstupuruṣamaṇḍala*). (Based on a drawing by A. Volwahsen.)

ROGA / PĀPA-YAKSMAN	AHI	MUKHYA	BHALLĀTA	SOMA	BHUJAGA	ADITI	DITI / AGNI
ŚOṢA	AHI	MUKHYA	BHALLĀTA	SOMA	BHUJAGA	ADITI	PARJANYA
ASURA	Rāja-yaksmān / Rudra	Pṛthvidhara		Āpaḥ / Āpa-vatsa			JAYANTA
VARUNA	Mitra				Aryaman	INDRA	
KUSUMA-DANTA	Mitra	BRAHMAN			Aryaman	SŪRYA	
SUGRĪVA	Jaya / Rudra	Vivasvān		Savitṛ / Sāvitra		SATYA	
DAUVĀRIKA	BHṚNGARĀJA	GANDHARVA	YAMA	BRHATKSATA	VITATHA	PŪSAN	BHṚŚA
PITARAH / MRGA	BHṚNGARĀJA	GANDHARVA	YAMA	BRHATKSATA	VITATHA	PŪSAN	ANTAR-IKSA / ANILA

Fig. 33 *left*
Sixty-four–square grid used for the construction of temples, indicating the names of deities and *padadevatās*.

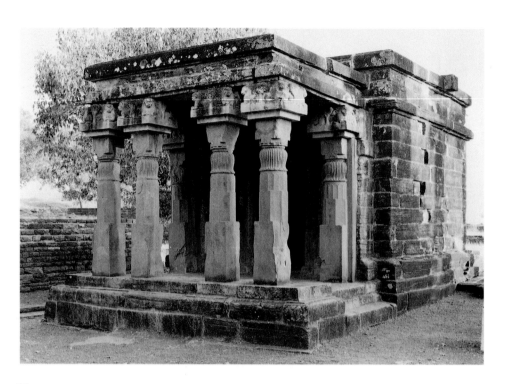

Form

While India's architects experimented with forms to define the temple as a shelter for both the deity and the worshiper, they began to extend the measure of the sanctum's sacred central spaces in ways that could be made visible on the temple's outer walls. To this end, they first applied a broad central buttress to each wall on which a sculpted image representing one aspect of the inner deity could be placed (see Fig. 39). By the early seventh century, applying the grid plan of the *vāstumaṇḍala*, architects began to give one plane of projection on each wall the width of the inner sanctum and a second plane (the central buttress, bearing a divine image in an architectural frame that was designed to suggest a doorway) the measure of the interior sanctum's *brahmasthāna* (see Fig. 40).[16] These stepped planes in effect added to the square altar/sanctum a "cross plan" of masonic piers on which images could be placed. (See also Darielle Mason's essay.)

Within the sanctum's *garbhagṛha*, the *mūrti* acted as the focus for a human's approach to divinity. Such a sculpture made it possible for an otherwise invisible and all-pervading divinity to seem present for worship at this chosen location. As a tool for meditation, such images made the deity actual—not as stone, but as a vision triggered by the image in the worshiper's mind.[17] In like fashion, the temple created an image of the cosmos. (In Western semiotic terms, it both *was* and *expressed* the cosmos.)[18]

Variation

A number of experiments with architectural forms for sheltering the divinity contributed to the final curvilinear (*nāgara*) temple tower typical of northern India. Small, "flat-roofed," pillared pavilions (*maṇḍapikā* pandals) were used as votive and probably funereal shrines in central India for a number of centuries. (Their superstructure, in fact, suggests an altar platform.)[19]

Some other shrines still used large wedge-shaped pent-roofs called *phāṁsanā*, sometimes for the sanctum but more frequently as the roof for the pillared hall in front (see Fig. 41).[20]

Rectangular shrines were sometimes built to house certain types of divinities (sets of mother goddesses, Viṣṇu in a reclining position, the nine planets). They occasionally also had *phāṁsanā* roofs, but often instead had a barrel-vaulted

Fig. 34
Temple no. 17, Sanchi, Madhya Pradesh, about A.D. 400–25.

98

superstructure (*valabhī*) that had been derived from the secular and urban wooden architectural forms of ancient India (see Fig. 42).[21]

The vertically banded (*latina*) tower of northern India's typical *nāgara* temple took the arched-window shape of the end of such a barrel roof and, using it instead as a small ornamental motif, spun a web of these patterns as vertical spines (*latās*) above the offsets in the wall below (see Fig. 43, p. 105).[22] These curvilinear bands tied together the outer walls of the temple and an upper "altar" (*uttaravedī*) that took the same dimensions as the inner sanctum (see Fig. 44, p. 105).[23]

This single-spired tower (*ekāṇḍaka*, that is, compared to the single "egg" of creation, Fig. 30) gradually took on a more complex shape, with its multiple forms clustered around a central spire (*anekāṇḍaka*, that is, "not one-egged"). Multiplicity could be produced in several ways. Initially, temples with internal paths for circumambulation of the sanctum placed additional *latina* models above the corner piers of their ambulatory walls (*pañcāṇḍaka* "five-egged").[24] Gradually, an additional layer of four models was added over the ambulatory (*navāṇḍaka* "nine-egged"). This elaboration increasingly gave the temple the appearance of a

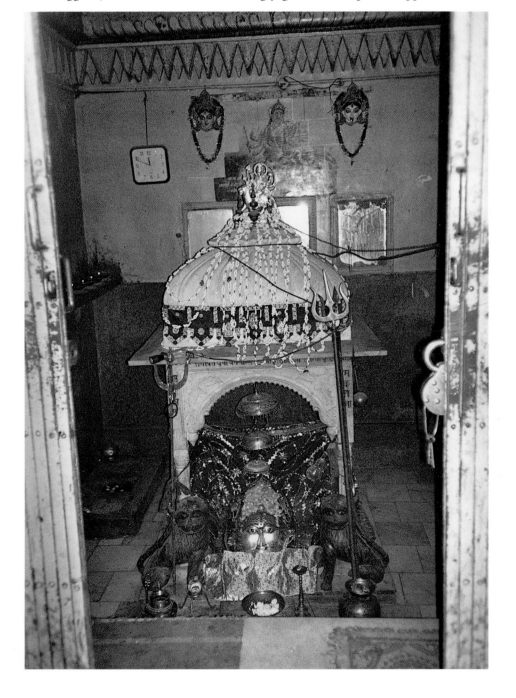

Fig. 35 *left*
Worship of the image in the sanctum of Dadhimatīmātā temple, Goth-Māṅglod, Rajasthan, about A.D. 850.

Fig. 36 *above*
Pillars with foliate ornament, Raṇchodji temple, Kheḍ, Rajasthan, about A.D. 850.

Fig. 37 *right*
Ground plan with constructing geometry of Udayeśvara temple, Udayapur, Madhya Pradesh, about A.D. 1080.

Fig. 38 *below*
Udayeśvara temple, Udayapur, Madhya Pradesh, about A.D. 1080.

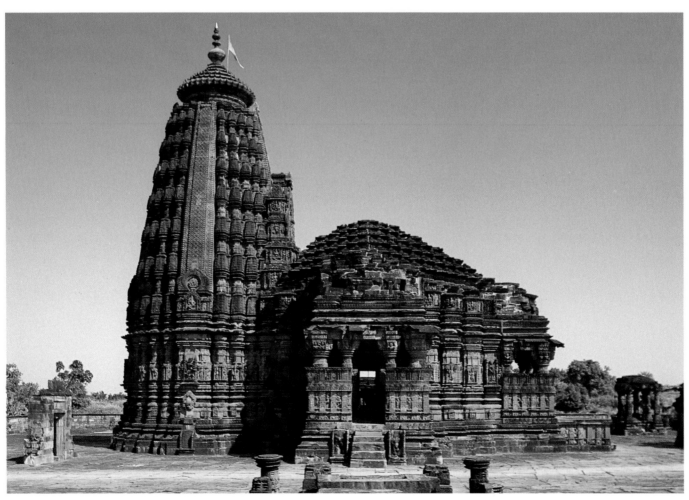

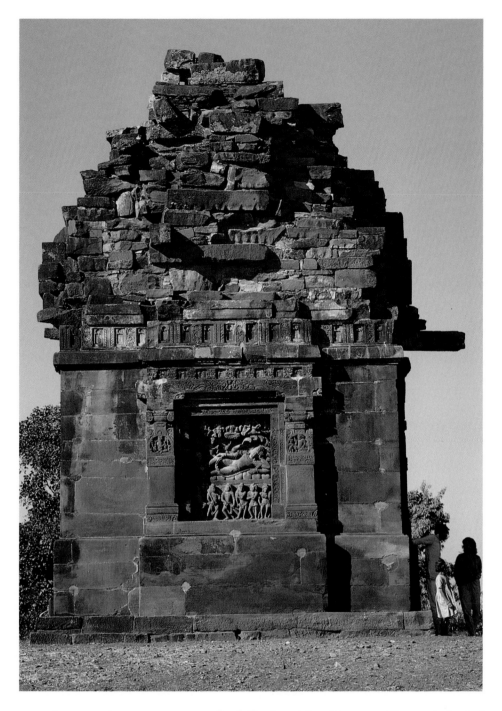

central mountain among many foothills (see Fig. 56, p. 111), an indexical reference with its own potent sign value.[25]

Ultimately, these distinct levels of subshrines were compacted into one form; each row of miniature replicas in the tower was set above an equilateral offset in the temple's plan. This evolution and multiplication of architectural elements (see Fig. 45) produced, by late in the tenth century A.D., a multispired formula known as *śekharī* that even in its own time was perceived as typifying northern India's high Hindu period (see Fig. 47, p. 107).[26] Such elaboration of ground plan and superstructure also had consequences for the increasing sculptural representation on the wall's frieze. (See the essay by Darielle Mason.)

A similar multiplication in the *phāṁsanā* roof over the temple's entry hall also led to an elegant new architectural structure known as *saṁvaraṇā* (a tiered pyramidal roof type made up of multiple staggered awnings and pinnacles; see Fig. 46).[27] Each of its miniature roofs was crowned by its own ribbed bell-shaped finial (*ghaṇṭā*) This structure, then, as in inscriptions that praise a number of

Fig. 39 *above left*
Viṣṇu temple, Deogarh, Madhya Pradesh, about A.D. 500–25.

Fig. 40 *above*
Ground plan with constructing grid of Śiva temple no. 2, Mahua, Madhya Pradesh, about A.D. 675.

101

famous sacred "crossings" (*tīrthas*), could be said to ring with "a thousand and one bells."[28]

Architects had also, in this period, undertaken other formal experiments to give the temple the symbolism of a multiplying, multilayered, and multidimensional universe. Brick temples built as early as the fourth to seventh centuries A.D. had already conceived of the temple as an infinitely varied, multistoried palace. Such symbolism had also been incorporated into the architectural morphology of the curvilinear *latina* tower.[29]

A later variation of the *nāgara* temple known as *bhūmija* placed a series of small temple models to form chains up the intermediate spines of its curvilinear superstructure.[30] This typology—as in the famous Udayeśvara temple at Udayapur in central India (Fig. 38) —was given the name *bhūmija*, in part, perhaps, after the many levels of earthly and cosmic reality (*bhūmi*) it was intended to evoke.

Ornament

Fig. 41
Front hall with *phāṁsanā* roof, Mahāvīra temple complex, Osian, Rajasthan, about A.D. 775.

God images placed on the exterior walls of the temple give personality to the inner deity; they multiply his manifestations, create a mythical family, and provide individualized forms for personal worship.[31] The images placed in the

subshrinelike niches on the wall's central cardinal offsets (*bhadras*) are today called *iṣṭadevatās*, that is, deities meant for an individual's personal devotion (see Fig. 48). In contrast to the iconic image that makes divinity present within the sanctum, these figures act primarily as part of the temple's peripheral mediating ornament.[32]

Such ornament, however, is essential to the temple's core symbolism. Little differentiates these deities from the fabric of other ornamental motifs that mark and measure the temple's variegated surface. There, a hierarchy of images—from insects and plants to humans, celestials, and divinities—was meant to materialize and make visible a single reality. It is in the sense of the temple as agent of human salvation that this exhibition's title, Gods, Guardians, and Lovers, seems appropriate. As the hierarchy of India's cosmogony was given visible form, the temple and its ornament became its embodiment. Its surface represents the atomic particles of creation; its base, superstructure, and upper altar the three levels of cosmic reality; and the multitude of deities enshrined by niches the particulate nature of divine manifestation.

Frieze

From the bare cube of early stone temples (see Fig. 34) to the most highly ornamented shrine (see Fig. 56, p. 111), the frieze of the temple represented the skin and fabric of cosmic parturition. As with a geode, the solidity of divine reality resided within the inner space of the sanctum. Access for ritual was through the sanctum's door. This inner reality could also loom visibly on the exterior walls through blind "doorways" projected from the temple's cardinal faces as "niches" (see Fig. 39). Such niches framed divine images and, in many later temples, took the form of small subsidiary shrines.

From other offsets in the wall, celestial attendants emerge, musicians hover, and an older order of deities stands guard. The temple branches into many forms, as had the trees of ancient tree shrines, its limbs entwined by the illusion of reality (*māyā*). It stands as an invisible cosmic being, its ornament the created world.[33]

Elevation

In its high Hindu form, the temple often stood on a broad rectangular platform, ornamented by moldings and with niches containing divinities. Secondary shrines often stood on the corners of this platform, as at Khajurāho (Fig. 49), giving material presence to the multiplicity of deities within this constructed cosmic environment. Both these and the central shrine often had separate plinths (*pīṭha*) ornamented in molded bands by rain-cloud elephants, sea creatures (*makara*), geese (*haṃsa*), divinized warriors (*vidyādhara*), vines, and other motifs to suggest a celestial abode (see Fig. 50). The wall moldings of the temple (*vedībandha*, "the altar's bonding") are usually placed above floor level, binding the sanctum. These include a "water-pot" molding (*kalaśa*) occasionally shown sprouting foliage and fruit, in reference both to the temple's rooting in India's water cosmology and to its ritual lustration.[34] Niches placed on these moldings contain images of subsidiary incarnations (for example, the Saptamātṛkās or Viṣṇu's *avatāras*) or sometimes mythic scenes from the narrative texts called *purāṇas*.

The frieze hierarchically places emphasis on the central divinity, with attending deities to either side and guardians of the eight directions on the corners. Celestial females, leogryphs (composite animals), musicians, and other ornaments flower from recesses in the walls. The transitional cornice moldings above the frieze sometimes carry narrative reliefs depicting scenes from the epics (the *Mahābhārata* and *Rāmāyaṇa*) or the *purāṇas*. Few images are placed above in the superstructure.

In its formal multiplicity, the temple's tower evokes the celestial realm of

Following page
Fig. 42
Barrel-vaulted (*valabhī*) roof of Teli-kā-Maṇdir temple, Gwalior, Madhya Pradesh, about A.D. 750.

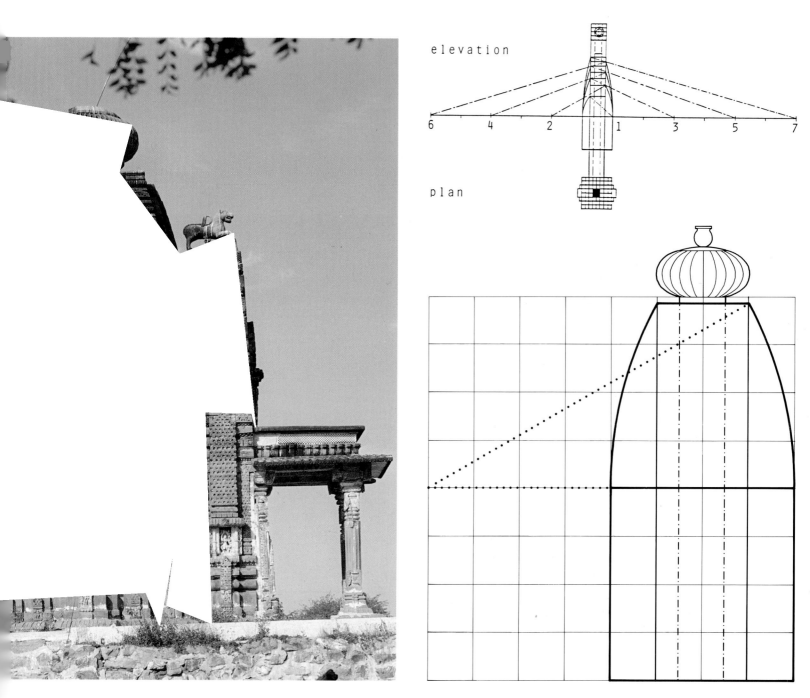

Fig. 43 *below left*
Sūrya temple with *latina* tower, Madkheda, Madhya Pradesh, about A.D. 925–50.

Fig. 44 *below right*
Method used to proportion the *latina* tower's elevation and the relation of the elevation to the plan.

elevation

6 4 2 1 3 5 7

plan

105

Fig. 45 *right*
Transformation of temple ground plans from A.D. 650–75 (A) to A.D. 875 (B) to A.D. 975–1000 (C).

Fig. 46 *below*
Saṁvaraṇā roof, subshrine to Saciyā Mātā temple, Osian, Rajasthan, 11th century, with later additions.

Opposite page
Fig. 47 *above*
Saciyā Mātā temple's superstructure (about late 11th century) with Sūrya temple no. 1 (about A.D. 700–25) in foreground, Osian, Rajasthan.

Fig. 48 *below*
Ambikāmātā (Devī) temple, Jagat, Rajasthan, about A.D. 961.

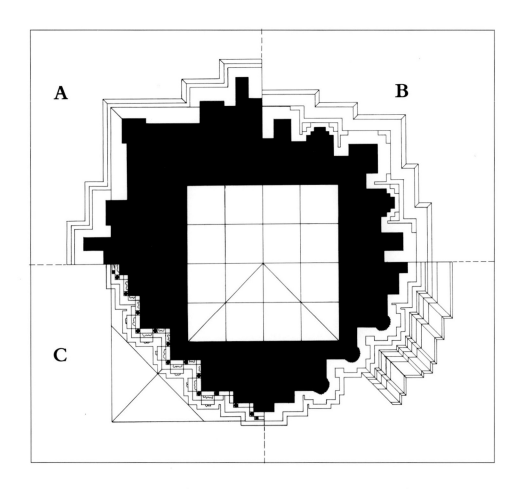

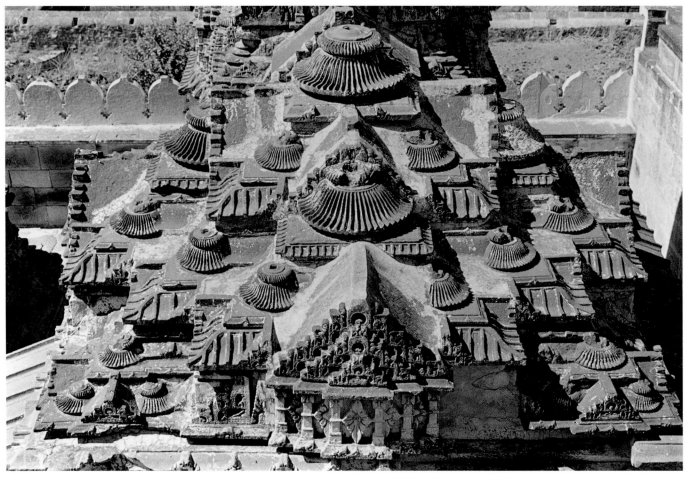

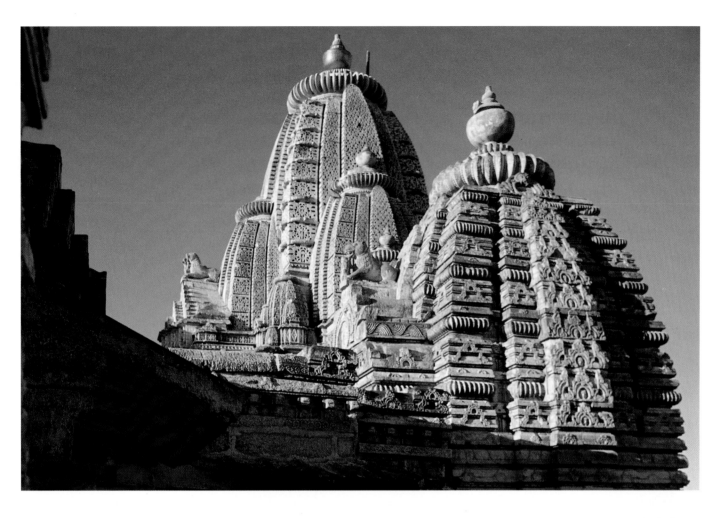

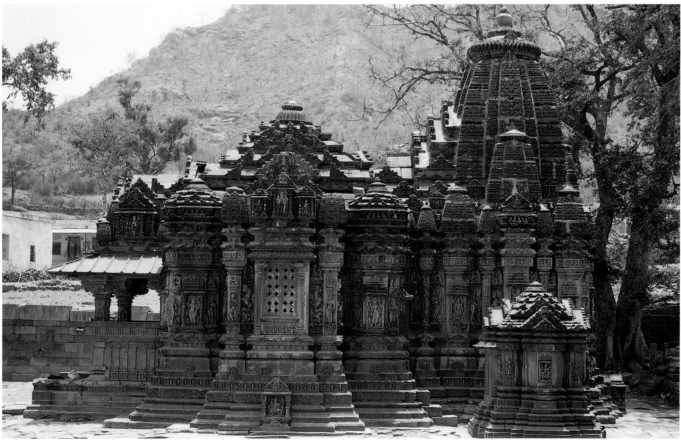

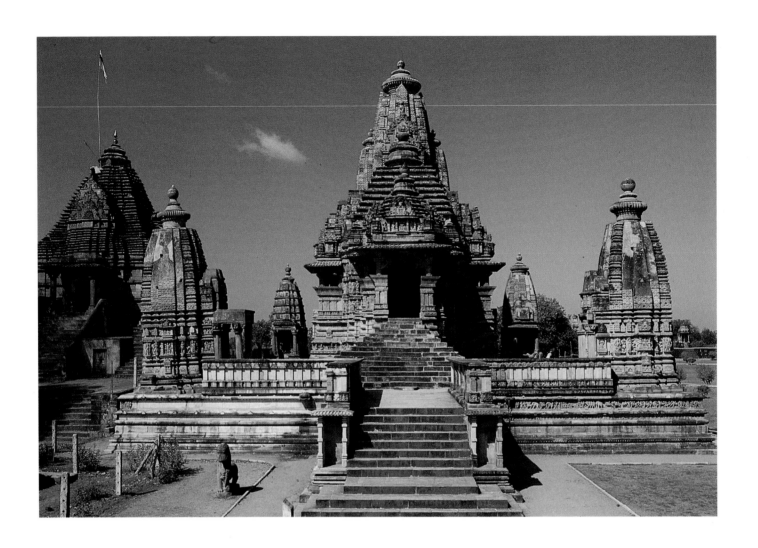

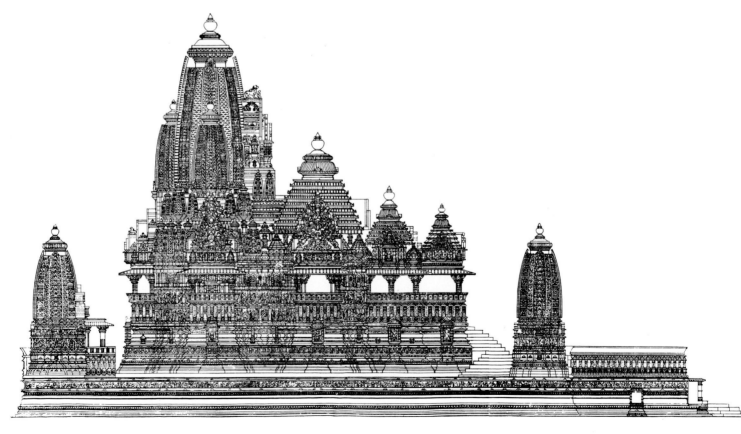

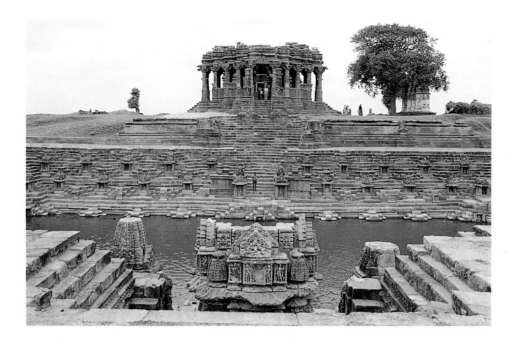

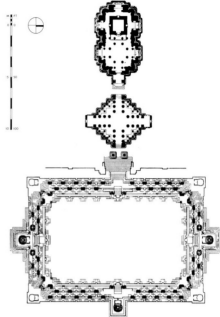

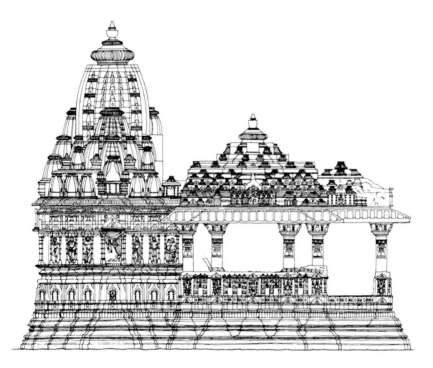

Mount Meru at the world's center and is crowned by the seed-form capital of the cosmic pillar. Each temple, thus, both centers and reveals the world while offering the worshiper a path by which to transcend it.[35]

Nature

As a monument, the temple intentionally is poised between the elements (see Figs. 51, 52). Always placed near water, built of and on the earth, through ritual it is the home of fire. Its tower is the embodiment of air, its apex—or the space above it—of ether. "Let the earth reside in the [temple's] hoof," reads a fragment of one ancient Indian text on architecture, and let the cosmos be distributed throughout the structure.[36]

Base moldings that support and bind the temple often have at their root the petals of the lotus flower.[37] This is the supernal support for deity in India as the

Opposite page

Fig. 49 *above*
Lakṣmaṇa temple complex, Khajurāho, Madhya Pradesh, about A.D. 954–55.

Fig. 50 *below*
Elevation of Lakṣmaṇa temple, Khajurāho, Madhya Pradesh, about A.D. 954–55.

Fig. 51 *above left*
Tank and hall of Sūrya temple, Modhera, Gujarat, about A.D. 1027–75.

Fig. 52 *above right*
Ground plan of tank, hall, and main shrine of Sūrya temple, Modhera, Gujarat, about A.D. 1027–75.

Fig. 53 *left*
Elevation of Nīlakaṇṭha Mahādeva temple, Sūnak, Gujarat, about A.D. 1075.

plant that spans the earth, water, air, and opens itself—that is its calyx, the potent seedpod—toward ether and eternity.

Among the basal moldings, elephant courses suggest the rain clouds hovering, like Indra's elephant, between earth and sky (see Fig. 53). Above is the temple-mountain—Śiva's Mount Kailāsa—which, like the Himalayas, hovers above the monsoon's water-laden clouds. The walls of the temple are themselves a cage (pañjara), a pillared structure giving body to air.[38] The five elements—water, light, air, sky, and earth—act "as wrappings in the wall of the temple," according to the Agnipurāṇa, "for the microcosm (brahmāṇḍaka)" located within the sanctum and guarded from all directions.[39]

The temple also has, in its overall ornament, a cosmic geography. It places on its doorway figures that represent the rivers of northern India as well as Himalayan sages (see Fig. 54). To either side on the jambs are the two great sacred rivers that define north India, the Gaṅgā and Yamunā, thus marking a specific Aryan earthscape. Often, the top of the doorjambs bear figures of female nature spirits (yakṣīs) sheltered under flowering trees.[40] The doorsill (udumbara), with its attendant and auspicious figures, is used to mark the liminal zone between the worshiper and the divine, ritual and "reality," the discipline of meditation and transcendence.[41]

Water and space are the fertile forge for the lotus and fruit (āmala) that mark the temple, in its role as cosmic generator, at its base and pinnacle. The flame of ritual within the sanctum produces growth, marked on the walls by spiraling vines that encircle the temple (see Fig. 36, p. 99; Fig. 54). At the center of the temple is divinity, an invisible presence that enlivens the mūrti used for worship. That image then multiplies and fragments into the many potent figures from India's divine cosmology that are placed on the temple's outer walls.[42]

Utility

The interior space of the temple provides a juncture between the divine and human worlds. It is a place of transition, invoking the potential for transformation of the worshiper. Between the entryway and the sanctum is the threshold across which ritual transactions were carried out by the priest. Early shrines had barely a portico for the single worshiper (see Fig. 34, p. 98). However, as the temple evolved, this "axis of access" became increasingly a focus for architectural expression.[43] Halls were added along it for congregation, dance, recitation, and ritual. Like the forest clearing before an ascetic's hut, these halls were surrounded by elaborately variegated pillars, framing a space for the worshiper that eventually was made coequal with the deity's proportion-guarded sanctum (see Figs. 55, 56).[44]

Both the proliferating architectural mass of the main temple and the expansion of its interior spaces from early to later temples evolved from a simple paradigm early in the fifth century—equating deity and worshiper—to much more complex, even "baroque," architectural expressions hundreds of years later. Each temple could be a "crossing" and every worshiper a transcendent being.[45] Every door was an entry and each buttress could become a door. Every niche frame was a gate and, potentially, with a divine image, provided a place for self-transformation.

Within the interior, bracket figures branched from pillars in the form of celestial creatures. These helped frame cusped and cantilevered ceilings meant to suggest a celestial canopy (see Fig. 57). A central space in the hall in front of the sanctum could be given its own ceiling, as if to provide the sacred umbrella held over the head of the patron-sacrificer (yajamāna) in Vedic rituals. As part of the temple's entrance pavilion, a toraṇa gate was used to initiate the worshiper's ritual direction.

A path, either provided by the open plinth or enclosed as a corridor within the fabric of the temple, allowed a worshiper to circumambulate the sanctum to observe the central divinity's many manifestations on its walls. It is as if, within the temple—itself the vision of celestial creation made manifest in stone—the

Opposite page

Fig. 54 *above right*
Doorway of Śiva temple, Baroli, Rajasthan, about A.D. 925.

Fig. 55 *above left*
Ground plan with proportioning grid of Kandariyā Mahādeva temple, Khajurāho, Madhya Pradesh, about A.D. 1025–50.

Fig. 56 *below*
Kandariyā Mahādeva temple, Khajurāho, Madhya Pradesh, about A.D. 1025–50.

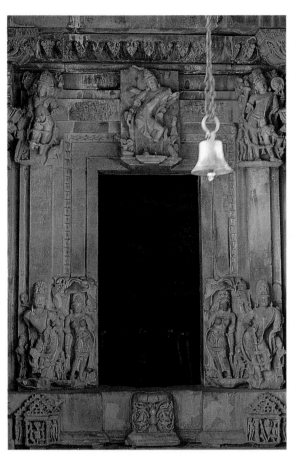

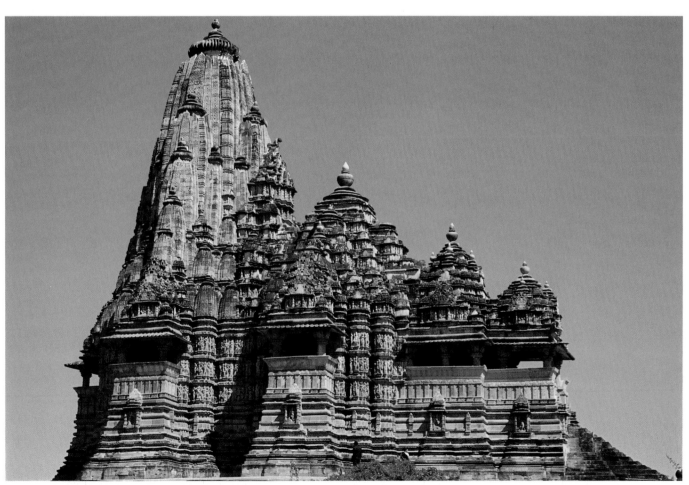

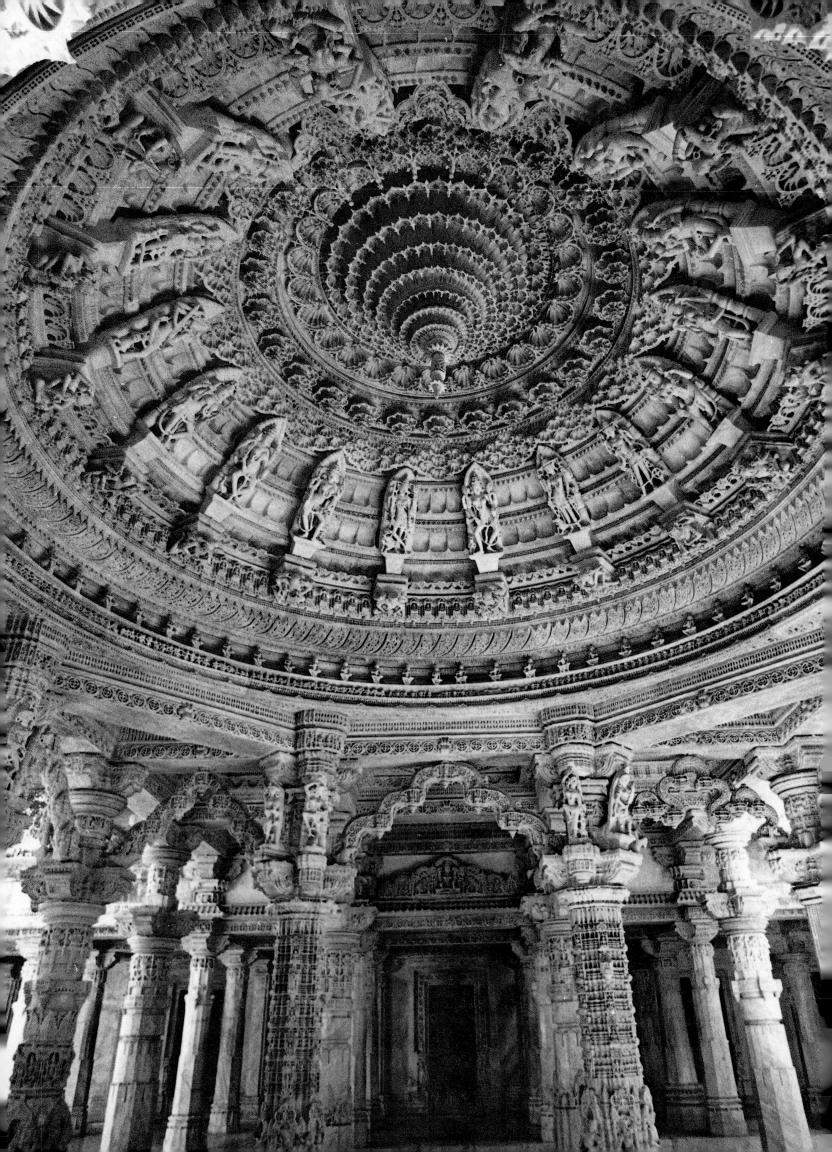

worshiper could step from his or her century into the energy of a modern video or be swept into "virtual reality" without a computer.

Worship

In a temple, worshipers perform special rites through the mediation of priests that extend beyond the personal rituals each Hindu performs on a daily basis in his home and heart. These may include calendric festivals, rites of passage, personal pledges, pilgrimage, as well as community events (see Fig. 58).

The rites of building a temple for the first time may have served one constituency, that of the donor, its iconography another, that of the sect being patronized. The constructed temple, however, needed to be polyvalent—able to serve a variety of needs over many years. In a few cases, one rigorous iconographic scheme may have continuously served a single sect. In most cases (in this world) the temple structure's broad validating cosmogonic frame was able, instead, to provide a ground for a variety of reuses and reassessments over time.[46] Today, few worshipers or priests are able to read the temple's iconography completely, yet they understand the temple's ritual utility and sense the cosmogonic and cosmological identities that form the core of its iconic power.[47]

Symbolism

The worshiper first enters the temple as an act in time, hoping to reinstate that originating cosmogonic singularity. The curvilinear tower of the temple in north India was designed to unite the interior space and the outer walls, resolving them both into one square upper altar (see Fig. 44, p. 105). Through the center of the sanctum, and emerging into view at the top of the temple, a pillar crowned by a ribbed seed form (*āmalaka*, "the myrobalan fruit") first marked the temple's cosmic potential for parturition.[48]

From the fifth to eleventh centuries, architects gave this superstructure increasingly complex forms—tied to an increasing proliferation and variegation in plan (see Fig. 45, p. 106; Fig. 48). This was, in part, a successful attempt by these architects to reify the temple as the visible expression of the cosmos's power for infinite, if indeterminately extending, generation (see Fig. 56).

On the temple's outer walls, central offsets carried incarnations of the interior divinity, giving "sight" to the worshiper as he or she circumambulated the structure. Corner buttresses of the temple from the eighth century bore images of deities to "guard the quarters." These eight protectors of the directions (*dikpālas*)—taken from a much earlier cosmogony of the Vedic period—helped to gird the structure, giving it order while protecting it from the chaos outside.[49] Intermediate buttresses bore attendant figures—celestials, heavenly females, musicians, plants, leogryphs—making the temple appear to flower and bear fruit (see Fig. 48).

Like a great celestial "wish-fulfilling" tree (*kalpavṛkṣa*), the temple represents both cosmic birth and the proliferating and unfolding forms of this creation.[50] This is both expressed through the temple's geometry and made visible by the abundant sculpture on its walls (see Figs. 55, 56).

This essay, then, has briefly outlined the evolution of the temple's form and defined its underlying iconic basis, mapped a preliminary hierarchy for the iconographically complex images on display in this exhibition, and attempted to suggest the changing range of rituals that temples and their outer ornaments were meant to serve. That temples were often clothed in elegant and powerful images may gratify Western aesthetic norms or challenge them.[51] Yet such images were made as kaleidoscopic fragments of a divine cosmology. Through them the cosmos itself unfolded, in all its multiplying glory, on India's temple walls.

Opposite page
Fig. 57
Hall and ceiling with bracket figures, Luna Vasāhi temple, Dilwārā, Mount Ābū, Rajasthan, about 13th century.

Fig. 58 *above*
Festival in Pune with images taken in procession to celebrate Gaṇeśa's birthday.

113

1. Stephen W. Hawking, *A Brief History of Time from the Big Bang to Black Holes* (New York: Bantam Books, 1988), glossary.

2. Stella Kramrisch, *The Hindu Temple*, 2 vols. (Calcutta: Calcutta University Press, 1946).

3. Stella Kramrisch, *The Presence of Śiva* (Princeton: Princeton University Press, 1981), p. 7.

4. *Ṛg Veda* 10.129. I thank George Hart for the use of his personal, unpublished translation.

5. Stella Kramrisch, *The Presence of Śiva*, pp. 1–2, states "Creation is an act of violence that infringes on the Uncreate, the undifferentiated wholeness that is before the beginning of things." See also, idem, "The Four-Cornered Citadel of the Gods," *Journal of the American Oriental Society*, vol. 75 (1955), pp. 184–87.

6. The *Bṛhatsaṁhitā* of Varāhamihīra, circa sixth century A.D., prescribes a grid of sixty-four squares for temple building and a grid of eighty-one squares for houses, palaces, and city planning. Later texts allow a variety of grids for both purposes.

7. Michael W. Meister, "Maṇḍala and Practice in Nāgara Architecture in North India," *Journal of the American Oriental Society*, vol. 99.2 (1979), pp. 204–19.

8. Michael W. Meister, "Temple: Hindu Temples," in *The Encyclopaedia of Religion*, ed. Mircea Eliade, vol. 14 (New York: Macmillan Publishing Co., 1987), pp. 368–73; *North India, Foundations of North Indian Style* (*Encyclopedia of Indian Temple Architecture*, vol. 2, pt. 1), Michael W. Meister, M. A. Dhaky, and Krishna Deva, eds. (Princeton: Princeton University Press, 1988).

9. Varāhamihīra, *Bṛhatsaṁhitā*, H. Kern, trans., *Journal of the Royal Asiatic Society*, vols. 4–7 (1869–74), appendices; idem, V. Subrahmanya Sastri and M. Ramakrishna Bhat, trans. (Bangalore: V. B. Soobbiah, 1947); Ajay Mitra Shastri, *India as Seen in the Bṛhatsaṁhitā of Varāhamihīra* (Delhi: Motilal Banarsidass, 1969).

10. This formless entity is not to be confused with the personified divinity of the later Hindu trinity known as Brahmā.

11. Stella Kramrisch, *The Presence of Śiva*, passim.

12. Diana L. Eck, *Darśan, Seeing the Divine Image in India*, 2d rev. ed. (Chambersburg, PA: Anima Books, 1985).

13. Stella Kramrisch, *The Hindu Temple*; Michael W. Meister, "Muṇḍeśvarī: Ambiguity and Certainty in the Analysis of a Temple Plan," in *Kalādarśana, American Studies in the Art of India,* Joanna G. Williams, ed. (New Delhi: Oxford & IBH Publishing Co., 1981), pp. 77–90;

idem, "Analysis of Temple Plans: Indor," *Artibus Asiae*, vol. 43 (1982), pp. 302–20.

14. Michael W. Meister, "Śiva's Forts in Central India: Temples in Dakṣiṇa Kośala and Their 'Dæmonic' Plans," in *Discourses on Śiva*, ed. Michael W. Meister (Philadelphia: University of Pennsylvania Press, 1984), pp. 119–43; idem, "Reading Monuments and Seeing Texts," in *Śāstric Traditions in Indian Arts*, A. Dallapiccola, ed. (Stuttgart: Franz Steiner Verlag, 2 vols., 1989), vol. 1, pp. 167–73; vol. 2, pp. 94–108, pls. 81–88; idem, "Analysis of Temple Plans: Indor"; idem, "The Udayeśvara Temple Plan," in *Śrīnidhih, Perspectives in Indian Archaeology, Art and Culture*, Shri K. R. Srinivasan Festschrift (Madras: New Era Publications, 1983), pp. 85–93.

15. See, for example, T. N., Madan, ed., *Religion in India* (New Delhi: Oxford University Press, 1991).

16. Michael W. Meister, "Measurement and Proportion in Hindu Temple Architecture," *Interdisciplinary Science Reviews*, vol. 10 (1985), pp. 248–58.

17. Michael W. Meister, "Seeing and Knowing: Semiology, Semiotics, and the Art of India," Proceedings of the XV Annual Colloquio, Mexico: Instituto de Investigaciones Esteticas (in press).

18. Michael W. Meister, "De- and Re-constructing the Indian Temple," *Art Journal*, vol. 49 (1990), pp. 395–400.

19. Michael W. Meister, "Construction and Conception: Māṇḍapikā Shrines of Central India," *East and West*, New Series, vol. 26 (1978), pp. 409–18.

20. Michael W. Meister, "Phāṁsanā in Western India," *Artibus Asiae*, vol. 38 (1976), pp. 167–88.

21. Meister, "Phāṁsanā..."; idem, "Geometry and Measure in Indian Temple Plans: Rectangular Temples," *Artibus Asiae*, vol. 44 (1983), pp. 266–96. For early wooden forms, see *Ananda K. Coomaraswamy: Essays in Early Indian Architecture*, Michael W. Meister, ed. (Delhi: Oxford University Press, 1992).

22. *Latina* refers to the morphology of vertical bands (*latās*) making up the temple tower; *nāgara* refers, instead, to north India's curvilinear typology, whether with a single tower or not.

23. For further information, see Michael W. Meister, "On the Development of a Morphology for a Symbolic Architecture: India," *Res, Anthropology and Aesthetics*, vol. 12 (1986), pp. 33–50.

24. Michael W. Meister, "Detective Archaeology: A Preliminary Report on the Śiva Temple at Kusumā," *Archives of Asian Art*, vol. 27 (1974), pp. 76–91; idem, "A Field Report on Temples at Kusumā." *Archives of Asian Art*, vol. 29 (1976), 23–46.

25. Michael W. Meister, "Jain Temples in Central India," in *Aspects of Jaina Art and Architecture*, ed. U. P. Shah and M. A. Dhaky (Ahmedabad: L. D. Institute, 1976), pp. 223–41.

26. I here choose to avoid the term *medieval*. The word *nāgara* in this period seems to have referred to the multispired *śekharī* form.

27. Meister, "Phāṁsanā in Western India."

28. For example, see Michael W. Meister, "Historiography of Temples on the Chandrabhāgā, Reconsidered," in *Indian Epigraphy, Its Bearing on the History of Art*, G. S. Gai and Frederick S. Asher, eds. (New Delhi: Oxford & IBH Publishing Co., 1985), pp. 121–24.

29. Michael W. Meister, "Prāsāda as Palace: Kūṭina Origins of the Nāgara Temple," *Artibus Asiae*, vol. 49 (1989), pp. 254–80. See also, idem, "Śiva's Forts in Central India"; idem, "On the Development of a Morphology for a Symbolic Architecture."

30. Krishna Deva, "Bhūmija Temples," in *Studies in Indian Temple Architecture*, ed. Pramod Chandra (Delhi: American Institute of Indian Studies, 1975), pp. 90–113.

31. Stella Kramrisch, *Manifestations of Shiva* (Philadelphia: Philadelphia Museum of Art, 1981), provides the rich religious and mythic setting for Śaiva sculpture. See also Michael W. Meister, "Display as Structure and Revelation: On Seeing the Shiva Exhibition," *Studies in Visual Communication*, vol. 7.4 (1981), pp. 84–89.

32. Oleg Grabar, *The Mediation of Ornament* (Princeton: Princeton University Press) (in press).

33. Stella Kramrisch, "The Temple as Puruṣa," in *Studies in Indian Temple Architecture*, pp. 40–46.

34. Ananda K. Coomaraswamy, *Yakṣas*, 2 vols.(Washington, D.C.: Smithsonian Institution Press, 1928), p. 31.

35. Ananda K. Coomaraswamy, "An Indian Temple: The Kandariyā Mahadeo" and "Svayamātṛṇṇā: Janua Coeli," in *Traditional Art and Symbolism, Coomaraswamy, 1; Selected Papers*, Roger Lipsey, ed. (Princeton: Princeton University Press, 1977), pp. 3–10, 465–520.

36. Dhaky, "Prāsāda as Cosmos," *The Adyar Library Bulletin*, vol. 35 (1971), pp. 215–17.

37. These moldings are called the "*vedībandha*" or the "binding" of the "altar" (*vedī*); see Meister, "Reading Monuments and Seeing Texts."

38. Michael W. Meister, "Symbol and Surface: Masonic and Pillared Wall-Structures in North India," *Artibus Asiae*, vol. 46 (1985), pp. 129–48.

39. My paraphrase from Dhaky, "Prāsāda as Cosmos," p. 220.

40. For the development of this doorway imagery in the early Gupta period, see Michael W. Meister, "Dārra and the Early Gupta Tradition," in *Chhavi II, Rai Krishna Dasa Felicitation Volume*, Anand Krishna, ed. (Banaras: Bharat Kala Bhavan, 1981), pp. 192–205.

41. For the concept of "meditational constructs" see T. S. Maxwell, "Nānd, Parel, Kalyānpur: Śaiva Images as Meditational Constructs," in *Discourses on Śiva*, pp. 62–81. For "liminality" in a different religious context, see Linda Seidel, *Songs of Glory: The Romanesque Façades of Aquitaine* (Chicago: University of Chicago Press, 1981).

42. This section, in part, is based on a presentation for the "Pañca–mahābhūta" Seminar held at the Indira Gandhi National Centre for the Arts, New Delhi, 1992.

43. Michael W. Meister, "The Hindu Temple: Axis and Access," in *Concepts of Space, Ancient and Modern*, Kapila Vatsyayan, ed. (New Delhi: Indira Gandhi National Centre for the Arts & Abhinav Publications), pp. 269–80.

44. Meister, "Measurement and Proportion"; idem, "Symbol and Surface."

45. Michael W. Meister, "The Hero as Yogin: A Vīrastambha from Chittor," in *Dimensions of Indian Art*, Lokesh Chandra and Jyotindra Jain, eds. (Delhi: Agam Kala Prakashan, 1986), pp. 283–86.

46. Michael W. Meister, "Temples, Tīrthas, and Pilgrimage: The Case of Osiāñ," in *Ratna-Chandrikā*, D. Handa & A. Agrawal, eds. (New Delhi: Harman Publishing House, 1989), pp. 275–82.

47. See Joanna G. Williams, "Śiva and the Cult of Jagannātha: Iconography and Ambiguity," in *Discourses on Śiva*, pp. 298–311.

48. Meister, "On the Development of a Morphology for a Symbolic Architecture"; idem, "Altars and Shelters in India," *aarp* (Art and Archaeology Research Papers), vol. 16 (1979), p. 39.

49. Meister, "Muṇḍeśvarī: Ambiguity and Certainty."

50. Richard Lannoy, *The Speaking Tree: A Study of Indian Culture and Society* (London: Oxford University Press, 1971).

51. Roger Eliot Fry, "Indian Art," in *Last Lectures* (Cambridge: Cambridge University Press, 1939).

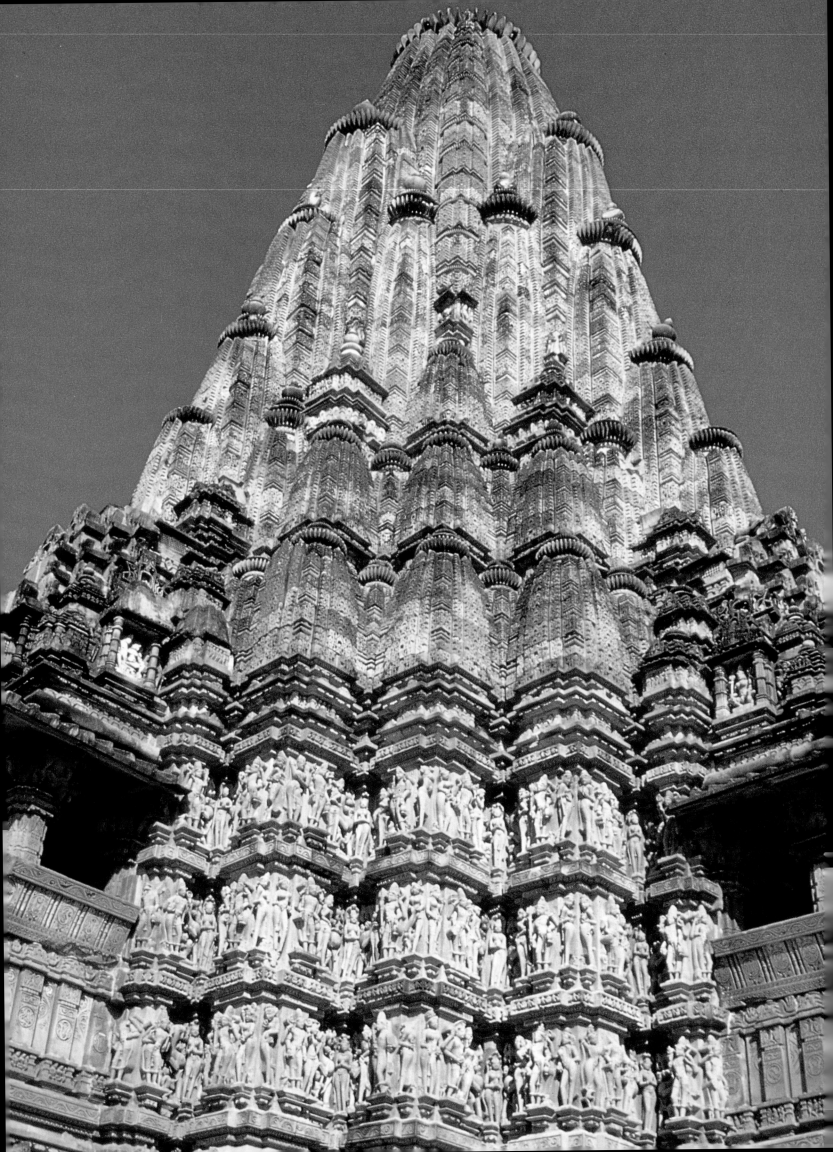

A Sense of Time and Place
Style and Architectural Disposition of Images on the North Indian Temple

Darielle Mason

Each of the numerous and varied temples of north India, whether a simple cavelike shrine or a full-blown colossus teeming with images (see Fig. 59), is a unitary work of art and faith. All express a single, coherent vision of reality;[1] yet each was conceived and executed according to the norms and practices of a certain group within a certain region at a certain time.

In the museum setting, the fragments from these monuments often exhibit strong, elegant forms and exquisite workmanship that make them objects to be appreciated in their own right. It requires both effort and imagination, however, to envision them within their original physical and symbolic configuration—the configuration within which their makers intended them to be viewed. Yet this is the only way that the historical significance as well as the full potency, impact, and indeed, beauty of these carvings may be rediscovered.

The aim of this essay is to free north Indian temple sculpture from the mythic realm of unchanging tradition and reimbue it with a sense of time and place. The approach is twofold: first, to begin to furnish these works with an art-historical context by probing the processes of formal development and diversification that led to their creation; and second, to explore the organizational principles behind the placement of important image types in the evolving temple structure. Clearly these are subjects for tomes rather than essays, and this preliminary treatment is admittedly cursory. It could be said that the larger aim of this essay and catalogue is to focus attention, both scholarly and popular, on a severely underscrutinized and underappreciated realm of our artistic heritage.

The groundwork for the study of the north Indian temple and its images has been laid over the last century.[2] It began with the extensive documentation of sites by the Archaeological Survey of India, took on universal significance with the pivotal explorations of form and symbolism by Kramrisch and Coomaraswamy, and entered the realm of modern art-historical discourse, comparable to that developed for Western art, with the recent work by a number of scholars to begin to categorize this vast diversity of architecture and sculpture by region and period, thus grouping monuments and loose images into coherent styles.

The concept of "style," defined by Ackerman as ". . . a depiction after the fact based on the observer's perception of traits common to a body of works,"[3] has been a stumbling block in India as in the West. Currently, the study of north Indian "medieval" architecture and sculpture is in the throes of attempting to develop a usable conceptual basis along with a nomenclature by which to draw stylistic boundaries. In struggling to create these artificial but necessary constructions, however, we see more fully formal differences and commonalities and move closer to an understanding of the reasons for variation.

Fig. 59
View of the exterior wall and superstructure of the Kandariyā Mahādeva temple, Khajurāho, Madhya Pradesh, about A.D. 1025–50.

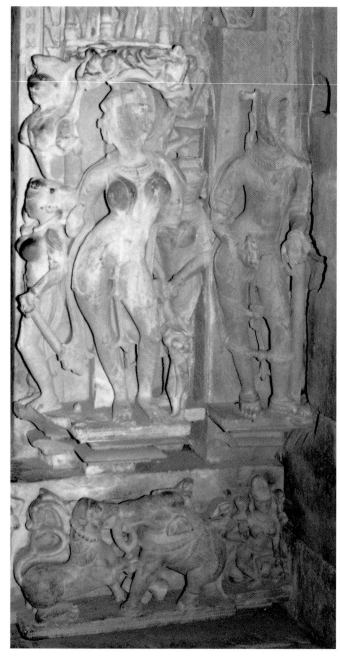

Fig. 60 *left*
Detail of figures on the relief of
"Viṣṇu on the Serpent Ananda,"
Viṣṇu temple, Deogarh, Uttar
Pradesh, about A.D. 500–25.

Fig. 61 *right*
Figures from the lower part of a
doorway, Jain temple no. 12,
Deogarh, Uttar Pradesh, dated A.D.
994.

Since 1867, when James Fergusson first utilized the word *style* to classify
Indian temple architecture according to religious affiliation, a fundamental
problem in the attempt to define sculpture styles and their development has been
the complex relationship of figure carving to a particular architectural setting and
the scholarly tradition of separating the two.

An example of this disjuncture in regularizing stylistic nomenclature that
results from regarding sculpture and architecture as hermetic entities is evident in
comparing S. K. Saraswati's essay on medieval temple architecture with Niharajan
Ray's discussion of contemporary sculpture—two essays published in the same
volume in 1957.[4]

Saraswati designated broad groupings of building form and plan as styles. He
writes of "*nāgara* (north Indian) style" and "*drāviḍa* (south Indian) style,"
subdividing them into "types" by either dynastic, ethnic-regional, or regional
designations. His refusal to consider the carving on the buildings he discusses is
reflected in his analyses. For example, he creates a chronology of the monuments
at Khajurāho based entirely on plan and mode of superstructure, oblivious to the
treatment of surface and other elements.[5]

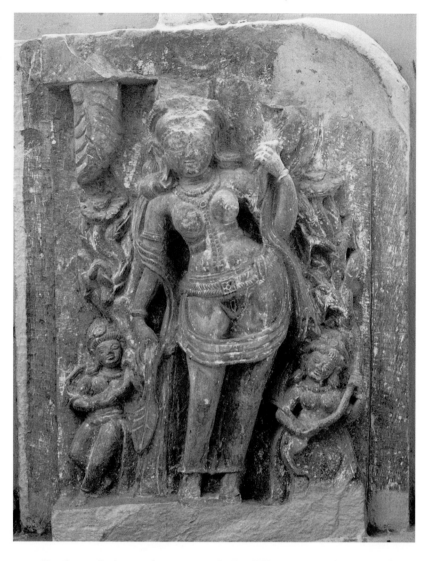

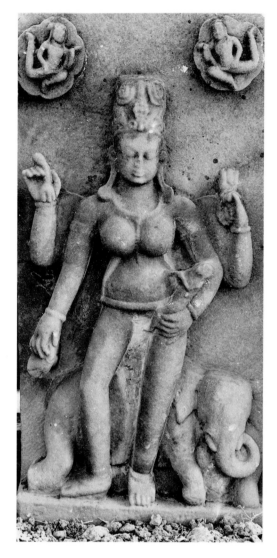

Ray's analysis employs an entirely different set of criteria for demarcating styles. Taking what is basically the Western classical/baroque duality, he classifies loose images according to the extent to which "classical" versus "medieval" values predominate in a work or region. He states, for example, that images from Gujarat dating from the tenth to twelfth centuries are slightly more "medieval" than those in contemporaneous Rajasthan. Not only are the terms questionable, however broadly relevant the formal concepts may be, but both the severing of "architecture" from "sculpture" as well as the division of region by modern state were and remain extraordinary impediments to scholarship.[6]

Recent scholarship on architectural morphology, together with similar analyses of images in situ, has made it increasingly evident that the continuity of craft tradition within regions played the primary role in creating coherent styles in north India throughout the period from circa A.D. 700 to 1200. Use of the words *style, idiom, substyle,* and *school* is particularly thought provoking. M. A. Dhaky utilizes the word *style* to designate a broad aggregate tradition and *school*, which seems synonymous with *substyle* in his lexicon, to denote a more localized aggregate tradition.[7] Meister, on the other hand, segregates *style* from *idiom* as essentially different viewpoints.

> "Style" is . . . an accumulation of general characteristics that reflect a broad cultural grouping: in India, "styles" generally coalesced as a result of political hegemony, changing with political power. "Idiom," by contrast, represents local traditions rooted in the work of local artisans, traditions which endure even as political authority shifts or declines. If the term "style" generally describes an average

Fig. 62 *left*
Female figure with attendants, Kalyāṇapura, Rajasthan, about A.D. 700.

Fig. 63 *right*
Indrāṇī, Nand Chand, Madhya Pradesh, about A.D. 700.

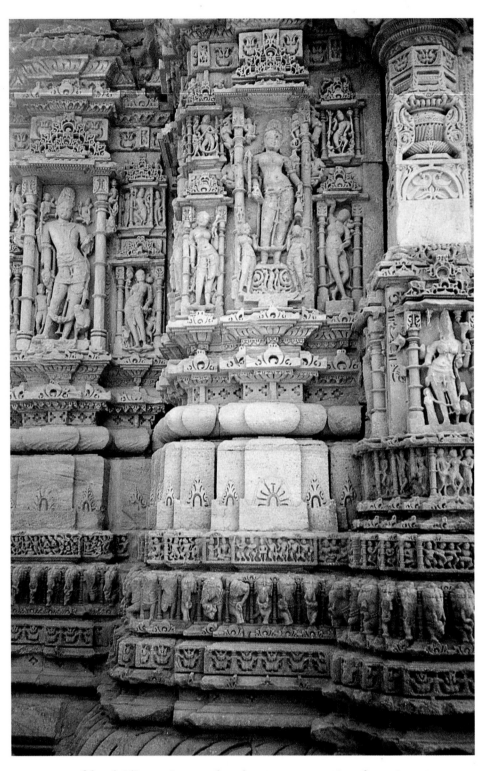

Fig. 64
Detail of the exterior wall, Sūrya
temple, Modhera, Gujarat, about
A.D. 1027–75.

of local idioms, it can also denote a generative force in art, one which affects and influences the craftsmen responsible for idioms; and though idioms may absorb the general characteristics of a style, they remain essentially cumulative and self-defining. I see idiom and style as independent rather than dependent variables, however much they may interact.[8]

This work will follow Dhaky's looser usage, with *style* designating broad commonalities of formal characteristics both in the treatment and choice of elements out of the full vocabulary available, regardless of patronage. *Idiom*, like *substyle*, will designate more site-specific (smaller and more closely related) groupings likely, but not necessarily, based on common craft groups.

The editors/authors of the *Encyclopaedia of Indian Temple Architecture*[9] have utilized nomenclature based on ancient regional labels, subdivided by patronage (the latter, more often than not, is speculative). Although the terms for ancient regions culled from contemporaneous texts and epigraphs are by no means fixed by firmly designated or unchanging boundaries or even by consistent names, the broad politicocultural units that they designate certainly appear to bear a greater relationship to the realities of formal coherence among monuments and individual carvings than do other possible geographic divisions (see map, pp. 16–17). The catalogue utilizes a somewhat modified form of these ancient labels. The changes that occurred in nomenclature and regional definition between the eighth and thirteenth centuries have, however, been necessarily ignored, and a "frozen" map, with ten regional designations (Gurjaradeśa, Mārudeśa, Meḍapāta, Uparamāla, Śūrasena, Gopādri, Madhyadeśa, Daśārṇadeśa, Jejekādeśa, and Dāhaladeśa), has been created for the sake of comprehensibility.

Except for the few pieces in this exhibition concretely linked to dated inscriptions, discussion of patronage in relation to these objects is necessarily hypothetical and conclusions concerning its bearing on style formation tentative. Indeed, patronage may be discussed more relevantly in terms of temple centers[10] than in terms of the sculptural forms themselves.

Figure Style

In discussing stylistic development and diversification, the comprehension of the enormous chronological[11] and geographic spread being considered is crucial. The period under examination is approximately five hundred years—in a comparable time span, Italian art could move from late Romanesque to early baroque. The area is approximately three hundred thousand square miles—about equal to France and Great Britain combined. Yet it is certainly possible to trace an overarching and ongoing shift in aesthetic priorities in figure sculpture common to the entire region during this time. It began as early as the sixth century when figures first came to occupy the exteriors of the newly developed freestanding stone temple form. It does not seem misleading to link this overarching trend with the growth and elaboration of these freestanding monuments over the next half millennium.

Although human images were incorporated into architectural carving in north India from as early as the first century B.C., the aesthetic for figure sculpture, developed between the fourth and sixth centuries, gave priority to the individual, autonomous image. In the increasingly elaborate monuments constructed from the seventh century onward, figures more and more became components in the overall compositional scheme. This change in the use of images gave artists both the freedom and desire to abstract the human form. In earlier autonomous figures, artists aimed at a naturalistic portrayal of the body both in details of dress and physiognomy, particularly in anatomical articulation. In other words, although highly idealized and stylized, the body would appear to function and be as organically composed as the actual human body. As the human figure became one element in a larger program, however, the tendency to make figures simultaneously readable from a distance and in harmony with the whole, i.e., to enhance and promote the unified design, superseded the aim of naturalistic portrayal. This becomes clear, even within the architectural context, when images such as those on the sixth-century Viṣṇu temple at Deogarh in Uttar Pradesh (Fig. 60) are compared with significantly later figures, datable to A.D. 994, on the door of another temple at the same site (Fig. 61).

As the size and complexity of monuments increased, so did the iconographic and visual complexity of individual images, while the subtlety of carving—anatomical and other—reciprocally decreased. In addition, the earlier focus on multifigure narrative compositions was displaced by an emphasis on multiple self-contained single figures, each relating to and defined by its placement within

the whole structure. The loss of anatomical credibility, exaggeration of movement, simplification of the body, hardening of carving, bold elaboration of details, and reduction and multiplication of single images that occurred between the sixth and fourteenth centuries can thus be seen for what they were—not a deterioration in quality but a change in intention.

Between about the late fourth and sixth centuries, the generative influence of the centers of power of the Gupta empire led to a certain uniformity in sculpture throughout much of north India.[12] As numerous autonomous political powers arose and as building in stone proliferated after the sixth century, distinctive regional styles emerged and matured. The fundamental characteristics of various early eighth-century regional styles are distinguishable and continue to separate the regions despite complex development, diversification, and regional interaction over the next half millennium. These demarcations are made evident by contrasting early eighth-century images from the westerly and easterly extents of the area, such as a goddess from the town of Kalyāṇpur in the ancient Meḍapāta area of the western state of Rajasthan (Fig. 62) and another from the site of Nand Chand in ancient Dāhaladeśa in central-eastern Madhya Pradesh (Fig. 63).

This stylistic diversification appears to be due more to the continuity of local craft tradition than to multiple patronage, yet without patronage the many distinctive craft traditions could not have flourished. Nevertheless, natural change and evolution of craft groups, together with the continual shifting of lines of political and cultural connections and influence, means that the formal relationships we see at one point in time (and thus the regional styles we define) do not remain static during the entire period but must continually be analyzed and reanalyzed, assessed and reassessed.

Oral tradition and the migration of craft groups and individuals undoubtedly played the largest role in the interregional transmission of forms. The few existing texts from this part of north India on the science of building, dating primarily from the eleventh century onward, can be fairly explicit about image placement but appear to be codifications of existing practices rather than innovative in nature. In addition, they speak only in oblique ways about actual treatment of motifs, i.e., carving and anatomical articulation, although they give prescriptions for proportions[13] and specifications for how images should appear. Although no examples exist from this region at this time, contemporaneous traditions in other regions as well as designs scratched in stone indicate that line drawings were also used as a means of transmitting motives, details of iconography, and architectural configurations.

It is not possible in this essay to cohesively or systematically describe the vast variety of regional treatments of the individual image features or to comprehensively discuss their development and alteration over five centuries.[14] However, certain aspects of the carved human form, particularly the distribution of weight or body mass and the treatment of flesh—indicate a differentiation of approach from region to region that demonstrates a surprisingly smooth interconnection across the entire area and persists throughout many centuries.

Multiple images, ranging in origin from west to east (from Gurjaradeśa, Meḍapāta, and Mārudeśa to Uparamāla, Śūrasena, Gopādri, and Daśārṇadeśa to Madhyadeśa, Jejekādeśa, and Dāhaladeśa), demonstrate a progression in the distribution of weight of the human body from a low to a high center of gravity. In other words, as the site of origin progresses eastward, the concentration of weight accordingly changes from sinking downward into the hips (breast on line with or behind the pelvis) to the torso (resting directly on line with the hips) to the chest (which is thrust upward and forward)—not unlike a progression from an outgoing to an incoming breath.

Following the same direction, flesh moves from the tactilely tangible, often defined by ripples or soft, full undulations, to a solid, congealed state defined by geometric shapes, linear outlines, and often, incisions as opposed to modeling. The foregoing is intended as a description of forms and bears no qualitative implication. It must also be noted that certain of these trends also occur within

regions as one moves from the eighth to the thirteenth century, but the generalization is accurate and provides an extremely useful primary regional indicator. The longevity and constancy of these progressions do not seem to imply influences in any direction. In fact, they seem to imply the opposite—regional continuity on a grass-roots level.

Taking these general trends as a starting point, certain characteristic features of images from the various ancient regions may be briefly enumerated. However, the following is intended only as an aid to understanding the type of features utilized in making regional attributions rather than as a statement defining specific regional styles.

From as early as the sixth century, images in southern Rajasthan (Gujaradeśa-Arbuda and Meḍapāta) and northern Gujarat (Gujaradeśa-Ānarta), such as the previously mentioned image from Meḍapāta (Fig. 62) or the well-known group from the site of Śāmalāji, display characteristics that can be seen to typify the region even into the eleventh century.

The well-preserved Ambikāmātā temple at Jagat in ancient Meḍapāta, dating from about A.D. 961, contains images typical of the region (Fig. 4, see also No. 40). Body parts are well integrated (the joints merge rather than separate the limbs and the trunk), and features such as breasts meld with the chest rather than emerge as individual geometric units. Flesh seems malleable, and gentle undulations rather than linear incisions separate and define such subcutaneous elements as musculature and fat. Ornament and clothing are also carved in full, rounded forms, making them contrast gently with flesh.

A downward concentration of weight predominates, with the major body mass sunken into the hips so that the figures appear well grounded. In profile, breasts tend to fall on line with or even behind the belly and hips. Although carving of the individual form shows fullness and dimensionality, rarely is the figure released from the plane of the relief to twist in space. Facial features are unexaggerated—eyes and mouths, for example, tend to remain short and rounded, while brows follow simple arcs confined to eye width. Finally, single images are surrounded by plain wall surface, relatively uncluttered by secondary elements.

That these characteristics applied farther west in Gujarat even into the eleventh century is clear from the images on the main body of the Sūrya temple at Modhera (Fig. 64), dating to about A.D. 1026. In northern Gujarat and abutting Rajasthan, images lost their sense of groundedness and increased in tension after the early eleventh century. The integrated body parts become sharply angular yet remain unified and usually appear as snakelike projections rather than separable forms. Fussy, even lacy, detail overwhelms these later images, familiar from the marble Jaina temples on Mount Ābū (Fig. 27); yet even these images display integrated ornament and body, but both appear to be products of the jeweler's rather than sculptor's art.

Despite a variety of idiom, there is a certain commonality of treatment of the body that links eighth-century images across the regions of northern Rajasthan, southern Uttar Pradesh and northern Madhya Pradesh [Mārudeśa (see Fig. 65), Śūrasena, Gopādri (see Fig. 66), and Madhyadeśa, respectively (see Fig. 67)]. This may represent a generative influence emerging from the politically crucial doab, the Gaṅgā-Yamunā valley area of Madhyadeśa around the city of Kannauj or it may represent the continuity of Gupta norms.

Characteristics of these images include pneumatic bodies, rounded to bursting, sharply delineated ridges of flesh, especially below the breasts of female figures, although the exact configuration of lines differs from region to region. The center of gravity is placed higher than in the previously described images, around midtorso. Limbs tend to be tubular but tapering. The relief plane, and thus the surrounding wall, is somewhat more crowded than in the previous grouping.

Within these generalities, however, these areas are separated by features that became more pronounced from the ninth century onward. Images from Mārudeśa, for example, (see Fig. 68) show a lower center of gravity than those

Opposite page
Fig. 65 *above*
A figure from the wall of one of the subshrines of Harihara temple no. 2, Osian, Rajasthan, about A.D. 750–75.

Fig. 66 *below*
Figures from the lower part of a doorway, Teli-kā-Maṇḍir temple, Gwalior, Madhya Pradesh, about A.D. 750.

Fig. 67
Detail of an attendant of Umā-Maheśvara, Kannauj, Uttar Pradesh, 8th century. (Kannauj Archeological Museum No. 75/5)

123

from areas to the east, linking Mārudeśa in this way with Meḍapāta and Gurjaradeśa. Carving, however, is lush but imprecise, unlike the crisply cut contemporaneous works from the area to the south.

Ninth-century images from the eastern area of Mārudeśa, ancient Sapādalakṣa, show petite bodies with doll–like rounded limbs (see No. 55). Female breasts are small, round, and high, while male images feature wide pectorals merging with narrow waists. Faces have rounded, bulging cheeks, and closely set eyes. Somewhat later, these features transform into willowy bodies with gently swelling musculature, long, thin torsos, and sensuously narrow waists (see No. 12). There is a softness of the flesh but not the full fleshiness of the images from Meḍapāta.

Works from neighboring Śūrasena consistently tend toward heaviness (see No. 28). Bodies are short with heavy and tapering limbs. The flesh congeals into an almost cementlike surface. Figures show little movement either laterally or away from the relief plane and images feel solid. Waists tend to be high and

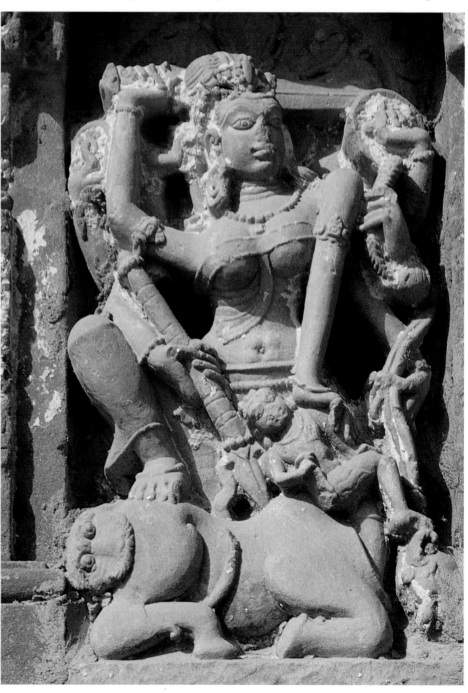

Fig. 68
Mahiṣāsuramardinī, Pipālādevī temple, Osian, Rajasthan, 9th century.

124

pinched. Faces are either square or oval with somewhat receding chins and narrow slanting eyes.

In Gopādri to the southeast, the faces of images tend to be longer with pointed features and closely set eyes that often taper downward at the outer corners. Chests and hips on both male and female figures incline toward narrowness. By the eleventh century, as the Kakanmadh temple at Suhānia, north of Gwalior, illustrates, the narrow chest was transformed into a distinct tube resting on wider yet relatively narrow hips (see Fig. 69).

Early Madhyadeśa images show full but flattened faces, usually having wide eyes that are pointed at the outer corners with defined lids, which sometimes cover half of the bulging eye. Female breasts from as early as the eighth century tend to resemble orbs positioned high on the chest and pressed together above a tiny waist and wide, smoothly swelling hips (Figs. 67, 70). Images from the ninth century onward maintain the short-waisted torso; breasts become even more globelike and limbs rounder. Lips tend to be full and often brows resemble cords arching upward at the outer corner of the eye, while noses are straight and flaring, closely abutting the mouth (see Fig. 71).

Typical images from Uparamāla around the Kota area from the eighth through tenth centuries show broad shoulders, narrow hips, and long waists that bend sharply sideways (see Nos. 8, 72). The gently rounded forms are ripe yet restrained, with limbs tapering to thin ankles. The images have sweet, circular faces, the chin a small mound of flesh and long horizontal, but open, eyes.

Images from the more westerly area around modern Mandasor (see Fig. 72) seem to blend this Kota type with the image characteristics of both Meḍapāta and Daśārṇadeśa–Avantī to the south. Figures from this latter region (see Fig. 73), although little known, are characterized by full three-dimensional forms, smooth, tapering limbs, and rounded joints. The swelling oval faces of the early images show a distinct single plane for the eyelid. Breasts are smooth and shallow, appendages gracefully weightless. Ornament is generally restrained and there appears to be a focus on full, smooth surfaces.

Farther east in Daśārṇadeśa, a large, varied area, bodies tend to be more weighty, often with wide hips, although the weight is in the midsection (see Fig. 61). Breasts are heavy but, unlike images from Madhyadeśa and especially those from Jejekādeśa and Dāhaladeśa to the east, they merge somewhat with the body and often, particularly on earlier images, show gentle, fleshy rolls beneath them. Legs are well contoured, the musculature defined despite thick ankles. Faces tend to be full and square with sensuously abundant lips, although the mouths are not wide. Eyes take a variety of shapes but never the long, pointed forms of the images of more easterly locations.

Images from Jejekādeśa (known primarily from Khajurāho) are closely related to those of neighboring Dāhaladeśa, but there is more play with overall linear composition (see Fig. 74). Breasts are aggressively full and round, and for both genders weight is concentrated in the chest. Eyes are long and pointed at the inner and outer ends, and chins are formed from a round ball, usually without the dimple common to Dāhaladeśa images.

Limbs are distinctly tubular, and there is a preference for turning postures that remove figures from the relief plane, although this is somewhat a factor of chronology, increasing after the tenth century (see Fig. 75 and No. 46). Flesh, even on earlier images, is relatively hardened compared to images from farther west. Drapery is smooth, almost invisible, sometimes with incised patterning but never with the rippling effect common to groups of images in Dāhaladeśa.

Dāhaladeśa sculptors from early on exhibit a preference for figures carved in the round; their backs, although unseen, are cursorily but fully articulated (see No. 62). Poses move away from the plane of the relief, often fully twisted like a corkscrew (see No. 49). Multiple subsidiary figures and decorative motifs crowd the relief plane. Drapery in the tenth century and later from around both Jabalpur in the south and the easterly Shāhadol District often takes a distinctive rippling form (see No. 50).

Fig. 69
Apsarās, Kākanmadh temple, Suhānia, Madhya Pradesh, about A.D. 1015–35.

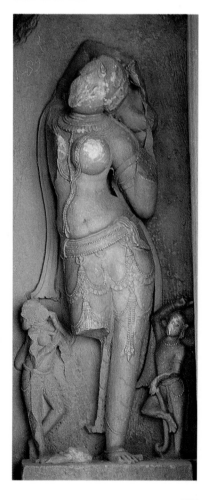

Breasts are full and round, often thrust far in front of the body, and again, the weight of both male and female figures is concentrated high in the chest as if the body were being pulled forward by the breast area (Fig. 76).

Although there are a number of physiognomic types within this region's images, facial characteristics are boldly stylized. Faces are wide, often heart-shaped, and frequently slope inward from chin to forehead (see No. 50). Chins tend to show a distinctive deep drop-shaped dimple, and eyes are elongated, stretching across the face. Carving is generally sharp and detailed, although flesh is smooth and unyielding.

Along with the above-mentioned west-to-east tendency toward harder flesh, more geometric forms, and a higher center of gravity, a corresponding difference in the treatment of pose and detail becomes apparent. As one moves eastward, figures show a greater tendency to turn in space and project away from the relief plane. While both features and details appear more exaggerated, forms are bolder and less integrated as coherent human units.

Architectural Placement of Images

It is clear from examining both existing structures with unfinished images[15] and continuing practice[16] that the majority of images were carved in place on the

Fig. 70 *left*
Ardhanārīśvara, Kannauj, Uttar Pradesh, 8th century. (Kannauj Archeological Museum No. 79/251)

Fig. 71 *right*
Detail of a female bracket figure, Jamsot, Uttar Pradesh, about 11th century. (Allahabad Museum No. 1048)

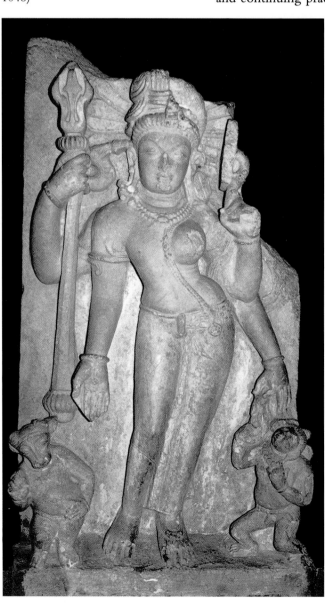

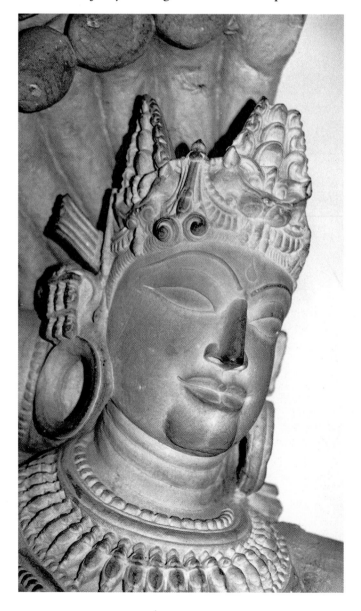

temple, the portion for relief left roughly raised in the center of the slab, reducing the possibility of damage during construction. Certain images, particularly the deities to be placed in larger niches, such as those in the central wall niches (*bhadras*), or detachable bracket figures were carved on separate slabs and set in place after construction.

Through a detailed examination of extant temples throughout north India, it becomes clear that the architect-priests who designed them developed an increasingly explicit coordination of architectural location and image type between the seventh and thirteenth centuries. From the monuments, we can conjecture that this occurred through a process of problem and solution, based not only on symbolic and ritual imperatives but also on such aesthetic concerns of the builder and patron as balance and grace, necessary for properly housing divinity as well as human pleasure or dynastic glorification.

Looking at this development through a wide range of standing monuments, abundant clues lead to the hypothesis that there is no single organizational principle or logic, such as the sequence followed in ritual circumambulation and approach, that determined the coordination of identity and location of all images. Rather, it appears that, as structures developed and were elaborated upon, specific groups of images came to occupy various fixed locations on the temple body, each group assuming its own internal "logic." It is the interplay of these "logics" that must be decoded in order to "read" the monument as well as to discover the

Fig. 72 *left*
Apsarās, Hinglajgarh, Madhya Pradesh, 10th century. (Indore Archeological Museum)

Fig. 73 *right*
Dancing Śiva (Naṭeśa), Ujjain, Madhya Pradesh, late 9th century. (Central Archeological Museum, Gwalior)

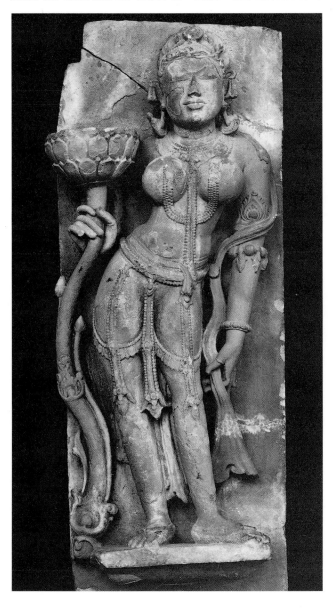

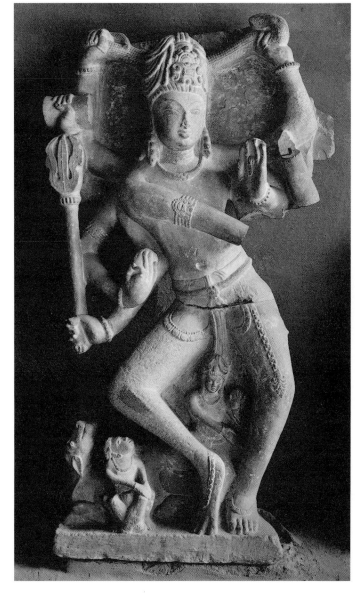

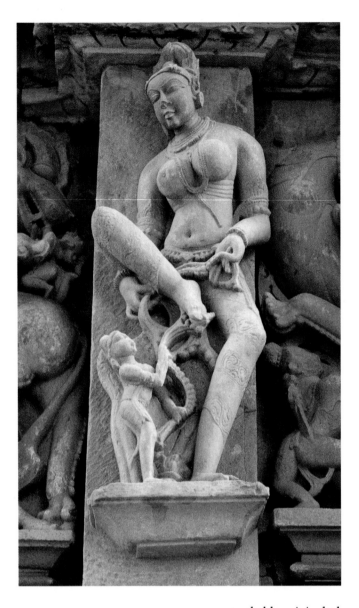

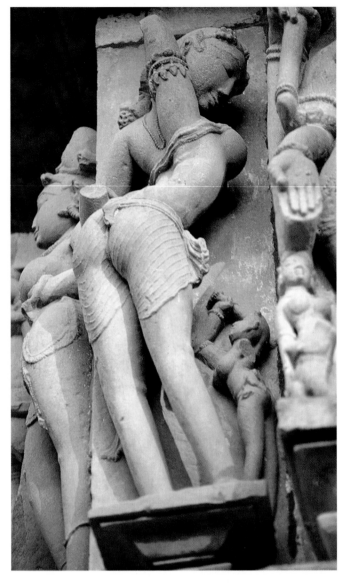

probable original placement of loose fragments.

The single essential image in any temple is the deity within the sanctum, the *garbhagṛha*. The god may, according to the dedication of the shrine, appear in aniconic or semi-iconic form, such as Śiva as *liṅga*, the pillarlike "mark" of the deity in his generative aspect (see Fig. 24). Likewise, representations of the divine may appear in human, iconic form, depicting the god in his or her most hierarchic/formal/absolute manifestation—often standing stiffly frontal with feet planted together (see No. 70). Elaborate frames, sometimes with garlandlike arches above, ensconce the deity in a form reminiscent of a door—like a portal from unmanifest to manifest. It is from this sanctum image that all other images are derived.

The exterior wall elevations of the sanctum display most lucidly the process of establishing locations and their "logics" that were worked out primarily between the eighth and tenth centuries. The frieze portion of these exterior walls, between cornice and binding moldings, will be examined in detail to give an idea of the fundamental process of fixing iconographic order throughout the monument.

The central buttress or offset (*bhadra*) from monuments with figured walls (from the sixth century on) holds reflections of the sanctum's divinity (see Fig. 39). These include active manifestations of the deity, close family divinities, or the sanctum deity repeated in iconic form. They are the most important images on the wall and are placed on an axis with the center of the *garbhagṛha*—the point of

divine manifestation, the temple's omphalos (see Fig. 40). Their identity, setting, and framing emphasize the role of the *bhadras* as secondary shrines — "exits" and "entries" for the deity to communicate with and manifest itself within the world of man.

The *bhadra* figure on the back wall of a temple, opposite the door, is axially the most closely related emanation of the inner image. Deities on this offset are frequently represented in a symmetrical, frontal manner. When the sanctum image is absent, the identity of this image gives an indication of the temple's dedication.[17] Since the majority of monuments face east, this back wall usually faces west.

In the placement of images on the *bhadras* of the side walls, compass direction often plays a large part in correlating identity and placement. For example, on many eighth-century and later shrines, particularly those dedicated to Śiva or Gaṇeśa, Śiva's elephant-headed son will consistently appear on the south; the goddess, at times in the form of Pārvatī, wife of Śiva, will appear on the north. It could be argued that this placement should be read as sequential according to circumambulation. Gaṇeśa, for example, is the god of auspicious beginnings and passage, and in this arrangement he is reached first. That the placement must be read as primarily directional and not according to circumambulation, however, can be construed from certain west-facing shrines. In such monuments as the Danebaba temple at Amrol, Gaṇeśa still appears on the south wall despite the fact that this is the last wall approached in a clockwise process. In this case Gaṇeśa may serve primarily as a protector since the south *bhadra* is also often occupied by a male deity in the act of destroying a demon.

On a few monuments, images on the *bhadras* can be read sequentially as one circumambulates, sometimes even suggesting a narrative order. Yet even in this rare type of configuration, the most strictly or typically iconic of the images appears in the back wall niche.[18] Thus secondary "logics," including compass direction and narrative order, can play a part in locating images on the *bhadras*; however, the primary "logic" of these images remains to be the axial connection with the deity in the sanctum interior. As Stella Kramrisch states, "A movement more powerful than that of any single figure propels . . . from the center each single figure together with the wall to its position on the perimeter."[19]

Images appear only on the *bhadras* in the earliest temples that bear niches on their exterior walls. Indeed, throughout the development of this architecture, numerous monuments, especially small ones, carried images only on these central offsets. As the temple form became codified in the early eighth century, and as the iconographic program of the exterior was elaborated over the following centuries, images began to appear first on the corners (*karṇas*) of shrines and then on the intermediary offsets (*pratirathas*).

However, the standard types of images that appeared during the tenth century on the corner and intermediary offsets did not emerge fully grown with the structure. It is possible to trace their development and, through this process, gain insight into the nature of iconographic change in relation to placement.[20]

On the majority of temples built throughout north India from the mid-eighth century onward, a set of eight guardians of the directions in space (*aṣṭadikpālas*) appears in a standard order, orientation, and placement on the *karṇas* of the sanctum exterior. These *aṣṭadikpālas* were originally elemental deities of the Vedic pantheon who in later Hinduism became subsidiary to the major gods such as Viṣṇu and Śiva and took on a protective function.

On early eighth-century shrines, images on the *karṇas* are a mixture of some "*dikpālas*-to-be" (identifiable as the Vedic gods but only occasionally placed in the direction they would later face) and other miscellaneous deities not closely related to the sanctum image (see Fig. 77). By about A.D. 725, with increasing regularity, these guardians were increased to eight so that each corner of the temple (and thus the corners of the square on which the temple is based) would be protected on both of its planes. Also by this time the *dikpālas* had been placed into a standardized and unchanging sequence, each facing, to the extent possible on a square, the fixed direction that they were thought to guard. Thus three lines of

Fig. 76
Profile of a goddess (*yoginī*), Yoginī temple complex, Bherāghāt, Madhya Pradesh, 11th century.

"logic" are being followed in the placement of this image type—relation to the sanctum as guardians of the corners, direction in space (compass direction), and sequence within a set.

That direction rather than circumambulatory order governs the placement of *dikpālas* is made evident by comparing shrines that have entrances to the west, such as on Harihara temple 1 at Osian (ca. 725–750). In these cases, despite the fact that the door of the shrine faces in a direction opposite to the norm, the compass directions faced by the *dikpālas* and their sequence within the set does not change. Thus on the south walls of both east- and west-facing temples, the *dikpālas* Agni and Yama appear. Indra and Īśāna flank east-facing entrances, while on west-facing shrines Nirṛti and Vāyu occupy the same location in relation to the door.[21]

Such interlocking "logics" can be tested by looking at an aberrant example, the north-facing Pipālādevī temple at Osian, dating to the ninth century. On this unusual shrine, the hall directly abuts the north wall of the sanctum, leaving no space for north-facing *karṇa* niches to house north-facing *dikpālas*. The architect has adjusted the final four *dikpālas* (Nirṛti, Varuṇa, Vāyu, and Kubera) on the west wall, occupying all the flanking offsets as well as the corners. It seems that in this case, the desire for a certain architectural configuration (the placement of the hall) was primary, the sequence of *dikpālas* within their set secondary, and their correct directional placement tertiary, allowing for the disruption of compass organization and superseding, in a way, both symmetry and protective function. Needless to say, the solution on Pipālādevī was unacceptable and has no successor within the tradition.

In all these monuments, the basic relationship between floor plan and wall is such that the central projection, the *bhadra*, loses width as it rises from lower moldings to frieze level, while the corner and intermediary offsets remain constant

Fig. 77 *left*
Rāmeśvara Mahādeva temple, view from the south, Amrol, Madhya Pradesh, about A.D. 725–50.

Fig. 78 *right*
Diagram of simple exterior temple wall elevation.

Opposite page
Fig. 79 *above*
Exterior wall of Śiva temple, Nohta, Madhya Pradesh, about A.D. 975–1000.

Fig. 80 *below left*
South wall of Harihara temple no. 2, Osian, Rajasthan, about A.D. 750–75.

Fig. 81 *below right*
Vāyu and Varuṇa, exterior wall figures, Sūrya temple, Tusa/Madhāriya, Rajasthan, about A.D. 940–50.

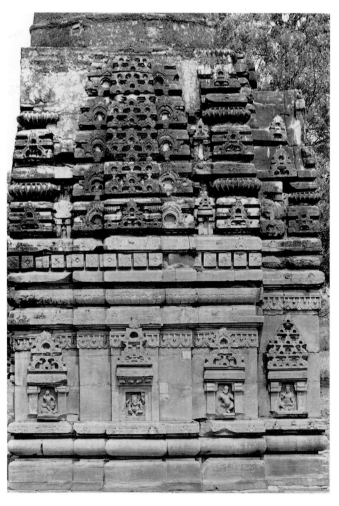

130

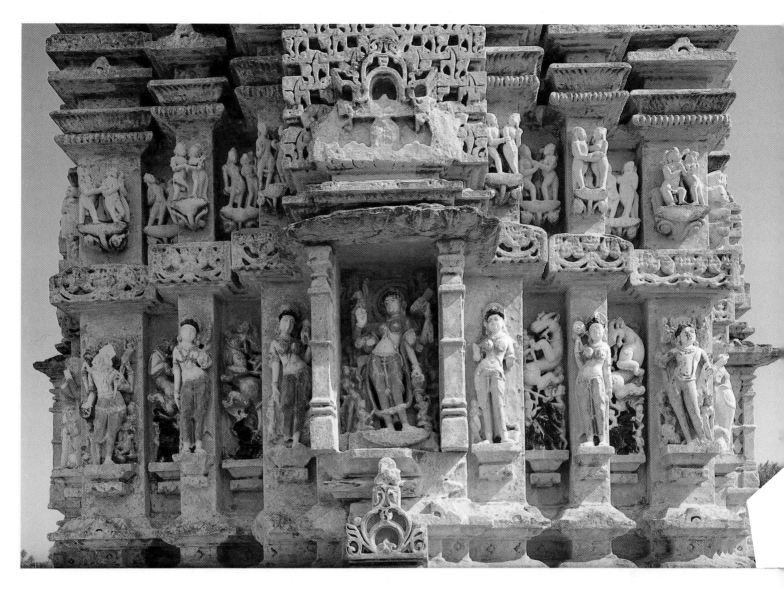

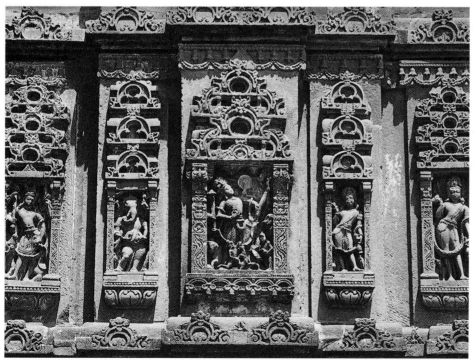

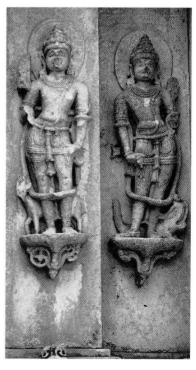

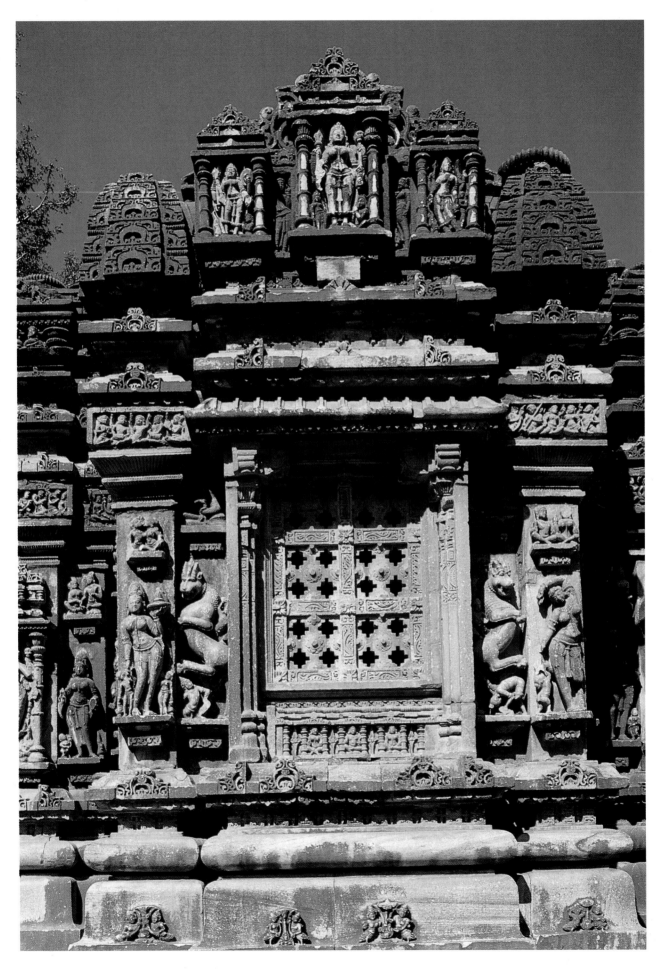

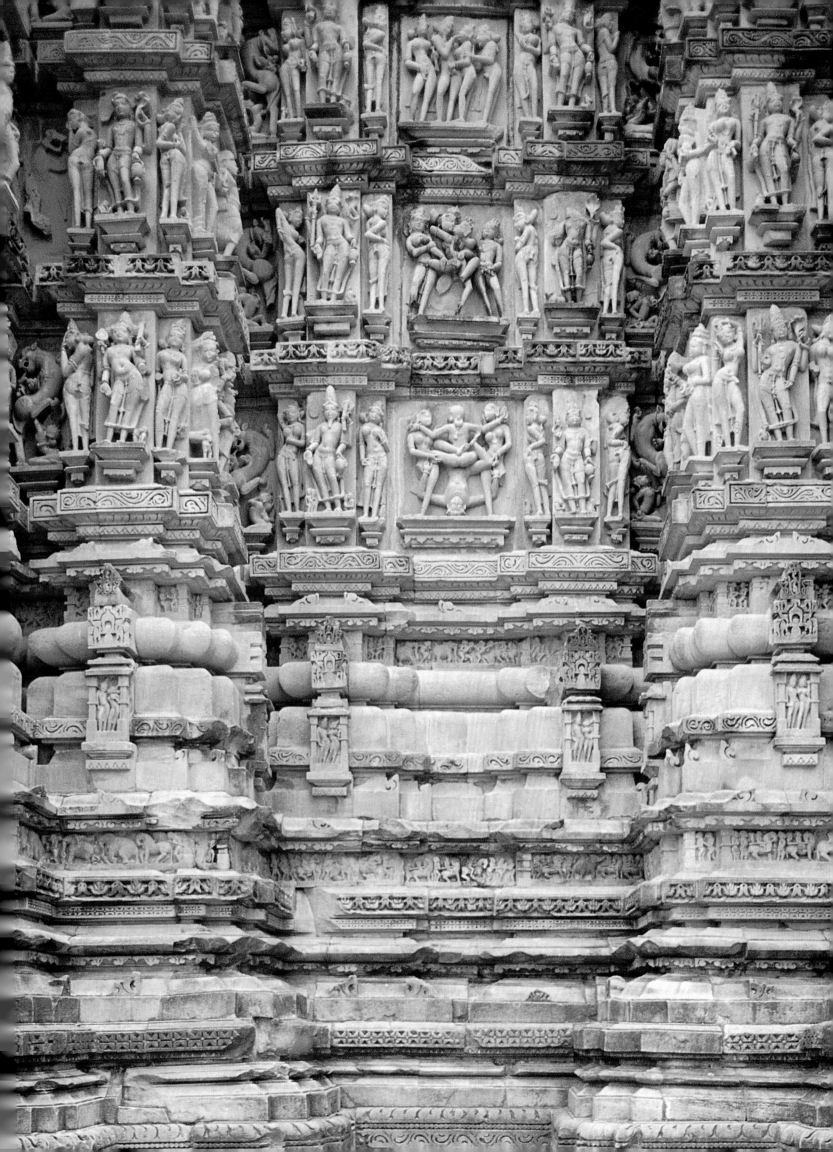

from plan to frieze, making them proportionally wider in relation to the *bhadra* on the wall frieze than they are on the lower moldings. The architects, therefore, were faced with the problem of restoring a visual hierarchy concomitant with the symbolic importance of the *bhadra* images and their location, especially in relation to figures that came to be placed on the side walls (see Fig. 78).

One solution, evident in the case of the *dikpālas*, was to reduce the significance of the images on the side offsets by substituting lesser beings for major deities. A second solution was to shrink the width of the side walls by altering the relationship between plan and elevation.[22] Yet a third solution, evident even in early temples bearing images in places other than the *bhadra*, was to develop a hierarchy of framing to give order to the wall's offsets. Thus the *bhadra* niche was articulated as a subshrine—sunken more deeply into the wall plane—or made more elaborate or larger than the niches of images on the side wall planes (see 'Fig. 4).

A fourth solution that became popular from the ninth century in western India and substantially altered the look of the wall was to indent a narrow inner section of the corner and intermediary offsets, restoring primacy to the *bhadra*, which was to retain its full width (see Fig. 80). These vertical recesses soon became a crucial, although optional, ingredient of the developed wall in all styles of north Indian temple architecture (see Fig. 79).

Ninth-century structures in both western and central India resolved the architect's search for appropriate occupants of the intermediary offsets (*pratirathas*) by treating the iconography of this offset as attendant to the *bhadra* [a hierarchy implicit in the plan (see Fig. 40)]. As with the corner offsets of early eighth-century monuments, these intermediary offsets on many eighth- and early ninth-century temples display a mix of deities, some major in and of themselves but usually subsidiary in relation to the monument's dedication (see Fig. 80).

In ninth-century temples, however, a different order of beings appears. After initial experiments with minor deities, female attendants became the fixed occupants of this offset. At first these women often held flowers or fly whisks, objects denoting their attendant function,[23] or they danced in celebration of the deity. Celestial females who have no specific divine identity (*apsarāsas, surāsundaris*) thus seem to have first appeared on exterior walls of north Indian temples as attendant figures on intermediary projections. Certain figures, especially those from the ninth and tenth centuries, are set in poses that visually relate them to the deity on the *bhadra* and their subsidiary position in the hierarchy is expressed by reduced scale.

An alternative to shrinking such lesser figures was to remove the niche frame altogether. The tenth-century temples called "Mahā–Gurjara," which appear primarily in Gujarat and southern Rajasthan, exhibit a preference for this solution. With the exception of figures on the *bhadras* and sometimes the corner *dikpālas*, all wall figures are unframed in this architectural configuration and directly addorsed to the wall surface where they frequently stand on single open lotuses whose stems sprout from the masonry body of the structure (see Fig. 81). This unframed configuration began to appear with increasing frequency from the mid-tenth century onward in central India as well (see Fig. 79).

A fantastic, rearing, lionlike animal (*vyāla*) finds a fixed location in the vertical indentations, which, as mentioned, allowed adjustment of the wall rhythm and hierarchy. The form of the *vyāla* may have migrated to these recesses from an earlier location as a prancing bracket to the sides of the colonettes that framed the *bhadra*'s niche (Fig. 43). By the tenth century it appeared in vertical indentations on monuments of varying wall articulation from Kutch to Khajurāho (see Figs. 4, 79). Although *apsarāsas* can also be found here, the *vyāla* is never placed on any projection. This is also the case with the ascetics (*munis*) who replace *vyālas* in the recesses in the eleventh-century western Indian temple, at times leering at the *apsarāsas*, linking the indentations and projections into a playful narrative.

Where flanking offsets have figures, females always appear in some relation to the intermediary offset. This is also true of the walls of enclosed halls, where

Previous pages
Fig. 82 *left*
Exterior wall and enclosed hall (*gūḍhamaṇḍapa*), Ambikāmātā (Devī) temple, Jagat, Rajasthan, about A.D. 961.

Fig. 83 *right*
Exterior wall, Kandariyā Mahādeva temple, Khajurāho, Madhya Pradesh, about A.D. 1025–50.

Fig. 84
Exterior wall, Nīlakaṇṭha Mahādeva temple, Sūnak, Gujarat, about A.D. 1075.

134

the space flanking the central window projections mimics the intermediary offset of the sanctum (see Fig. 82).

Poses and attributes of *apsarāsas* and *vyālas* show great variety. However, the variety is probably a function of the multiplication of such images and seems largely aesthetically motivated, although at times types bear literary significance. The placement of type within any designated location does not appear to be canonically dictated, although specific cases exist in which figures exhibit a clear relationship to the niches they flank by either pose or attribute. Thus the utilization and placement, including relative placement, of major deities, *dikpālas, apsarāsas,* and *vyālas* on walls seems to have resulted from a search for a hierarchy of significance to reflect the symbolic hierarchy of the floor plan. The differentiation made salient by framing and scale allows the wall's ornamental rhythm to visually present this hierarchy. Axiality in relation to the sanctum and door, compass direction, sequential arrangement, circumambulatory order, hierarchy within the wall, and visual coherence are all at play on the "medieval" temple exterior.

The foregoing reduces the iconographic program of the wall frieze to its essentials. After the ninth century the wall was seldom so simple, however, and varied greatly from region to region. In many parts of central India, for example, the frieze came to be divided by horizontal moldings into two or three repeating levels of images (see Fig. 83). Contemporaneous western India retained a single level of images but filled the larger walls with small figure groups or side offsets articulated as pillars with elaborate raised niches superimposed on them (see Fig. 4).

Figure sculpture on the temple exterior is by no means limited to the wall frieze (see Fig. 38). Images were placed in a variety of locations on the superstructure of both sanctums and halls, in niches on the binding moldings (*vedībandha*), and in the moldings of the basement (*pīṭha*) (Fig. 84) and platform (*jagatī*) and covered the hall exteriors as well (Fig. 82). The types of images placed in each of these locations were never arbitrarily chosen, however. Their selection resulted from reasoning that, if not always evident, can often be discerned by examination of the historical lineage of each type.

In addition, there were other forms of contemporaneous stone architecture that could include a retinue of images. These include the freestanding arch (*toraṇa*) and pillar, the monastery, and the sometimes elaborate step wells popular in western India (see Fig. 85). Sculptures from these types of structures, divested of their original context, are frequently iconographically and compositionally indistinguishable from images that were once part of standing temples.

The often multiple and multipurpose halls that came to front the temple were less strictly related to the cosmogonic function of the temple than were the sanctum walls. Thus architects were freer to be innovative with plan and decoration as it suited use and patron. In general, the interiors of these halls reutilize forms for both images and ornament found on the temple exterior. However, this interior space, sometimes with an overarching lotus ceiling (see Fig. 57), multiple pillars ornamented with bursting and winding vegetation, and repeated depictions of dancers and musicians has a function beyond the representation of the germinative nature of divinity. It is also the forecourt of the palace of heaven (the inner sanctum) in which the divine regent is celebrated in stone and life.

The door, while containing features and configurations characteristic of specific regions at particular points in time, also bears certain immutable properties. These include the river goddesses on the lower jambs, flanking the entry, along with other aquatic and protective motifs predominating in the lower portion. Celebratory and apotropaic images were located in the side jambs, and celestial images were featured in the lintel and overdoor. Vegetation entwined the whole.

Like the wall images, the elements of the configuration of doorways became well established early in the tradition—in fact substantially earlier than was the case with wall imagery. Doors of the late Gupta period make this evident (see Fig.

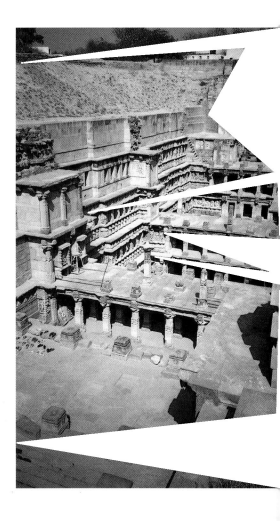

Fig. 85
Queen's step well (Rāṇi ki Vāv),
Patan, Gujarat, about A.D. 1060.

135

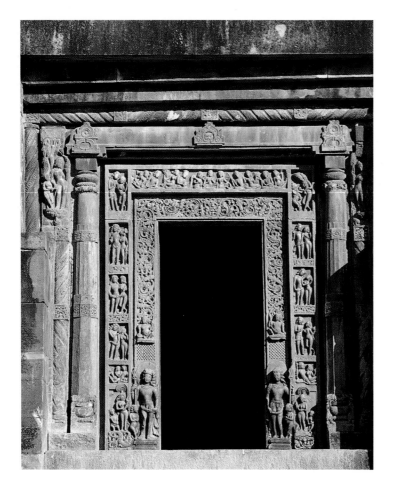

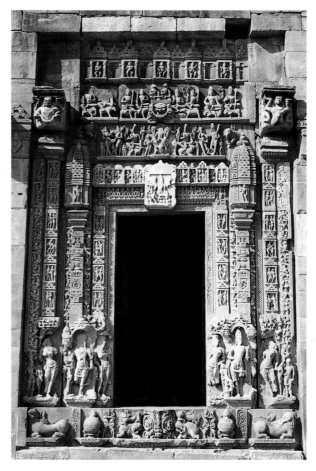

86). Through succeeding centuries, the forms became more diverse and elaborate and motifs multiplied (see Fig. 87), but an unvaried concept and overall configuration persisted.

The north Indian temple is a concretization of a world view and, in this sense, every temple is alike, whatever its specific form or dedication. Yet these monuments, with their multifarious images, were created by human minds and hands. Thus structure and image must be viewed not only as fragments from a divine cosmology, but also as fragments from history, imbued with and reflecting the time and place of their creation—as well as the hands and minds of their creators.

Fig. 86 *left*
Doorway, Pārvatī temple, Nachna, Madhya Pradesh, late 5th century.

Fig. 87 *right*
Doorway, Jarai-kā-Maṭh, ·
Barwasagar, Madhya Pradesh, about A.D. 900.

1. See the essay by Michael W. Meister.

2. See the essay by Vishakha N. Desai.

3. James Ackerman, ed., "On Rereading 'Style,' " *Art and Archaeology* (Englewood Cliffs, NJ: Prentice-Hall, 1963).

4. S. K. Saraswati, "Architecture" (chapter 20, part 1, pp. 530–40); Niharajan Ray, "Sculpture" (chapter 20, part 2, pp. 640–94), *Struggle for Empire* in the series *History and Culture of the Indian People*, R. C. Majumdar, ed. (Bombay: Bharatiya Vidya Bhavan, 1957).

5. Saraswati calls monuments with simple towers and no interior ambulatory path "early" and those with complex towers and interior ambulatory paths "late." More recent scholarship, particularly the writing of Krisna Deva, has shown that this simple equation is untenable as the examination of images and architectural details proves that architects at any one time had in their usable vocabulary a number of options for elements, including the configuration of hall and tower.

6. The first difficulty is evident in Odette Viennot, *Temples de l'Inde centrale et occidentale. Étude stylistique et essai de chronologie relative du Vie au milieu du Xe siècle*, 2 vols., *Publications de l'Ecole Française d'Extreme Orient, Memoires Archeologiques*, vol. 2 (Paris: Adrien Maison-nueve, 1976). As Joanna Williams wrote in her review of the book, " . . . One wishes the author had paid

some heed to sculptural style when there are few other bases for placing a monument," but this was a "self-imposed limit in a work dealing with architecture." The bugbear of modern boundaries is evident in such writings as Mary Lanius's 1972 article on Rajasthani sculpture ["Rajasthani Sculpture of the Ninth and Tenth Centuries," *Aspects of Indian Art,* Pratapaditya Pal, ed. (Leiden: E. J. Brill, 1972), pp. 78–84] as well as several more recent books and dissertations.

7. M. A. Dhaky, "The Genesis and Development of Māru-Gurjara Temple Architecture," *Studies in Indian Temple Architecture,* Pramod Chandra, ed. (New Delhi: American Institute of Indian Studies, 1975), pp. 114–65.

8. Michael W. Meister, "Bīthū: Individuality and Idiom," *Ars Orientalis,* vol. 13 (1982), pp. 169–86.

9. Meister, Dhaky, Deva, eds., *Encyclopaedia of Indian Temple Architecture,* vol. 2, pt. 1 (Delhi: American Institute of Indian Studies, 1988); vol. 2, pt. 2 (Delhi: American Institute of Indian Studies, 1991). This nomenclature can also be seen in Dhaky's work on the styles of western Indian architecture.

10. See the essays by B. D. Chattopadhyaya and Michael D. Willis.

11. Any sort of chronological system is, of course, intrinsically irrelevant to artistic change but necessary for analysis. This is true of the Christian era, which is also culturally inappropriate; however, it is being used for the sake of convenience—a number of chronological systems were in simultaneous use during this period in north India (the Vikrama era being only the most commonly utilized).

12. For discussion and debate on this issue, see Joanna G. Williams, "Vākāṭaka Art and the Gupta Mainstream," *Essays on Gupta Culture,* Bardwell L. Smith, ed. (Delhi: Motilal Banarsidass, 1983), pp. 215–33, among others.

13. John F. Mosteller, "Texts and Craftsmen at Work," *Making Things in South Asia: Proceedings of the South Asia Seminar, University of Pennsylvania,* ed. Michael W. Meister (Philadelphia: Department of South Asia Regional Studies, 1988).

14. It is hoped that the discussion of individual objects in the exhibition and the aggregate of catalogue entries will begin the process of defining chronology and specific regional styles apprehensibly. For this purpose a chronologically arranged list of objects by region appears at the end of the catalogue and images in situ relating to those in the exhibition are mentioned in entries.

15. The Duladeo and Caturbhuj temples at Khajurāho.

16. This is seen in the temples around Ahmedabad, Gujarat, now being constructed by the Sompura family of Gujarat. Construction is being done within traditional practice (with the aid of texts that have been maintained by the family for generations) by employing primarily masons and sculptors from the Jodhpur area of Rajasthan who likewise retain older practices.

17. Likewise indications are given by the image placed in the center of the overdoor and on the frontal projection of the tower.

18. A case in point is the Ambikāmātā temple at Jagat near Udaipur, Rajasthan, a monument that gives primary importance to the emanation of the goddess. Doors on the western end of the hall make it clear that circumambulation of the sanctum from the hall (not of the sanctum exterior and hall together) was intended. The three niches all contain images of the goddess destroying the buffalo demon (Mahiṣāsuramardinī). These radially similar iconographic images are subtly differentiated, however, allowing a sequential circumambulatory reading that suggests a narrative order—the demon in human form emerges in stages as one moves clockwise around the temple. However, the most iconically standard image for the region, that of the demon emerging from the severed neck, is placed in the back *bhadra* niche, producing an axial emphasis.

19. Stella Kramrisch, *The Hindu Temple,* vol. 2 (Reprint, Delhi: Motilal Banarsidass, 1976), p. 30.

20. At Osian, north of Jodhpur in Rajasthan, there are more than a dozen extant shrines that span the eighth to tenth centuries. This site is nearly unique in north India as a resource for understanding the evolution of image placement that resulted in the fully formed and figured tenth-century wall.

21. It is also possible to rotate the entire set one corner.

22. Meister's *karṇa* vs. *bhadravyāsa,* Michael W. Meister, *Form in the North Indian Temple: A Field Survey,* Ph.D. Dissertation, Harvard University, 1975.

23. This is evident from earlier placement of such figures on image frames and doorways.

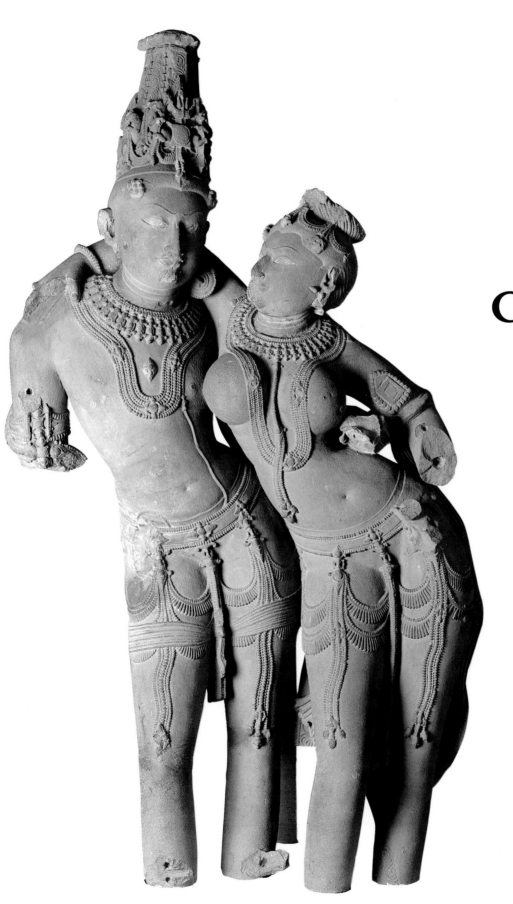

Catalogue

Catalogue Note

The objects have been arranged, within six sections, in accordance with their probable original position and function in relation to the temple structure. Information provided for each piece is as follows: exhibition number, name or description of the work, its function in situ, provenance, historic region to which the work is attributed, date of origination, medium and dimension (height precedes width), and lending collection.

The traditional practice of specifying sandstone color has not been followed for several reasons. For example, verbal description does not seem sufficiently precise, nor does color significantly determine or modify the stone's chemical composition or geographic provenance. Furthermore, stones of different color were frequently used to build portions of the same structure. Future studies of the chemical composition of the stone in situ may produce more substantial results.

I. Vertical Extension
Superstructures and Lower Moldings

1.
Small Shrine
Gwalior, Madhya Pradesh
(Gopādri)
About A.D. 750–775
Sandstone; 184 x 98 cm
Central Archeological Museum, Gwalior; 449

This detailed miniature shrine shows all the standard features of a small *nāgara* (north Indian) temple of the "period of early maturity."[1] Short of a visit to the subcontinent, it gives the clearest possible idea of temple format and the integration of sculpture and architecture crucial to an understanding of all objects in this exhibition.

The shrine is one of three[2] similar structures found in the fortress at Gwalior (ancient Gopādri) in northwestern Madhya Pradesh. According to local memory, they once lay in the area around the famous Teli-kā-Maṇḍir, and their architectural features accord well with the probable mid-eighth-century date of that monument.

The shrine interior, as in the vast majority of temples, is a square and undecorated sanctum. It is termed the *garbhagṛha*, ("seed" or "womb house"), wherein the manifesting deity often appears in his most abstract form. The austere and darkened cube once likely enclosed a *liṅga*, the rounded, pillarlike "mark" of the God Śiva as the Infinitely Expanding (Nos. 73, 74).

Like the majority of north Indian temples, a tall curving tower (*śikhara*, "mountain peak") rises above the sanctum. Its top is crowned by a great bulbous ribbed stone, the *āmalaka*, whose name is taken from an Indian fruit of similar form although the origins of the architectural element are likely solar. The *āmalaka* rises from the flat upper slab (*uttaravedī*, "upper altar") of the tower on a round, pillarlike shaft.[3]

The curved tower projects forward in three levels. The central tapering vertical band is formed of a web motif, which originated as intertwined round window forms (*candraśālās*). The corner and intermediary bands display levels of multiple moldings separated by squared-off *āmalakas*, each level a simplified replica of the tower itself. The moldings continue in the narrow

recesses between these projecting bands except at the level of the *āmalakas*, where small pillared niches fill the cavity.[4]

From the front of the tower, over the doorway, emerges the *śukanāsa*, or "nose" of the temple. Although damaged, its upper portion carries a single large *candraśālā* ornamented in pearls and floral rosettes. In the center of this imaginary window appears the God Śiva in his form as Naṭeśa, Lord of Dance, who propels the cosmic cycle of creation, preservation, and destruction through rhythmic movement (No. 2). The image indicates that the temple itself was dedicated to Śiva as the ultimate divinity. This dedication is confirmed by images around the walls.

Below Naṭeśa, a tall triangular pediment, like the central tower projection in design, tops the center of the door, as similar pediments top the wall niches. It overlays a cornice of two curved moldings sandwiching a layer of square bosses, references to the beam ends of earlier wooden construction. This triple cornice continues, at a slightly lower elevation, around the body of the building. A relief of bells hung with pearl swags ornaments the upper portion of the wall below the cornice.

A series of cornices, *āmalakas*, *candraśālā* pediments, and other architectural elements mimicking segments of the *śikhara* compose the overdoor, a form typical of early-to-mid-eighth-century monuments in Gopādri. A multitude of decorative and symbolic elements covers the door surround below (No. 51). In the center, the birdman Garuḍa, killer of snakes, flies forward grasping a row of what look like buds but are actually the scaly bodies of two snakes whose heads and hoods would have appeared on the lower jambs (now broken). Flanking Garuḍa are flying celestial figures carrying flowers and garlands. Figure jambs display cavorting dwarfs (*gaṇas*), some playing musical instruments as they dance. A molding of curved lotus petals lines the sides of the door, and the inner surround takes the form of an elegant foliate scroll.

On the lower portion of the jambs, nearly demolished, stand the embodiments of the two holy rivers of north India. Gaṅgā (Goddess of the Ganges) is on the right atop a crocodilian sea creature with a swirling tail (*makara*), followed by a smaller female attendant. On the opposite jamb stands Yamunā (Goddess of the Jumna) on a tortoise (Nos. 52, 53). Tiny celestial women

(*apsarāsas*) rise in relief on the flat walls to either side. Two lions guard the raised threshold, and a lotus flower grows from its center (No. 56).

A series of heavy moldings overlays the lower portion of the three walls. This *vedībandha* ("altar binding"), as its name implies, wraps around the wall above floor level, rather than acting as basement. Like the superstructure above, the walls (consisting of *vedībandha*, frieze, and cornice) step forward on three levels. The central and farthest step (*bhadra*) lies on axis with the central and most holy portion of the sanctum interior, the space crowned by the *āmalaka* high above.

In these central *bhadra* projections on the three walls reside divinities important to the worship and mythology of the sanctum divinity, in this case members of the family of the God Śiva. The wall to the left of the door, in an actual building, would be the first

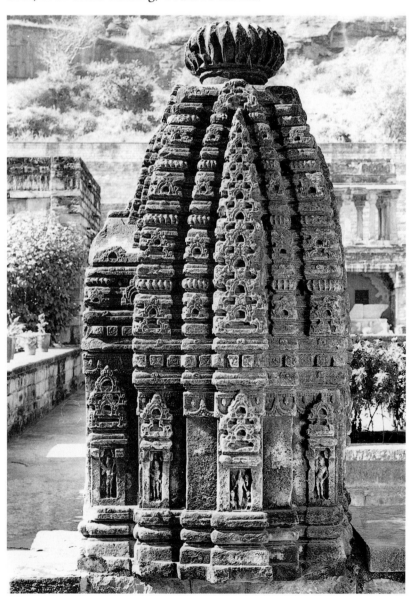

wall approached by the worshiper in the initial rite of clockwise circumambulation. If the temple faced in the standard easterly direction, it would be the south wall. In its central niche dances the rotund elephant-headed God Gaṇeśa (Nos. 16–18), son of Śiva and Lord of Prosperity and Easy Passage.

The back (west) wall shows another son of Śiva, the youthful Skanda (Kārttikeya), accompanied by a peacock. This wall, on axis with the door, tends to hold (of the three) the divinity most closely related to the god within the sanctum.[5]

The central niche of the final (north) wall carries a much-abraded image of Śiva's wife, the Goddess Pārvatī,[6] as she performs the penance of standing in the center of five fires. One is thought to gain power, both spiritual and temporal, through physical suffering, and Śiva himself is seen as the greatest of all ascetics. At Pārvatī's feet stand two animals, probably a lion to the left and a deer to the right.[7]

The niches housing these three important images are sunken into the plane of the wall with no flanking pilasters. More than the corner niches, they resemble additional axial doors to the sanctum, as if the deity, proliferating in varied forms, steps outward into the world of the devotee.

The corner niches, including the two additional niches at the sides of the door, on the other hand, show plain pilasters topped by crossed roll brackets that support the pointed decorative pediments. These eight niches, guarding the corners of the sanctum, appropriately hold images of guardians—the aṣṭadikpālas, or eight guardians of the directions in space.

Although the identifying traits of these eight male figures are difficult to distinguish, enough remains to see that they follow the standard order of such divinities, an order established on the temple only in the eighth century (Nos. 7, 8). Beginning to the left of the door and proceeding clockwise they are: Indra (E), Agni (SE), Yama (S), Nirṛti (SW), Varuṇa (W, the makara below his feet), Vāyu (NW), Kubera (N), and Īśāna (NE).[8]

In its structure, decoration, and iconography, this small shrine is closely linked to standing temples in Gwalior and its vicinity[9] that date to the first half of the eighth century, leaving little doubt that it did indeed originate in that important city. During this period, Gwalior and its surrounding area were likely ruled by the Maurya dynasty.[10] One of the numerous local clans of north India, the Mauryas appear to have conquered a large area to the east of Gwalior during the eighth century, including the city of Kannauj (Kānyakubja), but held this extended territory for only a brief time.[11]

A number of such miniature temples have been found in north India, although few are as detailed as the Gwalior examples. Their exact function is unknown, but the prevalence of small roadside shrines in India today and the reuse as shrines of these tiny older structures, such as the one near the Sūrya tank, make it likely that they were originally active, albeit small temples in their own right.

1. A term used by Michael W. Meister and M. A. Dhaky, eds., *Encyclopaedia of Indian Temple Architecture* (hereafter cited as *EITA*) (New Delhi: American Institute of Indian Studies [AIIS] and Oxford University Press, 1991) to designate the period from ca. A.D. 700–900.

2. At present, the second stands near this one in the courtyard of the Central Archeological Museum, Gwalior. The third, whitewashed, is placed as an active shrine beneath a small pavilion in front of the Sūrya Kund, the tank next to the Teli-kā-Maṇḍir (Fig. 42).

3. See the essay by Michael Meister.

4. For the significance of these indentations and their usefulness in dating, see Michael W. Meister, "Prāsāda as Palace: Kūṭina Origins of the Nāgara Temple," *Artibus Asiae*, vol. 49, no. 314 (1988–89), pp. 254–80.

5. The fairly unusual use of Skanda in the west niche is repeated in a number of eighth-century temples from this region (Naresar Śiva temple, temples at Amrol, Indor Śiva temple, and several shrines at Batesar), see *EITA*, vol. 2, part 2.

6. That the directional orientation of these side images—Gaṇeśa facing south and the goddess facing north—is even more important than their relative locations in the circumambulatory process is clear from the second temple at Amrol, the Danebaba, which faces west but retains Pārvatī in the north (thus initial) niche and Gaṇeśa in the south (final). We thus know from this example that the miniature shrine was intended to face eastward.

7. Implied by a similar and better preserved image of Pañcāgnitapas Pārvatī from the Śiva temple at Indor, Guna District, Madhya Pradesh.

8. See the essay by Darielle Mason.

9. See *EITA*, vol. 2, part 2, chap. 24, "Mauryas of Gopagiri and Kānyakubja," by Krishna Deva, pp. 2–25.

10. Not to be confused with the Maurya dynasty that ruled much of north India in the third and second centuries B.C.

11. For a summary of the dynasty's eighth-century history, see *EITA*, vol. 2, part 2, pp. 3–4.

2.
Śiva Dancing in a Circular Frame
(Naṭeśa in a *Candraśālā*)

Superstructure element
Udayeśvara (Nīlakaṇṭha) temple, Udayapur, Madhya Pradesh
(Daśārṇadeśa)
A.D. 1080
Sandstone; 89 x 105 cm
Central Archeological Museum, Gwalior; 181

At the center of the small village of Udayapur, north of Bhopal, towers an immense and well-preserved Śiva temple (Fig. 3). A large stone inscription embedded in a wall of its front porch states that the temple was completed by King Udayāditya of the Paramāra dynasty of western Madhya Pradesh in V.S. 1137 (A.D. 1080–1081).[1] Thus the structure is known for its builder as the Udayeśvara temple. As with the large temples at Khajurāho, the excellent preservation, profuse and well-executed ornamentation, and sheer size of the Udayeśvara temple give us a taste of how grandiose a royally patronized north Indian shrine would have appeared in its heyday.

The *śikhara* of the temple, amazingly complete, is a type found primarily in western Madhya Pradesh on monuments dating from the eleventh through the thirteenth centuries.[2] Its distinguishing characteristics are tall central spines of flat intertwined *candraśālās* with the corner spaces filled by vertical rows of miniature towers, diminishing in height as they rise. This is in contrast to more standard curving towers with sides formed of layered cornices marked by corner *āmalakas* (No. 1) or the later variant, found throughout western and central India from at least the tenth century, of abutting half towers of diminishing size.

At the base of each of the central spines on this *śikhara* appears a large *candraśālā* containing an image of Naṭeśa (Nos. 1, 60, 61). On the *śukanāsa*, or frontal projection of the tower, is an even larger round window form, likewise containing an image of Śiva as the Cosmic Dancer.

This piece, an exquisite but smaller *candraśālā*, is deeply and lushly carved in the red sandstone used for the entire temple.[3] Like the *candraśālās* at the tower base, (*siṁhakarṇas*) it was likely crowned by a great open-mouthed leonine "face of glory," a *kīrtimukha* (No. 55), as if the creature had

exhaled forth the round window form and the god within. The *candraśālā* is carved with an inner surround of two layers of tiny buds, and the circle is covered in a thick creeper of lotus-bud spirals surrounded by a simple molding of curved incisions. A dense three-dimensional foliate scroll forms the flanges of the *candraśālā* on the front, unfortunately battered in their upper portion. Sensitively modeled corner *kīrtimukhas* emerge from the vegetation at the lower sides. The fragment rests on a molding of floral diamonds alternating with rosettes and a flattened, leaflike undermolding.

The Udayeśvara temple is fronted by a great hall with three entrance porches. Only the rubble of the superstructures over these porches, remains (Fig. 38). It is likely[4] that this *candraśālā* once fronted one of these porches above the entrance, although conceivably it could have originated in the tower of a subshrine.

Within the lush circle dances the god himself. His ten arms carry many of his usual attributes such as trident, snake, bell, and skull cup. Other hands hold a bow and perform several *mudrās* of the dance. Rather than the more usual double drum, Śiva beats time with finger cymbals on his forward left hand.

The god, arching head and body, stands on his left leg, the knee severely flexed, while his right leg is drawn upward to where the knee is level with the hip. The entire figure tilts forward out of the circle. This tilting is not an attitude of the dance. Rather it is an adjustment for the intended angle of view from below. At Śiva's feet, two small male musicians accompany the god. Their contorted postures, in flying poses but falling forward and away from the platform, represent an even more striking perspectival adjustment.

Śiva's torso is the narrow and long tubular form familiar from somewhat later

145

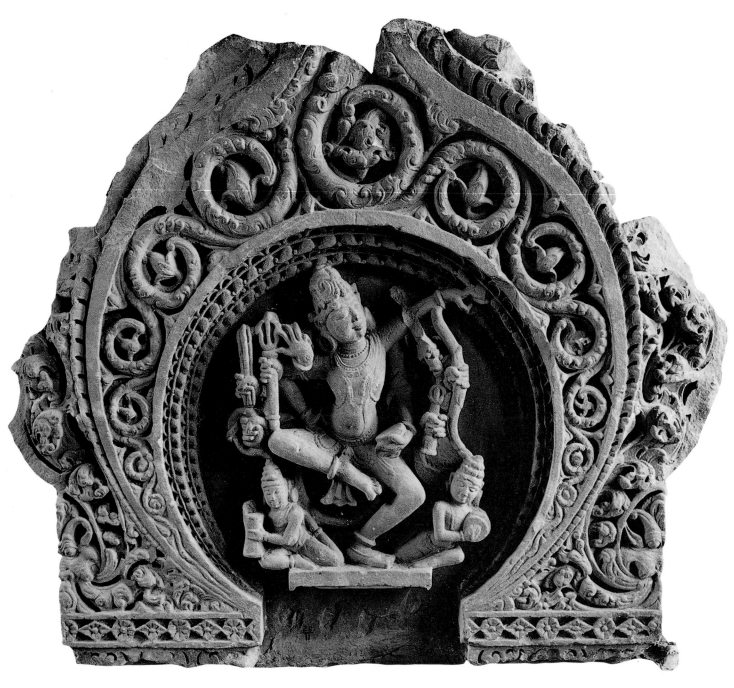

figures from the north (No. 26), but his upper belly is softer. This softness and the oval face with low forehead, small chin, and wide, firmly sealed lips, straight shallow nose, and lazy lids relate him, not surprisingly, to the slightly earlier eleventh-century Ambīka Yakṣī (No. 68), also carved under imperial Paramāra patronage.

Reference: Chakravarty 1984:84.

1. F. Kielhorn, *Indian Antiquary* (hereafter cited as *IA*) vol. 20 (1891), p. 83. For this dating, as opposed to the more usual 1059–1080, see Eliki Zannas, *Journal of the Uttar Pradesh Historical Society,* vol. 18, New Series, 1 and 2; and Eliki Lascarides-Zannas, "The Big Śukanāsa of Udayeśvara Temple at Udayapur, Madhya Pradesh," *Madhu: Recent Researches in Indian Archaeology and Art History,* Shrī M. N. Deshpande Festschrift, M. S. Nagaraja Rao, ed. (Delhi: Agam Kala Prakashan, 1981), chap. 29, pp. 188–94.

2. See Krishna Deva, "Bhūmija Temples," *Studies in Indian Temple Architecture*, Pramod Chandra, ed. (New Delhi: AIIS, 1975).

3. As Lascarides-Zannas, op. cit., p. 187, notes, there is evidence that the stone was quarried at the site, not an unusual practice.

4. The *bhūmija* Ambaranātha temple at Ambarnath in Maharashtra shows such *candraśālās* over the porches although the hall superstructure here is of an unusual form (Krishna Deva, op. cit., pl. 29).

3.
Lion Subduing an Elephant

Superstructure element
Reputedly Kari Talai, near Jabalpur, Madhya Pradesh
(Dāhaladeśa)
About first half of the 11th century
Sandstone; H. 129 cm
Durgawati Museum, Jabalpur

Embodiment of puissant but beneficent regality, this lion seems to celebrate its victory over the diminutive crouching elephant. One upraised paw prominently presents five fine-honed unsheathed claws. The great tongue laps the chest fur. It is a confident, alert cat, ears perked and sinuous tail erect, with the upper end twitched into a loop. The swelling body is smooth. Incised spirals emphasize the powerful shoulders, and spiral curls line legs and haunches as well as mark layers of the mane and whisker ends.

Around its neck the lion sports a chain of monstrous pearls. A single pearl appears between its eyes and its ears are ornamented with pearl and fang drops. The *Ādipurāṇa*[1] speaks of images of lions who "appeared intent upon vanquishing the heavenly elephants. The large pearls hanging from the faces of the lion looked like fame acquired by breaking open the temples of great elephants." The elephant is "treasure keeper of darkness,"[2] which is ignorance. In breaking open the storehouse, the lion releases and scatters the "pearls of wisdom" hidden within.[3]

Freestanding lions, often with an elephant or warrior beneath, frequently appear in the vicinity of large temples in north India.[4] Their arbitrary modern placement, often as stair guardians, confuses the issue of their original use. Yet on several of the large Khajurāho shrines and other well-preserved temples in north India,[5] such sculptures remain in place. They stand on the flat ledge above the frontal projection (*śukanāsa*) of the *śikhara*, which rises above the walls that connect sanctum and hall on the exterior (No. 1). The elevated placement of the lion is mentioned in one eleventh-century foundation inscription: "How can I possibly with words, tell of its [the temple's] height? The lion who has ascended its top, means to devour, it seems, the deer in the moon."[6]

The lion's role as both guardian and assistant in the process of divine illumination is clear from its prominent location. Like the lions that frequently occupy the sill of the door itself (see No. 56), these upper lions also mark this crucial liminal space, for they sit on the vertical axis directly above the sanctum threshold.

1. Translation from Stella Kramrisch, *The Hindu Temple* (Delhi: Motilal Banarsidass, 1976), vol. 2, p. 377, nt. 123.

2. Rai Bahadur Hira Lal, "The Sirpur Stone Inscription of the Time of Mahasivagupta," *Epigraphia Indica* (hereafter cited as *EI*), vol. 11 (Calcutta: Archaeological Survey of India, 1911–12), p. 190.

3. See Kramrisch, op. cit., pp. 332–37.

4. Two such monumental beasts stand cemented in place on the high basement platform (*jagatī*) of the Kandariyā Mahādeva temple at Khajurāho, one near the stairs, another in the porch of a small flanking shrine.

5. For example, the Sūrya temple at Madkheda, Tikamgarh District, Madhya Pradesh, mid-ninth century (Fig. 43), shows a lion and elephant ensemble in place (*EITA*, vol. 2, pt. 2, pls. 94 and 97). An apparently earlier photograph published in R. D. Trivedi, *Temples of the Pratīhāra Period in Central India* (New Delhi: The Director General, Archaeological Survey of India, 1990), pl. 148, p. 295, shows only the elephant, the lion having apparently fallen off and having been later replaced.

6. F. Kielhorn, "The Sāsbahu Temple Inscription of Mahīpāla of Vikrama-Saṃvat 1150," *IA*, vol. 15 (1886).

4 ▼

4.
Crouching Lion
Superstructure element
Provenance unknown, probably western Madhya Pradesh or neighboring Uttar Pradesh
(Daśārṇadeśa or Śūrasena)
About 8th century
Sandstone; 82.6 x 104.1 cm
Pritzker Family Collection

Like the previous image, this smaller red sandstone figure of a lion crowned the *śukanāsa*, or frontal projection, of a temple *śikhara*. In front of the lion rise two foliate volutes bound together with a carved band. This form resembles the standard upper termination for the *candraśālā* (see the niche overlaying the base moldings of No. 28). The face of the *śukanāsa* would have been covered with a large *candraśālā* (Nos. 1 and 2). Yet lions typically rest above this "window" terminal and these foliate volutes are likely a secondary projection from the *candraśālā*.

The heavy, bulging eyes of the lion show incised irises and pupils. His face is similarly defined by incisions accentuating the curve of eyes, nose, and cheeks. Below a humanoid nose, small holes indicating whiskers cover the rounded muzzle. The animal tucks its chin to its chest, pulls its lips back, and bares its teeth in an incipient growl. The tail snakes over the crouched back and thick mane.

Both the fullness of carving and specific features link the creature with earlier lion images of the late Gupta period.[1] The finial form with clearly defined binding cord also indicates a date fairly early in the temple-carving tradition, perhaps in the first half of the eighth century.

Remnants of plaster and pigment survive in carved crevices on both the animal and architectural element below, showing that the small temple from which this image came was likely painted sometime in its history, as many of these structures may have been.

1. See, for example, *Section of a Monumental Lion*, Museum of Fine Arts, Boston (acc. no. 66.233).

5.
Decorated Moldings
Segment of a temple basement
Somanātha temple, Somanātha (Prabhas Patan), Gujarat
(Gurjaradeśa-Ānarta)
A.D. 1169
Sandstone; 183 x 91.4 cm
Prabhas Patan Museum, Veraval; 165–69

From the earliest freestanding stone temples in the Gupta period (ca. fifth to sixth century), architects articulated the lower portion of the exterior wall as a series of horizontal moldings. This portion, called *vedībandha* (literally "altar binding"), wrapped around the sanctum above the level of the floor (No. 1). Initially only several undecorated layers of stone following the contours of the wall above appeared below floor level.

In parts of western India, however, architects soon expanded this level below the floor, and gradually the piled slabs were differentiated by a specific carved motif. By the eleventh century, especially in Māru-Gurjara–style temples[1] of western India, these molded basements (*pīṭhas*) have a relatively fixed sequence of elaborately figured friezes depicting the rise through the worlds of beasts to that of men, replicating the very order of life itself (Fig. 84).

This segment of *pīṭha* comes from the Somānatha temple on the coast of Saurashtra at India's far western extremity. Called "the Shrine Eternal," this Śiva temple, still an active pilgrimage site, shows evidence of constant building and rebuilding as far back as the tenth century, but its actual origins are likely much more ancient.[2] The penultimate structure on this holy site was built by the Solaṅki ruler Kumārapāla in A.D. 1169 and its remains were dismantled in 1950 to make room for a new temple, designed in a revival style not far removed from that of the twelfth-century structure.

The Solaṅki (Cāḷukya) dynasty rose to nearly imperial status at the end of the tenth century. Centered around the city of Aṇahilapāṭaka (modern Patan in north Gujarat)[3], they ruled a large section of western India until the fourteenth century. Fortunately, many fragments from the 1169 construction, along with earlier excavated material, are now housed nearby in the museum at Prabhas Patan.

This impressive layering of *pīṭha* moldings shows the architectural element at its most complex. Above several squared slabs sits a tall curved molding.[4] The surface of that molding is usually covered in long lotus petals. Here, however, the petals disappear in deep and fiery undercut foliate scrollwork. Above it projects a narrow knife-edged molding, followed by a recessed band topped by a small curved molding. Atop this rests a series of four figured layers: a band of *kīrtimukhas*, an elephant band, a horse band, and finally a human band.

The elephant band displays a line of elephants *en face*, charging outward at the viewer. The horse band shows a row of rearing and leaping equines, each with a small rider. Rather than the repetitive images covering the other three levels, the human upper band depicts a processional scene with cavorting musicians followed by a caparisoned elephant with mahout. It is likely that the rest of this molding would have displayed a variety of scenes of celebration, war, and other aspects of everyday royal life.

References: (The following contain photographs showing *pīṭha* courses in situ before demolition.) Cousens 1931: pls. II–V; Dhaky et al. 1974: pl. 1.; Munshi 1976: photo inset.

1. See M. A. Dhaky, "The Genesis and Development of Māru-Gurjara Temple Architecture," *Studies in Indian Temple Architecture*, Pramod Chandra, ed. (Delhi: AIIS, 1975), pp. 132–34.

2. M. A. Dhaky, H. P. Shastri, and J. D. Bhattacharya, *The Riddle of the Temple of Somanātha* (Varanasi: Bharata Manisha, 1974).

3. Not to be confused with Prabhas Patan, which is Somanātha.

4. This lower molding is termed *jāḍyakumbha*. Those above it, in rising sequence, are: *karṇikā*, *antarapaṭṭa* (recess), *kapota*, *grāsapaṭṭa* (row of *kīrtimukhas*), *gajapīṭha* (elephants), *aśvapīṭha* (horses), and finally *narapīṭha* (men).

6.
Women with a Water Pot

Drainage spout
Harṣamātā temple, Abaneri, Rajasthan
(Mārudeśa-Sapādalakṣa)
About A.D. 800–825
Sandstone; 45 x 61 cm
Amber Archeological Museum

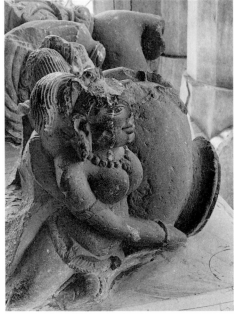

From the site of Abaneri in northeastern Rajasthan, in the ancient Mārudeśa-Sapādalakṣa region midway between Jaipur and Mathura, come some of the most exquisite of all Indian carvings. Built around the beginning of the ninth century, the large so-called Harṣamātā temple complex is now a monumental ruin with pieces scattered at the site and in several north Indian museums. The temple was likely patronized by the Cāhamāna rulers of the region just as they began to assert their independence from Gurjara-Pratīhāra overlordship.[1]

This ornate monument is situated on a high, molded platform with elaborate drainage spouts. The forms of the spouts range from literal representations of water pots held by women, as seen here, to more symbolic depictions of a mythic creature, the *makara,* associated with water and regenerative forces. Such drainage spouts were functional and served to keep water from seeping into the structure. A spout, utilizing either the motif of a woman with pot or a *makara,* also sometimes projects from the binding moldings of the temple to drain fluids used in ritual lustration of a sanctum image, particularly a Śiva *liṅga.*

1. Cynthia Packert Atherton has recently suggested that this temple may have been a construction of the esoteric Vaiṣṇava sect of Pāñcarātrin. "Levels of Meaning: The Harṣamātā Temple at Abaneri," Association for Asian Studies, 42d Annual Meeting, 1990 (unpublished).

7.
Guardian of the Southeast, Agni

Exterior wall, corner offset
Provenance unknown, probably central Madhya Pradesh
(Daśārṇadeśa)
About early 10th century
Sandstone; 82.5 x 25.4 cm
The Brooklyn Museum, Gift of Dr. and Mrs. Robert Dickes; 77.199

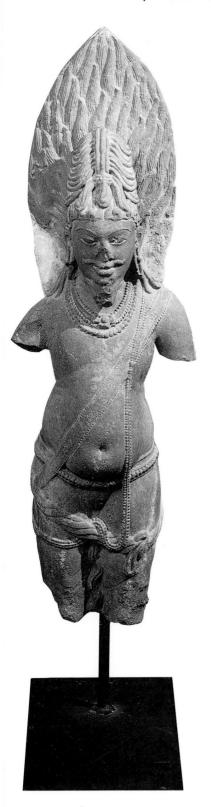

On the "medieval" temple, a set of eight guardians of the directions (aṣṭadikpālas) appears in a standard order, orientation, and placement on the corner offsets of the main shrine body (No. 1, Fig. 79). The necessity for protecting the corners of the monument stems back to the sanctifying of the Vedic altar, that perfect square from which the plan of the temple is descended. The *dikpālas* protect and contain sacred space, like the corners of the temple itself. They also extend the manifesting divinity outward in all directions to encompass the entire universe.[1]

The *aṣṭadikpālas* are for the most part Vedic deities who devolved through the centuries into this subsidiary, protective identity. Agni, Guardian of the Southeast, is always one of the easiest to identify by virtue of his fiery halo, here stylized as thick, striated tongues of flame. In the animistic Vedic pantheon, Agni is God of Fire, particularly the sacrificial fire, which, by its pillar of smoke, sends offerings to the gods and so connects heaven and earth.

Like Brahmā, the divine priest, Agni is usually shown with a paunch and beard, reflecting his sacerdotal function through the contemporary stereotype of a priest (*brāhmin*). In addition, as here, Agni is often portrayed with the matted hair of an ascetic and always wears the sacred thread of the twice born across his chest. If this figure were complete, Agni's vehicle or complement (*vāhana*), the ram, would most likely stand at his feet.

Texts specify Agni as guardian of the southeast, and he invariably appears on the south wall. When the temple faces in a direction other than east (as, for example, with a subshrine or north-facing goddess temple), Agni remains on the south, although now in a different relationship to the entrance and to the clockwise circumambulation of the devotee.

Like the majority of sculptures in this exhibition, this image of Agni bears no provenance. The simplicity of ornament and use of the low-slung scarf at first seem to indicate an early date apparently linking him to images such as those on the eighth-century Śiva temple at Indor near Gwalior, Madhya Pradesh.[2] Yet this first impression is misleading. The smooth finish of the sculpture, the natural handling of masses—both flesh and drapery—and numerous other details indicate that this Agni relates more closely to images from tenth-century central India, such as a group of most likely early tenth-century sculptures found at the site of Āshāpuri (Raisen District) in central Madhya Pradesh, the ancient Daśārṇadeśa region east of Bhopal. A number of pieces from Āshāpuri, particularly a standing Śaiva ascetic[3] from the Bhūtanātha temple, display similar facial features, including the swollen lower lip, curling mustache, distinctive goatee, and deep but smooth undercutting, along with comparably treated fleshy fullness, loosely waving drapery, and beaded swags[4] and imply Agni's regional affiliation.

Reference: The Asia Society 1978:86, no. 4.

1. See the essay by Darielle Mason.
2. *EITA*, vol. 2, pt. 2, pl. 32.
3. The iconographic identification is questionable. AIIS Neg. No. 230.14, Āshāpuri State Museum.
4. See also AIIS Neg. No. 241.39, Viṣṇu, in the Birla Museum 181; and Vāmana, AIIS Neg. No. 230.66, Āshāpuri State Museum, from Ashadevi temple.

8.
Guardian of the Northwest, Vāyu
Exterior wall, corner offset
Provenance unknown, probably Kota region, Rajasthan
(Uparamāla)
About A.D. 875–900
Sandstone; 111.7 x 43.2 cm
The Brooklyn Museum, Anonymous Gift; 86.183.3

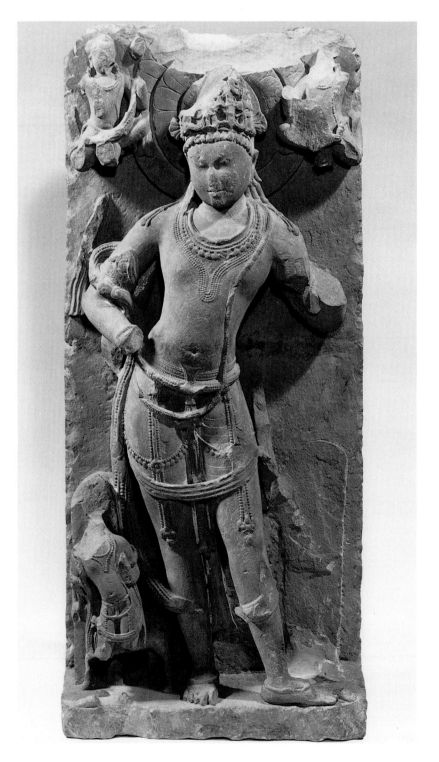

Vāyu, Vedic God of the Wind, is transformed on the north Indian temple into the directional guardian (*dikpāla*) of the northwest quarter of the universe, one of the set of eight such guardians (Nos. 1, 7). He usually resides in a niche on a corner of the north wall, most often the western corner.

This standing male figure can be identified as Vāyu by his *vāhana*, a deer, whose tiny form emerges to either side of the small attendant flanking his right leg. Although the muzzle of the deer has broken, its straight horns and hooves remain as clues to the larger figure's identity. In addition, over the *dikpāla's* right shoulder hangs a thin piece of drapery, apparently suspended in midair. It is a flag blowing outward in an unseen breeze, an attribute clearly referring to Vāyu's earlier elemental role. The *dikpāla* originally held the flagstaff (to which the cloth would have been attached) in his lower right hand.

Although damaged, a second set of arms can be distinguished on this Vāyu. *Dikpālas* first seem to display an additional set of arms in about the mid-ninth century, although initially limited to the Śiva-like Īśāna. This characteristic never became the rule, however, and so cannot help in determining date after the ninth century.

Behind Vāyu's head appears a halo of two concentric bands of lotus leaves, delineated as simple incised forms. He wears a long triple strand of pearls that narrows between his pectorals in a manner particularly common in images of the tenth century and later. His short lower garment is overlaid on the left leg with a sash, a configuration frequently noticeable in figures found near the city of Kota in eastern Rajasthan, ancient Uparamāla, such as contemporaneous figures from the site of Baroli.[1] Other details of dress, such as the crown with bowlike side projections (Nos. 58, 59), are also typical of this region.

The small male attendant to Vāyu's right matches the larger figure in details of ornament and dress. A second attendant who once must have flanked the left leg appears to have been deliberately chiseled off, leaving only a slightly raised relief plane. To either side of the *dikpāla*'s halo fly garland-bearing attendants, *vidyādharas*. They emerge from stylized clouds, a conceit more clearly articulated in certain images from farther east in central India.

Vāyu's body displays gentle undulations of flesh on a long, graceful torso and a sweet, round face. The legs taper to thin ankles that fuse awkwardly with flat, fleshy feet. He stands with head slightly inclined and torso tilted in an exaggerated bend at the hips over a straight, outturned leg. These characteristics are noticeable in figures from Uparamāla from as early as the eighth century.[2]

In the collection of the Kota Archeological Museum are two sculptures that make it possible to determine the origin of this Vāyu with relative exactness. These are images of two other *dikpālas*, fiery Agni with his ram and Yama, Lord of Death, with his small buffalo at his feet. The correspondences between these figures and this Vāyu are convincing both in terms of detail and treatment, and the three may have originated from the same set of guardians. The Kota Archeological Museum figures come either from the site of Atru, southeast of the city of Kota, or from the neighboring site of Kishan (Krishna) Vilas.[3]

The question of dating these images is somewhat more difficult since no monuments in this region from the period are concretely dated by inscription. By comparison with Baroli, whose early monuments probably range in date from about 900 to 950, as well as with a variety of loose images, it seems likely that they date to the final quarter of the ninth century or early years of the tenth. The necklace configuration and the flatness of the drapery may indicate an early tenth-century date but may also represent idiosyncrasies of the sculptors. Sculptures in the region dating nearer to the mid-tenth century[4] appear to soften and further exaggerate the simple outthrust hip into a sinuous C curve and otherwise alter the anatomy in ways not apparent in these images. Kota District lies within one of the easternmost spurs of the modern state of Rajasthan. The ancient Uparamāla region, on the other hand, stretched as far west as Chittaurgarh in Rajasthan. The region may be seen as forming a stylistic conduit during the late ninth and early tenth centuries between westerly neighbors such as ancient Meḍapāta (around Udaipur, Rajasthan) and those to the south and east in Madhya Pradesh. Yet the sweet and graceful figures and elegant temples of Uparamāla show a continuity of distinctive features over several centuries that unify the area and indicate a definable regional style.

1. See male images on the loose doorway from a destroyed temple at the site of Baroli, dating to early in the site's history, probably ca. A.D. 900. This feature also appears in a few temples in Mārudeśa especially the Nilakaṇṭha Mahādeva at Kekind (Jasnagar) near Merta, east of Jodhpur.

2. For example, some of the figures on the eighth-century triple shrine at Menal, particularly the Naṭeśa on the west wall of the south shrine.

3. Unfortunately the exact provenance of the figures is unclear. At the Kota Archeological Museum they are labeled as coming from Kishan Vilas, while according to the AIIS Art and Architecture Archive, the same pieces are from Atru. Both sites are large and a thorough survey could not be made. However, sculptures from Kishan Vilas date primarily from the ninth century and later from the eleventh through the fourteenth centuries. Atru has a greater number of remains from the tenth century; therefore, these pieces may tentatively be assigned to Atru.

4. For example, images from the Ghateśvara temple, Baroli.

9.
Dancing Celestial Woman
Exterior wall niche, probably intermediary offset
Provenance unknown, probably Rajasthan or Madhya Pradesh
(Mārudeśa-Sapādalakṣa, Uparamāla, or Daśārṇadeśa)
About A.D. 800
Sandstone; 67.6 x 34.9 cm
The Denver Art Museum, Gift of Irene Littledale Downs; 1972.60

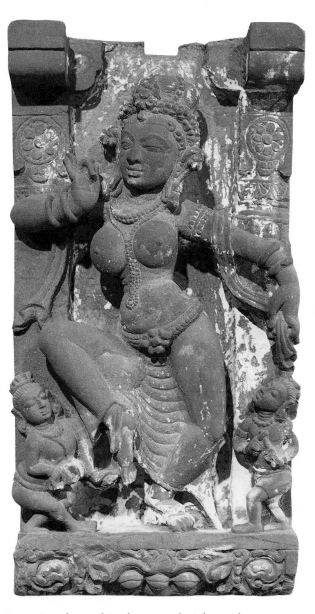

This gracefully dancing woman, who carries no attributes and bears no marks of divinity (such as multiple arms), very likely inhabited an intermediary offset on the exterior wall of a temple. She bursts from the niche behind, arms and knee overlapping the supporting pilasters in an extraordinarily naturalistic movement away from the temple body. Her figure is also strongly modeled, almost in the round. Horizontal folds of fabric draped between her flexed knees acutely reflect the rolls of flesh between breast and waist. The backward tilt of her hip balances the weight of her raised leg and her chin juts upward in a motion seemingly suspended on a breath. Two small musicians accompany her on percussion and gaze upward appreciatively.

The niche itself is quite shallow. Square pilasters with a floral rondel support crossed roll brackets. Lush foliage covers the niche base with the downturned head of a *kīrti-mukha* in the center, an unusual configuration.[1] In terms of the architecture and in certain respects of the figure, this sculpture might relate to some images found in the town of Amber near Jaipur in northeast Rajasthan. Although under the Cāhamāna rulers like the contemporaneous site of Abaneri (No. 55), it obviously differs significantly from the long and sinuous figures of that and related sites, although partaking of the same sweetness of expression.

During the ninth century semidivine women (*apsarāsas*) gradually became the standard occupants of the intermediary offset of the exterior sanctum walls. Poses visually relate them to the deity on the *bhadra*, and their subsidiary position is at times also expressed by making them substantially smaller than figures on other offsets. It is likely that, in her original architectural context, this dancing *apsarās* would have been found in such an attendant location, honoring the god in the central niche as the female dancers in the employ of the temple (*devadāsīs*) honored the god within the sanctum.

References: Indiana University Art Museum 1965:25, no. 6, no. 30; Heeramaneck 1979: no. 63; Denver Art Museum 1981:18–19.

1. A second *apsarās*, showing the same architectural arrangement (a mate to this piece, though much less elegantly carved), came from the same collection. See Pratapaditya Pal, *The Sensuous Immortals: A Selection of Sculptures from the Pan-Asian Collection* (Los Angeles: Los Angeles County Museum of Art, 1978), no. 43, p. 77.

10.
Celestial Woman
Exterior wall, probably intermediary offset
Provenance unknown, possibly eastern Rajasthan or western
 Madhya Pradesh
(Uparamāla)
About early 10th century
Sandstone; 42.9 x 17.8 cm
The Dayton Art Institute, Gift of Mr. John Goelet; 67.52

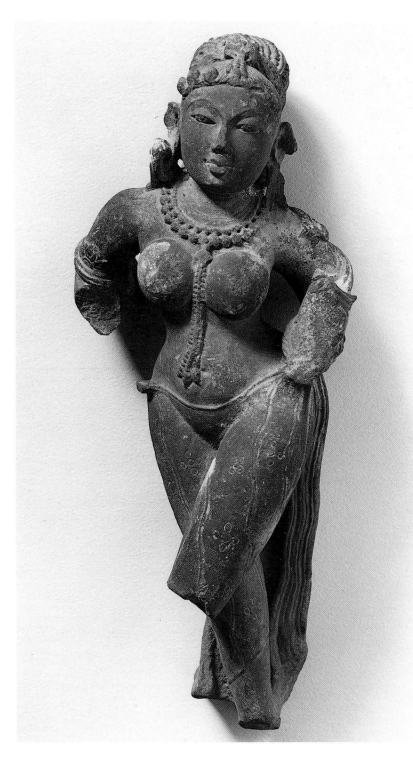

This small and fragmentary yet elegant *apsarās* once likely adorned the intermediary offset of an exterior sanctum wall or that of a hall. Both body and face are ripe but restrained, the flesh soft, breasts and belly gently rounded, full lips pouting and limbs swelling in gentle curves. The subdued ornament and drapery display their own almost fleshlike substantiality. The garment, although clinging to her contours, has a thickness and weight visible at the hem and in the rippling folds, quite different from the more common wavy incisions. Incising is used to indicate the rosette pattern of the textile and also to define the irises, half covered by languid lids, which give the image a lifelike focus.

Anatomy and details indicate that she may have been carved near Mandasor District. Mandasor is a spur of Madhya Pradesh that projects into and is surrounded by modern Rajasthan. In ancient times, it seems to have formed the eastern extension of the Meḍapāta region, connecting it with the area around Udaipur, Rajasthan. However, it is stylistically comparable to ancient Uparamāla. Best known at this period for a large group of images from the site of Hinglajgarh (Fig. 72),[1] scattered fragments from other sites in the area reinforce the impression that Mandasor partook of characteristics from many regions—the sweet delicacy of Uparamāla, the soft fleshiness of Meḍapāta, and the restrained elegance of Daśārṇadeśa-Avantī to the south.

Reference: Gazette des Beaux Arts 1968:47, no. 197.

1. Now mostly in the Indore Archeological Museum.

11.
Celestial Woman with a Lotus Flower

Exterior wall, probably intermediary offset
Provenance unknown, probably Kota region, Rajasthan
(Uparamāla)
About A.D. 950–975
Sandstone; 121.9 x 43.2 cm
The Denver Art Museum, Guthrie Goodwin Collection; 1962.295

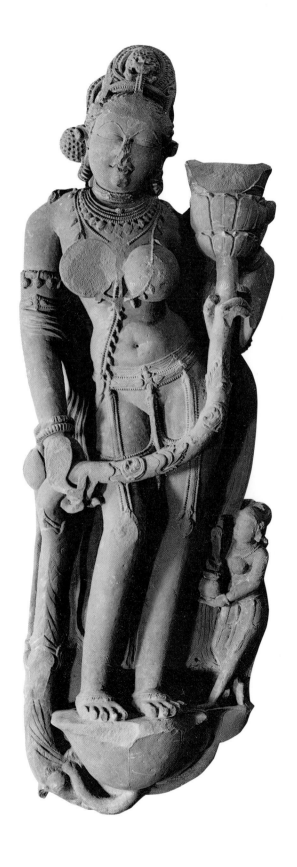

Sacred lotus and fecund young woman, the two most constantly reiterated motifs on the temple, intertwine literally and symbolically. Unlike other plants, germination of lotus seeds takes place within the pod, the ovary, rather than on the ground. Stella Kramrisch writes that "the processes contained in the pericarp on high refer to the mysteries of generation Within the flower the reproductive power has its seat. There, high above the muddy ground, above the water, the whole cycle of vegetation is accomplished."[1]

This celestial woman (*apsarās* or *yakṣiṇī*, among other general names) stands atop a lotus perianth as it grows from the temple body. With both hands she grasps the twisting creeper as it winds upward, crossing her thighs like another limb. It opens in a thick, three-tiered flower between her head and breast. On a secondary floral pedestal by her feet perches a small female attendant bearing a water pot from which bursts yet more vegetation. Another bud springs upward behind the larger stem, showing the multiple stages in the flower's life cycle.

From the thick stalk of the main lotus sprout small flamelike swirls and pointed multilayered leaves. The latter are reflected repeatedly in the woman's jewelry—on leg-drop endings, belt, arm bands, and necklaces. She wears a high beaded coiffure, including a ball that appears to be covered with buds but may replicate a lotus-stalk ornament, typical of the tenth century throughout north India. From the center of the bun peeks a *kīrtimukha*, as if from a *candraśālā* ("moon window"), disgorging pearl chains onto her forehead. She also wears multiple strands of pearls as chokers and necklaces as well as ribbed earrings and bangles. Her diaphanous lower garment reaches her ankles, defined only by lightly incised lines that convey waving parallel folds and a delicate vine border. Also incised, in

157

the center of her forehead, is the eye-shaped mark of the God Śiva, possibly indicating the sectarian affiliation of this minor figure.

The limbs of both *apsarās* and attendant taper somewhat but terminate in thick ankles and wide, flat feet. Breasts are full globes but adhere closely to the body. Despite these features, the flesh, particularly in the midsection, is depicted as gently yielding. Hips are slender and rise well above the belt line before narrowing into the waist.

The *apsarās* displays a face with full, round cheeks and slight double chin, the upper chin projecting as a gentle mound of flesh quite different from the aggressive, dimpled chins of central-eastern Madhya Pradesh and Uttar Pradesh. Her lips, although damaged, can still be seen as precisely drawn and pursed, the corners drilled into hollows of ambiguity. Large, long eyes display incised irises, drilled inner corners and folded lids. In a defined ridge, the brows, nearly joining at the nose, arc upward and then swoop back down to end in a small upturn far at the sides of the face.

Anatomy, physiognomy, details of dress and ornament (for example, the double pearl choker) as well as stone color link this image with those from the Kota region of Rajasthan, particularly with one relatively similar *apsarās* in the collection of the Kota Archeological Museum, said to have come from the site of Kishan Vilas, east of Kota city (Nos. 8, 58, 59). The ball-like breasts, tubular limbs, round face, and relatively sharp carving refer, to a certain extent, to the later female bracket from Baroli (No. 45). The repetition of the multilayered leaf motif and the attention to flesh also link the *apsarās* with many of the numerous sculptures found at the site of Hinglajgarh (Hinglaj Fort) in the Mandasor District of Madhya Pradesh.[2]

Reference: The Asia Society 1984:129, no. 14.

1. Stella Kramrisch, "An Image of Aditi-Uttanapad," *Artibus Asiae*, vol. 19 (1956), pp. 259–70, reprinted in *Exploring India's Sacred Art: Selected Writings of Stella Kramrisch*, Barbara S. Miller, ed. (Philadelphia: University of Pennsylvania Press, 1983), pp. 153–54.
2. The motif of the *apsarās* holding a thick-stemmed oversized lotus in front of her body is rare but found in a sculpture from Hinglajgarh now in the Indore Central Museum, Madhya Pradesh (Fig. 72; AIIS Neg. No. 322.15).

12.
Celestial Woman with a *Vīṇā*

Exterior wall, subsidiary offset or indentation
Harshagiri, Rajasthan
(Mārudeśa-Sapādalakṣa)
A.D. 956
Sandstone; 63.8 x 26.7 cm
Philadelphia Museum of Art, Purchased; 56-75-12

Harshagiri, "the Hill of Joy," rises high above the village of Harshanāth near the town of Sikar in northern Jaipur District, Rajasthan. The windswept site, with a modern temple to Śiva on its highest peak and numerous remains of older monuments covering the crown of the hill, commands a 360-degree vista of sweeping plains. Accessible by a winding road during the dry season, it is frequented by pilgrims scaling the hill on foot throughout the year.

The largest of the older structures is the temple of Harṣadeva (Śiva as God of Joy), called the Purāṇa ("old") Mahādeva. A long inscription discovered at the site in the nineteenth century likely relates to that temple and tells of its construction in A.D. 956,[1] its patronage, and the lineage of the Cāhamāna rulers of the region.

Of the temple itself the inscription reads that the architect "built this delightful house of Śaṅkara (Śiva) with its chapels, the beautiful porch which contains all the gods, like a portion of heaven made by the creator himself."[2] The binding moldings of the sanctum and some lower portions of this porch, actually an open hall (*raṅgamaṇḍapa*), remain intact. Above them, multiple fragments have been haphazardly cemented together to form the living temple as it now stands.

The inscription also notes that in front of the shrine was built "a beautiful court which, laid out with very smooth stones, is level and pleasant for walking."[3] Many of these stones remain in place along with broad stairs leading up to the court and the lower portion of what was once a monumental freestanding arch that marked the entry to the complex. In addition, the lower portions, or basements, of at least nine subshrines, some if not all approximately contemporary with the main shrine, surround the temple.

A number of sculptures from this site, brought together by Martin Lerner in a 1969

article, are now in various American and European collections. While not all necessarily come from the main temple, this exquisite image of a celestial woman, in the pose of a *śālabhañjikā* (tree goddess) against a rectangular relief plane, likely does. Sixteen similar but rather larger reliefs are now lining the interior of the main temple sanctum. Twelve of these must originally have inhabited both equal-width faces of the intermediate offsets of the main shrine, while others probably occupied a similar location on the hall. This smaller relief, along with several of comparable dimension,[4] may have filled the indentations between side offsets.

Behind the willowy form of this celestial woman emerges a thick lotus stalk that twists over her head to shelter her with a wide blossom—a configuration found frequently on the river goddesses flanking the door. Her right hand stretches sensuously behind her head to grasp the stalk. The plant blossoms at her touch and she holds one plucked flower in her left hand. On the base by her feet stand two dwarfish attendants with sagging bellies. The naked dwarf at her left frolics as he touches her leg tassel. The garbed dwarf on the other side holds up to her a large *vīṇā*. The theme of music and dance appears constantly in the sculptures for this temple of joy.

All of the women who once occupied the exterior of the monument stand on wide and naturalistically detailed lotus bases. The lotus stalk grows directly out of the wall plane, a form indigenous to western India and seen frequently in the early tenth century. The woman's body displays malleable flesh with rolls gently indicated at her neck and left side below her breast. Her breasts are fully merged with her body and the belly muscles swell slightly. This smooth yet soft treatment is neither the full fleshiness of Meḍapāta, to the south, nor the harder, stylized anatomy of images to the east.

As on all the Harshagiri sculptures, ornament is crisply and exquisitely carved, from her carefully incised hair with *kīrtimukha* in the bun to the lacy leg drops to her herringbone belt and waving drapery. The image is deeply undercut to allow shadows to give her the effect of a sculpture in the round; yet her stance never leaves a parallel with the relief plane. Although outside of the region, her ornaments, weight, and the softness of carving relate her to sculptures in Meḍapāta datable to circa 940–960 rather than those of 970 and

beyond[5] and confirm the likelihood that the main temple at Harshagiri was indeed erected around midcentury.

References: Kramrisch 1957:30–38, 1960:96, no. 85, pl. 38; Lerner 1969:361, fig. 10; Lanius 1972:81–82, pl. XLIVa.

1. The inscription may be found in F. Kielhorn, "Harsha Stone Inscription of the Chahamana Vigraharaja: The [Vikrama] Year 1030," *EI*, vol. 2 (1894), pp. 116–30; *IA* vol. 42 (1913), p. 57ff. The inscription gives three dates: A.D. 956, A.D. 971/2, and A.D. 973. Kielhorn's reading of verses 47 and 48 makes it clear that the temple itself was completed in A.D. 956, while the date of A.D. 971 refers only to the death of the sage Allata, who was responsible for the construction of the monument. A.D. 973 refers to the inscription itself.

2. Kielhorn, op. cit., p. 128, verse 44.

3. Kielhorn, op. cit., p. 128, verse 42.

4. For example, that in the Musée Guimet and several in recesses flanking the *dikpālas* still in situ on the east corners of the exterior wall of the monument above the binding moldings.

5. For example, the Ambikā temple at Jagat and the Sūrya temple at Tusa (see No. 40) as opposed to the Lakulīśa temple at Ekalingji, the Caturbhuj temple at Isawal, or images from Ahar. However, such cross-regional comparison when determining dates is admittedly dangerous.

13.

Celestial Woman Undressed by a Monkey
Exterior wall, subsidiary offset or indentation
Provenance unknown, probably Khajurāho, Madhya Pradesh
(Jejekādeśa)
About A.D. 975–1000
Sandstone; 60.4 x 26 cm
The Nelson-Atkins Museum of Art, Kansas City, Missouri, Bequest of
 Mrs. George H. Bunting, Jr.; 81-27/26

This sensuous and exquisite *apsarās* was only one of a multitude of similar divine and semidivine figures covering a temple wall. The piece likely came originally from an exterior wall of one of the late tenth-century temples at Khajurāho, religious center of the powerful Candella dynasty.[1]

Founded early in the ninth century, the Candella family, one of the thirty-six Rajput clans, grew into a major regional power in the tenth century after the waning of the Pratīhāras of Kannauj. Under King Dhaṅga (inscriptions range between A.D. 954 and 1002), first ruler of an independent Candella kingdom, Khajurāho began its rapid blossoming into a virtual temple city where a reputed thousand monuments once stood (Fig. 9).

Temples at Khajurāho for the most part consist of a sanctum connected to a large hall and fronted by a porch. On some, the sanctum wall is the exterior wall. Some, however, have an enclosed ambulatory path around the sanctum so that both the sanctum wall and surrounding walls bear figures on their exteriors. On smaller temples of the period, individual *apsarāsas* appear primarily on the intermediary offsets of the sanctum walls. On most of the larger Khajurāho temples with multiple levels of figures, however, this location is occupied by male divinities. *Apsarāsas* come to flank each male on slightly recessed portions of each offset not only on the sanctum exterior walls but also on the walls of the circumambulatory path and exterior walls of the entry halls. Consequently, the larger temples show enormous numbers of such women in an incredible variety of enticing postures (Fig. 74).

The *apsarāsas*, like all the wall figures at this period, with the exception of those on the central offsets, walls connecting hall and sanctum, and on the basement level, are not framed in niches. Rather, they grow directly from the wall plane, perched only on small molded bases. Although no two *apsarāsas* show precisely the same posture, the activities in which the women engage fall into categories relating to favorite types in contemporaneous literature. The placement of a type within any designated location, however, seems more motivated by aesthetics than by meaning.

This *apsarās* struggles to grab her patterned sari as it is snatched off of her by the rambunctious monkey (now headless) at her foot. Although the Khajurāho sculptors focused primarily on linear form and rhythm throughout their three-hundred-year history, tenth-century images do show a keen interest in the tactile quality of flesh. Here, the sculptor lovingly detailed the dimples and creases of the woman's back. Even the grain of the stone has been used to accentuate the roundness of her buttocks. He contrasted the texture of flesh with that of fabric, rather than the more usual jewelry, to accentuate the softness of her body. Each element is brought to tender perfection, and traditional Indian similes come readily to mind: eyes like lotus petals, brows like a curved bow, breasts like ripe melons.

By the tenth century, temples such as those at Khajurāho had grown so large and complex that artists consciously adjusted features depending on the angle from which the individual figure would be viewed. So adept were the Indian stone carvers of this period that it is almost always possible to discover on fragmentary sculptures the specific intended angle of view when all elements of a sculpture suddenly "click" into place.

It is clear from an examination of the intentional distortion of features, such as the eyes, as well as the relative finish of the carving on various parts of the body, that this *apsarās* was intended to be viewed from below and approached from the right. This is just how the devotee walking along the temple platform would approach the image as he or she progressed around the structure in the preliminary rite of clockwise circumambulation.

Reference: Taggart 1983:37, no. 39, cover.

1. See the essay by B. D. Chattopadhyaya.

14.
Mythical Beast (*Vyāla*) on an Elephant–head Bracket

Exterior wall, vertical indentation
Provenance unknown, probably Udaipur region, Rajasthan
(Meḍapāta)
Mid-10th century
Calcite(?); H. 109.2 cm
Courtesy of the Trustees of the British Museum; 1914.8.6.1

A mythical creature possessing a lion's body and composite head, the *vyāla* is one of the most common motifs in sacred architecture throughout the subcontinent. Frequently the head resembles a horned lion (like the *kīrtimukha*, No. 55) but it can also have the trunk of an elephant, a parrot's beak, a goat or even a human face.[1] In north India from the ninth century onward, it appears primarily in relief and tends to be shown rampant, as here, with one rear paw raised high.

Within an architectural context, the *vyāla* seems early on to have acted as a bracket abutting a pillar shaft to support an overhanging cornice. In the south Indian (*drāviḍa*) tradition, it retained this location, eventually abutting the multiple pillars of long colonnades. In the north, however, the motif became integrated into the body of the temple and appears in a limited number of locations (Figs. 82, 74).

In the tenth century *vyālas* of equal stature with exterior niche images came to inhabit the vertical indentations that developed to separate and adjust the projecting portions of the offsets on the temple wall.[2] Very likely the intermediary stage between the *vyāla* as bracket on a pillar and as indentation relief was its placement as a prancing pseudobracket on the *bhadra* niche frame, much as on the frames of sanctum images of deities (Nos. 28, 67). It was a logical move from there to utilize the form in the flanking vertical indentations. Indeed, since the intermediary offset (*pratiratha*) projection, at least in western India, bears a capital like a pilaster, the *vyāla* in the indentation flanking it repeats the earlier pillar-bracket form, now integrated into the wall plane (Fig. 4). Although the image of an *apsarās* can be found both on projecting portions of the wall as well as in the recesses, the *vyāla* is never placed on any projection. After the tenth century in western India, the

vyāla came to be replaced in the wall indentations by the figure of a sage or mendicant (*muni*).

The meaning of the *vyāla*[3] is based on that of the lion and lioness (Nos. 3, 4). The former plays a prominent role in visual arts as the incarnation of power and royalty from at least the fourth century B.C., when it appeared in north India in a form clearly derived from Achaemenid Persian models.[4] Lions support altars and the divine throne and the lioness is the *vāhana* of the goddess.[5] (Nos. 19, 20, 29, 69)

The rearing *vyāla* on the walls of the north Indian temple is almost invariably shown with two male human figures—one riding and the other crouching below the animal's upraised paw. One or both figures can bear sword or shield. Here, the lower figure stabs upward with a sword (now broken) held over his right shoulder while the rider cups his palms in reverent *añjalimudrā*. Although these are images of combat, they are embodiments of power—both royal and metaphysical—rather than displays of violence.

The elephant-head bracket supporting the *vyāla* is an architectural element particularly favored in southern Rajasthan during the tenth century, although found less prominently at other times and in other regions as well. The lion, royal glory, is frequently depicted overcoming the elephant, especially on the thresholds of doorways and on superstructures in central India (No. 3). Yet this bracket type appears in western India below figures other than *vyālas*, particularly *apsarāsas*, and is even used by itself as a bracket on the exterior of the benches that surround porches and open halls. Like so many figure elements in temple architecture then, neither *vyāla* nor elephant-head bracket can be interpreted in a finite, narrative sense.

Above the head of the *vyāla* and across the width of the relief runs a row of

kīrtimukhas (No. 55). This typical "face-of-glory" motif appears all over the temple. Decorative bands formed of repeated *kīrtimukhas* linked by pearl garlands spewed from their jaws become extremely popular from the tenth century onward throughout north India. Called *grāsapaṭṭakas*, these bands are used particularly to top the exterior wall frieze. The band on this fragment would most likely have run across all the undulating planes of the side offsets to be broken only by the tall pediment above the central offset (*bhadra*) niche.

The *vyāla* is a force of nature, and often, as here, the tip of its tail (seen like a huge flame behind the crouching man) and its joints are marked by swirling foliage. Garlands of pearls drape regally over the animal's mane, and its whiskers, undercut eyes, and even tongue are carefully detailed in the fine-grained stone.

The piece undoubtedly comes from a temple in the Meḍapāta region of Rajasthan. In fact, a careful examination of details shows that the carving is nearly identical to that found on the Jaina temple near the village of Ghanerao in southern Pali District, Rajasthan (very near the later important Jaina center of Rāṇakpur). Although this piece does not seem to have come from the walls of the existing Jaina temple,[6] which is datable by inscription to A.D. 954,[7] it was likely carved by the same hands.

Ghanerao in the tenth century was located midway between the territories of the Guhilas of Meḍapāta (modern Mewar) (No. 40) and a branch of the Cāhamāna dynasty located in the town of Naḍḍula (modern Nadol, Rajasthan).

Although the temple at Ghanerao is Jaina, there is nothing on this piece to indicate the sectarian affiliation of the temple from which it came. Apart from certain aspects of the overall temple complex plan and the identities of the sanctum, central offset, basement niches, and certain doorway figures, there is usually nothing in the iconography of the majority of figures covering the temple at this period to indicate whether the structure was dedicated to a Jaina *tīrthaṅkara* ("savior-saint") or to a member of the Hindu pantheon. Indeed, it is evident at some sites (for example, Osian, Khajurāho) that the very same group of artists carved temples for both Jainas and Hindus. The sectarian nonspecificity of this *vyāla* emphasizes the danger of correlating style with sectarian affiliation in early "medieval" India.

1. M. A. Dhaky, *The Vyāla Figures on the Mediaeval Temples of India* (Varanasi: Prithivi Prakashan, 1965).

2. See the essay by Darielle Mason.

3. Vasudeva Saran Agrawala, rev. and ed., *Samarāṅgana Sūtradhāra of Mahārājadhirāja Bhoja, The Paramāra Ruler of Dhārā* (Baroda: Oriental Institute, 1966), p. 643; Kramrisch, *The Hindu Temple*, p. 333ff.

4. Images of lions and tigers (interchangeable in the Indian context) appear as early as the third millennium B.C. in seals from the Indus Valley civilization (e.g., Interlinked Tigers on steatite seal from Mohenjo-Daro now in the National Museum, New Delhi).

5. Kramrisch, *The Hindu Temple*, pp. 332–37.

6. All *vyālas* are in place and show certain differences in organization. Directly above them is a small figure composition and the platform above the elephant-head bracket is articulated as an oriel displaying the slanted seat back (No. 33).

7. M. A. Dhaky, "Some Early Jaina Temples in Western India," *Shri Mahavir Jaina Vidyalaya Suvarnamahotsava Grantha*, 2 vols. (Bombay: Shri Mahavir Jaina Vidyalaya University, 1968), p. 332: "Informed sources say that the image in the sanctum once had a pedestal bearing a date equivalent to 954."

15.
Mythical Beast (*Vyāla*)

Exterior wall, vertical indentation
Provenance unknown, probably western Madhya Pradesh
(Gopādri or Daśārṇadeśa)
About late 11th century
Sandstone; 62.2 x 22.2 cm
The Brooklyn Museum, Gift of Martha M. Green; 76.179.3

The counterbalancing of tubular solids creates an intricate play of masses in this image of a *vyāla* with warriors. The rotundity of the beast's cheeks and muzzle and the gentle, though complete, torsion of its body belie the supposed ferocity of its great bulging eye. The diminutive warrior astride the *vyāla*'s back is licked by a beamlike tongue and is surrounded by a monstrous paw. In a responsive movement, the arm of the stately warrior kneeling below entwines the animal's tail. The emphasis on flowing lines and smooth solids, minimization of surface detailing, contorted postures, and anatomical abstraction typify images of the later eleventh and twelfth centuries in central north India. Almost absent are the rich vegetal joints of earlier *vyālas*. The florid tail end is understated, and cordlike lines define the creature's mane. The lower combatant wears a flat chest wrap and scarf typical of eleventh-century fighters.[1]

This *vyāla* likely inhabited a vertical indentation on the temple's exterior wall as did the previous piece (No. 14). On the *vyāla* from Meḍapāta, however, the integration of the upper decorative band, which ran just below the cornice on the monument, shows that it came from a fairly small structure. This *vyāla*, on the other hand, likely occupied one level of a multistoried wall. It was probably carved for a temple in ancient Gopādri or Daśārṇadeśa built during the overlordship of the Kacchapaghāta dynasty in the eleventh century. Multiple levels of sculpture on the wall (that do not indicate actual multiple stories on the interior) were a common feature of temples throughout central India from at least the mid-tenth century onward.

Rather than the elephant-head bracket of the previous piece, a molded base with double sawtooth below supports this *vyāla*. Such simple bases are also typical of central India. By this time in western India the *vyāla* had been replaced in the recesses of the wall by the male ascetic (*muni*). The motif of the *vyāla* continued to inhabit the recesses only in more easterly regions.

1. Not to be confused with a similar chest wrap (*kuchabandha*) and scarf (*dupaṭṭā*) worn by female figures.

16.
Dancing Gaṇeśa
Probably exterior wall, central offset
Provenance unknown, probably central-eastern Madhya Pradesh or
 neighboring Uttar Pradesh
(Madhyadeśa)
About 8th century
Sandstone; 125.7 x 67.3 cm
The Asia Society, New York, Mr. and Mrs. John D. Rockefeller 3rd
 Collection; 1979.13

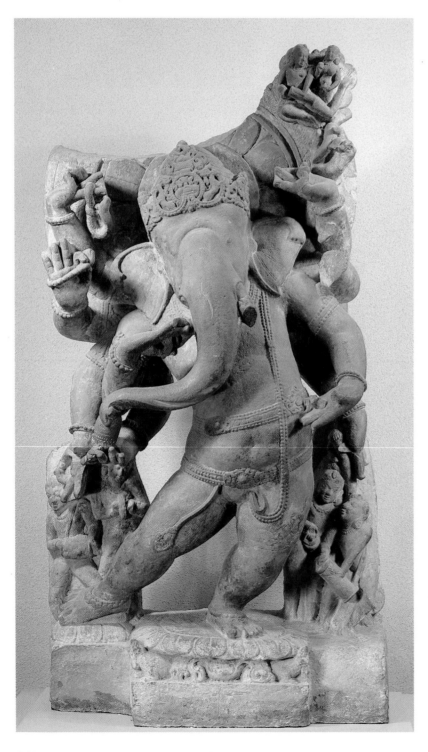

Gaṇeśa, elephant-headed Lord of Easy Passage and Good Fortune, sways his corpulence in graceful dance. A host of celestial musicians accompanies him on cymbals and drums. Most of Gaṇeśa's ten hands are held in a variety of dance postures. In two he carries the rosary and snake while a third grasps his broken tusk.

India abounds with legends about this deity. According to one, Gaṇeśa overindulged in his favorite sweets (his trunk is on the verge of snatching another). While riding his *vāhana*, the rat (seen beneath the lotus pedestal), he tumbled from its back and his stomach burst. The moon, gazing down at the sight, laughed. In embarrassed anger, Gaṇeśa snapped off one tusk and hurled it skyward; therefore, he is portrayed with the broken tusk in hand.

Legends also give Gaṇeśa a variety of origins, but in all he is somehow created by or born of Pārvatī and Śiva. The lion-skin skirt, delicately etched on his legs, connects him with the wild, ascetic Śiva, as do the snake and the matted locks of hair peeking from behind his crown. In the temple setting, however, he appears in various locations in monuments of many sect affiliations, not only in connection with the Śaiva pantheon.

Behind Gaṇeśa's head is set a large lotus halo surrounded by a hatchworked circle. Above it, a flying couple beats percussion to accompany the god's dance, as do the four male attendants at the base. The flying figures are backed by a stylized cloud, a convention particularly popular and visually prominent in the sculptures from Madhyadeśa and Dāhaladeśa in Madhya Pradesh throughout the eighth to tenth centuries, but met with in the south as early as the late sixth century.[1]

The format of this image makes it likely that it fit into a large exterior wall niche, probably on a Śaiva temple (although possibly on one dedicated to Sūrya, the sun). When placed in such a context from at least the

eighth century onward, Gaṇeśa often appears in the *bhadra* (central offset) niche of a southern wall (No. 1).[2]

Scholars who have published this sculpture have called it eighth century,[3] ninth century,[4] and ninth to tenth century.[5] A close examination of the carving as well as certain details, particularly of ornament, seems to warrant an early date—probably no later than the end of the eighth century.

Ornament is simple, as are the round lotus pedestal with stem, layout of figures and pierced relief ground. This Gaṇeśa is really carved in the round, the features of his back roughly but fully chiseled. The naturalism of the lotus pedestal as well as the soft undulating flesh and weight of the bodies also indicate an early date. The particular form of the *kīrtimukha* in the center of the crown, more monkey than lion, as well as the dimensionality of the foliate scrollwork connect this image of Gaṇeśa with monuments of the eighth century.[6] These forms retain a taste of earlier structures, such as the Muṇḍeśvarī temple at Ramgadh, Madhya Pradesh, datable to A.D. 636,[7] that are just emerging from Gupta conventions—conventions where the vegetal and animal forms that become stylized ornament by the ninth century still retain a clear vision of their prototypes in nature.

References: Lee 1975:17, 20, no. 8; The Asia Society 1981:11, 1982:3; Sutton 1983:364, fig. 9; Newman 1984:44, 75, 84; Bird et al. 1985:28, fig. 6; Chandra 1985:112–13, no. 46; Courtright 1985: pl. 1; Pal 1986:71, no. 16.

1. Doorway of Aurangabad Cave No. 6. See *EITA*, vol. 2, pt. 1, pl. 220.

2. See the essay by Darielle Mason.

3. Richard Newman, Paul Courtright.

4. Pramod Chandra.

5. Robert Brown.

6. See, for example, the probably late eighth-century fragment from Ahar, Madhya Pradesh, in the Archeological Museum, Lucknow University (*EITA*, vol. 2, pt. 2, fig. 168).

7. Ramgadh is located southeast of Varanasi. See *EITA*, vol. 2, pt. 1, pp. 115–23.

17.
Twenty-armed Gaṇeśa
Probably exterior wall, central offset
Provenance unknown, probably central-eastern Madhya Pradesh (Dāhaladeśa)
About early 10th century
Sandstone; 68.3 x 23 cm
James W. and Marilynn Alsdorf Collection, Chicago

His twenty arms fanned out around him like a halo, this dancing Gaṇeśa, elephant-headed Remover of Obstacles, combines extraordinary exuberance with a gentle, inward hesitancy. Left leg stepping forward in the dance, heel slightly raised to stamp, and right knee bent, he swings his hip and bulging belly backward, counter-balancing with his head and opposite shoulder. In his many hands Gaṇeśa holds an array of attributes, including his own broken tusk (No. 16) as cornucopia bursting with foliage (upper left hand), a reference to his early role as Lord of Agriculture and thus fertility.

As his name implies, he is lord of Śiva's host of rotund dwarfs (*gaṇas*) who mimic his own corpulence, probably indicative of his origin as a *yakṣa* or early Indian local nature spirit. Son of Śiva and Pārvatī, Gaṇeśa holds Śiva's smiling snake (upper right hand), crescent moon (center left), and skull cup (center right) as well as the conch (center left) and mace (center right) that may indicate an attempt to incorporate Vaiṣṇava affiliation.[1] His supple, curling trunk plucks a sweet ball from the ubiquitous bowl in his forward left hand. Other hands display *mudrās* of the dance and musical instruments. Gaṇeśa dances on a lotus pedestal similar in form to the earlier Gaṇeśa (No. 16). To his left a long, lithe rat, his *vāhana*, twists upward to gaze appreciatively at the god, while a second rodent crouches nearby. Directly above the god's head, a heavenly garland-bearer projects *en face* from an ornamental, multilayered cloud. Flanking clouds hold celestial couples playing music to accompany the dance. Additional musicians at the god's feet beat percussion as they sway vivaciously to the divine rhythm.

Gaṇeśa's corkscrew pose with one shoulder forward to balance an outthrust hip, seen even more clearly in the dancing drummer by the god's right leg, is a typical

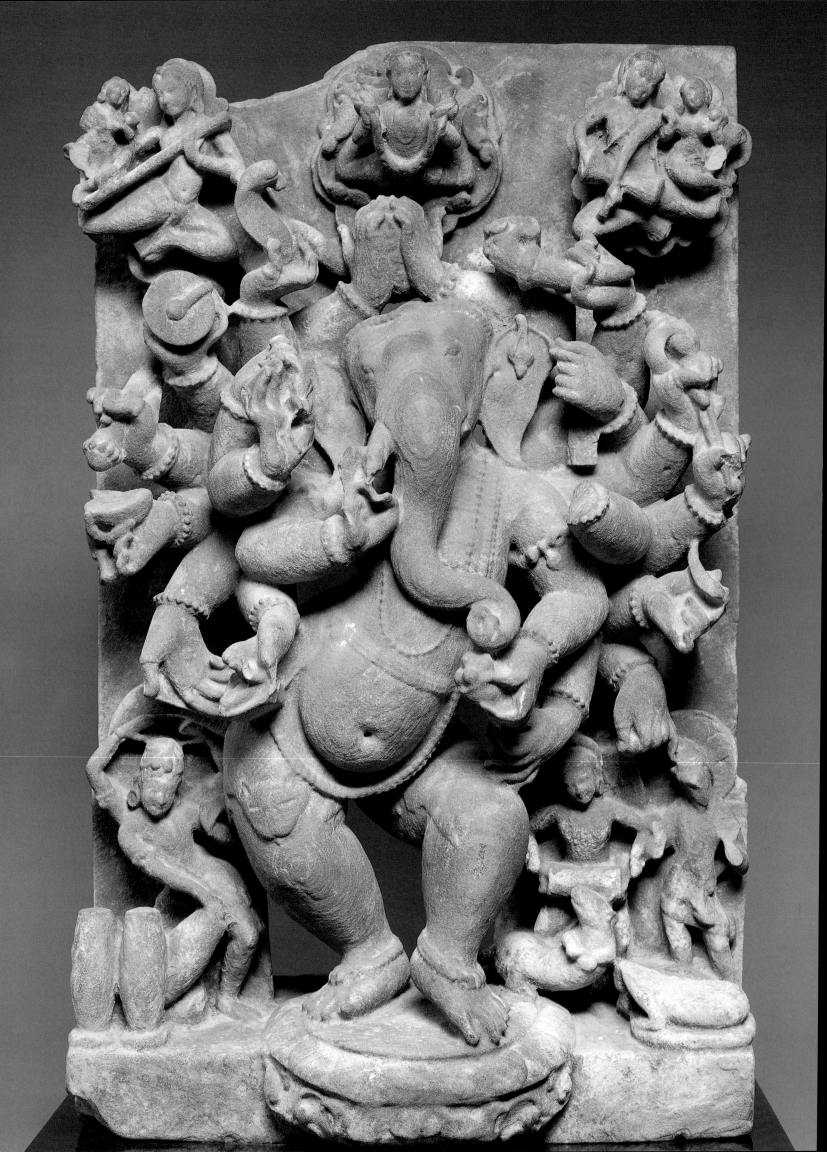

posture for moving and attendant figures from the ancient Ḍāhala region (especially eastward between the Mandla and Shāhadol districts of Madhya Pradesh,[2] Nos. 49, 50, 61) in the tenth century.

The heart-shaped faces with pointed chins, the heads often tilted gently sideways with the chin tucked slightly to the chest, and the gentle expressions also link the image with this easterly region. They are quite different from the forceful, sharp, and extroverted carving of other, probably later, images from the region, such as the monumental Śiva and Pārvatī from Gurgī now in the city park of Rewa.

Very little work has been done on the many images and standing monuments from this area to sort out the regional carving idioms which produced a range of spectacular sculpture during the tenth and eleventh centuries, most primarily under the patronage of the Kalacuris (Haihayas) of Tripurī near Jabalpur (No. 61). There may have been a number of quite distinct carving traditions (regional idioms) appearing simultaneously in the general area, as R. N. Misra speculates;[3] or, as Michael Willis hypothesizes,[4] the general trends may be more closely related and grosser differences are due to the passage of time.

In terms of architectural placement, such dancing images of Gaṇeśa show up in *bhadra* niches, usually on the south wall (No. 16), as well as in the niches superimposed on base moldings, where they tend to appear at the beginning of the clockwise circumambulation. Gaṇeśa is also the habitual inhabitant of subshrines. He is found, for example, in the sanctum of the southeast shrine in a common arrangement where four small subshrines surround a large central shrine (*pañcāyatana*).

1. See H. D. Bhattacharya in *The Age of Imperial Kanauj*, vol. 4 of *The History and Culture of the Indian People*, R.C. Majumdar, ed., 3d ed. (Bombay: Bharatiya Vidya Bhavan, 1984), p. 345.

2. See, for example, the dancing *gaṇas* and river goddesses of the spectacular doorway at Arjula, Shāhadol District, in R. N. Misra, *Sculptures of Ḍāhala and Dakshiṇa Kośala and Their Background* (Delhi: Agam Kala Prakashan, 1987), pl. XB, or the Dancing Gaṇeśa in the sanctum of the Kālika temple, Singhpur, Shāhadol District (AIIS Neg. No. 101.94).

3. R. N. Misra, op. cit., pp. 69–98.

4. J. S. Turner, ed., *Dictionary of Art* (London: Macmillan, forthcoming).

18.
Gaṇeśa with His Consorts

Probably exterior wall, central offset, basement niche, or subshrine sanctum
Provenance unknown, probably eastern Rajasthan (Śūrasena)
About A.D. 1000–1050
Sandstone; H. 41.5 cm
Museum of Fine Arts, Boston, John H. and Ernestine A. Payne Fund, Helen S. Coolidge Fund, Charles B. Hoyt Fund, and Asiatic Curators' Fund; 1989.312

Figure style and subject harmonize ideally in this image of the corpulent Lord Gaṇeśa executed in the heavy, bursting volumes of sculpture from ancient Śūrasena (parts of eastern Rajasthan and neighboring Uttar Pradesh). The austere ornament of the relief surface, from which the figures are almost fully released, emphasizes their pneumatic, fleshy presence. Overwhelming the pierced, drumlike throne on which he rests, Gaṇeśa, Auspicious Lord of Safe Passage and Success, tilts his elephantine head and gazes benevolently at the worshiper.

On the god's rotund thighs perch his consorts. Dwarfed by their lord, each stretches an arm upward to entwine his amplitude tenderly. One may be Riddhi ("abundance," "prosperity"), holding a lotus, the other Siddhi ("accomplishment," "attainment"),[1] carrying a bowl of *modakas* or *laḍḍu*, a kind of sweet ball used frequently as *prasāda* (the food presented to the god) in temple ritual. One *modaka* has been stolen from the bowl by Gaṇeśa's *vāhana*, the rat, who blithely gnaws on it with anthropoid teeth, in the center of the stepped image base. Flanking the rat two devotees kneel, their hands folded in reverent *añjalimudrā*.

In his right hand, Gaṇeśa holds what appears to be a mace but may originally have had the curved spike of an elephant goad (*aṅkuśa*), a frequent attribute. A snake, reminiscent of his father, Śiva, encircles his neck. Like the rat with a sweet ball, its forked tongue licks a pearl. The god's multilevel *karaṇḍamukuṭa* ("basket crown") is topped by a tiny *āmalaka*, mimicking the *śikhara* of the temple itself.

Ornament, like the thick, hourglass pearl necklace on the god or the side-swept tassels between the women's breasts, combines with the flattened molding forms, solid flesh, and anatomical features such as the prominent brows turning upward at both ends and tubular waists to indicate a date

169

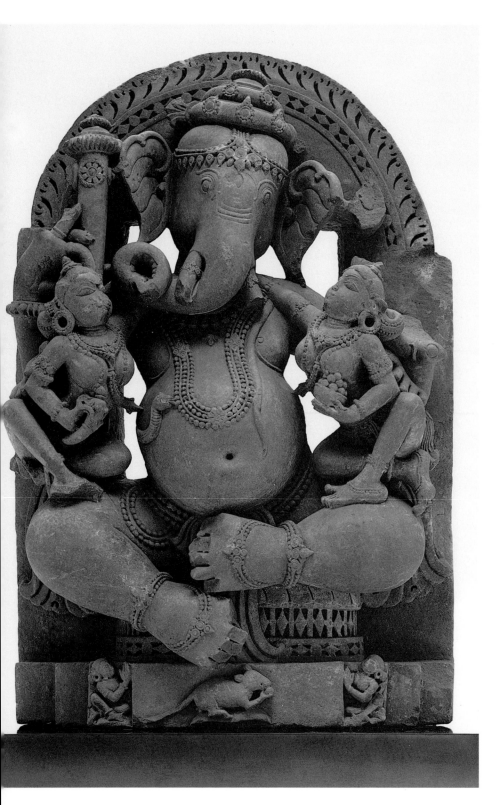

sometime in the first half of the eleventh century.

This is confirmed by looking at an image of Gaṇeśa dancing from Paranagar, thirty-eight miles southwest of Alwar, dated on its base inscription to A.D. 1044.[2] Although clearly not by the same hand, correspondences in anatomy, detail, and ornament are close enough to speculate that the seated Gaṇeśa originates in a nearby area and dates only slightly earlier. An even closer stylistic accord is with some of the other images from the numerous ruined temples at Paranagar, such as some on the Nīlakaṇṭha temple, which most likely dates to the eleventh century.[3]

References: The Asia Society 1991:106, fig. 7; Museum of Fine Arts, Boston 1991:206–07, no. 198.

1. These two figures cannot be positively identified as Riddhi and Siddhi. Other consorts of Gaṇeśa include Buddhi ("knowledge," "perception") and Śrī (Lakṣmī), Goddess of Wealth. The attributes of these consorts are complementary characteristics of the God.

2. For sculptures from Paranagar, Alwar District, Rajasthan, see Pupul Jayakar, "Medieval Sculpture: 11. Paranagar (Alwar)," *Mārg*, vol. 12, no. 2 (March 1959), pp. 61–73. This inscribed image of Gaṇeśa is in the Government Archeological and Art Museum, Alwar, no. 2/3 and is dated Vikrama-Saṁvat 1101. The AIIS archive label states that the image is said to be from Rajorgarh in the Alwar District. Jayakar, however, states that it comes from Paranagar, which seems likely. (AIIS Neg. No. 157.61)

3. According to Jayakar, op. cit., p. 62, "An inscription bearing the date of Saṁvat 1010 [A.D. 956] is said to have been found ascribing the [Nīlakaṇṭha] temple to one Ajayapal Raja of the Bargujars. Another source ascribes it to Lach, also one of the Bargujar kings." On stylistic grounds, however, the temple can date no earlier than ca. A.D. 1100.

19.
Durgā Destroying the Buffalo Demon

Possibly exterior wall, central offset, or sanctum image of a
 miniature shrine or votive image
Provenance unknown, probably Mathura region, Uttar Pradesh
(Śūrasena)
About late 9th century
Sandstone; 22.9 x 15.2 cm
The Metropolitan Museum of Art, Gift of George D. Pratt, 1933; 33.65.2

The "Destroyer of the Buffalo Demon" (Mahiṣāsuramardinī) is a favorite epithet of the great Goddess, Durgā. As recorded in the *Devī Māhātmya* section of the *Mārkaṇḍeya Purāṇa*, the gods, helpless in the face of the demon Mahiṣa ("buffalo"), pooled their energies to form the Goddess Durgā (Nos. 20, 21, 69). Just as the Saptamātṛkās, the "Seven Mothers" (No. 62), show their specific divine affiliation by holding the characteristic attributes of individual male gods, Durgā Mahiṣāsuramardinī, embodied energy (*śakti*) of all the gods, holds attributes of the entire pantheon in her multiple limbs.

In this small, abraded, but nevertheless powerful image, Durgā rests a triumphant foot (complete with miniature lotus pedestal) on the inclined back of the subdued buffalo. The great strength of the buffalo is indicated by the small man crushed beneath his hoof—yet the Goddess is greater. The buffalo's head is intact, but from its neck rises the demon in human form, wrenched out by Durgā's firm grasp on his hair. She has used the weapons of the gods well—Viṣṇu's *cakra* (discus) lies embedded in the buffalo's shoulder blade; with Śiva's trident she spurs the human demon to rapid capitulation.

Mahiṣāsuramardinī appears in sculpture throughout the subcontinent, but the interpretation of the theme differs significantly from region to region. In south India, for example, she either stands atop the buffalo's head with no body present or rides her lion toward combat with a Mahiṣāsura exhibiting buffalo head and human body. In the far eastern region of Orissa, he again appears with human body and animal head but, there, she stands with her foot planted triumphantly on his back. In western India, where this theme is particularly popular, she is most frequently rendered with the buffalo in full animal form. She stands above, triumphant, her trident thrust into the animal's shoulder (Fig. 68). Usually she has

severed the head of the buffalo, and the demon, in full human form, emerges from the stump to bow in homage.

In central India (including southern Uttar Pradesh), the theme is somewhat less popular. When it does appear, as here, the tendency is to follow the western Indian convention of showing the buffalo in animal form but to vary the method of the demon's appearance idiosyncratically. The demon could emerge from the mouth of the severed head, for example, or, as here, directly from the unsevered neck.

This relief of Mahiṣāsuramardinī can be attributed to the Mathura region, a major artistic center in the earlier Kuṣāṇa and Gupta periods, on the basis of several closely related pieces now in the possession of the Government Museum, Mathura. The most complete is an image of a seated animal-headed goddess (she may be the boar-headed Vārāhī). This relief of the seated goddess has similar surrounding elements: beaded halo, flying garland-bearers, and, most significantly, the identical flat swirling vine motif on the base. It is also of similar size. Another closely associated piece in the same museum, unfortunately with the lower half absent, is a relief of Viṣṇu as the dwarf Vāmana. Again the elements are nearly identical with the additional good fortune that the find spot of the piece has been recorded—the Mansa well in the village of Palikhera in Mathura District. It is extremely likely that all pieces were discovered together in this spot, extended immersion accounting for their weathered condition.

The square solidity, particularly in faces, so familiar in earlier sculpture from the region, reappears. The important religious center of Mathura, today in Uttar Pradesh, formed, with the regions around Bharatpur and Alwar in Rajasthan, ancient Śūrasena (Nos. 18, 28). Although practically nothing from the period stands around Mathura

today, loose sculptures displaying chunky bodies and wide, square faces show the areas to have exhibited a stylistic continuity.

This relief of Mahiṣāsuramardinī, like the related pieces in the Government Museum, Mathura may have once constituted the *bhadra* niche image on a very small shrine, although it could also have acted as sanctum image for a miniature shrine (No. 1) or even as a loose votive sculpture. If it did indeed rest in an exterior wall, it may have been placed in a north-facing niche, as is usual when Mahiṣāsuramardinī appears on the temple of a male deity (Śiva or Sūrya). On a goddess temple, however, she may have been placed in the *bhadra* niche opposite the entrance, thus either on the west wall or, as many goddess temples are oriented toward the north, on the south.

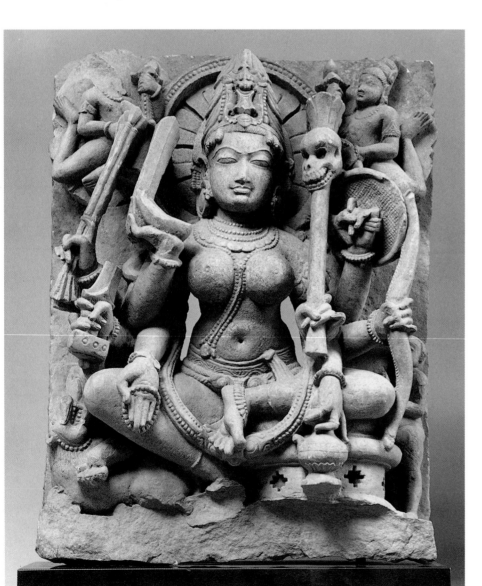

20.
Durgā with a Lion
Probably exterior wall, central offset
Provenance unknown, probably south-central Uttar Pradesh (Madhyadeśa)
About mid-10th century
Sandstone; 48.9 x 36.2 cm
The Denver Art Museum, Gift of Elizabeth B. Labrot in memory of Marjorie Mclntosh Buell; 1983.266

Sensuous and delicate yet formidable, the great Goddess Durgā sits enthroned in the posture of royal ease. Her eight arms fan out around her from the elbows, bearing a plethora of weapons and ritual objects. Prominent are a mace with grinning skull and a drinking cup formed of a human cranium that emphasize her connection with the darker side of the deity. Although carefully arranged curls adorn her forehead, she is crowned with the ascetic's matted coils of hair like the God Śiva. Below her knee her lion *vāhana* twists upward, baring its teeth.

Durgā is the name of the great Goddess in her supreme form. She is *śakti*, the energy that animates the universe and the gods; without her both are inert. She protects against adversity and, to her devotees, the Goddess is the universal creator, all is within her. Like Śiva and Viṣṇu, she has many aspects—Kālī is her destructive force, Pārvatī or Lakṣmī her beneficent, but as Durga alone she carries all stages of the universe within her.

The ornaments and anatomy of this sculpture, such as the high globelike breasts and short waist, as well as the treatment of weapons, seem to relate her to sculptures from Madhyadeśa, including the somewhat later *yoginī* (No. 30) from Kannauj.

References: The Art of India. 1969:24, pl. 10; The Asia Society 1984:129, no. 14.

21.

Cāmuṇḍā
Probably exterior wall
Provenance unknown, probably Rajasthan
(Meḍapāta or Mārudeśa)
About early 11th century
Sandstone; H. 113 cm
The Metropolitan Museum of Art, Anonymous and Rogers Fund, 1989;
 1989.121
(*Note: Restoration of the figure's right eye was undertaken subsequent to the
 taking of the photograph on the previous page.*)

Most deities on the north Indian temple are portrayed with the ideal bodies of young maturity. Women show the ripe, full breasts and taut, soft flesh that epitomizes fecundity in human form. In startling contrast is the image of the Goddess in her form as Kālī, the Dark One, given the epithet Cāmuṇḍā from her act of decapitating the demons Caṇḍa and Muṇḍa.[1]

Cāmuṇḍā embodies barrenness and decay. Flaps of loose skin and dry, drooping dugs cover her chest. A scorpion explores the hollow of her cavernously emaciated belly, its many legs repeating the twelve scrawny arms that radiate from her shoulders. Her eyes bulge from hollow sockets and tendons protrude from her neck. Cāmuṇḍā's coils of unkempt hair are bound with a diadem of skulls, flayed tiger skins wreathe her thighs. A snake entwines her neck as ornament, its body echoing the swags of her sagging skin.

Even more than Śiva in his dark form as Bhairava, such macabre images of the Goddess are common occupants of the exterior walls of temples. They appear both on shrines dedicated to Śiva and those to the Goddess herself. Rarer are monuments actually focusing on the Goddess in this hideous form. Cāmuṇḍā is also a member of the set of Seven Mothers, the Saptamātṛkās (No. 62), which at times can be carved as large images to inhabit the indentations between offsets on the exterior temple wall.

Although she is missing her extremities, it is clear from comparison with related images that this Cāmuṇḍā stood with legs straight, the right turned outward. Her front left hand would have been raised, a finger (of which a fragment remains) pointing into her grimacing maw. The starkness and uncompromising horror of this sculpture indicate an origin in Rajasthan or western Madhya Pradesh. Images of Cāmuṇḍā from more easterly regions, although gruesome, tend to have softer forms with the appearance of an overlayer of flesh. The erectness of her head, the breasts that emerge from under the folds of skin on the upper chest rather than overlapping them, and the squareness of the jaw also indicate a provenance in western India, possibly Meḍapāta. The extreme stylization of anatomy, however, makes attribution difficult pending a thorough survey of the type.

1. Recounted in the *Devī Māhātmya* section of the *Mārkaṇḍeya Purāṇa*.

22.
Śiva Slaying the Demon Andhaka

Exterior wall, central offset
Provenance unknown, probably southern Uttar Pradesh
 or neighboring Madhya Pradesh
(Daśārṇadeśa)
About second half of the 8th century
Sandstone; 69.2 x 41 cm
The Brooklyn Museum, Gift of the Ernest Erickson Foundation;
 86.227.145
(Note: Photograph is on previous page)

The Lord Śiva takes many forms, some beneficent and some horrific and vengeful for, like Viṣṇu and Durgā, he, within himself, is creator, preserver, and destroyer. Like many of Viṣṇu's avatars, Śiva often manifests in the human realm to destroy a variety of *asuras* (demons, titans) who, usually from excessive pride, ravage the earth and threaten divine order. Such was the case with Andhaka, king of the *asuras*, whose hubris led him to attempt the abduction of Pārvatī as she rested with her lord on rocky Mount Kailāsa (No. 23).

Śiva appears in this image as a fierce eight-armed avenger. A mass of flaming spiral curls forms his hair. He is fanged, bearded, and draped in a skull-studded garland. A ferocious, toothsome *kīrtimukha* adorns his short leg wrap, and a cobra ties itself around his neck. In his backmost arms he lofts a flayed elephant—a reference to another vengeful manifestation. It encircles his head like a gruesome halo, the tenderly rendered head hanging limply at the upper right of the relief. Another of Śiva's arms holds the *ḍamaru*, a double drum played with a swinging bead. The forefinger of his front left hand points upward in the gesture of rebuke and warning (*tarjanīmudrā*). In two hands he grasps the shaft of his trident (*triśūla*), its prongs embedded into the skeletal remains of Andhaka, whose spilled blood he catches in a skull bowl held below the body.

The emaciated goddess Yogeśvarī (Kālī, No. 21) sits atop the rocks at Śiva's left. She also raises a skull bowl to catch the drops, for each drop of Andhaka's blood is transformed into a new demon as it touches the ground. At the lower left cowers Pārvatī. Below the upraised foot of the god a man kneels in adoration. His identity is unclear; he may represent one of the gods, grateful for Śiva's intercession, or he may be Andhaka himself, transformed through his annihilation into a devotee, but more likely he is one of Śiva's

fighting host of dwarves (*gaṇas*).

On Śiva temples in north India the god appears in a number of vengeful forms. These tend to occupy the south-central (*bhadra*) niche on the exterior wall of shrines where they occur. Usually a more universal form of the god, such as Naṭeśa or Yogeśvara, appears in the west or back wall niche, while the goddess occupies the north. Indeed, western Indian texts on temple building dating from at least the eleventh century state this arrangement explicitly.[1]

Among other features, the rectangular faces and closely set eyes, which are pointed at the outer corners, tie this piece to images from ancient Daśārṇadeśa, particularly those of the late eighth-century Jaina temple 12 at Deogarh. Monuments and sculptures in this area at this time were likely produced under the sway of the Gurjara-Pratīhāra rulers (Nos. 51, 53, 57).

1. Dhaky, "Kiradu and the Māru-Gurjara Style of Temple Architecture," *Bulletin of the American Academy of Benares* (1967), pp. 35–45. In discussing the arrangement on the Someśvara temple at Kiradu in far western Rajasthan (datable to ca. A.D. 1020), Dhaky notes that the south *bhadra* houses Andhakāsura, the west Naṭeśa, and the north Cāmuṇḍā. He writes, "Thus, the Someśvara temple is one of the earliest fanes where these deities are placed on the walls according to the injunctions of the western Indian *vāstuśāstras*." Earlier structures with a similar order include the Ghateśvara temple at Baroli, where Gajāsuramūrti occupies the south, Naṭeśa the west, and the goddess the north *bhadra*.

23.
Rāvaṇa Shaking Mount Kailāsa
Exterior wall, central offset or basement
Provenance unknown, probably northeastern Rajasthan
(Mārudeśa-Sapādalakṣa)
About mid-9th century
Sandstone; 53.3 x 43.2 cm
Seattle Art Museum, Eugene Fuller Memorial Collection; 67.134

The gently smiling faces of the participants in this narrative belie the story's drama. Highly stylized rocky crags of holy Mount Kailāsa—inhabited by birds, snakes, and twisted trees—separate the composition. Below, many-headed Rāvaṇa, Demon King of Laṅkā, angered by his exclusion from Śiva's Himalayan home, reaches upward to shake the mountain from its foundations. His spiderlike arms bristle with diverse weaponry. Śiva rests above him on a round throne as Pārvatī, glancing downward toward the shaking rock, clutches her husband. Śiva, calm and all-powerful, presses his right toe against the mountain. The demon is quelled and imprisoned. At Śiva's knee stands his elephant-headed son, Gaṇeśa. Skanda, in a helmet but lacking his usual peacock, completes the family scene.

The base of the niche displays a curving molding overlaid with lotus petals typical of northern Rajasthan. The narrative is framed between pilasters with foliate capitals, the round shafts interrupted by ribbed bands reminiscent of the *āmalakas* that crown the temple tower (*śikhara*) and separate its smaller corner levels. This pilaster type became particularly popular in northern Rajasthan from about the third quarter of the ninth century through the mid-tenth.[1] Male and female attendant figures on lotus bases emerge from the upper half of the shafts.

The top portion of the relief, behind the heads of the divine couple, has been scraped clean. Judging from a later example at a related site,[2] the pilaster capitals were originally crowned by brackets from which sprang a semicircular *toraṇa* to overarch and frame the heads of the couple.

An earlier but closely related relief of the same scene comes from the site of Abaneri in Jaipur District, Rajasthan. Now in the Government Central Museum of Jaipur,[3] this relief shows certain differences in treatment indicative of its earlier date. For example, the rocks are less extremely stylized (in line with that of No. 22) and *ghaṭapallava* (vase-and-foliage) pilasters are utilized, which became more popular as a framing element early in the ninth century. In addition, there is greater movement in the Abaneri piece, particularly the lower portion. Figures are presented more as characters in a dramatic narrative than as the individual icons they became by midcentury.

Stylistically and iconographically, however, the Abaneri relief is clearly the forerunner of this image.[4] The petite bodies with tapering limbs, tiny waists, bulging cheeks, and sweet expressions are but a few of the characteristics indicating that this relief originally adorned a temple niche in the area of northern Rajasthan probably under the control of the Cāhamāna dynasty of Śākambhari (the area of ancient Mārudeśa termed Sapādalakṣa). This relief can be seen as intermediary between works from the early ninth-century temple of Harṣamātā at Abaneri (Nos. 6, 55) and the somewhat later carvings from the same region at, for example, the site of Nimaj in Pali District.[5]

The increased schematization of motifs such as the rocks and the hardening and sharpening of features, even the incised eyebrows, are all characteristics found at the Nimaj and even at the later and somewhat removed mid-tenth-century site of Harshagiri (Nos. 12, 43, 48). Indeed, the piece follows a clear chronological trend and aids in understanding the continuity of regional idiom apparent in the formally coherent area under Cāhamāna control.

Reference: Trauber et al. 1973:101.

1. This would be from about the time of the Pīpalādevī temple at Osian through the mid-tenth-century Nīlakaṇṭheśvara temple at Kekind (Jasnagar).

2. Mātā temple at Nimaj, Pali District, Rajasthan.

3. AIIS Neg. No. 157.79, Government Central Museum of Jaipur 59/64; Stella Kramrisch, *Manifestations of Shiva*, (Philadelphia: Philadelphia Museum of Art, 1981), pp. 52–53, no. 44; R. C. Agrawala, "Rāvaṇa Uplifting the Kailāsa: An Unpublished Stone Relief from Rajasthan," *Bharatiya Vidya*, vol. 16, nos. 3, 4 (1956), pp. 53–54.

4. A frieze showing Naṭeśa in the Museum für Indische Kunst, Berlin (MIK I 10140) may come from the same temple as this image.

5. Monuments from this period are published in *EITA*, vol. 2, pt. 2, chap. 33 (Nosal, Khidarpura, and Bhavanipur).

24.
Umā-Maheśvara
Probably exterior wall, central offset
Provenance unknown, probably around Allahabad, Uttar Pradesh
(Madhyadeśa)
About mid-8th century
Sandstone; 59.7 x 41.9 cm
The Dayton Art Institute, Museum purchase with funds provided in large part by
the Honorable and Mrs. Jefferson H. Patterson; 66.26

The great Lord Śiva (Maheśvara) rests in the posture of royal ease, gently embracing his consort, Pārvatī (Umā), in this tender icon of divine affection. His lower right hand is poised to caress her as they lean together, eyes locked and intimate smiles illuminating their rounded faces. In his upper right hand, Śiva holds a roughly carved flower in front of the thick body of a snake, which emerges from his crown of matted hair. The lower edge of a cloud can just be discerned above the snake on the broken relief plane. When complete, the area would likely have held a flying celestial, balanced by a second one above the goddess. Behind her left shoulder another divine attendant, with garland, gazes outward at the devotee.

The area below the couple's feet is crowded with figures. At either side stand male guardians; the one on the right sports the god's matted hair and holds a lotus, while the left figure, tempered by the overall air of sweetness, shows the bulging eyes and skull cup of Bhairava, Śiva's terrible form. In the center, rotund four-armed Gaṇeśa balances the dancing figure of the emaciated sage Bhṛṅgi, devotee of the God. The couple's other son, Skanda, Lord of War, appears in tiny effigy atop his peacock *vāhana* by the goddess's foot.

This piece entered the collection of the Dayton Art Institute with the dealer's attribution of Roda, a site in eastern Gujarat state near the border of Rajasthan.[1] The eight small shrines at Roda date to approximately the mid-eighth century.[2] Chronological similarities are evident, but an examination of figures in situ at Roda shows the impossibility of the attribution on stylistic grounds. Roda images display squarish faces with softly bulging eyes and full, square mouths, more yielding flesh, and precisely fluid lines.

This image, on the other hand, displays full but flattened faces, pointed eyes, broad foreheads, deep dimples, orblike female breasts placed high on the chest and immediately receding into a tiny waist above smoothly swelling hips, and bursting full relief. Rather than images from eighth-century Gujarat, it conforms more closely to sculptures from ancient Madhyadeśa, the Ganges-Jumna valley area and site of the important capital of Kannauj (Kānyakubja).

An exquisite Umā-Maheśvara from Kannauj itself, in the Kannauj Archeological Museum (Fig. 67), typifies eighth-to-ninth-century carving under the imperial Pratīhāras. Although more finely finished than this Umā-Maheśvara, with an extraordinary attention to detail and a high polish, the Kannauj couple displays an affinity in physiognomy and certain aspects of body type as well as mood. A bust of Pārvatī from Lachhagir, Allahabad District,[3] just south of Kannauj, is also comparable, showing the same flattened and striated female coiffure, double incised brows, deep dimples, pointed eyes, and rounded limbs of the Dayton piece, along with the motif of flanking garland-bearing celestials on stylized clouds, not found in contemporaneous Gujarati images.

References: Evans 1966:1–6, figs. 1, 3, 4; "Indian Art Abroad" 1967:117; Dayton Art Institute 1969:50–51, no. 11; Heeramaneck 1979: no. 52.

1. Misidentified in the dealer's attribution as on the Rajasthan-Madhya Pradesh border (unpublished records of the Dayton Art Institute). The Dayton Art Institute, in 1969, lists provenance as "Vicinity of Roda, North Central India."

2. It is likely that when the piece was sold in 1966, the dealer had seen the relatively recent publication of images from the site, U. P. Shah, "Sculptures from Śāmalāji and Roda," *Bulletin of the Baroda Museum and Picture Gallery*, special number (1960). At that time it was one of the few eighth-century sites to be

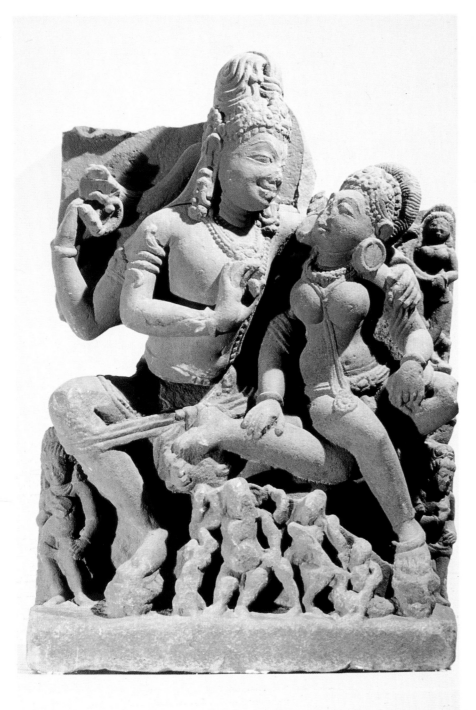

adequately published, and the clear chronological similarity of this piece to images from Roda makes this early attribution both feasible and insightful. A second piece (Dayton Art Institute, No. 66.25), the river goddess Gaṅgā (from a doorway of about the same date) was likewise attributed to Roda. In publishing the two pieces, Bruce H. Evans was hard put to account for their clear stylistic differences. ["Two Early Medieval Indian Sculptures," *Dayton Art Institute Bulletin,* vol. 25, no. 1 (September 1966), pp. 1–6.]

3. Allahabad Museum No. 283, AIIS Neg. No. 85.89. In general, however, the Lachhagir images show much lower relief than this Umā-Maheśvara or figures of this period from Kannauj.

25 ▶

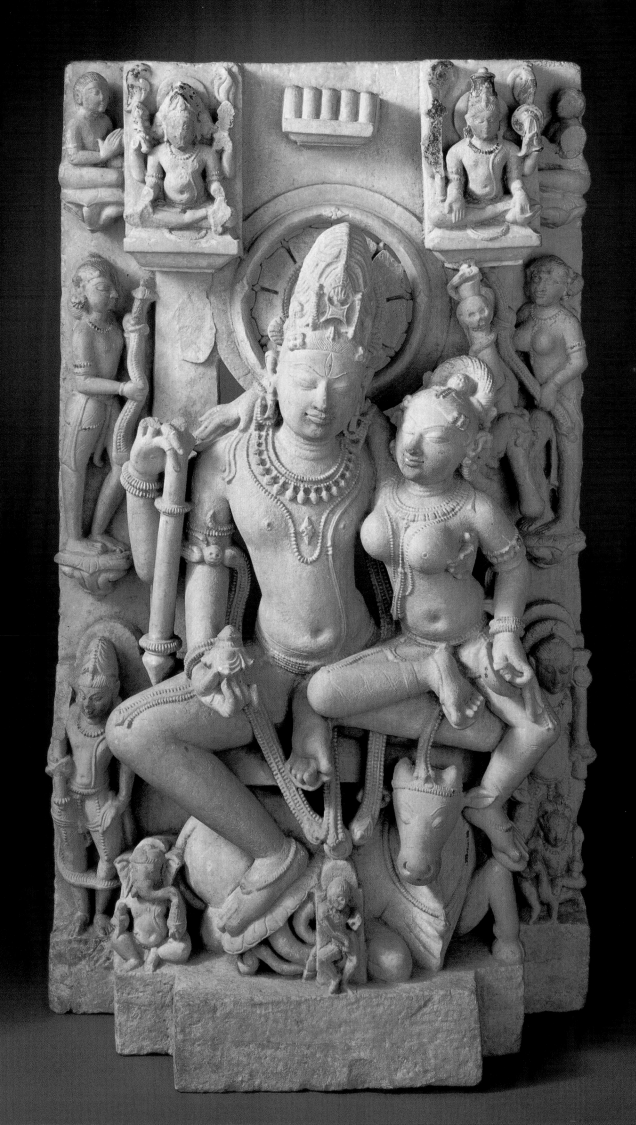

25.
Umā-Maheśvara with Nandī
Probably exterior wall, central offset
Provenance unknown, probably Haryana or neighboring Uttar Pradesh
(Śūrasena)
About mid-10th century
Sandstone; 85.7 x 50.2 cm
Los Angeles County Museum of Art, Gift of Mr. and Mrs. Harry Lenart;
 M.75.11
(*Note: Photograph is on previous page.*)

In standard rectangular format with offset base, this elaborate relief of Umā-Maheśvara (Śiva with his wife, Pārvatī) may have been inset into the central (*bhadra*) niche of a Śiva temple, perhaps on the west exterior wall opposite the entrance (No. 24). The south wall, first approached in circumambulation, probably displayed Brahmā and his consort while the north would show Lakṣmī-Nārāyaṇa (Viṣṇu and his consort, No. 26). Other possibilities for the placement of this image include a niche on the *kapilī* wall that connects hall and sanctum. Divine couples frequently inhabit this space, stressing its architectural function as juncture point—*kapilī* walls can also display copulating couples and hybrid deities.[1]

The Śaiva pantheon is depicted here in iconic manner, the narrative touches of the earlier Umā–Maheśvara reliefs (Nos. 23, 24) retained only in the gentle tilt of Pārvatī's torso toward her lord. Pārvatī holds a mirror in her left hand, perhaps to reflect the glory of Śiva as well as her own beauty. Four-armed Śiva holds his (now broken) trident in his upper right hand, a lotus flower in the lower, and a skull staff entwined with serpent behind Pārvatī's head. Below their seat rests the bull, Nandī.

The emaciated *ṛṣi* (sage), Bhṛṅgi, attendant of Śiva, dances before the couple. He is carved against a keyhole-shaped slab (perhaps conjoined slab and halo), as if a separate relief. Gaṇeśa, seated to the left with his bowl of sweets, is treated in the same manner, while Skanda, astride his peacock, rests at the far right against the main relief plane. Śaiva guardian figures, or perhaps the personified weapons of the god, flank the couple, the left figure holding the trident and the right the skull staff in imitation of the god above them.

Male and female garland-bearers atop lotus flowers that emerge directly from the relief plane border the couple's heads. Above, also on lotus bases, devotees kneel in adoration toward iconic images of Brahmā (on the left) and Viṣṇu (on the right). These latter deities are again treated as if they were independent reliefs, complete with base molding. Between the two gods is yet another molding platform supporting five small *liṅgas*, marks of the God Śiva (Nos. 73, 74).

Unadorned pilasters support the niches in which Brahmā and Viṣṇu sit. The plane of the relief does not continue between these pseudoarchitectural elements. Rather, the space between and behind the main figures is left open and Śiva's floral halo is also delicately pierced.

The approximate provenance of this carving can be determined by a similar sculpture now in the Chandigarh Government Museum and Art Gallery.[2] Like our piece, it is an image of Umā-Maheśvara. It was discovered at the town of Agroha, in the Hissar District of Haryana state, east of Delhi and near the Rajasthan border. Although smaller and more worn than this image, it is relatively similar in details of anatomy, ornament, and iconography, differing primarily in minor elements of organization.

Anatomically, both reliefs display related squarish faces, long pointed eyes with incised irises, carefully drawn mouths with corners drilled into a "Mona Lisa smile," and wide foreheads with no widow's peak. Their torsos are long and tubular with barely defined waists, smooth round navels, and a fleshy bulge at the girdles. Limbs are heavy, female breasts large and round but separated, conveying the impression of weight and natural growth from the body (as opposed to the appliquéd orbs found farther south and east). The male torso shows gently defined pectorals.

Islamic iconoclasm was fierce in the region around Delhi, and virtually no temples

remain standing, while loose sculptures tend to be badly defaced. This Umā-Maheśvara hints at the quality of monuments once present in the region. It is possible that the area was ruled at the time by the Tomara dynasty, one of the Rajput clans, who, according to tradition, founded Delhi in A.D. 736. The Tomaras were known to be feudatories of the Gurjara–Pratīhāras, at least at the beginning of the tenth century, and continued to rule their own region (approximately modern Haryana state) until the mid-twelfth.[3]

References: Pal 1978:24–25, 1988:34, no. 34.

1. Michael W. Meister, "Juncture and Conjunction: Punning and Temple Architecture," *Artibus Asiae*, vol. 41 (1979) pp. 226–234; Devangana Desai, "Placement and Significance of Erotic Sculptures at Khajurāho," *Discourses on Śiva* (Philadelphia: University of Pennsylvania Press, 1985/1986).

2. No. 3417; AIIS Neg. No. 433.3.

3. H. D. Bhattacharya in *The Age of Imperial Kanauj*, pp. 111–12.

26.
Lakṣmī-Nārāyaṇa

Probably exterior wall, central offset
Khajurāho, Madhya Pradesh
(Jejekādeśa)
About second half of the 11th century
Sandstone; 127 x 66 cm
National Museum, New Delhi; 82.225

Viṣṇu (Nārāyaṇa), identifiable by his conical crown, and his consort, Lakṣmī, lean together to form a single icon of regal elegance. Following standard textual descriptions, Lakṣmī stands to the left of Viṣṇu, whose left arm encircles her waist as she extends her right arm around his neck. The couple would have stood on the temple's exterior wall, their divine identity indicating that they likely occupied a large niche on the central projection (*bhadra*) of the sanctum.[1]

As is typical of eleventh-century figures from throughout north India, the sculptor has sacrificed accurate anatomical representation to linear rhythm and grace. This is most evident in the unnatural extension of Lakṣmī's torso, which stretches to conform to the line of her husband's body, while both breasts maintain their full volume and appear to be almost at equal height. The whole appeases the eye through the formal balance of solids and the graceful interplay of curving line. At the same time it evokes an impression of serene authority and tenderness.

Lakṣmī and Viṣṇu are adorned with wide hourglass pearl chains. They wear necklaces and multiple thigh swags formed of long, spiky beads or stylized buds. These ornaments, among other details, link the image to such later eleventh-century temples at Khajurāho as the so-called Caturbhuj temple. As is the case with these figures, the flesh on that monument's more finished images is still taut and sleekly rounded and the body parts are full. In contrast, images on the latest of the Khajurāho shrines, the Duladeo, datable to about A.D. 1117 or soon after,[2] exemplify a treatment of the human form, especially the torso, as a series of thin cylinders with roughly carved and exaggerated ornament, indistinguishable from that of the unmodeled flesh.

Thus this image of Lakṣmī-Nārāyaṇa comes from a period during which artists at

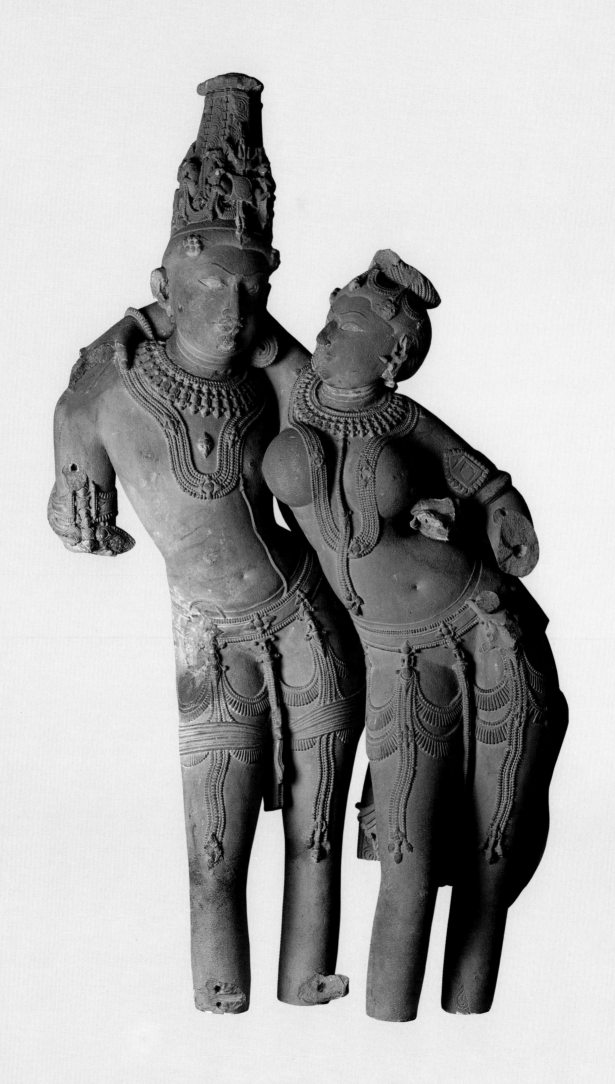

Khajurāho had attained a tenuous balance between the requirements of the autonomous image and those of the entire composition. Even on the temple from which this image came, it is likely that figures of lesser importance already tipped that balance to the needs of the whole (No. 46), as was true of all sculptures on temples built by the subsequent generation.

<hr />

1. This is not certain, however, since the large temples of Khajurāho frequently display such divine images, even couples, in other offsets as well. For example, the unusual Pārśvanātha temple repeats images of standing Lakṣmī-Nārāyaṇa without niches flanking the windows on the exterior of the ambulatory path.

2. Deva, *Temples of Khajurāho*, vol. 1, pp. 23, 240.

27.
Viṣṇu
Probably exterior wall, central offset
Provenance unknown, probably central-eastern Madhya Pradesh (Dāhaladeśa)
About early 11th century
Sandstone; H. 119.3 cm
Museum of Fine Arts, Boston, David Pulsifer Kimball Fund; 25.438

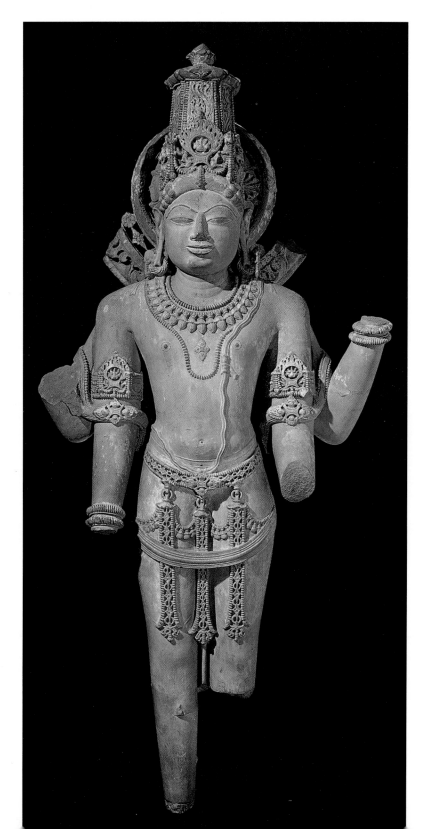

His four arms, frontal stance with legs together, and diamond-shaped mark of divinity (*śrīvatsa*) on his chest signify, despite his missing limbs, that this standing male is a god. The high, conical crown and remnants of a long garland indicate his specific identity as Viṣṇu. In his four broken hands he likely held the conch, *cakra*, mace, and lotus, in any of twenty-four configurations, making him one of the *caturviṅśatimūrti* ("twenty-four aspects of Viṣṇu," No. 70).

Smooth, solid flesh contrasts vividly with the metallic precision of hair, ornament, and physiognomy. The level of detailing, achieved with extremely fine undercutting, is extraordinary in the relatively grainy medium of sandstone—the stone carver's art here reached a peak of technical perfection. Although he was cutting a relief with a large and elaborate halo behind, the sculptor conceived of the figure in the round. Like those in many tenth- and eleventh-century images from central India, especially this area of Madhya Pradesh, the back of the image, never to be viewed, is still fully, if roughly, carved (Nos. 16, 61).

The motif of a *kīrtimukha* peeking from within a flaming *candraśālā* is repeated on crown and arm bands. Naturalistic long floral buds form his necklace. He wears a girdle of floral diamonds linked by rings, a pattern familiar from the Harshagiri figures (No. 12) and common in several regions throughout the tenth and early eleventh centuries.

The face of this image is broad and squared but flattened. Well-defined brows rise in low arcs, nearly merging at the straight, flaring nose. Eyes are long with defined irises but remain on the flat frontal surface of the face. A deep dimple appears in the chin just below the mouth, and the lips are heavily outlined with a narrow upper lip and a central upward peak subdividing the lower.

This Viṣṇu has, in the past, been identified as being from Khajurāho, and the attribution has stood through the years. Although it does bear numerous resemblances to the Khajurāho sculptures, particularly those of the Viśvanātha temple, datable by inscription to A.D. 1002, this sculpture definitely was not carved by the guild of sculptors who carved the shrines at that site.

The Candella images at Khajurāho show softer flesh, longer, often curved noses, brows that usually turn upward at the corners, more sloping faces, shorter eyes, and fleshier mouths. These are only a few of the differences between this figure and the surprisingly homogeneous sculptures of early eleventh-century Khajurāho (No. 26). In terms of details, one element is convincing: nowhere at Khajurāho are such pierced leg drops utilized—they are always solid streamers with or without beading.

If the persistent idea of Khajurāho is abandoned, we can look to the numerous fragmentary sites and loose sculptures from Jejekādeśa and Dāhaladeśa for correspondences. One striking similarity in terms of facial features is with an *ekamukhaliṅga* from the Kalacuri site of Bilhari southward from Khajurāho in the direction of Jabalpur. There are also similarities, especially in terms of the solidity of the body and treatment of drapery and ornament, with apparently mid-eleventh century images from Gurgī near Rewa to the southeast of Khajurāho, such as the monumental standing Śiva and Pārvatī now in the park in Rewa city.

Although none of these resemblances is close enough to attribute this image to a known site, the likelihood that it did indeed originate in this region under the domination of the Kalacuris (Nos. 17, 49, 50, 61) is quite convincing.

Reference: Museum of Fine Arts, Boston 1982:172, no. 162.

28 ▶

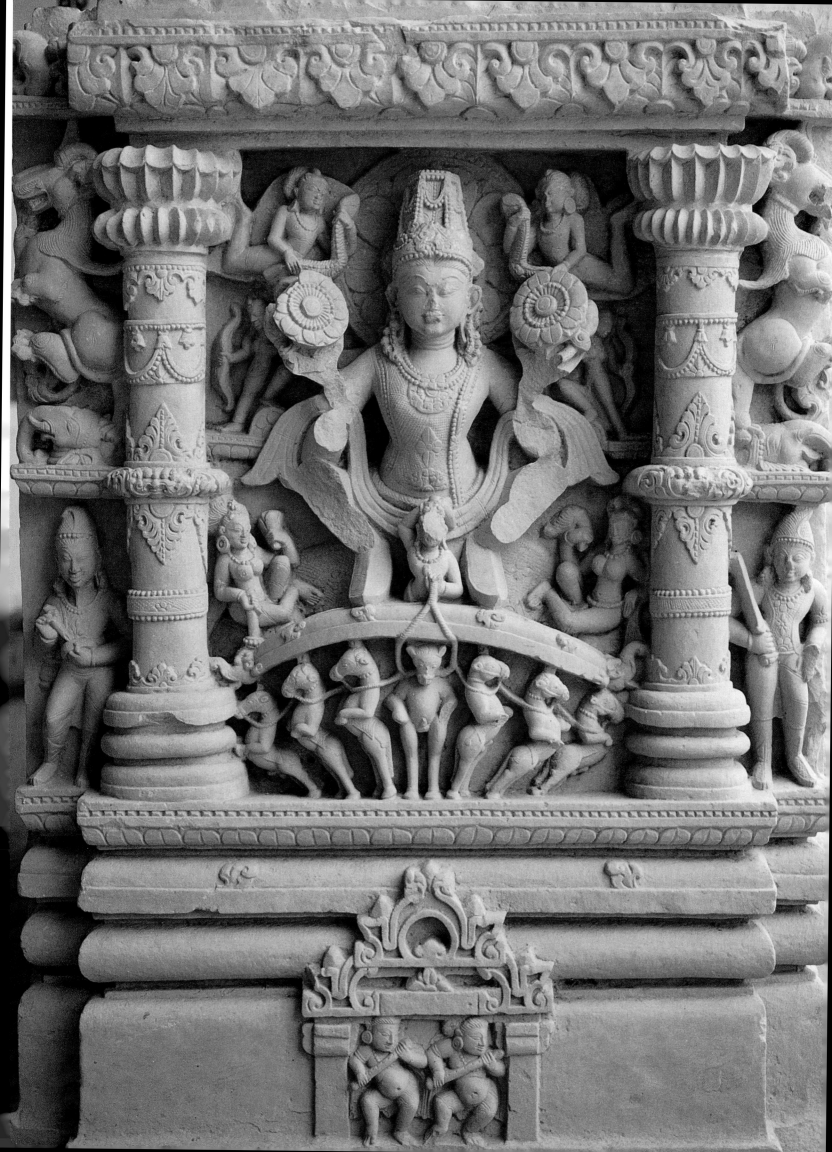

28.

Sūrya

Probably central exterior wall segment or basement offset
Madaur, Mathura District, Uttar Pradesh
(Śūrasena)
About A.D. 850–875
Sandstone; 104.5 x 77 cm
Government Museum, Mathura
(*Note: Photograph is on previous page.*)

This well-preserved segment of the wall of a small temple, complete with binding moldings (*vedībandha*), recently entered the rapidly expanding collection of the Government Museum, Mathura after having been "excavated" from a mound by a local dacoit (highwayman).[1] Located on the River Yamunā (Jumna), Mathura is renowned as the birthplace of Kṛṣṇa (Krishna). The town and its surroundings were a focus of building activity from at least the second century B.C., although virtually nothing remains standing.

Sūrya is the sun. That a cult focused around him, either on his own or intertwined with Viṣṇu, is evidenced by numerous temples throughout north India. Elaborate and crisply carved, this image represents the deity within a pillared niche. He wears high, pointed-toe boots and a crosshatched breastplate or jacket that denotes his central Asian, possibly Scythian, origins, and he has been linked to a Zoroastrian fire deity. In his hands he holds symmetrical diurnal lotuses, fully blossomed in his light. Between his legs appears the small figure of his charioteer, Arjuna, grasping the reigns of Sūrya's seven-horse chariot.

The chariot itself is indicated by a curving seat, its front ledge terminating in *makara* heads. Garland-bearing celestials hover by his crown. Below them, on small lotus moldings, the female archers Uṣas ("dawn") and Pratyūṣa ("daybreak"), at times considered wives of Sūrya, rout the night with their arrows, their feet propped on half lotuses rising like the sun. To either corner of the chariot recline additional attendant women, possibly the goddesses Rājñī and Nikśubhā, also wives of the God.

Flanking the niche and also dressed in foreign battle garb stand his attendants Daṇḍa (on the right with sword) and Piṅgala (on the left with palm-leaf manuscript and stylus). Above them rear *vyālas* on elephant heads (No. 14) as brackets to the niche.

The base of the niche consists of a narrow molding overlaid with flattened lotus petals topped by a beaded band. Below, the binding moldings follow a typical format of inverted cyma-recta molding, pot molding, and shoulder molding with no indentation between the upper two (No. 1). In form they are typical of central as opposed to western India at this period. A small niche enclosing two cavorting dwarves (*gaṇas*) playing flutes overlays these moldings. A triangular pediment (*udgama*) crowns this lower niche as a similar but larger pediment likely topped the niche containing the god himself.

The entire niche is shaded by a cornice molded with half-lotus drops filled with floral half diamonds (a format more often used below the niche in contemporaneous temples). The half-lotus drop motif is seen in closely related forms on the mid-ninth–century temples of central India to the south of Mathura, such as the Sūrya temple at Madkheda, Tikamgarh District, Madhya Pradesh (ancient Daśārṇadeśa). Indeed, the organization of both the niche and Sūrya resembles that of the central offsets of the Madkheda temple, built in ancient Daśārṇadeśa under strong Pratīhāra influence.[2] Yet the square face and heavy, congealed body of Sūrya with high pinched waist typifies images from ancient Śūrasena rather than Daśārṇadeśa during the early "medieval" period (No. 70; see also No. 52) and even later (Nos. 18, 19).

1. Personal communication from Dr. Pushpa Thakurail, Director, Government Museum, Mathura.

2. *EITA*, vol. 2, part 2, pp. 45–48, pls. 94–96.

29.
Ambikā Yakṣī

Probably exterior wall, central offset
Provenance unknown, possibly Ujjain region, Madhya Pradesh
(Daśārṇadeśa-Avantī)
About late 8th to early 9th century
Sandstone; 64.8 x 36.9 cm (at top), 28.8 cm (at bottom)
Royal Ontario Museum, Gift of Carol and James George; 988.97.1

Ambikā—literally "mother"—is the name of this seated goddess. Partly descended from the early Indian female fertility genius, the *yakṣī*, Ambikā relaxes beneath a branch of plump leaves heavy with succulent mango fruit. She grasps the hanging fruit with one hand while the other encircles a male infant on her knee, who cradles her breast as if presenting it. An older son, at her lower right, stretches upward toward the mother. The goddess sits on a growing lotus pedestal beneath which sprawls her *vāhana*, a large, panting lion.

In the Hindu tradition, Ambikā is one form of the great Goddess Devī. She is a focus of *śākta* worship like Durgā or Pārvatī, both of whom are also accompanied by the lion (No. 20). Yet such are the cross-fertilizations of religions in India that the Goddess Ambikā, bearing the same name but a different (albeit intertwined) origin, is also a minor but popular deity in Jainism. Indeed, the elements of this composition are those common to the Jaina divinity Ambikā Yakṣī, rather than her Hindu namesake.

In Jainism, from about the sixth century onward, male *yakṣas* and their corresponding female *yakṣīs* evolved from the older local nature genii into the attendants and protectors of the *tīrthaṅkaras* (Jaina savior-saints, No. 67). As U. P. Shah notes, it was recognized that a *tīrthaṅkara*, a perfected being himself freed of worldly attachments, "could not be approached for fulfillment of worldly desires."[1] In order to fulfill such desires—to conceive male children, marry well, or even profit in business—a less sublime deity was necessary. Such deities were present at the popular level, and so, as frequently occurred not only in Jaina but also in Buddhist and Hindu belief, the *yakṣas*, *yakṣīs*, and others were assimilated as subsidiary deities into the Jaina pantheon. They both filled a need and aided in bringing the masses, for whom such deities were integral to everyday life, into the fold of the newer and less immediately comprehensible religion.

Until about the ninth century, when distinctive *yakṣa-yakṣī* pairs began to be assigned to each of the twenty-four *tīrthaṅkaras*, a single pair, of which Ambikā was the female half, accompanied all *tīrthaṅkaras*. The pair often appeared as part of the *tīrthaṅkara*'s image frame. At times, however, they were set in separate niches, as here,[2] where the molded base of the niche remained attached to the back slab. An undecorated halo can barely be discerned behind the goddess's head, partially obscured by the branch and by her billowing scarf.

The full, pillowy forms of goddess, lion, and vegetation appear extraordinarily detached from the plain ground. So high is the relief that heavy shadows fill the undercutting and give the impression of a sculpture in the round.

This Ambikā may facilitate the understanding of sculpture from one of the major cultural hubs of "medieval" north India, the city of Ujjain in southwestern Madhya Pradesh, ancient Avantī. That Ujjain was a major political, religious, and artistic center from "premedieval" times is well attested by literary and epigraphic evidence. Yet virtually no monuments remain standing in the region that can be dated prior to the eleventh century (No. 68), and sculptural style can be determined only by a small number of loose pieces.

The best known of these is a Naṭeśa now housed in the Central Archeological Museum, Gwalior (Fig. 73). His body is characterized by fluid, gentle movement, smooth tapering limbs with rounded joints, and minimal, delicate adornment. The soft swelling face is oval with a wide forehead with widow's peak. The mouth smiles slightly at the corners and diamond-shaped eyes show irises. The brows are particularly

30.
Esoteric Goddess (*Yoginī*) on an Owl

Probably interior surrounding niche of a hypaethral temple
Kannauj, Uttar Pradesh
(Madhyadeśa)
About first half of the 11th century
Sandstone; 86.4 x 43.8 cm
Lent by the San Antonio Art Museum, John and Karen McFarlin Fund, and Asian Art Challenge Fund; 90–92

Scattered throughout north India, usually removed from ancient urban centers, are temples of a type that invert the architectural norm of an enclosed sanctum roofed by a tall tower. These temples are open and usually consist of a circular surrounding wall, plain on the outside but having a continuous row of niches or open subshrines facing inward with a single pavilion at the center. In these niches sit or dance usually sixty-four goddesses, the *yoginīs*.[1] Their bodies are voluptuous but, while some have beautiful heads, many have the heads of animals such as lions, sheep, boars, horses, snakes, or even rabbits.

Still feared in India, these goddesses are icons of an esoteric cult, and details of their worship were likely transferred orally from *guru* to initiate. Vidya Dehejia, in her recent study of the cult and its monuments, concludes that they are associated with the esoteric Śaiva Kaula sect, whose rites involved practices offensive to mainstream Hindu/Brahmanical society, such as drinking wine, eating flesh (human at times), and engaging in sexual intercourse leading toward the acquisition of occult powers. The *yoginīs* appear to have centered around Śiva, especially in his horrific form as Bhairava, and it is likely that the medial pavilion in their shrines contained his icon.

This *yoginī* sits atop an owl. Her front hands point to her partially open mouth with its neatly detailed teeth, while her rear arms grasp a shield and sword. Her symmetrically planted feet rest upon growing lotuses flanked by small devotees, and celestial garland-bearers fly toward her pearl-festooned crown. Her name is not inscribed on her pedestal, and the names of these deities vary so widely in both texts and inscriptions that it is impossible to identify her. From her open mouth and gesture, Dehejia speculates that she may be identified with one of the *yoginīs* with names like "She

distinctive. They form a continuous curving ridge that merges into the nose and slants inward in a single plane to form the lids.

A second fragment now in the Vikram Kirti Mandir in Ujjain, said to have come from the region, is a bust of Ambikā.[3] The mango tree, the face, the smooth and shallow breasts, the treatment of relief, and the detailing resemble those of this full Ambikā and confirm the regional attribution of this piece.

1. U. P. Shah, *Jaina-Rūpa-Maṇḍana (Jaina Iconography)*, vol. 1 (New Delhi: Abhinav Publications, 1987), pp. 213–23.

2. Ibid, p. 116.

3. AIIS Neg. No. 232.14.

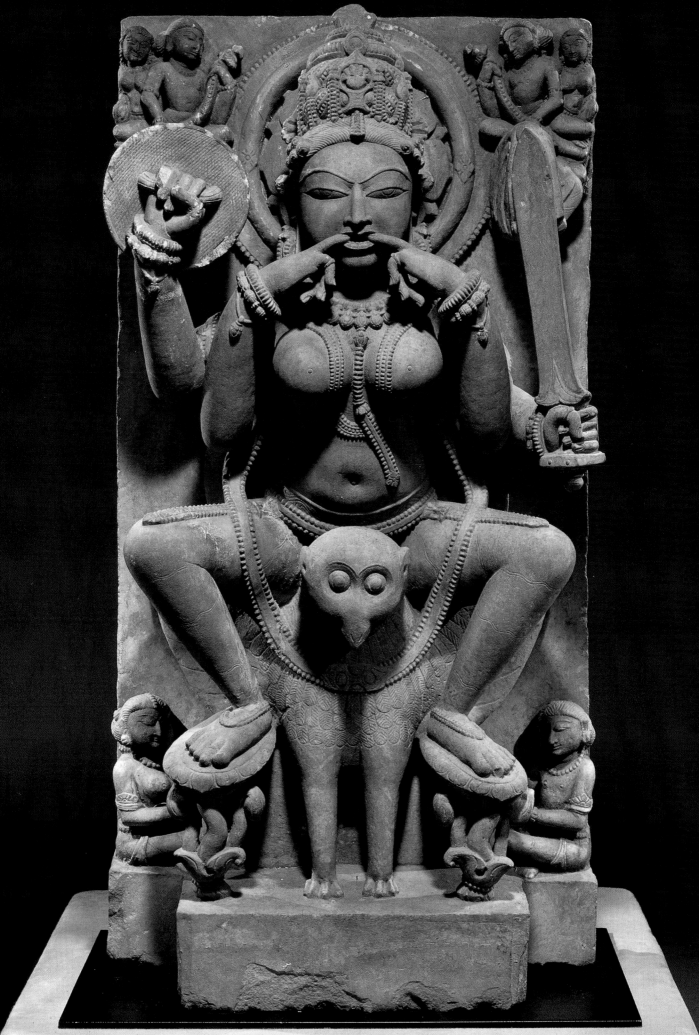

Who Makes a Loud Noise."[2]

The preservation of this sculpture is extraordinary. Old photographs[3] as well as local memory show that, in the first half of this century, she was embedded in a small brick shrine in the city of Kannauj in Uttar Pradesh. Stylistically her full, square face, triangular nose, short waist, and globelike breasts, among other features, agree with the few late tenth- and early eleventh-century images known from this region (No. 33).

There seems to be no reason to attribute her, as does Vidya Dehejia, to the workshop that created a group of *yoginīs* (most likely datable to A.D. 1189 by an inscription) at Naresar in ancient Gopādri, four hundred miles east of Kannauj.[4] While her thick pearl necklace and asymmetrical tassel are similar, this is a widespread type of ornament particularly popular in the eleventh and twelfth centuries. The carving on the now mostly headless Naresar pieces exhibits a harsh flatness with solid flesh, navels that resemble round holes drilled into the evenly curving surface, extremely tubular torsos, long feet, and heavy ankles that bear little resemblance to this piece.

Indeed, the Madhyadeśa attribution is strengthened by a related image, unfortunately quite fragmentary, of a goddess (possibly Vaiṣṇavī) seated on a winged human mount (the birdman Garuḍa), from the town of Jhusi in Allahabad District, Uttar Pradesh.[5] While not displaying precisely the same carving as the *yoginī*, this image does possess similarly treated ornament together with closely related anatomy, including a short waist and globelike breasts. In addition, as opposed to one Naresar *yoginī* who rides a bird with stubby, sketchy ornamented wings, our *yoginī* and the Allahabad piece show wings that are large and flat, arc upward behind the legs, and are detailed with curving incised lines.

If this sculpture did come from Kannauj or its vicinity, it greatly increases our knowledge of sculptural style in Madhyadeśa in the eleventh century. In addition, it demonstrates the spread of such esoteric beliefs. The high quality of this image certainly leads to questions of royal patronage. A *yoginī* temple, possibly dating from the late ninth century,[6] still stands on a hill at Khajurāho, some distance from other temples. Dehejia speculates that certain Candella rulers or their families may have been adherents of the cult responsible for such monuments and, possibly, patronized

their construction.[7] Kannauj and its vicinity were likely under Candella rule at some time during the second half of the tenth century, the city was probably held by the Kacchapaghāta family, centered around Gwalior, when this image was carved. It must have come from an extraordinary *yoginī* temple, the location and patronage of which are still in question.

References: Dwivedi 1971:60–62; Pal (*The Sensuous Immortals*) 1978:70, 68 (photo); Tandon 1978: fig. 116; Dehejia 1986:148–50, 29 (color photo), 149 (B.W.).

1. For a comprehensive discussion of these unusual temples and the cult that created and utilized them, see Vidya Dehejia, *Yoginī Cult and Temples: A Tāntric Tradition* (New Delhi: National Museum, New Delhi, 1986).

2. Dehejia, op. cit., p. 150.

3. V. P. Dwivedi, "An Unusual Devī Image from Kanauj," *Oriental Art*, vol. 17 (1971), pp. 60–62.

4. Dehejia, op. cit., p. 148. Dehejia (p.150), however, believes on stylistic grounds that the Naresar images date to ca.1000—one of her reasons for linking this image to them. She compares them with images from Dāhaladeśa and concludes that the inscription was added later. Using the dated larger Sās Bahu temple at Gwalior (A.D. 1093, *IA*, vol.15, pp. 33–46) as a fixed point of comparison for style within Gopādri, however, there seems to be no reason to question a date for the *yoginīs* in the second half of the twelfth century.

5. AIIS Neg. No. 619.99.

6. Krishna Deva, *Temples of Khajurāho* (New Delhi: Archaeological Survey of India, 1990), p. 26.

7. Dehejia, op. cit., p. 88.

31.

A Pair of Mythical Aquatic Creatures *(Makaras)*

Springers for an arch fronting a porch
Khajurāho, Madhya Pradesh
(Jejekādeśa)
About late 10th century
Sandstone; 70 x 106 cm each
Shri Sadu Shantiprasad Jain Art Museum, Khajurāho; K1186, K121

Auspicious and purifying, the *makara* is a mythical sea creature combining the jaws of a crocodile, trunk of an elephant, and, often, paws and ears of a lion, fish's tail, and ram's horns. Like the *vyāla* or *kīrtimukha*, the *makara* can appear in a number of locations and configurations within the temple, each fixed by tradition. The *makara* is the *vāhana* of the personified river goddess Gangā (Ganges, No. 52) and of the directional guardian Varuṇa, ancient Vedic Lord of the Waters (No. 58, Fig. 81). Frequently it is through the mouth of a projecting *makara* gargoyle that lustral liquids flow outward from the sanctum. Most frequently, however, *makaras* appear as terminals for an arch.

When the arch acts as upper portion of an image frame (Nos. 64, 65), the *makaras* tend to face outward. When they anchor a free-hanging or detached arch, on the other hand, they face inward. This latter configuration is depicted on the slanting seat back (No. 33), where the arch itself is often spewed from the creatures' gaping jaws. Such elaborate free-hanging arches, called *makara toraṇas*, are frequently polylobed and covered with intricate carving.

These garlandlike arches can appear in several locations. In the temples of western India of the tenth century and later, they often link the freestanding interior pillars of the hall. At Khajurāho, the origin of this pair, single elaborate *makara toraṇas* still front the entry porches of several of the standing temples. Ascending steep stairs, the worshiper passes between and below the sea creatures and under the waving stone garland.

The *toraṇa* terminals closest in form to these are on the arch remaining in place on the best known of the Khajurāho temples, the Kandariyā Mahādeva, built in approximately A.D. 1025. As opposed to the *toraṇa* on the mid-tenth–century Lakṣmaṇa temple nearby, where the garland-arch emerges from the mouths of the animals, that on the Kandariyā, as on these pieces, springs from the top of the head and displays additional niches with figures on attached impost blocks.

The size of the pieces, which may exceed even those on the Kandariyā, implies an extremely large structure. In the early 1970s, at least one of these two *makaras* lay in the compound of the Śāntinātha temple at Khajurāho, a recently rebuilt shrine within a group of Jaina structures to the east of the town. Two other temples remain at this site, one (Ādinātha) in a reasonable state of preservation and the largest (Pārśvanātha) partially original and partially rebuilt utilizing old carvings. Numerous fragments also litter the area. Many, like the *makaras*, are now incorporated into the collection of the museum just outside of the temple precinct.

Although the iconography is curious, it is a good supposition that this *makara* pair did indeed originate on a Jaina temple. Unlike the clearly Śaiva figures in a similar location on the Kandariyā Mahādeva temple, the figures in the niches on these pieces are difficult to decipher. One piece shows, on one side, a man, possibly divine, seated in the posture of royal ease on a sprouting lotus. His left hand rests on his knee, while his right cradles a blossom. To his right, a male attendant holds a hand upward, possibly in the reverential gesture of *añjalimudrā*, although the figure is too badly defaced for clarity. The opposite side (*opposite, right*) has survived better and depicts a male and a female musician, he playing the flute and she the tambourine.

The second *makara* has on its left (*opposite, left*) a seated male holding a lotus in one hand as the other embraces a woman, perched on his knee. Behind them, a smaller male kneels, clearly displaying *añjalimudrā*. The opposite frieze depicts a seated male waving a scarf with his left hand.[1] In front of him a second man appears to be kneeling

while raising four fingers of his left hand. A male attendant crouches behind.

The carving of these spectacular pieces exemplifies the best in Khajurāho and indeed in high "medieval" north Indian sculpture. Flaring lashes and ears and delicate leafy overlays blend animal and vegetal in exuberant fantasy. The beaded ears almost hide spiraling horns. The undercut eyelids transform the eyes into turgid orbs, a triumph of the sculptor's skill. From behind the horns peeks the beginning of the *makara*'s usually swirling tail—again animal and plant blend as the tail sprouts from the neck in the form of multiple thick lotus stems.

The interior of the jaw of both pieces, invisible from ground level when they were in situ, is only roughly hacked. On the flat upper surface, a square hole above the figure panels constitutes the socle for the pillar above. The rough-hewn end pieces would have been embedded into the supporting side pillars, which likely sat on the benches flanking the entry (Nos. 33, 34). The stone arch linking the *makaras* rested in the squared indentation behind the eyes. Each *makara* would have been held in place by a combination of the pillar juncture and an additional bracket below, probably in the form of a splayed dwarf (No. 35).

A very fragmentary temple, called the Ghaṇṭai ("bell") because of the bell-and-chain motif adorning its prominent front pillars, stands to the northwest of the main Jaina complex at Khajurāho. Krishna Deva[2] dates this monument to approximately the late tenth century based on its structure and elegant carving. Although only the pillars of its halls and hall door remain, they imply an extremely large construction, while the

iconography on the door contains the temple's Jaina (Digambarā) dedication. These factors, together with the similarity in craftsmanship, make it a distinct possibility that the *makara* pair originally upheld the entry *toraṇa* on this temple.

1. According to Jitendra Nath Banerjea, *The Development of Hindu Iconography* (1956; reprint, New Delhi: Munshiram Manoharlal Publishers Pvt. Ltd., 1985), p. 262, this cloth-waving gesture is termed *cellukhepa* (Pali) and signifies great joy.

2. Deva, *Temples of Khajurāho* pp. 250–54.

32.
Pillar
Gwalior, Madhya Pradesh, or vicinity
(Gopādri)
About late 11th to early 12th century
Sandstone; 259 x 35 cm
Central Archeological Museum, Gwalior

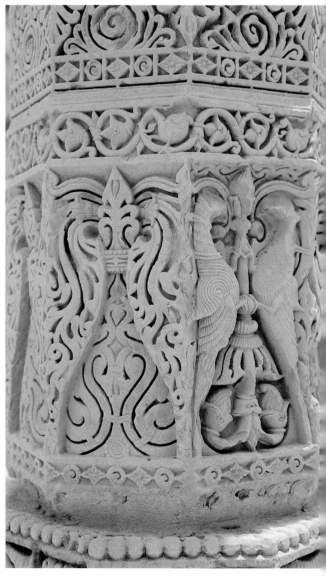

At its base, this florid and varied pillar is octagonal. As it rises through numerous decorative bands, its angles lessen to reach an upper circular band. The central shaft consists of fluting in the form of elongated petals over which hang chains ending in bells. Below and subdividing this segment are figure bands formed of multiple pillared niches—the upper containing single figures, many dancing, the lower with multifigure compositions. Although the pillar is badly defaced, the presence of Śiva, Gaṇeśa, and other Hindu divinities indicates that it belonged with a Hindu rather than Jaina shrine.

A circular frieze of *haṅsas* (ganders) (No. 39) crowns the shaft. Below it, additional flat lotus petals bulge outward in the semblance of a ripening blossom. Above the central fluted portion, the pillar is encircled by a row of *kīrtimukhas*. Their round, characterless eyes suggest a date late in the eleventh or early in the twelfth century as do other decorative motifs.

Below the lower figure band, rich braided pearl swags link floral bells. Farther down, a smaller ring of pecking *haṅsas* subdivides two elaborate bands of flattened scrollwork. The lowermost shows, on one side only, stylized peacocks intertwined with the scrollwork. The striking combination of flatly carved and roundly carved motifs is typical of later (eleventh-to-twelfth-century) monuments at Gwalior such as the larger Sās Bahu temple at Gwalior (A.D. 1093).

Reference: Chakravarty 1984: flyleaf.

33.
Slanted Seat Back
Bench around a hall or porch
Kannauj, Uttar Pradesh
(Madhyadéśa)
About second half of the 10th century
Sandstone; 56 x 89 cm
Kannauj Archeological Museum; 75/42

The sides of front porches, lateral projecting porches of open halls, and enclosed ambulatory paths in the north Indian temple carry built-in seating of stone benches with outward-slanting backrests or seat backs (*kakṣāsanas*; see Figs. 1, 3). Plain on the inside, seat backs form profusely carved balustrades on the outer face, adding to the richness of the temple exterior.

This fragment consists of the seat back together with the outer facing for the seat slab itself. The former has an upper molding of an elaborate vine spewed from the mount of a partial *kīrtimukha*, an intermediate frieze of inhabited pillars, and a lower incised molding. The latter displays two inverted cyme moldings (*kapotas*) with overlaid *candraśālās*. These moldings bracket a row of floral diamonds interspersed with four-armed dwarves in tiny niches who act as atlantes for the molding above them. Below the lowermost *kapota* would originally have been placed a solid wall, disguising the void between seat slab and floor and having a decorative railing on its outer surface. This whole configuration would have rested on the basement moldings of the temple (No. 5).

Although from a small temple, this fragment is fluidly and deeply carved. This is not surprising given its provenance of the wealthy capital city of Kannauj (No. 35). Just who ruled the city in the second half of the tenth century is problematic, however. The Pratīhāras are known to have retained their hold only until about A.D. 960. Between that time and the end of the century it may have passed briefly into the hands of the Candella dynasty before coming under Kacchapaghāta dominance sometime before A.D. 977.[1]

The *kīrtimukha* in the upper scroll exhibits the smooth carving, heavy eyelids, and nearly human nose typical of central India. The vine itself is richly carved, including a tendril encasing a small elephant;

yet the waving foliage bears little likeness to any natural form. The pillars of the frieze below, all with ribbed shafts, depict three distinct capital forms, indicating the great variety of motifs available to architects and sculptors at any one time. Those bordering the figures show small foliate capitals topped with square blocks with central diamonds, linked by *makara-toraṇas* (No. 31) with lotus-bud drops. Flanking these are pillars with fairly simple inverted bell capitals between which are thicker pillars with large foliate capitals and garland bands around the upper portion of their shafts.

The figures in the niches are the usual auspicious loving couples (*mithunas*) in the central and right niches and a pair of musicians in the left. Below them, the dry and schematic molding of commalike incisions, probably a desiccated representation of the earlier lotus petal form, represents a type of carving that becomes more and more common from the end of the tenth century.

The relatively small height of this *kakṣāsana* retains a human scale. In the huge temples of the second half of the tenth and eleventh centuries,[2] such as the Kandariyā Mahādeva temple at Khajurāho, the form is

retained but grows out of all proportion to its users, the seat slab at times resting well above head level. The presence of the form itself and its usability in the majority of shrines, however, support written evidence that the temple's halls were intended as much more than simple passages of approach to the sanctum. Indeed, the halls, with their built-in seating, acted not only as stages for a variety of ritual activities, drama, dance, and music but also as temporary shelters or even sleeping places for travelers.[3]

1. H. D. Bhattacharya in *The Age of Imperial Kanauj,* p. 38 and n. 105.

2. Smaller shrines continued to be built throughout this period, of course.

3. See the essay by Phyllis Granoff.

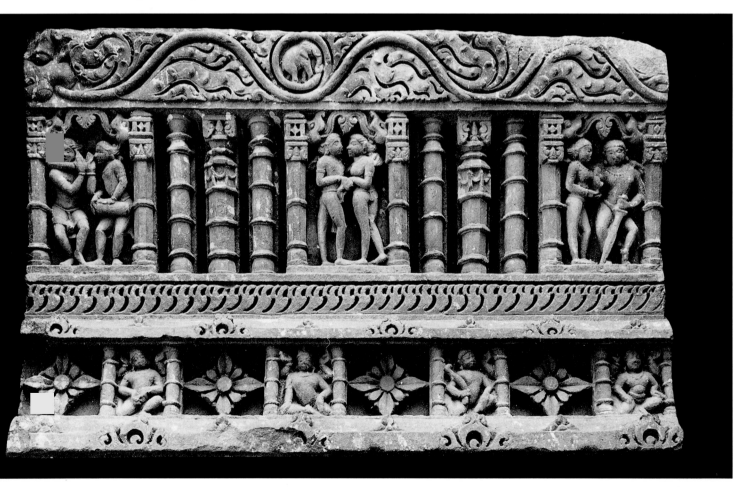

34.

Vase-and-Foliage Pillar

Probably topping a bench, from a porch or hall
Provenance unknown, probably northern Rajasthan
(Mārudeśa)
About mid-8th to early 9th century
Sandstone; 109.9 x 25.4 cm
The Cleveland Museum of Art, Purchased by income, Edward L.
 Whittemore Fund; 38.14

This square dwarf vase-and-foliage (*ghaṭapallava*) pillar would most likely have been one of several topping the built-in benches (No. 33) of a porch or open hall in a temple from northern Rajasthan.

The pillar begins at the top with a double foliate swirl like the volutes of an Ionic capital. Above this piece, however, would have rested a separate capital, probably in the form of crossed roll brackets that would have supported the ceiling beams. Below the foliage is squeezed a partial octagonal pot ornamented with a beaded band and sprouting leaves. It rests on a double row of upturned lotus petals.

Under this petal molding appears the large pot from which the pillar type (*ghaṭapallava,* "pot-leaf") takes its name. Also ornamented with a beaded band, this full, round water pot sprouts swirls of ebullient foliage that spill over the sides. It rests on a beaded stand that is incised with diagonal lines representing the twisted ring of cloth used to protect one's head when carrying a full water pot. To the sides of the pot are additional volutelike loops, from the centers of which descend pearl festoons. On early pillars, these loops are often clearly depicted circular holders for swags of fabric or beads. The foliate ends of the festoons are bound together and a single leaf, its veins carefully detailed, projects from the juncture.

Widely spaced pointed fluting underlies the bottom half of the pillar. Crossing it is a band of interwoven half diamonds filled in with open lotus flowers. This form reflects a favorite decorative device found in the basement, binding, and cornice moldings of eighth- and ninth-century temples in the ancient Mārudeśa region of Rajasthan and traceable to Gupta prototypes.[1] Below, a partial rondel filled by an open lotus flower is flanked by additional volutes, the rondel format being typical of pillars from the Gupta period onward throughout north India. The

lowermost portion of the shaft remains uncarved since it would have stood below the level of the slanting seat back.

Lotuses and water pots, with or without sprouting foliage, like the fertile young women or amorous couples found all over the temple body, express the generative force of the divine (No. 54).

The decorative devices and organization of the *ghaṭapallava* pillar form are traceable to monuments of the Gupta period (such as the Viṣṇu temple at Deogarh dating from about A.D. 500) and reflect the Gupta lineage of the monuments of northern Rajasthan. In comparison to the carving of the earlier temples, however, this pillar has reduced the once pneumatic natural forms to fairly linear schema. It does, on the other hand, retain the integrity of the decorative components. These factors and comparison with numerous related pieces from datable monuments in Mārudeśa, such as the Mahāvīra temple at Osian (late ninth century) or the Pārvatī temple at Buchkala (A.D. 815), place the pillar both temporally and geographically, although the precise quality of its carving may indicate the southern portion of this area on the border of Gurjaradeśa.[2]

References: College Art Association 1935: no. 6; Hollis 1939:5–6, cover; Cleveland Museum of Art 1958:751; Czuma 1977:109–10, fig. 41; Heeramaneck 1979: no. 59.

1. For example, on the Mahādeva temple at Carcoma, Rajasthan, datable to about A.D. 500; see *EITA* vol. 2, pt. 1, pl. 90.

2. According to Dhaky's stylistic categories, on the border between Mahā-Maru and Mahā-Gurjara. M. A. Dhaky, "The Genesis and Development of Māru-Gurjara Temple Architecture," pp. 114–65.

35.
Loving Couple
Bracket
Kannauj, Uttar Pradesh
(Madhyadeśa)
About early 9th century
Sandstone; 27 x 32.5 cm
Kannauj Archeological Museum; 75/133

Soaring forward in effortless flight, this male celestial gently cradles the breast of his companion. The pair supports a pile of slab moldings detailed with standard motifs, including a row of blossoms, particularly common in ninth-century structures throughout north India. The whole bracket once projected from a pillar to brace some other architectural or figure piece above it.

Although brackets with single figures, usually corpulent dwarves (*gaṇas*) are an omnipresent form in north Indian temple decor, such pairs are relatively rare.[1] This couple shows full yet rectangular faces, heavy lips, downturned, slightly sleepy eyes, and low foreheads. Her breasts are high, gently rounded, and close together, while a single sweeping line depicting pectorals divides his narrow chest.

The above characteristics, together with the bursting ripeness of flesh and ornament and the serenity of expression, typify eighth- and ninth-century sculptures from Kannauj, once the foremost city of north India. This piece, like a number of others now housed in the Kannauj Archeological Museum and in nearby temples and homes, emerged from one of the numerous mounds that shelter a great unexcavated city.

Throughout the eighth and ninth centuries, Kannauj (ancient Kānyakubja) acted as key to the control of the fertile Gaṅgā-Yamunā valley of central India. Numerous powers contended for the city. Foremost among them were the Palas of Bihar, the Rāṣṭrakūṭas of the Deccan, and the Pratīhāras of western India. The Pratīhāra dynasty, which rose to prominence through its early success in fending off Islamic incursions, wrested control of Kannauj from the Palas and vaulted to imperial status early in the ninth century under the powerful King Bhoja.[2]

Bhoja ruled for nearly fifty years (from at least A.D. 836 to at least 882) and spread Pratīhāra authority throughout north India, from Gujarat to Bengal. Yet only a small portion of this territory came under direct Pratīhāra rule. The majority remained in the hands of "feudatories," local families such as the Guhilas of Meḍapāta or the Cāhamānas of Mārudeśa-Sapādalakṣa who retained regional authority as a part of the Pratīhāra administrative system.

The imperial capital of Kannauj and the artists patronized by the imperial court (if they had an impact on other craft guilds as the communality of style in this period indicates) must have influenced the majority of the empire indirectly as the hub to which smaller powers gravitated. Until systematic archeological excavation can be undertaken, we must extrapolate from the loose bits of sculpture culled from the wreckage in order to understand the forms developed under imperial patronage.

1. Although they are not unknown in structures of the late eighth and ninth centuries. For example, see the tank at Osian, *EITA* vol. 2, pt. 2, pls. 455–56.

2. Not to be confused with the eleventh-century Paramāra King Bhoja.

36.
Flying Celestial
Drainage spout
Provenance unknown, attributed to the monastery at Candrehe,[1]
 Madhya Pradesh
(Dāhaladeśa)
A.D. 973
Sandstone; 60.3 x 29.2 cm
Virginia Museum of Fine Arts, Richmond, The Nasli and Alice
 Heeramaneck Collection, Gift of Paul Mellon; 68.8.19

The monastery at Candrehe in the Sidhi District of Madhya Pradesh can be reached today only by taking the local boat across the Son River. The monastery and the exquisite round Śiva temple adjoining it stand in a gently wooded spot just beyond view of the river (Fig. 11). After centuries of abandonment, the aura of serenity remains. This was a place of devotion, of learning, of meditation, and of practicing the austerities that bring both spiritual power and temporal influence. According to the monastery's dedicatory inscription:

In this place monkeys kiss lion cubs, the young deer suck at the breasts of lionesses, so other natural enemies take leave of their enmity in this forest of austerities and the minds of all become calm.[2]

Texts and epigraphs speak of the presence of numerous monastic groups throughout north India between the eighth and thirteenth centuries. Yet little survives of the many monasteries in which they must have lived, for the majority were likely constructed of impermanent or semi-

permanent materials such as brick or wood. Only five stone monasteries[3] remain, of which Candrehe is perhaps the best preserved. These few follow a general square plan with two floors of varying-sized rooms surrounding an open-air court. At Candrehe, pillars topped by an architrave with stone awning enclose the court. Above this is a balustrade formed of the outward-slanting seat backs of benches surrounding the second-floor veranda (No. 33). Dwarf pillars topped the seats (No. 34) and supported the roof. This image of a flying celestial undoubtedly comes from this atriumlike configuration.

A similar figure remains in situ[4] while another lies among other fragments outside the monastery at the site. Once they projected outward from the architrave, one above each pillar, and acted as drainage spouts for the rainwater that flowed from their mouths. To the monks and visitors gathering in the court below, these heavenly beings brought "the garden of the gods" within view as they soared overhead, backs arched and legs tucked behind, pouring down the "divine stream."

At least four of the remaining stone monastic constructions, including that at Candrehe, appear to have been built for adherents of the Mattamayūra ("drunken peacock") sect.[5] Worshipers of Śiva, the Mattamayūras were patronized by several of the royal families of what is now Madhya Pradesh, particularly the Haihayas of Dāhaladeśa, a branch of the Kalacuri dynasty, who, according to inscription, appear to have been financially responsible for the Candrehe edifice.

The body of this image retains a modicum of attention toward the softness of the flesh in the roll above the belt. The drapery, flung behind as if the figure were in rapid forward motion, is formed of full rounded, although regularized, folds. These characteristics indicate a somewhat earlier date for this celestial than the regionally related Viṣṇu (No. 27; see also Nos. 17, 49, 50, 61, as well as images probably from Khajurāho, Nos. 13, 46). Indeed, according to the dedicatory inscription in the porch of the Candrehe monastery, its builder, the ascetic abbot Prabodhaśiva, constructed the monastery and a tank in the year A.D. 973, near the temple erected by his spiritual predecessor.

Thus this image and its companions, together with the figure sculpture

surrounding the doorways in the monastery, constitute one of the very scarce chronological anchors to sculptural development in the region. The gargoyle takes on even greater importance because of both its identifiable patronage and the little-known but highly significant type of building it once inhabited.

Reference: Rosenfield 1966:57, no. 46 (photo).

1. This was first suggested by Pal in 1966.
2. Verse 15, Candrehe inscription of Prabodhaśiva. Translation from R. D. Banerji, *The Haihayas of Tripurī and Their Monuments*, no. 23, *Memoirs of the Archaeological Survey of India* (Calcutta: Government of India, 1931), p. 122.
3. Another of these remains at the site of Surwaya (No. 44).
4. This image (also headless) was published in R. D. Banerji, op. cit., fig. IVa, and remains in place today.
5. Donald M. Stadtner, "A Central Indian Monastery," *Discovery: Research and Scholarship at The University of Texas at Austin*. vol. 6, no. 2 (Winter 1981), pp. 16–19.

37.
Lotus Ceiling
Porch or hall
Ajmer, Rajasthan
(Śūrasena)
About late 11th century
Sandstone; 104.8 x 101.6 cm
Victoria and Albert Museum, 577–1883

This small, square ceiling (in an unusual state of completeness) has several elements typical of hall ceilings from both western and central India. A large lotus flower dominates the slab with three levels of flatly carved petals and a central bulbous drop. Raylike secondary petals appear between the points. The correspondence between lotus and sun emerges clearly. To transform the round flower into a square, four *kīrtimukha*s occupy the corners, with elaborate foliage spewing from their mouths along with crests to fill the block to its angles.

Here the vegetal scrolls are crudely carved and actual foliage is indistinguishable in the vermicular tangle. Small feline ears project from the creatures' swelling temples and incised striations mark their whiskers. The lower portion of each face opens in a wide grin to emit foliage. This gaping mouth, together with the bulging, deeply undercut eyes and the Simon Legree-like whiskers, often gives the *kīrtimukha* a startling ferocity, especially on earlier pieces. By the late eleventh and twelfth centuries, however, the motif, like many others, had become a repetitive decorative device, fully subsumed in structural concerns and rarely holding its own as a separable sculpture.

Such small lotus ceilings can appear over a number of small spaces in temple halls. Square ceilings may canopy the front porch or the pillared bays surrounding a central bay with a larger multilayer ceiling.

38.

Warrior Rondel
Central section of flat ceiling, hall, or porch
Provenance unknown, probably southern Rajasthan
(Meḍapāta or Gurjaradeśa-Arbuda)
About late 9th century
Sandstone; 65 x 78 cm
Ashmolean Museum, Oxford; 1985.5

Eight flying male figures, each brandishing a sword in his right hand, interlock in a circular formation reminiscent of dance. Each right foot emerges behind the subsequent figure while the left feet form an inner ring. Each man grasps the sword arm of the one in front, and they lean forward in a rhythmic interchange that makes the rondel appear to spin of its own accord. Filling the space between the figures' heads are multi-

layered flames that seem to burst from the sword points.

Such rondels, depicting warriors, female dancers, or multiple deities in *maṇḍala* format are not uncommon in western India. Judging from extant monuments, they tend to appear in the square center section of a flat ceiling. They are held in place visually by surrounding orthogonal pseudobeams. Structurally, however, they tend to have

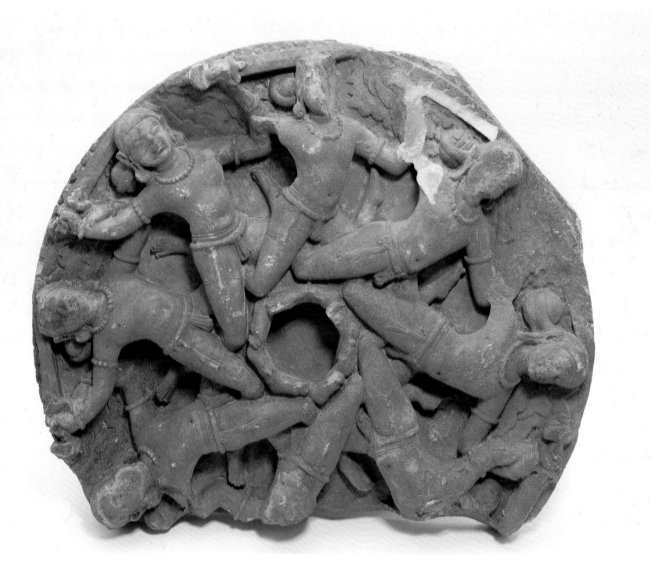

been carved as a single slab with the surrounding square; although at times the background is recessed to visually transform the rondel into a separate drop.

It is uncertain whether the warriors, who are identical, bear individual or even a specific group identity. James Harle[1] speculates on possible identities for the group, mentioning the eight directional guardians, the elements, and the more generic *vidyādharas* ("bearers of knowledge," magical air beings). Although Harle states that *vidyādharas* "do not, as a rule, carry swords," the latter possibility appears most probable, if, as Kramrisch believes,[2] the frequently repeated motif of the flying swordsman on the north Indian temple can be labeled a *vidyādhara* carrying the sword of knowledge (*vidyā*), which cuts through ignorance.

The architectural form, together with the soft fleshy bodies, full round faces, low brows, and relatively naturalistic eyes of these figures, links them to sculpture from north Gujarat and southern Rajasthan, particularly the somewhat later images of ancient Meḍapāta, around the modern city of Udaipur in southern Rajasthan (Nos. 14, 40). The sandstone from which this piece is carved was apparently painted over with a red-orange pigment. The relative simplicity of garment and ornament on these figures, which apparently led Harle to date them to the mid-eighth century, is common for small subsidiary images, especially those to be viewed from a distance, even on the tenth-century structures of the region.[3]

Reference: Harle and Topsfield 1987:24–25, cover.

1. J. C. Harle and Andrew Topsfield, *Indian Art in the Ashmolean Museum* (Oxford: Ashmolean Museum, 1987), pp. 24–25, no. 32.

2. Kramrisch, *The Hindu Temple*, vol. 2, p. 344.

3. See, for example, the superstructure images on the Ambikāmātā temple at Jagat or the niche brackets and window musicians at Ghanerao.

39.

A Row of Ganders *(Haṁsas)*
Lower molding of a circular hall ceiling
Provenance unknown, probably Uttar Pradesh (Madhyadeśa)
About late 10th century
Sandstone; 45.7 x 76.2 cm
The Art Institute of Chicago, Lent by James W. and
 Marilynn Alsdorf; 11.1983

In Indian mythology the *haṁsa* (gander) flies from earth to heaven, linking the realms of men and gods. In this way the bird is like the fire of the Vedic sacrifice in which the pillar of smoke sends man's offerings and prayers to heaven. The *haṁsa* is the *vāhana* of the God Brahmā, the Divine Priest or Sacrificer, and of Sarasvatī, Goddess of Wisdom. It symbolizes knowledge and the means toward *brahman* (absolute reality).

This curved frieze has a line of pecking *haṁsas*. It is a fragment of a continuous circular molding from the lower portion of a corbeled, domed ceiling that once covered a temple hall (*maṇḍapa*; see Fig. 57). The common placement of such a *haṁsa* frieze at the springing point for a lotuslike dome is an architectural literalization of its symbolism—the creature that links heaven and earth likewise links the lower hall, gathering place of men, with the celestial vault overhead.

The artist has carefully differentiated the seven *haṁsas* seen on this fragment. Each stands before a growing lotus. The lotuses, too, are varied—on one perches a tortoise, on another an elephant, and on a third a lion-bodied *makara*, while a fourth sprouts in graceful spirals. The birds nip at the lotus buds or preen, one biting at his foot, another

scraping his pinions. While the *haṁsa* frieze continues as a ceiling component after the tenth century, the birds lose this quirky naturalism and become stiff and repetitive.

The bodies of these *haṁsas* are sharply undercut, full, and round. Their beaks feature nasty teeth, a characteristic found in both India and Iran, anatomically inaccurate, perhaps, but capturing the animal's aggressive nature. Multiple sharp, overlapping folds compose their wings and give the carving its visual impact. The dense but salient dimensionality of the entire ceiling can be extrapolated from this fragment alone.

40.
Celestial Woman Playing Ball
Ceiling bracket of an open hall
Provenance unknown, attributed[1] to Madhariya (Tusa), Rajasthan (Meḍapāta)
About A.D. 940–950
Sandstone/Calcite(?); 90 x 41 cm
Museum Rietberg Zürich, Gift of Reinhold H. and Ann Schüepp; RVI 300
(Note: Photograph is on page 208.)

Western Indian architecture in the tenth century and onward covered the halls fronting the temple sanctum with elaborate and intricate ceilings. Grand circular ceilings formed of concentric corbeled moldings and supported by pillars became the common coverings for open "dance" halls (*raṅgamaṇḍapas*) in the region (Fig. 57). Such ceilings are carved to resemble a great three-dimensional lotus flower, potent and ancient symbol of the universe's generative force. This lotus, in bloom, stamen pendant, shelters and encompasses the devotee.

Often superimposed across the layers of petallike cuspate moldings are large bracket figures, one above each of the usual eight pillars forming the hall. Taking the form of beautiful celestial women (*apsarāsas*) in various enticing or playful postures, they lie almost flat against the dome of the ceiling in a very different configuration from the *apsarās* brackets that rise from pillar to ceiling (Nos. 41–46).

This *apsarās* plays with a ball, held up to her by a small female attendant. Her posture and anatomy are slightly adjusted so that she may appear graceful and correct when suspended at an angle well above the viewer's head. Originally she would most likely have stood on a bracket in the shape of an elephant springing out from the wall. Her right arm would have reached upward toward a mass of fruited foliage behind her head in the posture of the *śālabhañjikā* (tree goddess), a pose descended from the fertility-related *yakṣīs* (female nature spirits) of early Indian art.

Ancient Meḍapāta, the region around the city of Udaipur in eastern Rajasthan, contains four temples datable by inscription to the third quarter of the tenth century.[2] The *apsarās* bears a very close stylistic resemblance to images from these monuments, particularly those of the Ambikāmātā temple at Jagat of ca. A.D. 961

(Fig. 4). It even more closely matches figures on the Sūrya temple at Madhariya (Tusa; see Fig. 81),[3] a small village on the outskirts of modern Udaipur, particularly the five remaining bracket figures in the *raṅgamaṇḍapa*. By comparison with the dated monuments, the Madhariya Sūrya temple appears to have been constructed ca. 940–950.

The woman's body is soft and fully rounded, the flesh gently swelling and receding rather than displaying the harsher, stylized anatomy of central India. Her face is round and plump; almond eyes small, slightly bulging. Brows form two simple arcs in a low forehead, lids are depicted by gently curving planes. Undulations rather than lines or ridges define the flesh of the torso. The relaxed stance of the figure, relatively naturalistic, sinks into a low center of gravity with weight concentrated in the hips and thighs. Both breasts and ornament, although palpable, merge gently with the body.

Although this bracket typifies the style of tenth-century Meḍapāta images, the fundamental characteristics of her figure type within the region reach as far back as the sixth century. In opposition, late tenth- and eleventh-century sculptures from Meḍapāta begin to display a harsher contrast of flesh and ornament, sharper features, a more geometric configuration of body parts and, by transferring the center of gravity to the upper body, a loss of the earthly substantiality that so well complements the fleshiness of earlier images.

A branch of the Guhila dynasty, which had originated in southern Gujarat, ruled the Meḍapāta region from about the seventh century A.D. onward. Their early capital was the city of Nagada (ancient Nagahrada), north of Udaipur where Ekalingji, an important seat of the Śaiva Lakulīśa sect, was located. Sometime in the mid-tenth century, the Guhilas moved their royal capital southward to Ahar (ancient Āghāṭa), abutting modern Udaipur. Both towns were religious centers from an early date, and Nagada remained an important local political as well as religious power throughout the tenth century.[4]

From the mid-ninth through the first half of the tenth century, the Guhilas of Meḍapāta appear to have been feudatories of the powerful Pratīhāras of Kannauj. Inscriptions indicate that around the mid-tenth century the Guhilas asserted their independence from Kannauj. For the next two hundred years they maintained that independence only marginally, however, as a number of other Rajput dynasties whose strength had waxed after the Pratīhāra demise vied to annex Guhila territory. Inscriptions also show mid-tenth-century Meḍapāta to have been a center for trade from the Deccan as well as many parts of north India.

Notwithstanding the constant political, military, and mercantile interaction of this region with other north and central Indian powers, it is safe to attribute most of the relatively large number of stylistically homogeneous temples built in Meḍapāta in the tenth century (No. 14) to the Guhila dynasty. This bracket exemplifies this style. At the same time, the strong links in carving and body type with much earlier images in the vicinity, probably dating from even before Guhila dominance, indicate that this homogeneity is due as much to craft continuity as to consistent royal patronage.

1. This attribution was first suggested by Michael W. Meister. It was subsequently confirmed following site visits by Vishakha N. Desai and Michael W. Meister.

2. Durgā temple, Unwas: A.D. 959/60 and Lakulīśa temple, Ekalingji: A.D. 971/2 (by foundation inscriptions); Ambikāmātā temple, Jagat: A.D. 961 (by an inscription discussing repairs) and Mahāvīra temple, Ghanerao: A.D. 954 (by an inscription recorded from a lost sanctum image, see No. 14).

3. R. C. Agrawala, "A Newly Discovered Sun Temple at Tusa," *Bharatiya Vidya*, vol. 22 (1963), pp. 56–58 and Michael W. Meister "The Śivaite Sūrya Shrine Near Tusa," *Journal of the Indian Society of Oriental Art*, 2d of Moti Chandra Commemoration volumes (1978), pp. 60–65.

4. For the history of the Guhilas of Meḍapāta (modern Mewar), see H. C. Ray, *The Dynastic History of Northern India* (Calcutta: University of Calcutta, 1931–36), vol. 2, pp. 1153–97 and D. C. Ganguly in *The Age of Imperial Kanauj;* pp. 109–10.

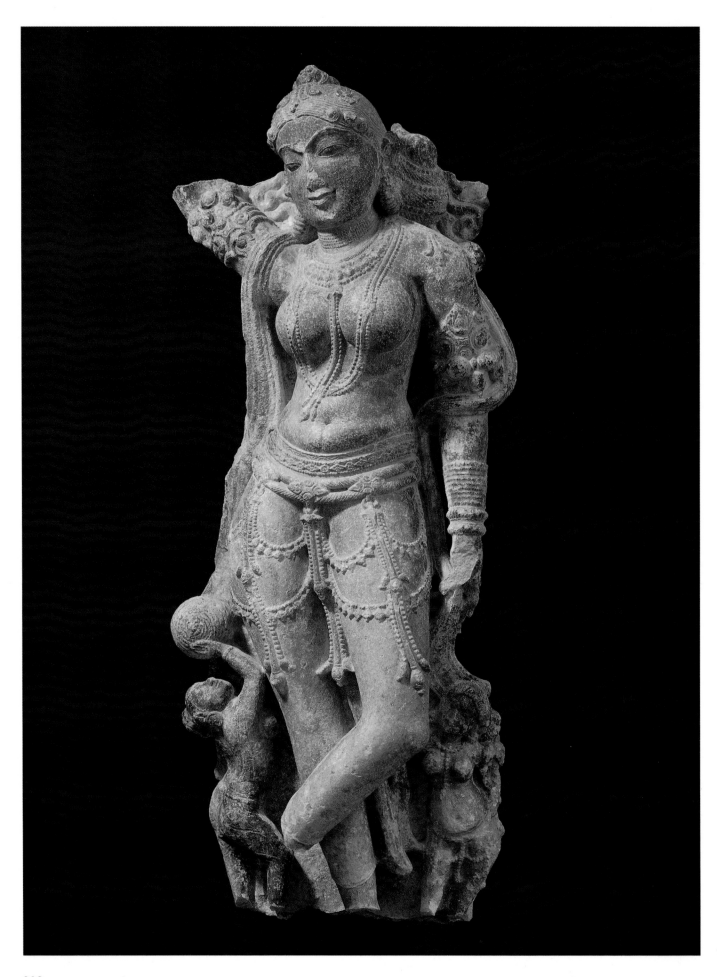

◀ 40

41.
Celestial Woman Beneath a Mango Tree
Pillar bracket
Provenance unknown, possibly southern Uttar Pradesh
(Madhyadeśa or Daśārṇadeśa)
About mid-9th century
Sandstone; 63.5 x 38.1 cm
Berthe and John Ford Collection, Baltimore

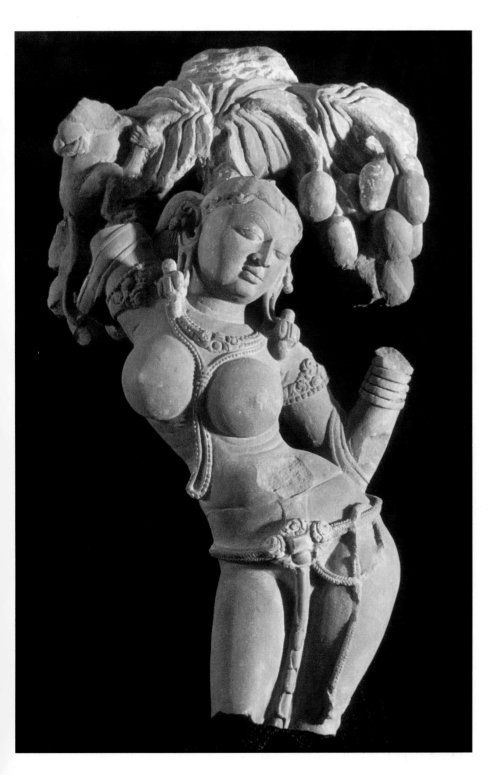

The three-dimensional nature of this carving, weightiness of the tree above, exaggerated bend with downturned head of the figure, and primarily the rough-hewn block at the top that once affixed it to a hole in the ceiling show that this bracket projected outward from a pillar. It most likely rose to the ceiling from an impost block in the form of a dwarf (No. 35) above the pillar capital. This type of *apsarās* pillar bracket is quite distinct from the *apsarās* bracket that lay flat across a concentrically cuspate ceiling in an open hall (No. 40).

The *śālabhañjikā* pose of a woman entwined with a flowering or fruit-bearing tree, her fertile touch causing the vegetation to respond in kind, is a motif often repeated in numerous locations in the temple (Nos. 11, 12). It became a standard type for such brackets across north India. The *apsarās* is but one of the multiple references to animal and vegetal fertility within temple decoration—multivalent as well, for it represents not only earthly fertility but the generative force of the divine.

In style, this bracket female conforms so closely to the image of a river goddess (No. 54) that little doubt remains that they came from the same workshop, if not the same temple and hand.

References: Heeramaneck 1979: no. 69; Pal 1986:189, no. 3.

42.
Celestial Woman with Monkeys
Pillar bracket
Provenance unknown, possibly Mandasor region, Madhya Pradesh
(Uparamāla)
About 9th century
Sandstone; H. 27.75 cm
Private Collection

This well-preserved and relatively early *apsarās* bracket combines motifs of the *śālabhañjikā* (No. 41) with that of the woman having her lower garment pulled off by a mischievous monkey (No. 13). Here she futilely, and not too strenuously, struggles to uphold the undulating folds. This latter motif seems related to an equally common one wherein the woman herself parts her garment to reveal her vulva, perhaps undressing for her lover. When such images are placed within reach on the temple wall, frequent abrasion of the genitalia gives evidence of *yonipūjā* (worship of the female generative organ) and displays how individual minor figures on the temple body frequently become the foci of popular worship within the multilayered belief system that is Hinduism.

The small monkey perched on top of the tree above the woman's head in this image reaches to grab a mango, his tail twisting up his back. The large monkey at her foot, on the other hand, is anthropomorphized to the extent of wearing a short dhoti and ornamented girdle. His actions, however, are purely simian. While he grabs her garment with his left hand, his right clutches a stolen piece of fruit, and one foot scratches at his crotch. In comparison, the attendant dwarf at her other foot appears serene.

The elaborate coiffure of the *apsarās*, with curls and pearl bands, as well as her oval earrings and multiple necklaces give a clear representation of actual adornment. The distinctive form of the mango-tree motif, with a circle of leaves from which emerges a cluster of small hanging fruit, is familiar from images in the Uparamāla area (No. 45) and one likely from Daśārṇadeśa-Avantī, bordering on Uparamāla (No. 29). This is quite distinct from its treatment in other regions (Nos. 41, 44, 47) and, along with anatomy and physiognomy, could indicate a provenance in the western portion of Madhya Pradesh or southeastern Rajasthan, possibly relating the piece to the sculpture of the area around Mandasor (Nos. 10, 11).

43.
Celestial Woman and Attendant
Pillar Bracket
Harshagiri, Rajasthan
(Mārudeśa-Sapādalakṣa)
Second half of the 10th century
Sandstone; H. 54.6 cm
The Cleveland Museum of Art, Gift of Mr. and Mrs. Severance A. Millikin; 67.202

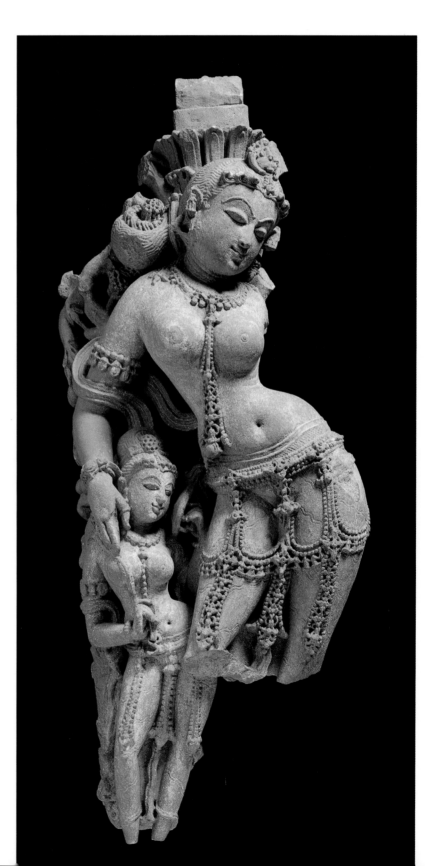

Undoubtedly one of the most finely detailed and elegant examples of north Indian temple sculpture extant, this pillar bracket in the form of an *apsarās* with female attendant comes from the site of Harshagiri (Nos. 12, 48) in the ancient Sapādalakṣa region of northeastern Rajasthan. A second similar image is in a French collection[1] and at least one more seems to be embedded into the wall of a relatively recent subterranean shrine at Harshagiri dedicated to Śiva as the ferocious Bhairava.[2]

The brackets may have come from the hall interior of the main temple at the site, the Harṣanātha temple, called the Purāṇa Mahādeva and built in A.D. 956 (No. 12). However, many other structures once formed this hilltop temple complex, including numerous subshrines, a monumental freestanding entry arch *(toraṇa)*, and a multilevel pillared tank.

The woman who forms this bracket curves into a graceful S shape, the triple bend called *tribhaṅga,* as she rests a hand on her attendant. The attendant holds up a mirror with her left hand. Suspended by a long chain over her shoulder is a double sack ending in a pot. Her right hand grasps the S-shaped hook by which the sacks and pot could have been hung. The extraordinary attention to the minor details of this and other objects is characteristic of the meticulous carvers of Harshagiri. Behind the pair rises the winding stalk of a mango tree, complete with a tiny twisting monkey. The pierced link ornament and swirling scarf are further triumphant testament to the skill of the nameless craftsman.

The image is carved in a yellow-buff sandstone, distinct from the darker red or brown tones of certain other pieces from the same site (Nos. 12, 48). As with most sandstone formations from which these monuments were carved, the outcropping at Harshagiri shows a range of tones from buff and yellow to deep purple-red. At Harshagiri and in many monuments, particularly in western India, architects were clearly conscious of color variation and chose to utilize different color stone for different portions of the temple and its carved surfaces.[3]

References: Royal Academy of Arts 1947–48: pl. 42, fig. 268; Cleveland Museum of Art 1967:347, no. 169, 333 (photo); The Asia Society 1968-69:110, fig. 13; Lerner 1969:358 (fig. 5), 360 (fig. 8); Cleveland Museum of Art 1978:301; Mookerjee 1985:42.

1. Martin Lerner, "Some Unpublished Sculptures from Harshagiri," *The Bulletin of the Cleveland Museum of Art* (December 1969), p. 360.

2. This image and a possible second are nearly obscured by accretions.

3. This is readily apparent in certain monuments in Gujarat such as the temples at Kerakot and Kotai in Kachchh where red sandstone is utilized for the basements and yellow for the upper portions. Architects of the Sompura family of Gujarat continue to practice this tradition, believing that the red stone is more dense and thus appropriate to the lower levels.

44.
Celestial Woman Beneath a Flowering Branch

Pillar bracket
Provenance unknown, attributed to Surwaya, Madhya Pradesh
(Daśārṇadeśa)
About late 10th or early 11th century
Sandstone; 78.7 x 24.1 cm
Mr. and Mrs. Nathan L. Halpern, New York

The distinctive anatomy and exquisite carving of this female bracket figure link it firmly with the regional idiom of Shivpuri District, Madhya Pradesh, during the end of the tenth and the early eleventh century. In particular it relates to the three standing temples, monastery, miniature shrine, and scattered fragments found at the site of Surwaya, probably constructed during the rule of the Kacchapaghātas, who controlled a large area of central-western India between the mid-tenth and early twelfth centuries.[1]

The most individual feature of this *apsarās*, as with all the images at the site, is undoubtedly her elongated midsection—drooping with rolls of puckered flesh that sag like festoons beneath the low, full breasts and spill over the girdle. Also distinctive are the facial features—puckish pointed chin; dainty, calligraphically curving eyelids; and brows sweeping from midnose in bowlike arcs. The mannered hip-shot pose, carefully detailed textile pattern, and specifics of coiffure and ornament are all indicative of Surwaya and a group of sculptors who had developed a distinctive human form.

The three fairly small temples at Surwaya, all apparently dedicated to a form of Śiva, are today in various stages of completeness. No superstructures and only one pillared porch remain. The ceiling of this porch displays holes for such brackets. Thus, this bracket figure, if it did indeed originate at Surwaya, may have come from the porch of one of these temples. Although other images from the site exhibit the exaggerated sway of the hips, their heads and upper bodies tend to remain erect. The inclined head and chest of this *apsarās* are clearly and consciously adjusted for her position well overhead, her gentle glance ushering devotees toward the god within.

1. See Krishna Deva, "Kachchhapaghāta Temples," *The Researcher* (Directorate of Archaeology and Museums, Government of Rajasthan, Jaipur, 1963/64), pp. 3–4.

45.
Celestial Woman Beneath a Mango Tree
Pillar bracket
From the detached *raṅgamaṇḍapa* of the Ghateśvara temple, Baroli,
 Rajasthan
(Uparamāla)
About first half of the 11th century
Sandstone; 97.2 x 29.2 cm
The Denver Art Museum, Gift of Robert H. Ellsworth in memory of
 Christian Humann; 1982.198

Grasping a mango from the laden branch above her head, this *apsarās* repeats the familiar form of the *śālabhañjikā*. As two smiling monkeys gorge themselves on the fruit, she stands below, her figure equally laden with heavy breasts and thighs, but her expression is remote. On her shallow lotus pedestal, the small feet of a (now absent) attendant appear to her left while the remnants of the mango trunk emerge at her right. Beaded leg drops, multiple necklaces, a pearl choker, and wide cuffs of pearl bangles adorn her.

Yet jewelry and flesh are equally adamantine. Her round, solid face, the carefully delineated lips, and overstated horizontal eyes magnify and solidify regional characteristics familiar from earlier Uparamāla sculptures (Nos. 8, 11, 72).

James Tod, a British captain whose 1834 *Annals and Antiquities of Rajasthan* first brought the extraordinary legends and monuments of the Rajputs to Western consciousness, wrote of the site of Baroli:

> [T]he temple of Barolli [sic] suddenly burst upon my view from amidst the foliage that shrouded it. The transition was grand; we had for some time been picking our way along the margin of a small stream that had worked itself a bed in the rock. . . .As we neared the sacred fane, still following the stream, we reached a level spot overshadowed by the majestic karoo and amba, which had never known the axe. We instantly dismounted, and by a flight of steps attained the court of the temple. To describe its stupendous and diversified architecture is impossible. . . .[1]

Although the stairs do not remain (unless Tod approached via the temple tank), Baroli exists even today as an oasis of divine tranquility in the often desiccated Rajasthan landscape.

The largest of the nine standing monuments (the one to which Tod refers) is known as the Ghateśvara temple. This Śaiva shrine consists of a sanctum with an elaborately carved attached porch. Separated by several yards from the porch is an equally large open "dance" hall (raṅgamaṇḍapa), which Tod calls the nuptial hall. The hall interior shows four pillars on a central raised platform surrounded by built-in benches (Nos. 33, 34) topped by pillars supporting a florid coffered ceiling. It is from one of the central pillars that this apsarās bracket once ascended. The roughly carved tenon projecting above the mango tree once lodged in a still-visible hole in the ceiling.[2]

An intricate roof of concentrically placed groups of layered cornices, each topped with a fluted bell (Fig. 46), covers the raṅgamaṇḍapa. This roof form, called saṃvaraṇā, evolved from an earlier layered form in the latter part of the tenth century (Fig. 41).[3] The relatively mature form seen on this building implies that the structure likely does not date earlier than the beginning of the eleventh century. The architectural formula and carving of the main shrine and porch, on the other hand, lead toward a date in the first half of the tenth century and may relate to an inscription of A.D. 927 found at the site.[4]

Thus the raṅgamaṇḍapa, as is not uncommon,[5] was constructed somewhat later—in this case probably approximately seventy-five to one hundred years after the shrine that it fronts. What is illuminating, however, is not the hardening and sharpening of carving that distinguishes this apsarās bracket from images on the main shrine and other early shrines at Baroli but the extraordinary similarity in details of ornament[6] as well as basic anatomy and physiognomy.

Comparing this bracket with the Baroli image of "Viṣṇu on the Serpent Ananta" (No. 72) and other figures from the area around Kota raises perplexing and perhaps unanswerable questions about the artist responsible for this image. Did grandsons, perhaps, of the sculptors who created the earlier temples perpetuate the practices of their forefathers? Or did the makers of the raṅgamaṇḍapa consciously replicate details and general features that they saw on the main shrine while adapting in a manner agreeable to the aesthetic requirements of their own era?

Reference: L. K. Tripathi 1975: pl. XB.

1. James Tod, *Annals and Antiquities of Rajasthan or the Central and Western Rajpoot States of India* (New Delhi: K. M. N. Publishers, 1971), pp. 564–65. Baroli is described on pp. 564–72.

2. An old photograph from the Archaeological Survey of India archive, published in L. K. Tripathi, *The Temples of Baroli* (Varanasi: Amitabha Prakasana, 1975), pl. XB, shows this figure in situ.

3. Michael W. Meister, "Phāṁsanā in Western India," *Artibus Asiae*, vol. 38 (1976), pp. 167–88. Dhaky, "The Genesis and Development of Māru-Gurjara Temple Architecture," pp. 132–34.

4. Tripathi, op. cit., pp. 60–61. Inscription published by Georg Bühler, *IA*, vol. 13 (1884), pp. 250–51. Tripathi dates the Ghateśvara raṅgamaṇḍapa along with the "ruined Śaiva temple," which probably refers to the freestanding pillars and the loose doorway lying at the site, to the mid-twelfth century. The doorway appears to be one of the earlier fragments from the site, however, while the pillars are more in line with the main Ghateśvara temple and thus datable to ca. 925. While the raṅgamaṇḍapa was undoubtedly erected later than the main shrine, it was not two hundred years later. Carving on the so-called Sūrya temple at Jhalrapatan, Bhumija (see Krishna Deva in *Studies in Indian Temple Architecture*, p. 107), datable to the end of the eleventh century, shows no relationship to this image. Likewise, the Ghateśvara superstructure, while a full-fledged saṃvaraṇā, is still significantly more rudimentary than that, for example, on the Mahāvīra temple at Kumbharia, firmly dated to A.D. 1062.

5. See M. A. Dhaky, "The Date of the Dancing Hall of the Sun Temple, Modhera," *Journal of the Asiatic Society of Bombay*, vol. 38 (1964), pp. 211–22. See also the raṅgamaṇḍapa of the Ambikāmātā temple at Jagat, Udaipur District, Rājasthan.

6. With the exception of the cufflike bangles, which are more typical of eleventh-century ornament.

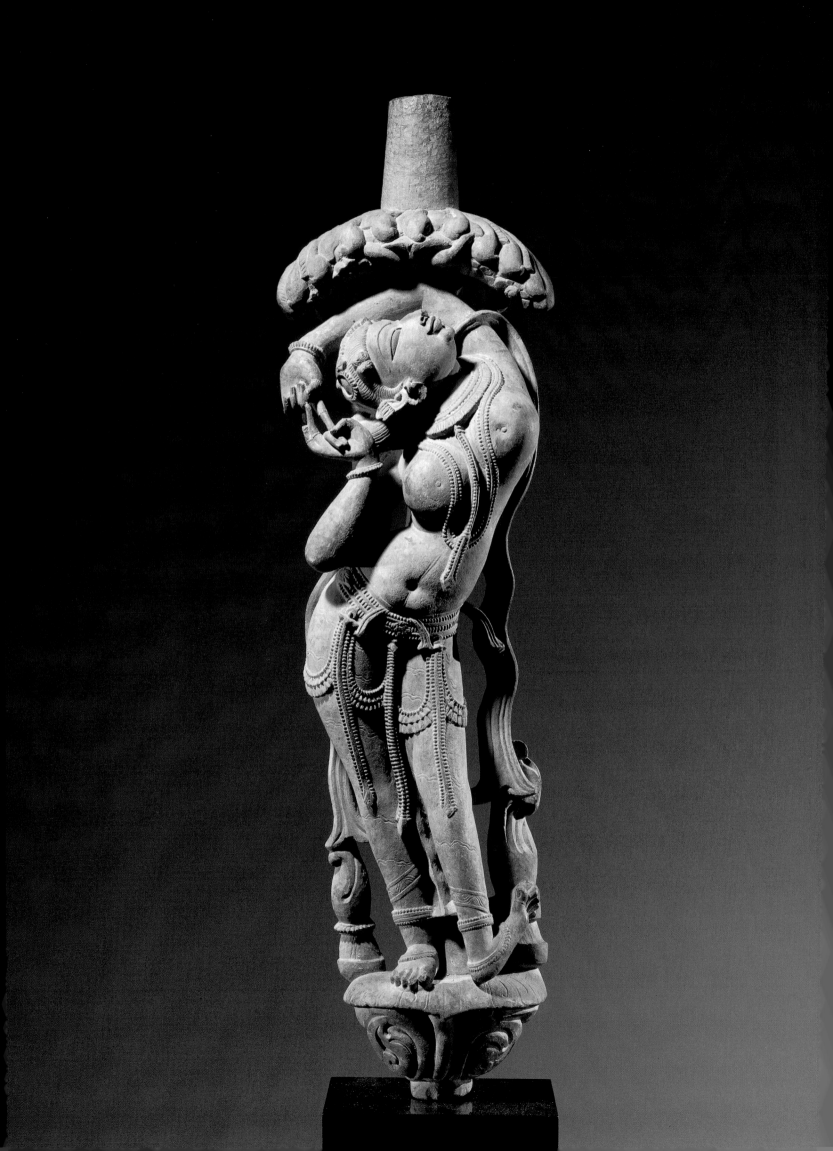

46.

Celestial Woman Under a Tree Branch

Pillar bracket
Provenance unknown, attributed to Khajurāho, Madhya Pradesh
(Jejekādeśa)
About A.D. 1075–1100
Sandstone; H. 80.6 cm
Amita and Purnendu Chatterjee

In general, the carving at Khajurāho from the tenth century through the twelfth focuses on creating forms through dramatic line and linear rhythm rather than through modeled flesh (No. 27). By the second quarter of the eleventh century, when the famous Kandariyā Mahādeva temple was created, curving lines and sinuous solids had become paramount and the whole temple pulsated to a stupendous linear crescendo. Sculptors curtailed incised or modeled detail, and the bold figures became undistracting, perfectly coordinated parts of the greater whole while retaining a certain integrity as individual pieces of carving. By the end of the century, however, when this image was carved, this integrity along with any semblance of natural anatomical articulation were well on the way to being subsumed by the requirements of overall composition.

The emphasis on the curves of composition is particularly evident in this sculpture—yet another variation on the theme of *apsarās* and mango tree. Languorously she stretches her arm above a head thrown back in profile, tugging the stretch to contortion with the fingers of her opposite hand. The overarching arm forms an exquisite circle with the diagonally tilted breasts. Like a dancer's, her left foot rises at an extraordinary angle to march the viewer up a ladder of toes to rejoin the flowing scarf and reach the focal point of head and breasts.

Yet for all the attention to composition, each part of her anatomy, perhaps somewhat too consciously, concretizes the descriptions of the poets. As the poet Kālidāsa wrote of the young Pārvatī:

A delicate line of young hair crossing the knot of her skirt and entering her deep navel seemed a streak of dark light from the blue gem centering her belt.[1]

Reflecting such descriptions, a deep double incision rises from the *apsarās*'s belt, sinks into the hollow of her navel, and fades upward following the diagonal bend of her torso.

The upper peg that would have attached this image to the architecture above her is carefully rounded, the top squared although it would never have been seen. Additional interesting evidence of the craftsman's hand is the left nipple. Carved originally too high and too far to the left for balance, he attempted to shave it down and recarved it in the proper location—the placement of the image near the ceiling would certainly have made this minor revision invisible to viewers at floor level.

1. Hank Heifetz, tr., *The Origin of the Young God: Kālidāsa's Kumārasambhava,* with annotation and an introduction by Hank Heifetz (Berkeley: University of California Press, 1985, 1990 paper), p 27.

47.
Mythical Beast (*Vyāla*) with a Warrior
Pillar bracket
Khajurāho, Madhya Pradesh
(Jejekādeśa)
About second half of the 10th century
Sandstone; 106 x 30 cm
Indian Museum, Calcutta

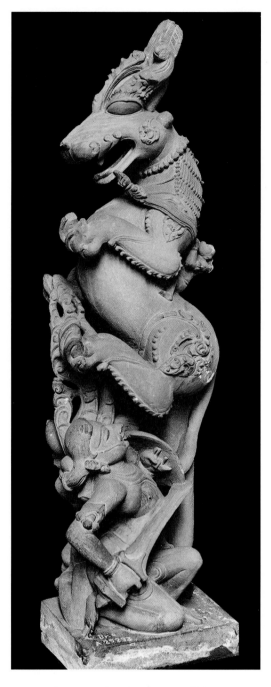

The majority of loose north Indian sculptures from the tenth through the fourteenth centuries in Western collections have at one time or another been labeled "Khajurāho," whether they evidence stylistic ties to the site or not. This *vyāla*, however, did originate on one of the monuments of that well-known temple city, and it typifies characteristics of the temples constructed toward the beginning of Khajurāho's building boom.

A mythical creature with a lion's body and composite head (Nos. 14, 15), the *vyāla*, finds its place in a number of locations on both the exterior walls of the multistoried Khajurāho structures (in the vertical indentations) and in the interior of the hall. The fact that this *vyāla* is carved in the round and the presence of an unfinished stone projection above its head indicate that it once rested on a carved impostlike block bracket partway up a large pillar in a hall, its top embedded in a second block that supported a ceiling beam (Nos. 41–46).

Judging from such images still in place in the *mahāmaṇḍapa* (great hall) of the Lakṣmaṇa temple at Khajurāho, datable by inscription to A.D. 954, the *vyāla* alternated with *apsarāsas* encircling the upper portion of each of four large pillars in the center of the hall. The carving is indeed so close to the style of the Lakṣmaṇa temple that the piece may be one of the missing brackets from this monument.

The *vyāla* rears above a large warrior (*vidyādhara*), who throws back his head and shoulder preparatory to thrusting his sword into the beast. In his left hand he fends off the animal's overarching paw with a small shield. He is bearded, his hair is twisted on itself, and he wears a short lower garment. A minute rider, dwarfed by the towering mount and nearly thrown from its rearing back, grasps a strap around the creature's shoulder. Flamelike fur defines the animal's legs and neck, while its great tail, joints, and horns are transformed into swirls of foliage.

As opposed to late eleventh-century figures from Khajurāho (No. 46), images such as this one from the tenth century (and No. 13) retain some of the substantiality and detailing descended from Gupta-period prototypes. However, they also show the transition from independent image to true architectural ornament that comes to fruition in the Candella-patronized monuments of the following generation.

Reference: Zimmer 1968 [1955]: pl. 347.

48.
Umā–Maheśvara with Musicians and Dancers
Probably interior frieze above a hall architrave
Harshagiri, Rajasthan
(Mārudeśa-Sapādalakṣa)
A.D. 956
Sandstone; 45.7 x 85.7 cm
The Nelson-Atkins Museum of Art, Kansas City, Missouri (Nelson
 Fund); 35-304

Amid swaying dancers and musicians, Śiva and Pārvatī (Umā-Maheśvara), arms entwined, appear as an icon upon the sedate Nandī. The relief comes from Harshagiri (Nos. 12, 43) and, like others from that site, reflects an acute, jewelerlike attention to fine detailing, as seen in the woven rattan basket on the arm of the flex-limbed ascetic to Śiva's right.

As with other Harshagiri images, bodies are willowy with long torsos and sensuously narrow waists. Faces are fairly wide and round, yet have sloping jaws. The plane of the face is flat; features stand out in sharp contrast. Eyes, for example, are deeply carved within sharp outlines (rounded on the inner corner, pointed on the outer), and brows form curving cordlike lines across the forehead, nearly meeting at the nose.

The scene is enacted on a single plane, all figures resting on a shallow ledge,

underlaid by a row of flattened, leaflike ornament. Although this piece has been well published, mention has never been made of its probable original location within the architecture of, presumably, the large temple at Harshagiri (the Harṣanātha, known as the Purāṇa Mahādeva). Just where did this relief and others like it (not only from Harshagiri but throughout north India) originally appear?

Early in this century the temple was reconstructed above its binding moldings using a miscellany of pieces collected at the site, few in their proper locations. Fortunately, the hall retains its original lower portions with lateral projecting porches, a rectangular space in front of the sanctum door (antarāla) marked by two pillars, and a raised central platform. Four partially original pillars stood on the corners of this platform. Although unfinished blocks are used as

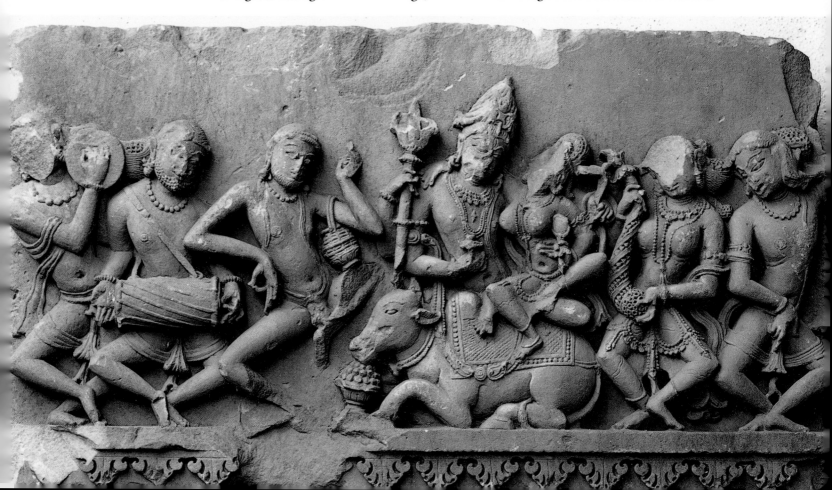

architraves above these six pillars, they likely reflect an original form and this relief may have acted as facing for the area above one of these architraves.

A number of other fragments of relief showing dancers and musicians also originated at the site.[1] These lack the lower decorative molding, however. They also show much more varied postures, with figures leaving the relief plane by turning to the side or twisting fully around to display their backs. James Harle compared one of these reliefs with this one, concluding that in the dancer relief "the rhythm of the dancer and her skillfully grouped attendant musicians is conveyed with great subtlety," while this "frieze is manifestly later [than the dancers]; here the writhing legs forming repeated geometrical patterns give a wilder, stronger rhythmical effect."[2]

There are indeed differences between the two, not only in composition but also in details of physiognomy and anatomy. Looking at the numerous fragments from the site both in situ and out, there is clearly more than one master hand at work. Whether these various hands represent a difference in the time of carving, however, is another question entirely. Like the decoding of the medieval cathedrals of Europe,[3] the answer, if it is available, awaits a careful study of all surviving sculpture and reconstruction of the original state of all the structures built at this complex and intriguing site.

References: Nelson-Atkins Museum of Art 1941:142, 1949:185, 1959:229; R. C. Agrawala 1959:69–72; The Asia Society 1960: no. 22; Shah 1965–66:78, no. 24, pl. XXXIX; Lerner 1969:357, fig. 4; Taggart et al. 1973:125; Sivaramamurti 1974:328, fig. 212, 1977: fig. 348; Newman 1984: fig. 48; Harle 1986:229–30, pl. 173.

1. One is in the collection of The Cleveland Museum of Art (No. 69.34), published in Lerner, "Some Unpublished Sculptures from Harshagiri," figs. 1 and 2.

2. James C. Harle, *The Art and Architecture of the Indian Subcontinent* (New York: Viking Penguin Inc., 1986), pp. 229–30.

3. Although written records are unavailable, Harshagiri and other complex sites warrant the same thorough analysis as, for example, that conducted by Whitney Stoddard for Chartres. Whitney S. Stoddard, *The Sculptors of the West Portals of Chartres Cathedral: Their Origins in Romanesque and Their Role in Chartrain Sculpture* (New York: W. W. Norton & Company, 1952).

49.

The Solar God (Revanta) and His Entourage

Probably interior frieze of a hall
Provenance unknown, probably central-eastern Madhya Pradesh (Dāhaladeśa)
About second half of the 10th century
Sandstone; 58.4 x 114.3 cm
State Museum, Dhubela

This relief with its elegant, multilayered carving represents the high point reached by "medieval" stonecutters, probably under the Haihaya (Kalacuri) dynasty of Dāhaladeśa in the late tenth and early eleventh centuries (Nos. 27, 50, 61).

In the foreground of the relief, three horsemen ride in procession, their saddlery, including strapped-on swords, painstakingly and accurately depicted. The foremost, holding a small clublike object, perhaps a fly whisk, twists around as if to speak to those behind him. The central rider displays a tall blooming lotus in his left hand, his right cupped around a shallow vessel. Similarly, the rear rider holds aloft a flower, here in bud form, in his left hand.

In the middle ground walk six attendants. One holds an umbrella above the head of the central horseman, indicating his royal status. Another holds a curved hunting knife. Between the legs of the horses, three rotund boars face directly outward, their identity discernible from their cloven feet and the intact snub snout and tiny tusks on the animal at the left. Behind the feet of the two foremost horses rear several long-tailed creatures with extended, toothy muzzles.

Tall palmlike plants rise up behind the horses, while the entire ground of the relief is covered with an amazing explosion of intertwining scalloped vegetation, giving the whole an unsurpassed richness. Overhanging the scene are a row of flying male celestials bearing garlands, interspersed with celestial couples, the male with a garland, the female, behind him in *añjalimudrā*.

While the carving is extraordinary, the scene is not unusual in this region at this time.[1] B. N. Goswamy, who published this piece, speculated that it might represent Revanta, a son of Sūrya (No. 28), who is often shown hunting. Although Goswamy does not mention it, the open lotus held prominently by the central rider helps to

confirm this identification.

A related relief that seems to represent the royal party entering a battle is still in situ in the huge *sabhāmaṇḍapa* at the site of Paḍhāvali, Morena District, near Gwalior, Madhya Pradesh.[2] This phenomenal structure, only the hall of what must have been an enormous temple, has a series of internal bays formed by pillars connected by architraves. Between architrave and ceiling on both sides rise high and profusely carved friezes.

The friezes of the side bays at Paḍhāvali display a similar format to this piece, with a row of small repetitive figures overhanging a long and intricate narrative frieze resting on a molding of half floral drops overlaying curved lotus petals. Although the hall of no other temple in central India possesses such extensive interior frieze ornament, fragments such as this demonstrate that the format found at Paḍhāvali was not unique. The grandeur and exquisite carving of this piece imply that the temple from which it came was indeed one of the "wonders of the medieval world."

Reference: Goswamy 1986:177, no. 162.

1. See AIIS Neg. No. 101.82 (Sohagpur, Shāhadol District, M.P.), AIIS Neg. No. 101.58 (Arjula, Shāhadol District, M.P.), and Chandra, *Stone Sculpture in the Allahbad Museum* (Poona: AIIS, n.d. [1970]), pl. 260 (Bhita, Allahabad District, U.P.) for similar relief fragments. A related frieze is in the Archaeological Museum at Khajurāho (No. 1318), AIIS Neg. No. 383.97.

2. AIIS Neg. No. 303.3.

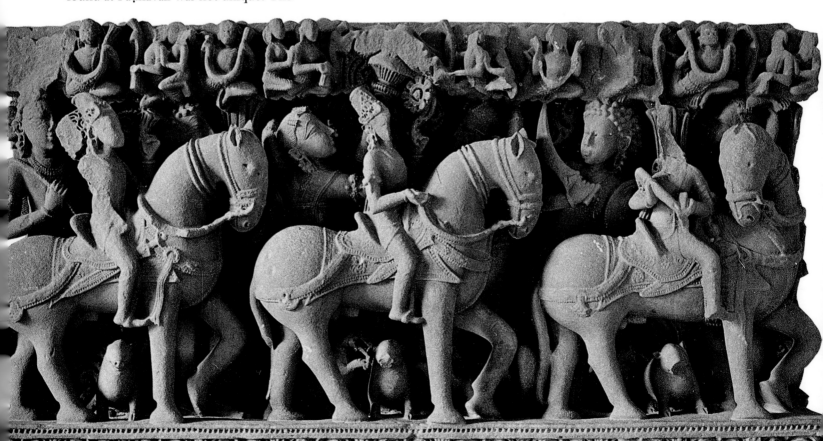

50.
Nursing Mother
Possibly interior frieze
Shāhadol District, Madhya Pradesh
(Dāhaladeśa)
About early eleventh century
Sandstone; 31.8 x 58.4 cm
State Museum, Dhubela; On long-term loan by the
 Government of India to The Asia Society, New York; 1979.34

This exquisitely preserved relief depicts a mother lying, nearly floating, on a couch and tenderly offering her breast to an infant son. Her head is haloed in the multiple hoods of a giant cobra. A female attendant, seated on a jewel-festooned pillow atop a growing lotus, massages her upraised foot. Behind stand six male guardians, most with curved swords, and a central female attendant holding a fly whisk. A third female attendant at the right grasps a rectangular object, possibly a manuscript. Below the lotus-petal–covered couch (a *charpoy*, or wooden cot, which, unlike that in No. 72, does not sag under her weight) appear three vessels and a tripod supporting a conch shell. The identities of the woman and child, however, are debatable.

She has been called the mother of the Jaina *tīrthaṅkara* Pārśvanātha, the mother of Kṛṣṇa, and Śiva Gṛhapati ("Lord of the House"). Certainly Kṛṣṇa and Pārśvanātha, in their adult forms, are sheltered by or adorned with *nāgas* (snakes). Other clues, such as the conch shell, are also ambiguous as it is both the cognizance of Viṣṇu (of whom Kṛṣṇa is a form), one of the auspicious symbols of the Jainas, and a more general ritual implement. Reclining or nursing mothers of the *tīrthaṅkaras* are perhaps more common in extant sculptures from this time and region than the other birth stories, and this seems the most probable identification.[1]

An extremely closely related relief of the same scene in the collection of the Birla Museum at Bhopal[2] is stated to have come from the mound of remains at Gurgī, Rewa District, Madhya Pradesh. Easily mistaken for this piece, it does, however, show some differences in composition and carving. Most obviously, the woman's head is to the right and only six male and no female attendants stand behind. The woman's arm is at an awkward right angle with one simple bangle. (The lower arm may have been recarved.) Subtle stylistic differences agree with the Gurgī identification. Compared with the piece discussed here, the faces, particularly of the attendant males, show squarer chins and less angular treatment of both face and body.

The delicate carving, rippling drapery, outthrust pointed chins, and numerous other features certainly link this piece with other carvings from ancient Dāhaladeśa, the Haihaya-Kalacuri–dominated region of central-eastern Madhya Pradesh (see Nos. 27, 49, 61). And indeed, this relief actually bears an original provenance of Shāhadol District.[3]

Shāhadol District lies to the east of Rewa. From there comes one of the most spectacular pieces of carving from the subcontinent: the door frame from Arjula now built into a temple at Singhpur, Shāhadol District. The figures on this relief are quite similar to those of the Arjula frame in their heart-shaped faces, sharp features, and numerous details of carving and ornament, such as the treatment of the wide multiple bangle on the mother or her oddly bent wrist posture.

———————————————

References: Dikshit 1955–57: pl. XII; Washburn 1970:329–39, no. 5, fig. 11; Young 1970:198–200, fig. 2; Lee 1975:30–31, no. 19; Rahman 1980: pl. 28; The Asia Society 1981:19; Newman 1984:44, 76, 84.

1. The numerous images of Sadyojāta (infant Śiva with Pārvatī as his mother) found in Bihar and Bengal invariably display one or more sectarian identifiers such as the *liṅga* or bull but no *nāga*. See Enamul Hague, *Bengal Sculptures: Hindu Iconography Up to c. 1250 A.D.* (Dhaka: Bangladesh National Museum, 1992), pp. 295–99, pls. 236–39.

2. Birla Museum No. 860, AIIS Neg. No. 241.8.

3. S. K. Dikshit, *A Guide to the State Museum, Dhubela, Nowgong (BKD.), Vindhya Pradesh (1955–1957)* (Chhatarpur: State Museum, 1955–57), pl. XII. The connection with Shāhadol was realized in the early 1980s when it was discovered by The Asia Society that the relief at some past date had been stolen from the State Museum, Dhubela, in Madhya Pradesh. The museum and the Government of India were informed, and a generous arrangement was made to allow the piece to remain on view in New York.

V. Transition
Doorways

51.
Door Frame

Provenance unknown, probably central Madhya Pradesh
(Daśārṇadeśa)
About A.D. 800–850
Sandstone; 102 x 111.8 cm
Private Collection

Even on the plainest temples, carvers focused particular care on the doorway to the *garbhagṛha* (sanctum, literally the "womb" or "seed chamber") to accentuate its symbolic content. For the door is the final transition or link between human and divine, manifest and absolute. Although the exact figures placed on the door vary from region to region and over time, its fundamental symbolism remains constant from the Gupta period through the fourteenth century and beyond in north India.

The surround of the temple door can be divided into four parts: overdoor (*uttaraṅga*, literally "overbranch"); jambs (*śākhās*); lower jamb friezes (*pedyās*); and threshold (*udumbara*) (Figs. 86, 87). Specific decorative and symbolic elements are assigned by tradition to each portion of the door. As with all elements of the temple, however, this was never a static system. First, certain of the inhabitants of the door (although not its organization) vary by cult affiliation. Second, the decoration and organization of the door exhibit characteristic preferences according to craft group and region. Finally, the diversity within sites shows that the architect-priest could choose and combine the elements within circumscribed limits as he thought appropriate for individual structures.

This doorway is one of the most complete examples outside India. It lacks only the threshold and the upper band of lotus petals encircling the lintel, and possibly a second upper level of figures on the lintel.

Surrounded by a continuous outer band of lotus petals, the entire door itself can be conceived as symbolically paralleling the lotus, one of the most potent and recurrent motifs in Indian art. From the mud of the lake bed the lotus rises through the water to open in the sun. It thus represents the links among the three worlds of demons (*asuras*), men, and gods. Likewise, the door displays,

on its lower jambs and threshold, images emblematic of water, while celestial figures inhabit the lintel.

On this door, as on all north Indian temple doors of the period, the lower jamb friezes bear the divine personifications of north India's two holiest rivers, Gaṅgā (the Ganges) and Yamunā (the Jumna). Gaṅgā, on the right, stands atop a *makara* (Nos. 31, 52) while Yamunā, on the left, rests on a tortoise (No. 53). Gaṅgā more frequently appears on the right, Yamunā on the left but, judging from numerous extant examples of the reverse, this is by no means a rule.

Each river goddess bears in her hand a water pot from which vegetation burgeons. This is the "full pot" (*pūrṇaghaṭa*) or "leaf-filled pot" (*ghaṭapallava*), denoting fertility, and frequently is incorporated into other architectural members (No. 34). Behind each goddess and her smaller female attendant grows a thick, oversized lotus stem, the flower opening above the goddesses' heads like a royal umbrella.

Above the water pots and lining the entire opening of the door rises a *śākhā* (literally "branch or limb") of woven snake tails ending in human upper bodies. Snakes (*nāgas*) are themselves emblematic of water (and thus fertility) and are particularly appropriate to the door as they denote liminality. They turn toward the deity within the sanctum, expressing their reverent devotion through hands folded together in *añjalimudrā*.

Between this *nāgaśākhā* and the outer lotus band runs the figure jamb (*rūpaśākhā*). On this door, the figure jamb bears a series of dwarves dancing and playing musical instruments, separated by square floral bosses (No. 1). Such figure bands generally display either dancers and musicians celebrating the appearance of divinity, as here, or amorous couples (*mithunas*), accentuating the fecund and proliferative aspect of the manifesting

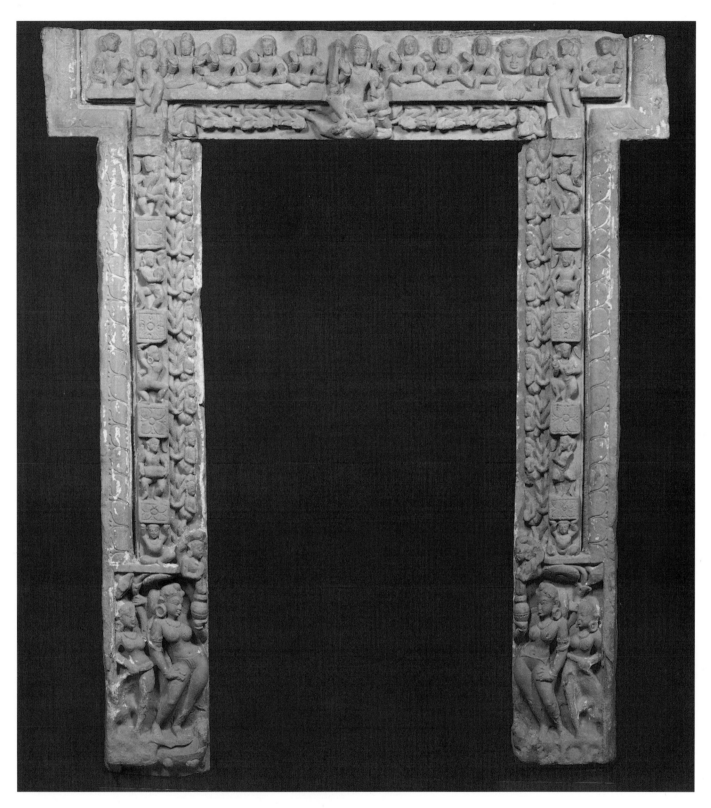

deity. On this door, the lowermost dwarves on either jamb act as atlantes, crouching to support the niches above and mimicking the frequent use of dwarves as impostlike blocks above pillar capitals (No. 35).

Atop the figure jamb stand celestial women (*apsarāsas*) holding fly whisks, like attendants to royalty. Next to them are small but obese seated men. They are either

dwarves as on the figure jamb or multiple representations of Kubera, God of Wealth and Prosperity, a frequent inhabitant of the door surround, although seen more usually on the threshold. The T shape of the doorway, with lintel projecting past the side jambs, was the norm during the Gupta period and appears sporadically on monuments in central India even as late as the ninth century.

Between the fly whisk-bearing *apsarāsas* sit the nine planets (*navagrahas*), the most common set of inhabitants of the lintel. The set begins on the left with Sūrya, the sun. He wears the distinctive breastplate and boots. In either hand he holds a lotus that opens wide in the light of the sun (No. 28). On the far right, the set ends with the dark (or ascending) and light (or descending) phases of the moon. The dark phase is represented by the severed hands and head of Rāhu (literally, the "seizer"), a demon who tried to swallow the divine elixir of immortality (*amṛta*) and whom Viṣṇu decapitated in retaliation. The light phase is shown by the dragon-tailed Ketu, sometimes considered Rāhu's body. Between sun and moon sit the six known planets, represented as identical males in the posture of relaxation (*lalitāsana*). They raise their right hands in the gesture of protection (*abhayamudrā*), perhaps in imitation of the god Viṣṇu, whom they flank.

The large image of Viṣṇu in the center projects through the *nāgaśākhā*. He rides his humanized bird mount, Garuḍa, who gently supports Viṣṇu's foot and knee rather than grasping the tails of the surrounding snakes in the more usual posture. Viṣṇu himself is represented as having four arms, carrying his attributes of discus (*cakra*, here with foliate end) and mace (*gāḍha*) in his secondary hands while his primary display *abhayamudrā* and an oddly elongated conch shell (*śaṅkha*).

The elements utilized (e.g., the square floral bosses), their organization, the fairly simple ornaments, and the naturalistic fleshiness of the figures indicate a date sometime in the first half of the ninth century.

The presence of a *nāgaśākhā*, along with the relatively large size and continuous friezelike nature of the lower jamb, show that the door comes from central India or northern Rajasthan, as these elements are characteristic of the architectural traditions that stemmed directly from those of the Gupta empire. The carving, especially the body types, forehead curls, and faces with small, diagonally slanted eyes, suggest the eastern portion of ancient Daśārṇadeśa. Figures with similar features can be found, for example, on many of the ninth-century monuments at the site of Badoh-Pathari, not far from Bhopal in Madhya Pradesh, where a large number of whole and partial temples of the ninth through eleventh centuries stand today.

228

52.
The River Goddess Gaṅgā
Lower left jamb frieze of a doorway
Provenance unknown, probably near Mathura, Uttar Pradesh (Śūrasena)
About mid-7th century
Sandstone; 108 x 49.7 cm
The Cleveland Museum of Art, Purchase, John L. Severance Fund; 66.119

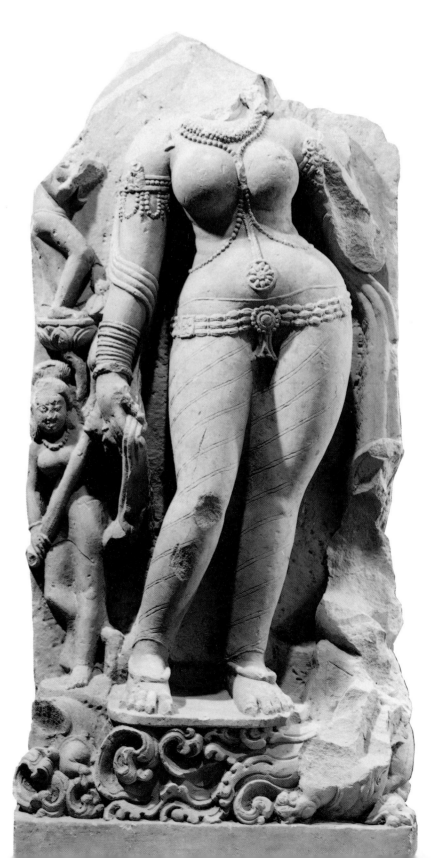

The opulent body of this river goddess, formed of heavy, bursting volumes fully integrated into a single figure, represents sculpture from the early period of the north Indian temple-carving tradition, firmly linked to images from the late Gupta period at sites from Rajasthan to Bihar. Yet the specifics of her figure, ornament, surrounding motifs, and even the face of her attendant connect her with the area around Mathura[1] and its sculptural legacy stemming back to the Kushan dynasty as early as the second century B.C.

Although headless, the image is monumental in both size and physical presence. At her feet appear the lower portion of an animal followed by wavelike scalloped swirls and a second small creature caught in the frenzy. When complete, the large animal undoubtedly had the reptilian features and elephantine trunk of the *makara*. This alone would be enough to identify the woman as Gaṅgā, the personified holy river Ganges. Her swaying pose and attendant provide additional clues not only that she is Gaṅgā but that she originally formed the lower left section of a door surround. In this location on the temple body, her purifying waters could cleanse entrants to the sanctum and her voluptuous presence increase the creative force of the temple and its applicants.

Tucked in behind and to the sides of the goddess are heavy lotus flowers and buds. Their full-blown, natural forms replicate her own and emphasize the early date of this image. The small female attendant by her foot wears a high bun and a smooth ankle-length garment with an upper covering draped around her and dangling to a point, the flesh of her side peeking past it. Above her head, on a growing lotus pedestal, stands a second, incomplete attendant. The goddess's own garment, also ankle length, is detailed with unwaving double-parallel incised lines. Her jewelry shows forms

familiar from late Gupta sculpture: the multistrand belt of oval beads slung low on the hips, the heavy, twisted pearl necklace, strings of pearls swooping below the breasts, and the single round pendant.[2]

This Gaṅgā is undoubtedly the earliest sculpture in the exhibition, dating perhaps even to the first half of the seventh century, a time when the temple itself was in its formative stage. That the river goddesses flanked and guarded the door even at this period shows that their presence was crucial to the symbolic functioning of the structure (Fig. 86).

References: Cleveland Museum of Art (September) 1966:23, 254–55, no. 142, 1978:292; Lerner 1969:359, fig.6; Wiesberg and Janson 1975:15, no. 8; Czuma 1977:107, 109, fig.38.

1. Following Martin Lerner, Stanislaw Czuma, in "Mathura Sculpture from the Cleveland Museum of Art Collection," *Cleveland Museum of Art Bulletin*, vol. 64, no. 3 (March 1977), p. 109, attributed this image to the Mathura area. He notes, "The stone. . . is not the typical Sikri sandstone [used for the majority of Mathura images] although the reddish veins in it may suggest that it comes, broadly speaking, from the area of the Karri quarries." A number of sandstone color variations come from the area around Mathura and, as with all areas, await chemical analysis coordinating site and image.

2. See Joanna Williams, "The Sculpture of Mandasor," *Archives of Asian Art*, vol. 26 (New York: The Asia Society, 1972–73), pp. 50–66.

53.
The River Goddess Yamunā
Lower left jamb frieze of a doorway
Provenance unknown, probably central Madhya Pradesh
(Daśārṇadeśa)
About early 9th century
Sandstone; 65.4 x 36.8 cm
Museum of Fine Arts, Boston, Frederick L. Jack Fund; 67.2

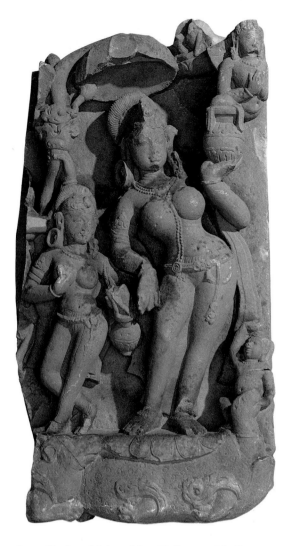

Flanking sanctum doorways throughout north India on the lower level of the jambs, are invariably female personifications of the two most sacred rivers of the region: the Ganges (Gaṅgā) and the Jumna (Yamunā). Yamunā stands atop a tortoise, as in this image, while Gaṅgā rests on a *makara* (No. 52). Other water imagery surrounds the goddesses.

This river goddess holds a water vessel aloft in her left hand, and vegetation bursts from it. Beside her, a smaller female attendant carries a similar pot and, in her right hand, a lotus flower grasped delicately between thumb and forefinger. The thick stem of a lotus rises to her left to end in an umbrella-like blossom that overshadows and encapsulates the goddess. On the far left of the fragment would most likely have stood a male door guardian (*dvārapāla*). A hand, grasping the lotus stem, remains.

The tortoise, his shell detailed by small incised circles, is shown below. The swirling waves surrounding his back-stretched feet suggest that he is swimming. His naked head, complete with anthropomorphized eyebrow, stretches upward as he gently nips the hand of a small dwarf (*gaṇa*). The *gaṇa* sports a fat belly and piglike nose and reaches up to push the goddess's draperies from his face. Behind the tortoise appears a rather bovine water creature carved in low relief, a motif found occasionally in this location on the Gurjara-Pratīhāra–related monuments of the late eighth and ninth centuries.[1]

Above the goddess's water vessel, a curly headed *nāga*, his snake tail merging into the relief plane and his hood broken, cups his hands together in *añjalimudrā*. Above him would likely have risen the inner jamb of braided snakes (*nāgaśakhā*) typical of eighth- and ninth-century monuments in northern Rajasthan and western Madhya Pradesh.

Bodies are weighty, breasts heavy with gentle fleshy folds beneath, and contoured legs display thick ankles. Full squarish faces have sensuously abundant lips. These features, like the continuous frieze format (as opposed to images relegated to separate vertical jambs), are indicative of central India, particularly certain sites in ancient Daśārṇadeśa.[2] The rounded bun of the coiffure, simple herringbone belts with side loop and rough jeweled buckle, as well as the clear double pearl necklace with asymmetrical pendant, all point toward a date early in the ninth century, if not late in the eighth.

References: Rosenfield 1966:18, 44, no. 32; Museum of Fine Arts, Boston, 1982:170, no. 160.

1. For example, the doorway of the Mālādevī temple, Gyaraspur.
2. See *EITA*, vol. 2, part 2., chap. 25, pp. 26–60, pls. 52–134.

54.
River Goddess

Lower right jamb frieze of a doorway
Provenance unknown, possibly southern Uttar Pradesh
(Madhyadeśa or Daśārṇadeśa)
About mid–9th century
Sandstone; H. 66.7 cm
Mr. and Mrs. Stanley Snider Collection

Although her specific identity as either Gaṅgā or Yamunā cannot be determined because of the absence of a *vāhana*, the water pot in her hand, hip-shot pose, attendants, and traces of stylized water or foliate tail below confirm that this image is indeed the personification of one of India's holy rivers. Indubitably she once occupied the lower segment of the right jambs of a sanctum doorway.

Geometrically rounded forms merge to construct the body of the goddess, giving her a fullness accentuated by her separation from the original relief ground.

A diaphanous ankle-length lower garment with central rippling folds marginally covers the goddess's lush body. Her low-slung chain belt carries a heavy jeweled clasp, and a herringbone rope loops over the belt and ends in a bell grasped by one of her dwarflike attendants. A thick double strand of pearls adorns her neck, and a longer strand, bound together, hangs between her full breasts. These ornaments and her bouffant hairstyle are typical of images from throughout north India from the seventh through the ninth centuries.

In her right hand, the goddess bears a bulbous water pot, overlaid with a lotus-petal-and-pearl motif, brimming with foliage and stuffed with a coconut. It is the *pūrṇaghaṭa*, ancient symbol of fecundity. Her left hand rests on the head of a rotund female attendant who carries a piece of fruit in her hand, further emphasizing the life-giving aspects of the river goddess.

The flesh of her belly is defined by parallel lines beneath each breast that rise and meet at a central incision. Such linearly defined flesh characterizes eighth- and ninth-century female images, particularly in northwestern Madhya Pradesh and southern Uttar Pradesh.

Her facial features are delicately carved, the exquisite full lips particularly notable.

Long cordlike brows arch upward toward the outer end of eyes shaded by heavy, half-closed lids. These and other features link her to a group of sculptures from an unidentified site (probably in ancient Madhyadeśa), particularly the *apsarās* bracket (No. 41) also in this exhibition.

References: Pal (*The Sensuous Immortals*) 1978:74–75, no. 41; Heeramaneck 1979: no. 68.

55.

[Overdoor with] Umā-Maheśvara with Lovers and Protective "Faces" (*Kīrtimukha*)

Upper section of a doorway
Harṣamātā temple complex, Abaneri, Rajasthan
(Mārudeśa-Sapādalakṣa)
About A.D. 800–825
Sandstone; 40 x 156 cm
National Museum, New Delhi; 69.133

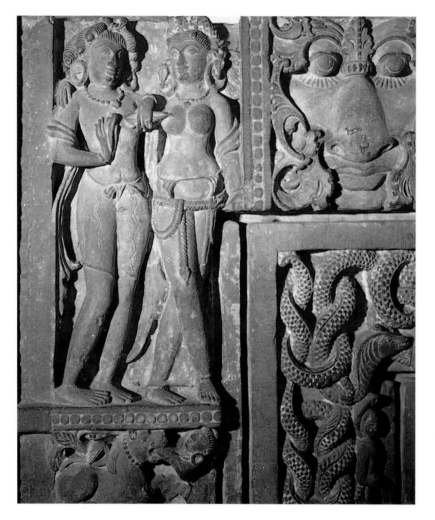

This section of overdoor (*uttaraṅga*) from the site of Abaneri (No. 6) matches several other fragmentary pieces of lintel at the site and in the Amber Archeological Museum. In the center sit Umā-Maheśvara (Śiva and his consort, Pārvatī). Although the temple appears to be dedicated to a form of Viṣṇu, other loose fragments of sculptures relating to the Śaiva pantheon are found as well.[1] The site also includes an elaborate step well, incorporating numerous images, such as a temple tank.

The innermost surround of this door consisted of an elegant, multidimensional foliate scroll, seen along the bottom of the fragment. So deeply undercut is the carving that it appears pierced. Swirling leaves merge at the center to form the shadowy shape of a *kīrtimukha* (No. 37). This motif parallels the larger ones above, whose leonine characteristics are minimized in favor of a human-vegetal coalescence.

The *kīrtimukha* (literally, "face of fame" or "glory") is one of the most common motifs in temples throughout India, appearing in north Indian architecture from at least the early sixth century[2] and much earlier as a jewelry motif. It shares many characteristics and symbolic origins with the *vyāla* (Nos. 14, 15, 47). Like the *vyāla*, its features are basically those of a horned lion, although often in earlier central India it merges human and animal characteristics. As a representation of nature's vigor it combines with swirls of vegetation.[3]

A snake jamb (*nāgaśākhā*, No. 51) separates the two levels, one indicator of the stylistic link between northern Rajasthan and central India in the eighth and ninth centuries. The artist has lovingly modeled the scaly skin and striated underhoods of the cobras. A flying male, Viṣṇu's birdman vehicle, Garuḍa, joins the two halves of the jamb by grasping the innermost snakes in a stranglehold.

Celestial couples flying on the upper level attend Śiva and Pārvatī; the male on the right beats a drum while the one on the left strums a *vīṇā*; females carry flowers and a

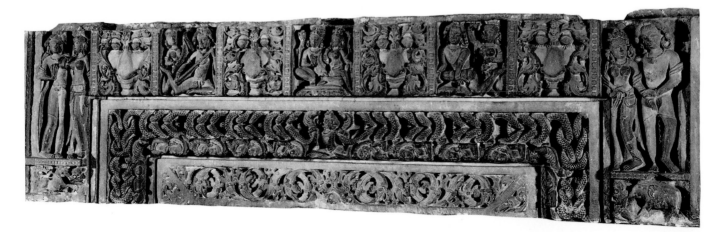

floral garland. Both music and floral offerings form part of *pūjā*, the worship or honoring of the deity.

Amorous couples (*mithunas*) stand to either side topping what, on the complete door, would have been the figure jamb (No. 51). Most likely the entire jamb consisted of such couples interspersed with scenes of animal-man combat. The complete jambs must have provided an extraordinary exploration of the shades of erotic attraction—the interplay of coyness and affection. Sculptors in this period rarely allowed such motifs, included for their auspicious as well as apotropaic effect, to degenerate into monotonous ornament. Rather, standard motifs became, especially on well-patronized monuments, the springboard for imaginative variation and aesthetic delight.

The stylistic characteristics of the Cāhamāna-Pratīhāra carving from Sapādalakṣa are also epitomized in this piece (Nos. 6, 23). Bodies display smooth, very round, and elegant limbs; as well as high, thin waists with gently swelling hips. Female breasts are small, round, raised high on the chest, and have incised nipples, while male pectorals merge undefined with the ribs. The rounded, bulging cheeks on these images give the faces an appealing, infantlike appearance. Mouths abut wide noses, eyes are close together, and carefully etched coiffures top low foreheads.

References: Arts Council of Great Britain 1982:120, no. 42; Chandra 1985:130, no. 56; Meister, Dhaky, and Deva 1991: pl. 536.

1. Including Pañcāgniparvatī, Ardhanārīśvara, and Skanda.
2. For example, the lintel from Sarnath with *jātaka* scenes. See *EITA*, vol. 2, pt. 1, pl. 95.
3. See Kramrisch, *The Hindu Temple*, vol. 2, pp. 322–31, for an in-depth discussion of the possible symbolic origins of this motif.

56.
Threshold with Lions

Lower part of a doorway
Provenance unknown, probably eastern Rajasthan or southwestern Uttar Pradesh
(Uparamāla or Śūrasena)
About first half of the 9th century
Sandstone; 45.7 x 76.2 cm
The Art Institute of Chicago, Lent by the James W. and Marilynn Alsdorf Collection; 491-2.1983

Raised sills form part of the sanctum door composition on even the earliest structural temples in north India. The images that came to occupy these thresholds from about the seventh century onward reinforce the multivalent significance of the door itself (No. 51). It is both protective barrier and preparation for entry to the holiest of holy places, the sanctum.

The center and farthest projection of this sill is marked with a growing lotus, symbol of the purity and sanctity that comes from water, like the river goddesses who would have stood on the lower portions of the jambs (Nos. 51–54). To enter the *garbhagṛha*, the priest or devotee must walk over the lotus, passing through the cleansing waters from which it grows, as in an act of ritual ablution.

To either side are lions. They function as guardians by their power and emphasize the regal nature of divinity (Nos. 3, 4). In the recesses between appear *kīrtimukhas*, who here combine leonine, human, and vegetal features reminiscent of those on the overdoor segment from Abaneri (No. 55), likewise datable to the early ninth century.

Unlike the flat, compartmentalized sills of contemporaneous temples in Gujarat, the rich carving and motifs such as the lions link this piece with the host of temples built in northern Rajasthan, Uttar Pradesh, and Madhya Pradesh by the numerous feudatories

of the northern Gurjara-Pratīhāras. These groups most clearly continued the artistic precedents of Gupta architects and sculptors.[1]

1. Compare this threshold, for example, with the related one on Temple No. 2 at Amvan in ancient Uparamāla, dating from about the second quarter of the ninth century (*EITA*, vol. 2, part 2, pl. 711). Also compare that on Subshrine 2 in the Mahanaleśvara compound at Menal in the same region, which shows the same thick framing of each offset (pl. 627). It should be noted that the abutting shrine (No. 1) at Menal (pl. 626), while displaying the same motifs, does not treat them in the same fashion. Meister has noted that (especially in relation to the two quite different images of Naṭeśa in the rear niches of these shrines), while Shrine No. 1 partakes clearly of a regional Uparamāla type continued through the next several centuries in the region around Kota, Shrine No. 2 reflects the aesthetic of the Gurjara-Pratīhāra realm, seen as far west as Osian.

57.
Overdoor with Viṣṇu and Goddesses

Provenance unknown, probably central Madhya Pradesh (Daśārṇadeśa)
About mid-9th century
Sandstone; 40.6 x 127 cm
Doris Wiener

The constant referencing in each part of the temple to other parts displays itself in the planar variation of this nearly complete two-level lintel (*uttaraṅga*). On either end of the lower level, two *vyālas* rear over elephant heads in a condensed version of the *vyāla*-and-elephant-head bracket (No. 14). On a plane projecting from between each pair of addorsed *vyālas* is a swaying *apsarās* in two stock poses: as *śālabhañjikā* (Nos. 12, 41–46) and disrobed by a (now missing) monkey (Nos. 13, 42). The configuration is similar to that of the temple exterior wall as it developed in the late ninth and early tenth centuries when the intermediary offset (*pratiratha*) became separated from the flanking offsets by indentations (*salilāntaras*). However, it likely does not reflect the wall configuration of the temple from which it came. Rather it shows an organizational concept developing in or being imported into the region that only later bears fruit as the quintessential "medieval" wall (Fig. 4).

Between the innermost *vyālas* sit the *navagrahas* (No. 51). Here, however, the set is flanked by two other figures, probably forms of Viṣṇu, one in meditational posture, the other mounted.[1] Viṣṇu sits prominently in the center as crest figure (*lalāṭabimba*). Rather than multiple human-bodied snakes with interwoven tails as interior surround (No. 51), this doorway possessed what appears to be a row of buds but is actually the scaly body of a single snake. Above the *navagrahas* fly, alternately, male and female heavenly beings carrying garlands. The artist has cleverly varied their postures to create a lively frieze rather than a repetitive decorative band.

The upper level of the *uttaraṅga* displays five projections, each bearing one of the multitudinous manifestations of the great Goddess Durgā. On the far left is the emaciated Kālī (or Cāmuṇḍā), and on the far right is an unidentified goddess with what

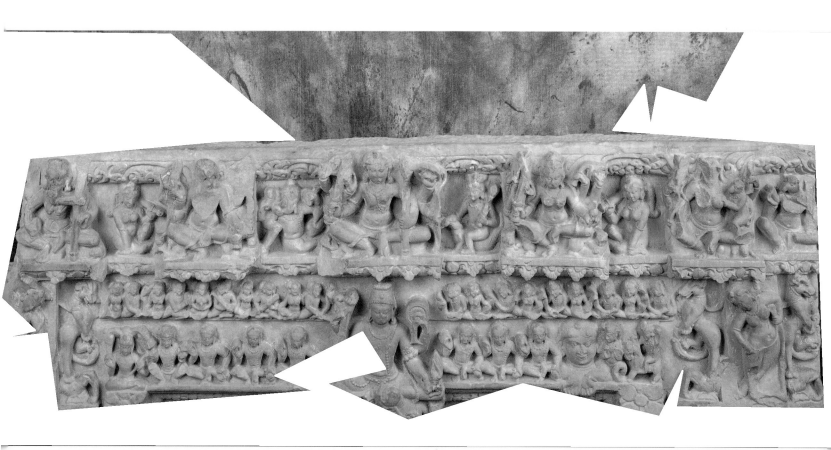

appears to be a sheep's head. She holds a sheep-headed child and is flanked by a similar female attendant.

In the center is most likely the absolute form of Durgā herself, with multiple weapons astride a single lion. The goddess to her left has both bull and lion as *vāhanas* and may be a form of Pārvatī (Gaurī), while two lions accompany the one to Durgā's right (No. 69). The forms of the goddess are numerous and their equally numerous names as given in texts are often difficult to connect with specific image types.

Flanking the three central goddesses are *cāmaradhāriṇīs* (fly whisk-bearing female attendants). The sons of Pārvatī and Śiva fill the remaining spaces—elephant-headed Gaṇeśa on the left and youthful Skanda atop his peacock to the right. It is difficult to determine from this piece to which deity the temple was dedicated—perhaps Viṣṇu or the Goddess.

In terms of regional style, this relief relates most closely to ninth-century monuments in the area around Vidisha, near Bhopal in Madhya Pradesh, ancient Daśārṇadeśa. The decorative motif of the leaf-drop molding is omnipresent at sites in this area.[2] Wide faces and hips are another constant characteristic. The configuration of the *navagrahas* with the curly headed demon

Rāhu holding his hands downward to project through the molding below is yet another regional idiosyncrasy (No. 51). The distinctive lines of flesh, which appear below the breasts of the seated goddesses, only hinted at in the other female figures, may be a reflection of the slightly earlier practice for depicting female anatomy, since iconic figures often retain not only archaic iconographic but also stylistic features.

1. They may be two of Viṣṇu's *daśāvatāras* ("ten descents"). The horseman is probably Kalkin, final and future avatar. The cross-legged figure is more problematic—Buddhāvatāra usually shows snail curls and/or a *uṣṇīṣa* (cranial protuberance), *mudrās*, and other attributes of Buddha (No. 70).

2. For example, Mālādevī temple at Gyaraspur and temples at Badoh-Pathari.

58.
Corner of an Overdoor with Śiva

Provenance unknown, probably Kota region, Rajasthan
(Uparamāla)
About second half of the 9th century
Sandstone; 73 x 99 cm
Los Angeles County Museum of Art, From the Nasli and Alice
 Heeramaneck Collection, Museum Associates Purchase; M.74.5.6

This right corner section of an overdoor (*uttaraṅga*) shows the god Śiva seated on his *vāhana*, the bull Nandī. He bears a (now broken) trident in his upper right hand and a lotus in the hand below, while the left hands carry a snake and a water pot, respectively. When first published,[1] this image had been identified as Kubera, God of Wealth, because of the pot in his hand. More recently, Pratapaditya Pal,[2] while correctly reidentifying him as Śiva, stated that the lintel fragment must have come from a Śaiva temple and speculated that this figure would have balanced a second manifestation of Śiva "on the other side." Such a configuration, with two seated manifestations of Śiva in this location, would indeed be an anomaly.

First, in such a configuration as this, three rather than two such large figures invariably completed the overdoor—a balancing figure on the far left and a similar divinity in the center. In this case, the raised left forearm of the central deity can just be discerned. Second, if a large seated Śiva is present on the right, the center almost always presents Viṣṇu and the opposite corner Brahmā. Since it is usually safe to assume that the large image in the center of the overdoor represents the tutelary divinity of the temple, the fragment should come from a Vaiṣṇava shrine.

Above Śiva's head on this corner fragment sit the nine planets, *navagrahas* (only seven are visible, Nos. 51, 57). At the far left Sūrya, the sun, garbed in armor, holds his double lotuses. The missing portion on the right would have carried the decapitated head of Rāhu together with the fish-tailed Ketu. The remaining six planets are identical, each holding a pot and rosary. The section opposite, on the missing left half of the lintel, likely held the Seven Mothers (Saptamātṛkās, No. 62).

On the level below are somewhat rarer, though by no means unknown, inhabitants of the overdoor—the *aṣṭadikpālas*. Appropriately celestial for the overdoor, although more familiar from the exterior corners of temples (Nos. 1, 7, 8), these guardians of the directions in space always appear in a fixed order that accords with their location on the compass.

At the left of the fragment stands Nirṛti, guardian of the southwest, with his sword and a dog as *vāhana*.[3] Next comes Varuṇa, guardian of the west and Vedic Lord of the Waters, with *makara* at his feet. He is followed by Vāyu (northwest) with deer and flag (No. 8). Partially missing at the right, to Śiva's left, stands the portly Kubera, guardian of the north, with his pot of wealth at his feet and a drinking cup in his hand. Reading from left to right, as one reads Indian languages, the figures follow a clockwise progression around the compass, just as a devotee circumambulates the temple. The missing opposite side of the lintel must have completed the set with, from left to right, Īśāna, Indra, Agni, and Yama.

It is fascinating to compare this configuration with that on the door of an approximately contemporaneous temple, the Jarai-kā-Maṭh at Barwasagar (Fig. 87). Here, instead of beginning the set with Īśāna, as would have been the case if our lintel were complete, it begins with Indra. The sequence of the set is not altered, but the locations are rotated one step clockwise on the compass. Exactly the same possibility of one-step rotation occurs on temple exteriors. Sequence is immutable but, since the eight directions work only imperfectly on the corners of a cardinally oriented square structure, the exact location, within strict limits, was left to the discretion of the builders.

The fine-grained, dark purple-red sandstone in which this image is carved is typical of a number of sites in the Kota region of Rajasthan, ancient Uparamāla (for

example, Nos. 8, 11). The anatomy and details of the figures also indicate this region (No. 8). The roundness of the faces, double-incised projecting arch of the brows, sharp sideways bend at the waist, and numerous other features linking these figures with the earliest pieces from the early tenth-to-eleventh century site of Baroli in Kota District further help in assigning a geographic origin (No. 72). So, too, does the exceptionally large and elaborate foliate tail of the *vyāla* at the right, which appears in numerous fragments from the Kota region,[4] including some at the site of Atru.[5]

Atru (No. 8) had a number of shrines from the second half of the ninth century and perhaps the tenth, most of which are nearly destroyed, though numerous fragments remain at the site. Many of these fragments closely conform to the carving of this over-door segment as well as that of the following doorway piece,[6] and Atru seems the most likely provenance for both fragments.

The configuration and relative scale of the figures is also typical of Kota, a region that, although distinctive, blended the format of areas to the east and west. Utilizing three very large deities cutting through the overdoor, for example, is typical of Madhya Pradesh. General anatomy and certain details of dress, such as the fold of fabric on one leg of male figures, although typical of the Kota region, looks northwestward toward Mārudeśa-Sapādalakṣa.[7]

References: Rosenfield 1966:21, 49, no. 38; Trabold 1975:18, no. 13; Heeramaneck 1979: no. 74; Pal 1988:122–23, no. 49.

1. John Rosenfield, *The Arts of India and Nepal: The Nasli and Alice Heeramaneck Collection: Museum of Fine Arts, Boston* (Boston: Museum of Fine Arts, 1966).

2. Pratapaditya Pal, *Indian Sculpture 700–1800, Vol. 2, A Catalogue of the Los Angeles County Museum of Art Collection* (Los Angeles and Berkeley: Los Angeles County Museum of Art and University of California Press, 1988), pp. 122–23, no. 49.

3. Nirṛti (literally, "misery, destruction") was originally associated with death. According to Hindu belief, the dog is associated with graveyards and thus pollution. It appears as the *vāhana* of Śiva in his terrifying forms. Pal, op. cit., p. 123, calls this figure Kubera, referring to M. T. de Mallmann, *Les Enseignements iconographiques de l'Agnipurāṇa* (Paris: Presses universitaires de France, 1963), p. 134, who, in discussing iconography as culled from the *Agnipurāṇa*, states that Kubera at times carries a sword and has a sheep as a *vāhana*. However, Kubera is more frequently seen with attendants but no *vāhana*. At times, as on the Ambikāmātā temple at Jagat, one of the attendants may be a *brāhmaṇa*, or a *vāhana* (*naravāhana*) of Kubera. See Gösta Liebert, *Iconographic Dictionary of the Indian Religion: Hinduism, Buddhism, and Jainism*, 2d. ed. (Delhi: Sri Satguru Publications, 1985), p. 143. Kubera usually appears with a potbelly and frequently holds or is offered a pot, moneybag, or fruit. It is Nirṛti who carries the sword.

4. Especially evident in a number of door fragments currently in the garden of the residence and hotel of the Mahārāja of Kota (Briraj Bhavan). Although the provenance of these pieces could not be determined, they clearly were brought from the general vicinity of the city.

5. Particularly the *garbhagṛha* doorway of the Shyam Sundar temple at Atru (AIIS Neg. No. 642.12). Pal, op. cit., p. 123, writes, "The mythical *śārdūla* . . . seems to be attacking his own tail, which assumes the form of a highly stylized, rearing serpent. The exact significance of this curious motif is not immediately apparent; it may merely have been the result of the artist's whimsy. Below this composition is yet another *śārdūla* with equally curious scrolling tail." Actually, the "snake" is swirling foliage while, as stated, the motif of a large *vyāla* tail is the norm in the Kota region throughout the second half of the ninth century and the early tenth. This is even apparent on the fallen doorway at Baroli.

6. One striking resemblance is to a fragment showing Śiva with his consort Pārvatī seated on Nandī, which is now built into the south wall of the more modern Gosainji's temple (AIIS Neg. No. 614.93).

7. The latter characteristic can be seen on contemporaneous figures on the Nīlakaṇṭha Mahādeva temple at Kekind (Jasnagar).

59.

Śaiva Guardian

Lower left jamb frieze of a doorway
Provenance unknown, probably Kota region, Rajasthan
(Uparamāla)
About second half of the 9th century
Sandstone; 92.7 x 54.6 cm
Los Angeles County Museum of Art, From the Nasli and Alice
 Heeramaneck Collection, Museum Associates Purchase; M.74.5.5

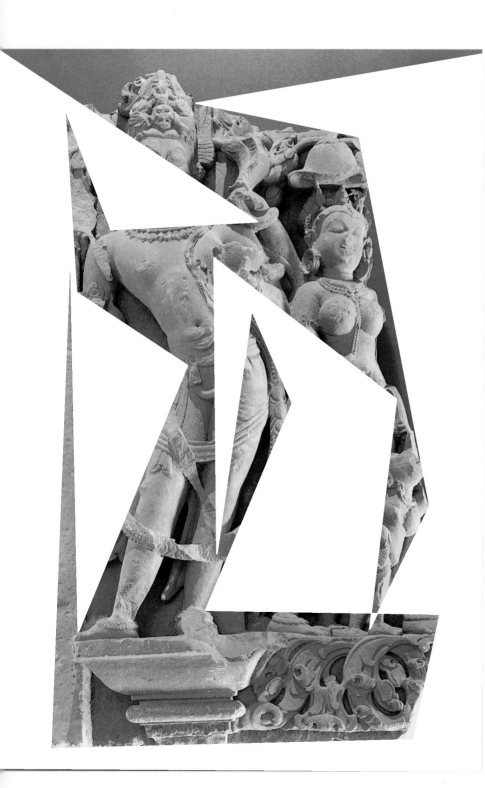

This fragment of a lower jamb frieze (*pedyā*) from the left of a door bears a large Śaiva door guardian (*dvārapāla*). Mimicking Śiva in his horrific form as Bhairava, this terrifying four-armed guardian carries a trident and snake (*nāga*) in his rear hands and a skull cup (*kapāla*) in his extant front hand. His bearded face displays Śiva's third eye, a cavernous mouth, and bared fangs and is crowned by the ascetic's matted locks *jaṭāmukuṭa*.

Next to the *dvārapāla* stands a female attendant facing inward. Her breasts are high and round with gentle rolls of flesh below. At her feet, a dwarfish female, apparently holding a cosmetic bag, gazes upward toward the (now missing) river goddess who would once have completed this portion of the composition (Nos. 52–54). The river goddess's foot remains, along with the foliate tail of her sea creature below her attendants' feet.

The scales of both this fragment and the previously discussed segment of overdoor (No. 58) imply that the doors from which they came were quite monumental—probably between thirteen and fourteen feet high from the floor to the top of the overdoor. Although the scale and carving on the two pieces are identical, however, the iconography raises questions as to whether they come from a single doorway or from doorways on different temples created by the same artisans.

At first glance, the repetition of the Śaiva theme would seem to reinforce the connections between the two pieces, but, as discussed (No. 58), an examination of numerous standing monuments points toward the conclusion that the overdoor segment came from a temple to the God Viṣṇu.[1]

In terms of regional and chronological origin, however, the two fragments undoubtedly coincide, originating in the Kota region of Rajasthan (ancient

Uparamāla), possibly from the site of Atru. A greater softness and fullness of carving are readily evident when, for example, this *dikpāla* is compared with the Vāyu from the Brooklyn Museum (No. 8). This, along with details of anatomy and ornament that connect it more firmly with carving of the mid-ninth century rather than the early tenth, lead to a probable date sometime in the third quarter of the ninth century.

References: Rosenfield 1966:48–49, no. 37; Lanius 1972:78–84, pl. XLIIIb; Heeramaneck 1979: no. 75; Pal 1988:120–21, no. 48.

1. There are, however, several exceptions to this rule that lead to the possibility, although by no means the likelihood, that the two come from the same shrine. In one exception, the temple would be dedicated to Śiva, in the second, to Viṣṇu. The first exception stems from an iconographic transference. Most eighth- and ninth-century temple doorways in central India and northern Rajasthan show one jamb as a band of intertwined snakes (see Nos. 55, 57) —water-associated semidivinities appropriate to the purifying, fructifying entryway. Viṣṇu's *vāhana*, Garuḍa, kills snakes and is often depicted with them in his beak or talons. When Viṣṇu is represented in the upper center of a door bearing such a jamb, Garuḍa frequently clutches the tails of the entwined serpents. This motif evidently became so popular in eighth- and ninth-century north India that it even began to appear on Śaiva overdoors (for example, the late tenth-century Temple 1 at Surwaya, Shivpuri District, M. P.). The second exception, even less likely, is that the Śaiva guardian appeared on a Vaiṣṇava shrine. This is indicated by instances in which certain Śaiva characteristics, particularly *jaṭāmukuṭa*, are seen on guardians of Vaiṣṇava temples, such as those at the Lakṣmaṇa temple at Khajurāho. (Dr. Devangana Desai first pointed out this peculiarity.) However, in this instance, the more distinguishing characteristics of *triśūla*, *kapāla*, and fierce expression are absent.

60.
Śiva as the Cosmic Dancer

Section of an overdoor
Provenance unknown, probably western Madhya Pradesh or eastern
 Rajasthan
(Daśārṇadeśa or Uparamāla)
About late 9th century
Sandstone; 43.1 x 26.5 cm
Museum of Fine Arts, Boston, Frederick L. Jack Fund; 69.1047
(*Note: Photograph is on following page.*)

Although it is carefully chiseled to resemble the independent sculptures so valued by Western collectors, a few clues remain indicating the original architectural location of this fragment and its place in a temple's iconographic program. The image represents the god Śiva as Lord of Dance (Naṭeśa), creating and dissolving the cosmos through rhythm and motion. At Śiva's lower left stands his bull *vāhana*, Nandī. At his right, a member of his dwarf host accompanies the lord's dance on drums.

The two projections at the upper corners of the relief are all that remain of cross-shaped capitals, indicating that the image once stood within a niche flanked by pillars (No. 9). Śiva dances on an inverted cyme molding overlaid with a "moon-window" motif (*candraśālā*). If this had been a wall or superstructure niche, the moldings, minus the *candraśālā*, would have been right side up to support the image. The molding, then, must once have acted as cornice above another image in a niche below it.

The fact that no cornice tops the Naṭeśa, despite the enclosing pillars, supports the idea that this odd configuration is due to a method of construction. Just such a configuration occurs commonly in both western and central India during the late ninth and tenth centuries[1] when three horizontal slabs of stone are used to form the upper portion of a temple door. The topmost slab usually includes the outer jambs as well as cornices for the uppermost level of figures. The middle slab, from which this piece was likely taken, likewise contains the capping molding for the band below it. The lowermost slab tends to include a second row of figures together with the innermost jambs.

The placement of Naṭeśa within such a trilevel configuration, as well as the type of niche, indicate that the image probably formed part of a set of Saptamātṛkās (No. 62).

239

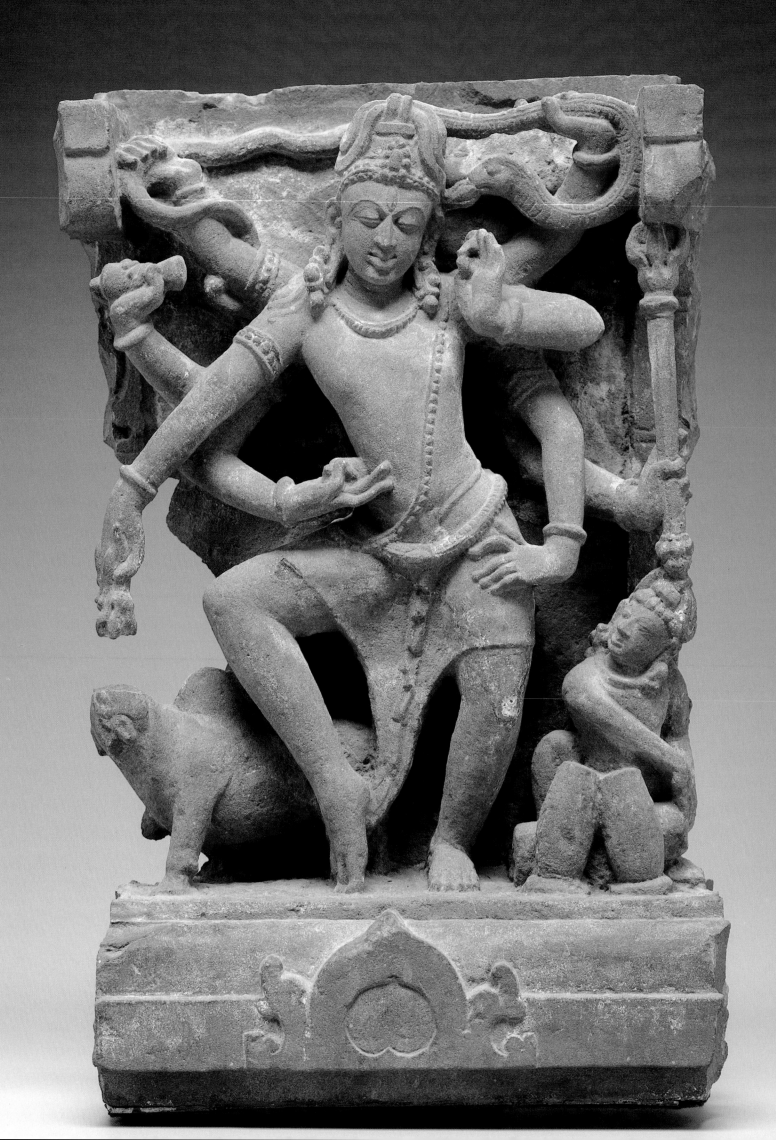

Although they can appear on temples dedicated to any of the Hindu deities, the Saptamātṛkās are closely related to Śiva. On the north Indian temple, they are grouped together with some form of Śiva and with his elephant-headed son, Gaṇeśa. Conventions regarding which form of Śiva and where he appears within the set vary from region to region. This image must have followed the practice prevalent in western India where Śiva commonly appears as Naṭeśa and is placed in the center of the mātṛkās.

This eight-armed version of Naṭeśa displays certain unusual iconographic features. Śiva's right arm usually crosses diagonally in front of his chest as he dances (in the position taken here by the dwarf, No. 61). In this image, however, the right arm reaches downward to his side and holds a lotus flower that mimics the shape of the trident (triśūla) lifted prominently by his backmost left arm. With his raised upper hands he stretches the snake Vāsuki above his head in a manner more common with a flayed elephant skin, as when Śiva appears in his manifestation as destroyer of the elephant demon[2] (No. 22).

Śiva's central right hand grasps the double drum (ḍamaru) with which he beats time as he dances the universe through creation, preservation, and dissolution. His remaining hands are held in various hand postures (e.g., the upper left is in vitarkamudrā and second right is in tripatāka) from classical dance. Indeed, the physical language of dance and the body language by which the gods and goddesses of stone communicate and identify themselves are one and the same. Iconographic texts describe the gods as possessing the graceful bodies of eternally youthful dancers.

References: Kramrisch (Manifestations of Shiva) 1981:43–44, no. 36; Museum of Fine Arts, Boston 1982:167, no. 157.

1. The pieces of the door frame from the Śiva temple at Kerakot in Kutch, now in the Lalbhai Dalpatbhai Museum in Ahmedabad, Gujarat, are a clear example. See the essay by Darielle Mason.

2. The pose is unusual but not unknown, for example, on a relief on the east devakulikā (subshrine) of the Rājīvalocana temple at Rajim, Madhya Pradesh, where a scarf is held up in place of Vāsuki. (See R. N. Misra, Sculptures of Ḍāhala and Dakshiṇa Kośala and Their Background, p. CI).

61.
Śiva as the Cosmic Dancer
Section of an overdoor
Provenance unknown, probably central–eastern Madhya Pradesh
(Dāhaladeśa)
About early 11th century
Sandstone; 44.5 x 31.6 cm
Museum of Fine Arts, Boston, Marshall H. Gould Fund; 1992.12

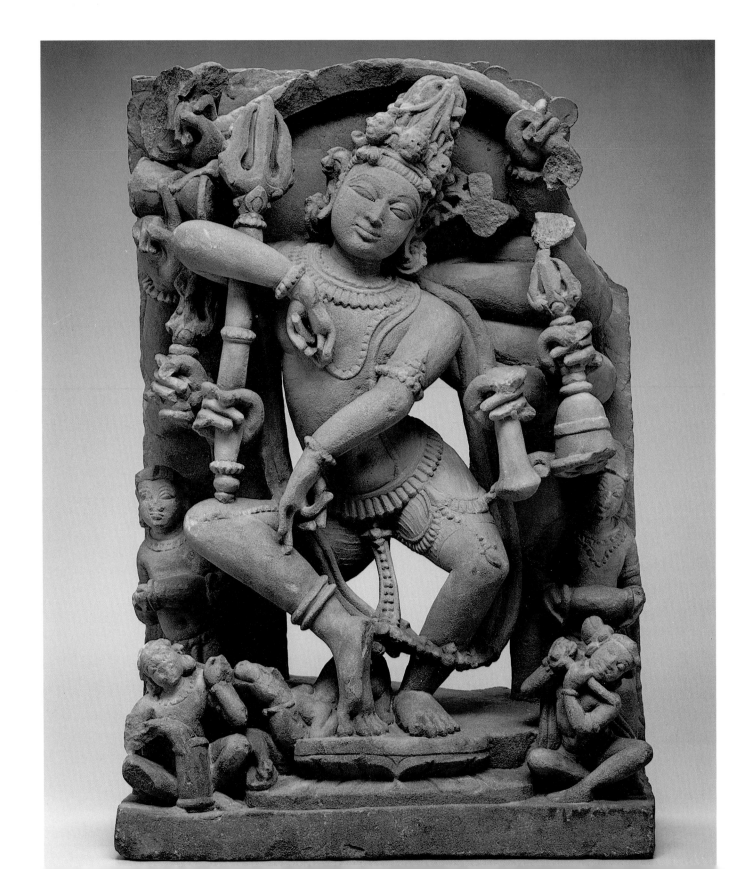

Head and arm inclined to balance a sharply raised elbow and knee, this eight-armed Śiva as Naṭeśa (Lord of Dance) sways sinuously in the rhythms of creation, preservation, and dissolution. Like the previous Naṭeśa (No. 60), this small image was most likely once incorporated into the lintel of an elaborate temple doorway fronting either a hall or sanctum.

Unlike the previous piece, however, this Naṭeśa did not constitute part of a Saptamātṛkā set. Rather, as on many doorways of Śiva temples still in situ in central India,[1] he probably projected from the center of the lower portion of a lintel, crossing through various jambs of smaller figures, possibly with equal-sized deities[2] marking the corners of the lintel on the same level (Fig. 54).

Naṭeśa stands on a flat double-lotus base with the tiny Nandī kneeling behind, the bull's broken head once thrown back in ecstasy. Four symmetrically placed musicians accompany Śiva's dance on percussion and flute. The heads of the two seated musicians tilt directly sideways, as does the god's. Śiva's raised right foot turns outward to bare the sole and ends in long toes curled under, a distinctive treatment met frequently in the images of *yoginīs* from Bherāghāt near Jabalpur City.[3]

The god wears a short lower garment, the fabric delineated with narrow, rippling folds. Long beads decorate his necklace, belt, and leg drops. Śiva's front arms, one placed across his body and the other raised at the elbow and looped around this trident, show *mudrās* of the dance. His backmost arms carry aloft the serpent Vāsuki, while his remaining hands hold the double drum, an unidentified ritual implement, the trident, possibly a mace, and a bell with trident handle. Behind the serpent emerge layers of crisply outlined clouds.

The image was clearly intended to be viewed from well above eye level. From eye level, Śiva's dancing posture is static and posed. When one looks from below, however, the body appears proportionate and sinuously graceful, and the kinetic tension of the separated front arms becomes palpable.

The god's full, square face has a round, projecting chin with a deeply incised, drop-shaped dimple. His eyes are long and undercut with heavy double lids; brows are defined as smooth ridges ending in an upsweep. The nose is a modern replacement. Carving is sharp and flesh solid and

unyielding. The whole agrees well with images from sites such as Bherāghāt and Tewar, near Jabalpur City, almost precisely in the center of Madhya Pradesh.

Very near these monuments is the site of Tripurī, ancient capital of the Haihaya rulers (a branch of the Kalacuri dynasty). Adherents of the Śaiva sect of Mattamayūra[4] (No. 36), the Kalacuri-Haihayas emerged as major power in eastern-central India as the Gurjara-Pratīhāras declined in the early tenth century. It is a reasonable guess that this elegant image of Naṭeśa, clearly from a large and well-patronized monument, may once have adorned the doorway of a temple built under this dynasty at the height of their rule late in the tenth or early in the eleventh centuries.

1. For example, the temple at Nohta or the Śaiva monastery at Candrehe. Although these Naṭeśas stand against an unbroken relief plane, other large lintel figures in central India display a pierced plane (for example, at Kadwaha).

2. In this region, when Naṭeśa is placed in the center of an overdoor (which is usual), not only can Brahmā and Viṣṇu appear at the corners but, depending on the shrine's dedication, other images can as well. (For example, on the Vīrateśvara temple at Sohagpur, Shāhadol District, Gaṇeśa dances on the right corner, Sarasvatī sits on the left, and Naṭeśa is in the center.)

3. Vidya Dehejia, *Yoginī Cult and Temples: A Tāntric Tradition*, p.138, convincingly dates the temple of eighty-one *yoginīs* at Bherāghāt to ca. A.D. 975–1025.

4. For inscriptions and monuments concerning this sect, see V. V. Mirashi, *Inscriptions of the Kalachuri-Chedi Era, Corpus Inscriptionum Indicarum*, vol. 4, pt. 1 (Ootacamund: Department of Archaeology, India, 1955) Ali Rahman, *Art and Architecture of the Kalacuris* (New Delhi: Sundeep Prakashan, 1980); and R. D. Banerjea, *The Haihayas of Tripurī and Their Monuments.*

62 ▶

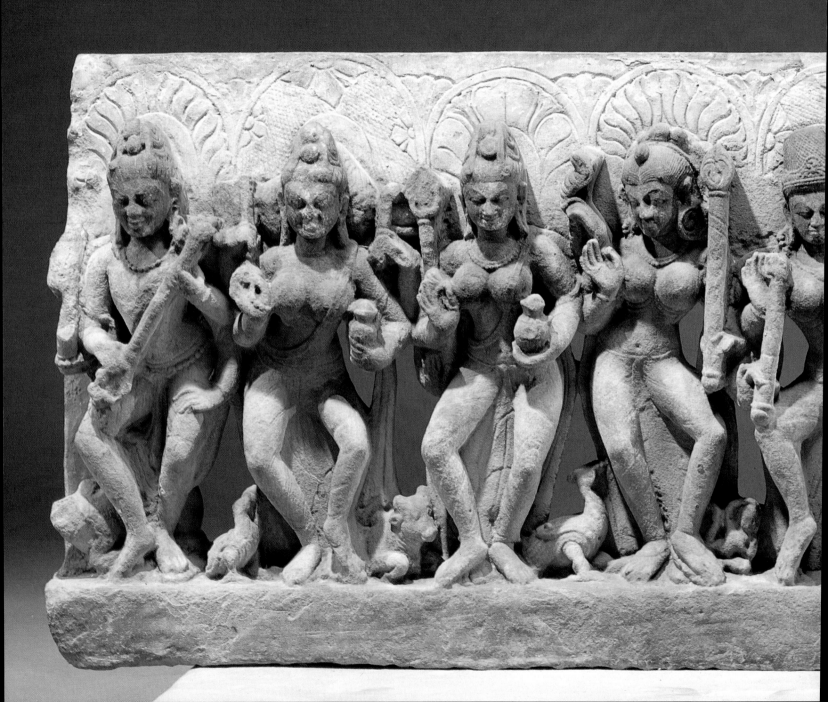

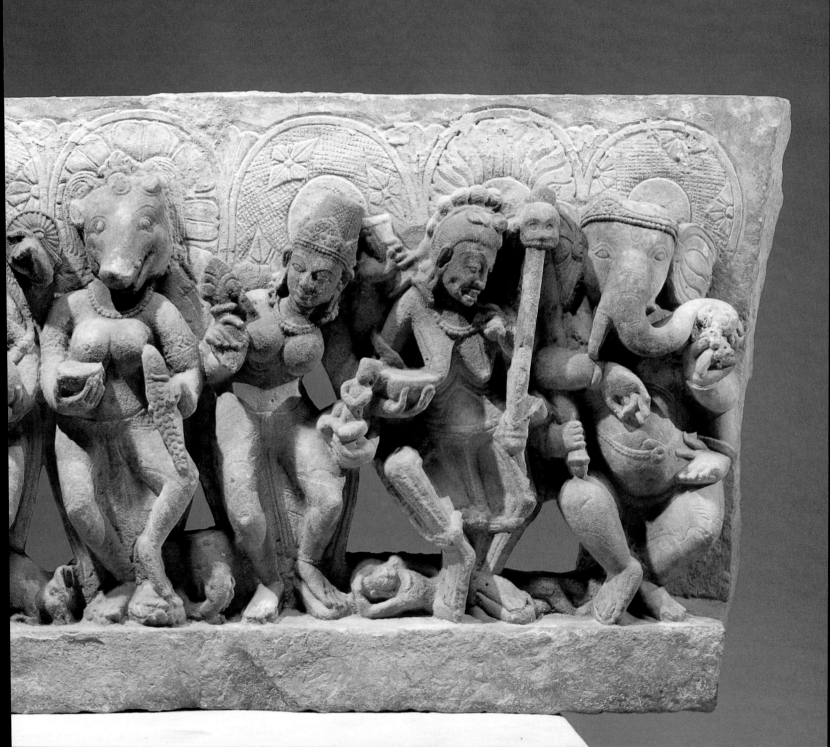

The Seven Mother Goddesses

Section of an overdoor
Provenance unknown, probably southern Uttar Pradesh
(Madhyadeśa)
About late 8th to early 9th century
Sandstone; 50.8 x 134.6 cm
Dorothy and Richard Sherwood
(*Note: Photograph is on previous pages.*)

They are called the Seven Mothers (Saptamātṛkās), but the mythology behind these figures is more martial than maternal. They are *śaktis,* the embodied energies of each of the male gods, created from the great Goddess to help subdue *asuras* (Nos. 19–21). Each *mātṛkā* bears the weapons and other attributes of the god with whom she is affiliated, but she cannot be considered his wife or consort. Rather, she is the active principle of the god himself.

The order in which the seven *mātṛkās* stand is not precisely fixed, but almost invariably begins on the left with Brahmāṇī (the second figure from the left in this relief), *śakti* of the four-headed god-priest Brahmā. Like him, Brahmāṇī has multiple heads, her *vāhana* is the gander (*haṁsa,* No. 39), and she carries ritual implements (bell, palm-leaf book, and holy water pot). Reading from left to right, Māheśvarī usually stands or sits next in line. She is *śakti* of Śiva, who is Maheśvara ("Great Lord"). Trident and bull identify her.

The order of the following four seems interchangeable. In this relief, Kaumārī flanks Māheśvarī. She is *śakti* of Kumāra (literally, "young man"), also called Kārttikeya and Skanda. Kaumārī appears as an elaborately coiffured young girl, head lowered bashfully. She grasps Kumāra's spear in her hand, and his peacock gazes at her from near her feet. Vaiṣṇavī, Viṣṇu's *śakti,* bears his usual attributes (*cakra,* mace, and conch) while the birdman Garuḍa twists into an awkward flying position in the confined space below her. Vārāhī, *śakti* of Viṣṇu as the boar Varāha (No. 71), stands next, showing her porcine countenance in an unusual frontal view. Her *vāhana,* the chthonic buffalo, kneels in adoration beside her. She clutches a fish in her left hand and a skull cup in her right.

To the right of Vārāhī is Indrāṇī, *śakti* of the Vedic sky king, Indra. Crowned, she grasps the *vajra,* a stylized thunderbolt, in her right hand. The storm elephant of Indra

peeks from behind her. Indrāṇī bears a child in her left arm. The final *mātṛkā* is Cāmuṇḍā, *śakti* of the Goddess herself (No. 21). Sagging and emaciated, she holds a bell, skull cup, and skull-topped staff and points her finger to her fanged jaws as she cavorts atop her *vāhana,* a corpse.

At times, all the Saptamātṛkās on doorways carry children, with the exception of Cāmuṇḍā. As does Indrāṇī here, they usually display their defining attributes at the same time. The children may reflect the early blending of the myths of the *mātṛkās* with that of the Kṛttikās, the personified stars of the Pleiades, who gestated and nursed the god Kārttikeya, son of Śiva. The Saptamātṛkās were coopted into a primary relationship with Śiva at least as early as the sixth century in north India. In the sets on "medieval" temples, they appear together with a form of Śiva and with his elephant-headed son, Gaṇeśa. Despite the connection with Śiva, however, the set may appear on the doorways of temples of any sectarian affiliation.

This relief follows the central Indian convention of bracketing the *mātṛkās* between Śiva as Vīṇādhara, Lord of Music, on the left and Gaṇeśa on the right, as opposed to the western Indian convention of placing Śiva as Naṭeśa (Lord of Dance) in the center (No. 60).[1] Vīṇādhara, with four arms, accompanies his dance on the *vīṇā* held diagonally across his chest. Gaṇeśa, with ax in one hand and bowl of sweets in the other, indulges in the latter as he dances.

All nine figures in the relief bend both knees and sway their bodies as they dance, but the posture of each is different. The composition thus gives the feeling that each moves to the same music but individually as the music moves them. The poses reinforce the character of each; Brahmāṇī, for example, remains iconically frontal, Cāmuṇḍā stamps viciously downward, and Indrāṇī bends

sideways, like a tree in a storm. The halo incised behind the head of each figure, no two exactly alike, further emphasizes the artist's conscious attempt at variety.

A fruitful stylistic comparison can be made between this panel and several other pieces in the exhibition (Nos. 30, 35), attributed to the area around Kannauj (Kānyakubja), the ancient Gurjara-Pratīhāra capital, as well as to other pieces firmly linked to the site. A partial Saptamātṛkā panel in the Kannauj Archeological Museum,[2] although significantly more massive and finished than this one, shows a comparable liveliness and variety, similar order and iconographic details, along with related anatomy and physiognomy. On both panels, breasts are full, projecting, and comparatively low; waists are stout and torsos are short with rounded hips and low-slung girdles; the feet are notably fleshy. As on the Brooklyn Museum Durgā (No. 69), rolls of flesh peek from below breasts. Faces, although less rectangular than that image, have a similar wide, fleshy mouth abutting a straight, flaring nose. They display the same low fluid arch of brows ending at the sides of the nose, along with wide, horizontal eyes that barely taper at the corners.

Few standing monuments survive in the region around Kannauj, which later became the heart of Islamic power in India and the recipient of frequent iconoclastic forays. The extreme political importance of Kannauj in the eighth and ninth centuries, however, makes it likely that the rulers of that city and their neighboring vassals patronized temples in a large surrounding area, and this lintel fragment may have come from one such monument.

1. Michael W. Meister, "Regional Variations in Mātṛkā Conventions," *Artibus Asiae*, vol. 47 (1986), pp. 233–46.
2. Published in Pramod Chandra, *The Sculpture of India: 3000 B.C.–1300 A.D.* (Washington, D.C.: National Gallery of Art, 1985), pp. 108-09, no. 43.

Reference: Pal (*The Sensuous Immortals*) 1978:64–65, no. 35.

63 ▶

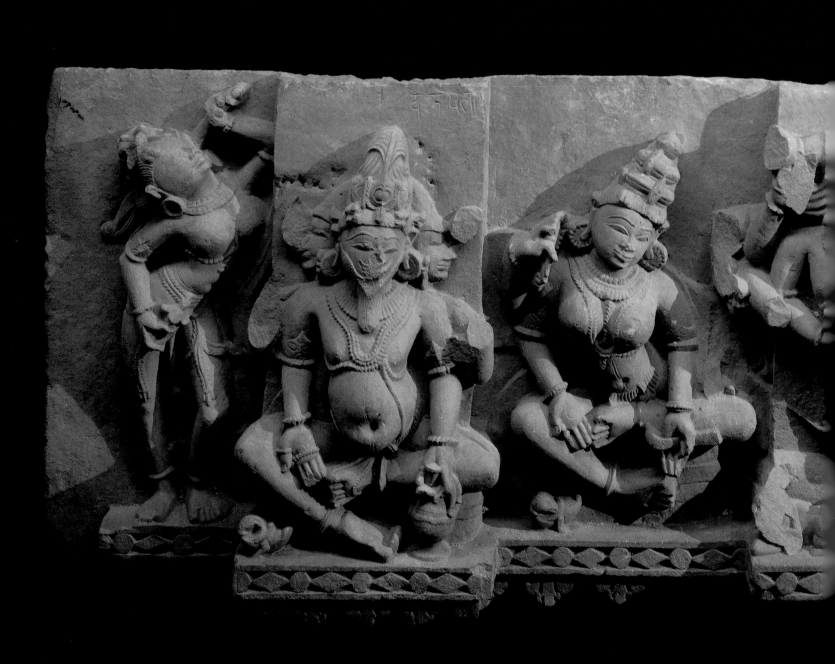

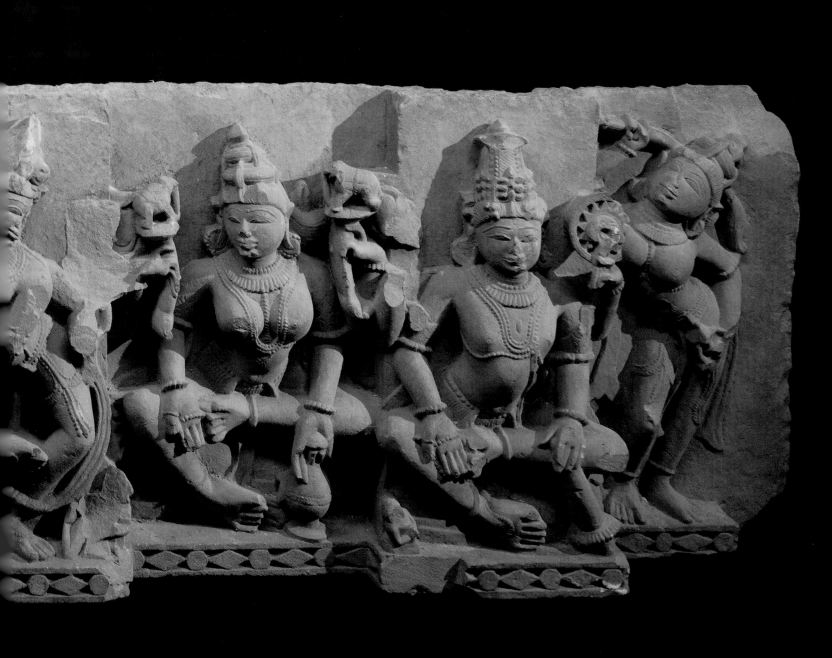

63.

The Trinity and Goddesses
Probably an overdoor
Provenance unknown, probably near Gwalior, Madhya Pradesh
(Gopādri)
About 12th century
Sandstone; 55.9 x 188 cm
Private Collection
(*Note: Photograph is on previous pages.*)

In the center of this monumental overdoor, Śiva performs his cosmic dance with the contortions typical of eleventh- and twelfth-century central India (No. 13). On the offsets to either side sit the remaining members of the Brāhmaṇic trinity, Viṣṇu, with his *cakra* on the right, and three-headed Brahmā on the left. Lakṣmī, Goddess of Prosperity, flanks her consort Viṣṇu, holding two elephants on lotus stalks and a water pot. The river Gaṅgā flows from her hair as it does from Śiva's. A second goddess sits in the indentation to the right of Brahmā. She is Sarasvatī, Goddess of Learning. She holds a manuscript of long palm leaves and shares with her consort, Brahmā, the *vāhana* of a *haṁsa*, seen preening at the lower left of both deities. Two female attendants, their bodies eccentrically arched, terminate the slab. A flat lower molding of alternating circles and diamonds follows the offsets.

The bodies of these figures are assemblages of tubes and orbs, although even at this period breasts merge more fully with the body than in contemporary and earlier images from farther east in Madhya Pradesh. Faces in this lintel appear as smiling masks of accumulated stereotypical features. Structure has fully subsumed the individuality of images; symmetric composition and bold legibility triumph.

Carvings of the eleventh and twelfth centuries from around the Gwalior region[1] (ancient Gopādri) allow this piece to be dated at least into the twelfth century. That it does indeed come from this region can be determined by comparison with many pieces, particularly with images from the Kākanmadh temple at the site of Suhānia, Morena District (north of Gwalior), where numerous sculptures remain in situ (others are in the collection of the Central Archeological Museum, Gwalior). The temple is datable by an inscription to A.D. 1015–1035.

The relative softness, finer detailing, and more naturalistic postures of figures on this temple imply that it dates significantly earlier than the overdoor, however. Nevertheless, the features of the Suhānia images are the forerunners of those found, hardened and schematized, on the overdoor. Slitlike eyes, wide smiling mouths, wide low foreheads, and smoothly curving, undecorated stone on both body and structure are but a few of the correspondences.

The format of a projecting Naṭeśa in the center of an overdoor with Brahmā (on the south/left) and Viṣṇu (on the north/right) is one found ubiquitously throughout Madhya Pradesh and neighboring regions from the tenth century onward. This slab was likely topped by a second slab bearing pediments for the offsets below, if not for all five divine images.

1. The Sās Bahu temple at Gwalior (1093); the *Yoginī* sculptures from Naresar (1189); Kākanmadh temple, Suhānia (1015–1035).

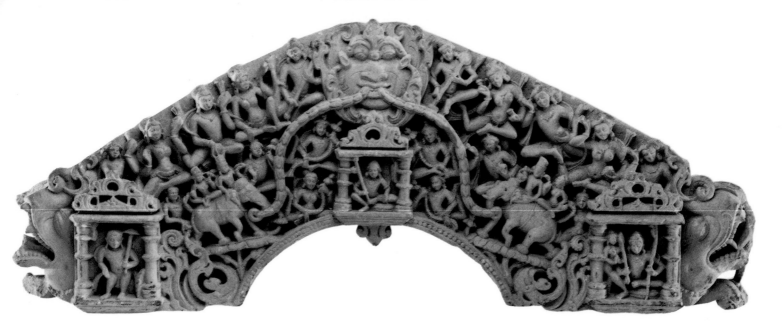

64.

Vaiṣṇava *Parikara*

Upper portion of an image surround, sanctum interior
Provenance unknown, probably eastern Rajasthan
(Mārudeśa-Sapādalakṣa, northern Meḍapāta, or Uparamāla)
About mid-9th century
Sandstone; 31 x 82.7 cm
National Museum of American Art, Smithsonian Institution, Gift of
 John Gellatly (Courtesy of the Arthur M. Sackler Gallery,
 Smithsonian Institution); LTS 1985.1.592

Although the windowless interior walls of the cube-shaped *garbhagṛha,* the sanctum sanctorum, usually appear smooth and undecorated, an elaborate frame (*parikara*) almost always surrounds the image of the deity that resides there (Fig. 2), except in the case of the centrally placed Śiva *liṅga* (Fig. 24). This frame bears a structural format and symbolic motifs that make it analogous both to the door and to the temple as a whole (No. 67).

In this upper portion of a *parikara,* two *makaras* (No. 31) appear at the sides. The relief displays three prominent male figures in niches: the dwarf Vāmana on the left, seated Paraśurāma in the center, and seated Rāma with a female attendant on the right. They are the fifth, sixth, and seventh *avatāras* of the God Viṣṇu (No. 70). The sides of the frame, like the jambs of a door, most likely would have displayed similar niches completing the set of ten (the first two likely conjoined). If the central image represented an avatar such as Varāha, the remaining six would have fit evenly onto the two jambs.

The surface of the arch is filled to overflowing with flying celestials bearing garlands, flowers, musical instruments, and offerings in celebration of the God. Above the central niche, a great *kīrtimukha* sprouts a garland of buds, the ends of which are grasped in the curving trunks of two elephants bearing additional celestial couples. The *kīrtimukha* exhibits the very human nose and lips familiar from other ninth-century images (Nos. 55, 56). Likewise, it displays the same extraordinary merging of animal and vegetal forms. Flaring foliage encircles its face. Small striations replicating the filaments of an open lotus flower discreetly overlay the lip and lower eyelids.

The bodies have long waists and doll-like rounded limbs. These anatomical features link the piece somewhat to images from ninth-century Mārudeśa-Sapādalaksa (Nos. 23, 55) but the crispness of carving bespeaks a tie to monuments from the Mahā-Gurjara[1] milieus farther south in Meḍapāta or perhaps to the somewhat related contemporaneous structures in Uparamāla.[2]

1. See Dhaky, "The Genesis and Development of Māru-Gurjara Temple Architecture."

2. See the overdoor from Chittor, National Museum, New Delhi.

65.

Sūrya *Parikara*

Upper portion of an image surround, sanctum interior
Provenance unknown, possibly central Madhya Pradesh
(Daśārṇadeśa)
About late 10th century
Sandstone; 59.7 x 127 cm
Seattle Art Museum, Margaret E. Fuller Purchase Fund; 66.10

This piece consists of a series of moldings in a semicircle with three complex niches above and terminates in *makara* heads facing outward with *haṅsas* in their jaws. Identified at one point as a *toraṇa* or arch, it was assumed to have come from the entrance porch of a temple, presumably between the pillars.[1] There the architectural identification was abandoned and discussion concentrated on iconographic identification. Looking again at the scale and configuration, however, it becomes clear that, rather than a free arch, this piece originally formed the upper portion of the frame (*parikara*) of a large image, probably the cult focus located in the *garbhagṛha* (No. 64).

Such complex frames remain on stone images primarily in the Jaina temples of western India (No. 67), but the configuration was quite common and widespread. It consisted, in addition to the arched top, of side pieces with multiple jambs (*śākhās*), like the sides of a doorway; an offset thresholdlike base; and a finial in the form of a pot, like that crowning the *śikhara* of the temple itself. Thus the frame combines elements of the door and the overall temple.

The jambs of this frame would have continued on separate blocks of stone in the same triple offset configuration evident below the two side niches, with central projection like the figure jamb (*rūpaśākha*) of the door (No. 51). The finial would also have been a separate stone resting in the round hole now visible above the central niche.

The seated figures in the arch itself have no specific identity—they are musicians and devotees honoring the deity. In the center of the central arch stands the sun, Sūrya (No. 28), evident by his breastplate, boots, and symmetrically held sun-opening lotuses. In the smaller niches to either side, female attendants flank him. They were previously identified as several of his possible wives, but their standardized attendant poses make it

more likely that they are generic celestial beauties (*apsarāsas, surasundarīs*) seen in a similar configuration on the intermediary offsets flanking the *bhadra* niche of the temple's exterior wall (Nos. 9–13). Likewise, generic attendants, male and female, flank the two horse-headed divinities in the side niches. These horse-headed figures, replacing Sūrya's usual attendants Daṇḍa and Piṅgala, are the Aśvinīdevatās, twin divine physicians often associated with Sūrya.

Given the prominent placement of Sūrya in the iconography of the arch, it is likely that a large image of Sūrya, probably standing, occupied the space below. The *makaras* show the unusual attribute of holding *haṅsas* in their mouths, while awkwardly contorted male figures sprawl between their heads and the extrados.

The niches consist of round pilasters with smooth bell bases and capitals, their shafts broken by ribbed *āmalaka*-like bands. On the pilasters rests a configuration mimicking the roof of the temple porch. A ribbed awning (*chādya*) protects the niche and extends around to the sides following the offsets below. Above this rests a roof of laminated cornices (*phāṁsanā*), as can be seen at the sides. This roof is fronted by intertwined *candraśālās* mimicking in their offset configuration the *śukanāsa*, or nose of the temple, which projects from the *śikhara*. The continuous *chādya* as cornice did not come into common use until the early eleventh century. The *phāṁsanā* roof, on the other hand, developed from the late seventh through the tenth centuries[2] to be replaced by the more complex *saṁvaraṇā* in the eleventh (No. 45). The form, in miniature, was long retained, however, as a way to connect the niche pediment (*udgama*) with the wall behind on both large exterior niches and on such smaller replicas as these.

Two of the three decorative moldings below the figure band—undercut flamelike

molding and the flattened, leaflike pattern—are common throughout Gujarat, Rajasthan, and the western half of Madhya Pradesh from the second half of the tenth century onward, regionally and temporally distinguishable only by specifics of carving. The curved foliate scroll, however, appears most commonly in ancient Daśārṇadeśa at this period at sites such as Gyaraspur and may indicate a regional affiliation.

The carving of the figures on this *parikara* is quite crude and choppy. Rather than indicating the quality of carving of the remainder of the temple from which it came, however, the fairly large size and complexity of the fragment make it likely that this crudeness indicates a hierarchy of carving wherein the sculptor lavished care on the sanctum image itself but skimped on the minor figures of the frame. Indeed, the frame, like many smaller or more distant segments of the temple's carved surface, was visually as well as symbolically dwarfed by the god within.

Reference: The Asia Society 1967–68:102.

1. Douglas Barrett in a letter to Richard Fullar, June 17, 1966; Seattle Art Museum files.
2. Meister, "Phāṁsanā in Western India," pp. 167–88.

66.
Marīcī
Probably sanctum interior
Provenance unknown, probably central Madhya Pradesh
(Daśārṇadeśa)
About first half of the 10th century
Sandstone; H. 95.9 cm
Mr. and Mrs. Joel Shapiro

Like the solar deity Sūrya (No. 28) in the Hindu pantheon, the Goddess Marīcī ("shining"), Buddhist divinity of the dawn, rides a chariot. Rather than horses, the chariot is pulled by seven swine. The creatures spread outward below her on a triple-stepped base. A lion, frequent accompaniment of goddesses, joins the swine (far right). Each animal tramples the contorted body of a male dwarf, possibly representing, as Pal has speculated, "the demons of darkness."[1] The severed head of Rāhu (No. 51) acts as charioteer. A *cakra* appears over his head, multivalent as solar disk and wheel of Buddhist law.

The monumental goddess, knee flexed in the archer's posture, once bristled with ten arms. She has three faces, the one emerging to her left, a swine.[2] Four female attendants flank her, none rising above her waist. The outer two bear jeweled garlands, the inner, fly whisks. The attendant by her right knee might be carrying a mirror, perhaps reflecting the light of her radiant mistress.

The figures are placed against pilasters that once formed a pierced frame. The remnants of a lotus halo and small pedestal, probably supporting a subsidiary deity, can just be discerned behind the goddess's crown. The width of the relief and layout of the frame make it likely that this image stood in a temple or monastery interior rather than within a wall niche.

In north India by the tenth century, Buddhism (in both its Mahāyāna and Tāntric manifestations) was concentrated primarily in the eastern regions of Bihar and Bengal under the patronage of the Pāla dynasty. Yet scattered remains and inscriptions, particularly around sites historically significant to the religion (for example, Sarnath or Bodh Gaya), testify to the occasional continuation of belief and patronage in central India even as late as the twelfth century.[3]

Sanchi, near Vidisha in ancient Daśārṇadeśa, is best known for the Buddhist *stūpas* (reliquary mounds) constructed there around the turn of the millennium. Yet, from remains at the site, it is clear that Buddhist monuments continued to be constructed at Sanchi into the tenth century.[4] Although these remains deserve concerted study, the stylistic characteristics of remnants apparently dating to the late ninth or early tenth centuries are not inconsistent with this image.

Full, square faces with small eyes and high, short mouths pushed close to the nose above chins marked by a mound of flesh with no body, spatulate feet, and weighty yet tapering legs with gently defined musculature characterize the Sanchi images as they do this Marīcī. Even certain details such as the treatment of the goddess's lotus pedestal or the leg drops of the attendants, with a single beaded side, can be found in the mutilated images at the site.

This is not to say that the Marīcī does indeed come from Sanchi. Yet, based on what we know of other images from ancient Daśārṇadeśa in approximately the first half of the tenth century and the obvious continuation of Buddhist patronage at Sanchi, the figure's attribution to Vidisha does seem likely.

The single standing temple from approximately the late ninth or early tenth century at Sanchi (Temple 26) shows its Buddhist dedication through the images in its *bhadra* offsets. In other respects—structurally, iconographically, and stylistically—it utilizes forms and formats common to Hindu shrines in the area, yet another example of the commonality of craft traditions among religious sects.[5]

References: Pal (*The Sensuous Immortals*) 1978:69–70, no. 38; Heeramaneck 1979: no. 89.

1. Pal, *The Sensuous Immortals: A Selection of Sculptures from the Pan-Asian Collection*, p. 70, no. 38.

2. In this form she is at times considered *śakti* of Hayagrīva. Generally she is *śakti* of the Dhyāni-Buddha Vairocana, originally a solar deity. See Liebert, *Iconographic Dictionary of the Indian Religions*, p. 174.

3. See N. N. Das Gupta in *The Struggle for Empire*, vol. 5, *The History and Culture of the Indian People* (Bombay: Bharatiya Vidya Bhavan, 1979 [1957]), pp. 421–24.

4. Temple 26 and its adjacent monastery date to approximately the late ninth or even early tenth century, and scattered fragments in the vicinity show carving typical of even later periods.

5. The area around Vidisha may have been under the political control of the Paramāra dynasty when this image was carved (Nos. 2, 68).

67.
Tīrthaṅkara Ṛṣabhanātha

Sanctum or subshrine interior
Chandravati, Sirohi District, Rajasthan
(Gurjardeśa-Arbuda)
About 11th century
Marble; 161 x 61 cm
Museum Rietberg Zürich, Eduard von der Heydt Collection; RVI 213

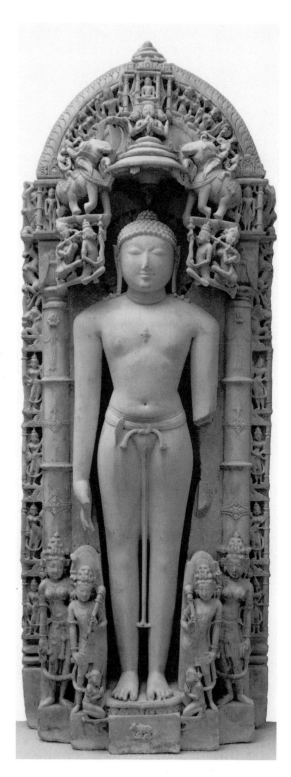

Ṛṣabhanātha, or Ādinātha, is the first of the twenty-four *tīrthaṅkaras* or Jinas (enlightened teachers, savior-saints) of the Jainas. His specific identity is denoted by the bull (*ṛṣabha, vṛṣabha*) carved in the center of his offset base. Simple and serene in contrast to his complex frame, he stands in the frontal meditation posture common to Jaina teachers, feet together and unbent arms hanging to his knees (*kāyotsargamudrā*). The presence of the lower garment on this image indicates that he was carved under the patronage of the Śvetāmbara ("white-clad") sect of Jainism, as distinct from the Digambarā ("sky-clad," that is, nude).

Like those of the familiar image of the Buddha, Ṛṣabhanātha's earlobes are stretched from heavy earrings worn before renunciation. Likewise, his head is covered in snail curls with a central protuberance, emblematic of great wisdom. Locks of uncut hair appear on his shoulders, however, and distinguish him from other *tīrthaṅkaras*. The legend of his life explains that he relinquished temporal kingship and abandoned all worldly accoutrements. He sat beneath an *aśoka* tree (its leaves here flanking his triple umbrella) on holy Mount Kailāsa to attain enlightenment. So devoted to the path of complete renunciation did he become that he began to pull his hair out by the handful. When but one handful remained, Indra, King of Heaven, distressed by the loss of such beauty, pleaded with Ṛṣabhanātha to leave the final locks. At times he is shown with a full crown of matted hair. This, together with his bull cognizance and connection with Kailāsa, link him to the mythology of the god Śiva.[1]

Like Prometheus, Ṛṣabhanātha, the primordial *tīrthaṅkara*, taught mankind the arts, including the kindling of fire, that separate men from beasts. He also established the basic structures of society by dividing people into classes according to their occupations.

A complete and elaborate *parikara* (image frame), defined by thin pilasters topped by leaf capitals, surrounds the *tīrthaṅkara*. At his feet stand male attendants with fly whisks, tiny kneeling donors, and two large females—two of the set of sixteen *vidyādevīs*, Jaina goddesses of knowledge. Royal elephants, flying celestials, and a host of Jaina goddesses (six more *vidyādevīs*), and other *tīrthaṅkaras* ornament the upper

portion. Flanking the pilasters, like the figure jambs on a doorway, rows of small niches house the final eight *vidyādevīs*. These are topped by the familiar *vyāla* on an elephant bracket, above which outward-facing *makaras* mark the terminals of the *parikara* arch (No. 65).

This image apparently[2] originated at the city of Chandravati in southern Rajasthan, at the foot of Mount Ābū, on which stands the famous group of spectacular marble Jaina temples dating from about the late tenth to thirteenth centuries. Today Chandravati is a vast field of carved fragments and mounds, but it was once a major capital, first of a branch of the Paramāra dynasty and then, after about the mid-eleventh century, of the Solaṅkis (Cāḷukyas) of Gujarat (No. 5). This area of western India is a bastion of Jainism even today and the numerous elaborate temples in the area were patronized not only by rulers but also by many wealthy merchants.

Until the tenth century, the Jaina temple was distinguishable from comparable Hindu constructions only by the identities of the images in certain key locations. In tenth-century western India, however, a distinctive format for these structures began to evolve, which included a high enclosure wall with a succession of subshrines surrounding the interior.

The temples in and around Mount Ābū are built of fine local white marble. The stone is often abraded rather than chiseled, allowing an extraordinary undercutting and fineness of detail that have led many to describe the temples as "lacy."

The moonlike faces with pointed chins and noses make the figures of southern Rajasthan and northern Gujarat distinctive in this period. Long bodies sway in increasingly abstract postures, but not with the extreme torsion of contemporaneous images to the east, such as those at Khajurāho. Rather, the torsos of these figures bend like wire while tapering limbs form angular patterns around them.

References: "Messrs. . . ." 1922:112; van Lohuizen-de Leeuw 1964:110–17; Zimmer 1968 [1955]: pl. 389; Jain and Fischer 1971:31, pl. xxxviii; Shah 1987: pl. LIX, no. 107.

1. U. P. Shah, *Jaina-Rūpa-Maṇḍana*, p. 87.

2. "Messrs. Luzac's Collection of Indian Sculpture," *Rupam*, vol. 11, p. 112, fig. B.

68.
Ambikā Yakṣī

Probably sanctum interior
Exact provenance unknown, attributed to Onkar Mandata,[1] East Nimar District, Madhya Pradesh
(Daśārṇadeśa-Avantī)
Dated A.D. 1034/35
Sandstone; 129.5 x 52.1 cm
Courtesy of the Trustees of the British Museum; 1880.19

The inscription on the base of this image of a standing four-armed goddess gives a wealth of historical and iconographic information all too rare in the context of Indian sculpture. The figure was long misidentified as the goddess Sarasvatī (Vāgdevī), Patroness of Learning. A recent article by Kirit Mankodi,[2] however, reassesses the iconography of this sculpture and rereads the inscription to convincingly identify her as the Jaina Yakṣī Ambikā (see No. 29). By this time, Ambikā had become the specific attendant *yakṣī* of Neminātha, twenty-second *tīrthaṅkara*. She could either have flanked him in a sanctum or, as seems more likely given the inscription, have been alone in a shrine dedicated to her.

Unlike Sarasvatī, whose *vāhana* is the *haṅsa*, Ambikā is most often accompanied, as here, by a lion. As in No. 29, she is shown with her two young sons. Here the older perches on the lion's back while the younger stands to the other side of his mother, both holding fruit, possibly mangoes. In the inscription, the sculptor is stated to have "fashioned. . . the auspicious image of Amba that has great brilliance and bestows fortunes evermore."[3]

As a historical and thus stylistic anchor the inscription is even more significant. It gives the names of both sculptor and scribe, and its final line gives a date: Saṁvat 1091 (A.D. 1034/35). In addition, mention is made both of a site, likely modern Onkar Mandata on the banks of the Narmadā River, and of a ruler, "the illustrious and shining Emperor Bhoja."[4]

Bhoja ruled from about 1000 to 1055 as head of the Paramāra family from his capital at Dhārā, south of Ujjain. His kingdom encompassed a huge area of central-western India. Although he is said to have built over one hundred temples and a university (termed a "temple of Sarasvatī"),[5] only one extant monument can be safely attributed to

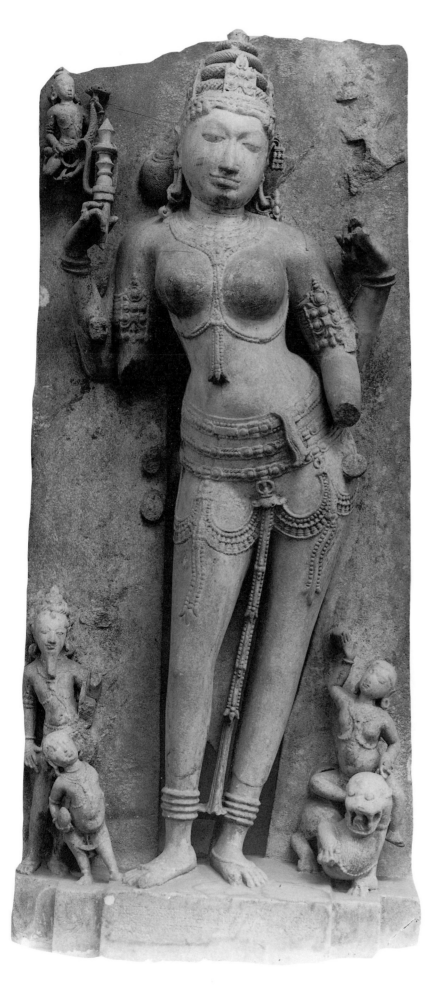

him, the Śiva temple at Bhojpur.[6]

The images on this unusual shrine, particularly the female figures flanking the door, although less sensitively carved than this image, concur in the treatment of body, physiognomy and dress. Faces are oval with low foreheads, diminutive chins, flaring noses, and distinctive wide mouths with shallowly carved lips, and have a gentle expression imparted by a downward tilt of eyes and head. Bodies are smoothly rounded, joints and breasts defined as gentle bulges. Ornament is equally restrained, although it includes the elaborate multiple belts and piled ankle bangles typical of the eleventh century.

Although Bhoja, like other rulers of his line (No. 2), is known from a variety of historical sources to have been devoted to the Lord Śiva, he was openly supportive of Jainism, patronizing several Jaina poets. Undoubtedly this enlightened ruler may also have actively patronized the construction of Jaina temples. At the same time, based on the few remaining images from the region of ancient Avantī before the eleventh century, it seems that the general treatment of face and body used here, including the restrained and smoothly rounded surfaces, characterized images from this region long before Bhoja's birth (No. 29).

References: Codrington 1926: pl. LXIV A; Gangoly and Dikshit 1942:1–2; Mankodi 1980–81:96–103, 1988:111, fig. 13.; Huntington 1985:483, fig. 20.41; Shah 1987:no. 105, pl. LVIII.

1. Kirit Mankodi, "A Paramāra Sculpture in the British Museum: Vāgdevī or Yakshī Ambikā?" *Sambodhi*, vol. 9 (April 1980–January 1981).

2. Ibid., pp. 96–103.

3. Ibid., p. 101; inscription reread and translated by H. C. Bhayani.

4. Ibid., pp. 100–01.

5. When this sculpture and its inscription were originally published in O. C. Gangoly and K. N. Dikshit, "An Image of Sarasvatī in the British Museum," *Rupam*, vol. 17 (January 1942), pp. 1–2, it was believed to be the very image enshrined in Bhoja's temple of learning.

6. Raisen District, Madhya Pradesh. See Kirit Mankodi, "Scholar-Emperor and a Funerary Temple: Eleventh-Century Bhojpur," *Royal Patrons and Great Temple Art*, Vidya Dehejia, ed. (Bombay: Mārg Publications, 1988).

69.
Durgā with Two Lions
Probably a sanctum image
Provenance unknown, probably southern Uttar Pradesh
(Madhyadeśa)
About second half of the 9th century
Sandstone; 63 x 41 cm
The Brooklyn Museum, Anonymous Gift; 79.254.2

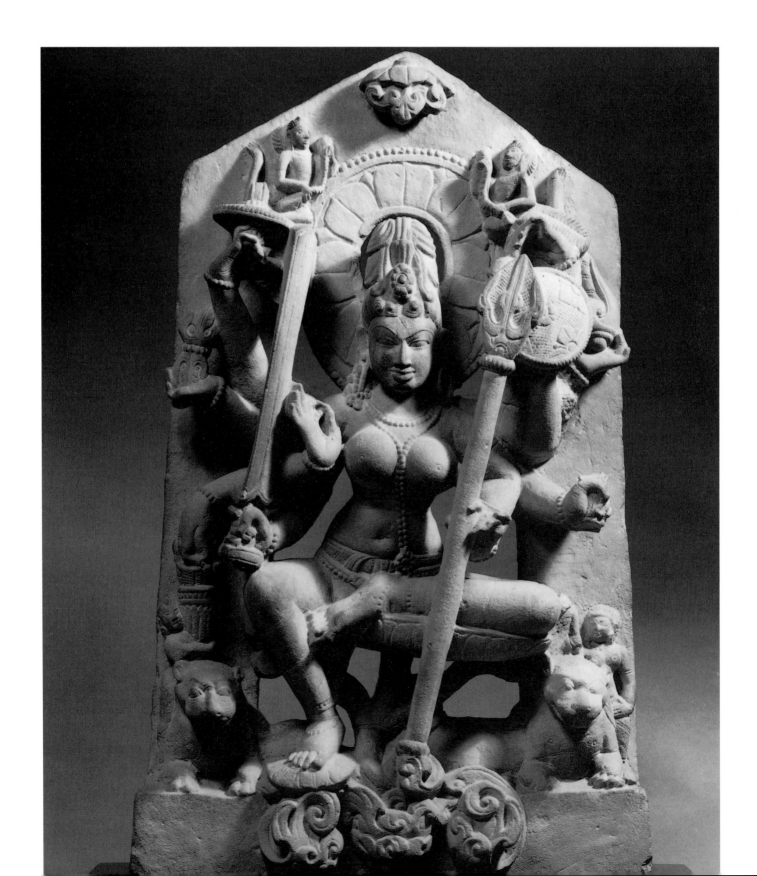

The goddess Durgā's ten hands carry weapons and attributes of the pantheon of male deities of whom she is the embodied energy (śakti, Nos. 19-21, 62). Her right hands hold Viṣṇu's discus (in an unusual horizontal position), Indra's thunderbolt, a sheaf of arrows (supported by a small attendant), a rosary, and a sword. The left ones bear a bell, Viṣṇu's conch shell, a shield, a bow (now broken), and Śiva's trident. Her hair is piled into a crown of matted locks like that of the ascetic God Śiva, emphasizing her close but independent relationship to him.

Durgā's vehicle is the lion, and here two recline at her feet.[1] She sits on a lotus pedestal with one leg pendant in a relaxed posture. A female attendant with fly whisk balances the sheaf-bearer to her lower right, while small, garland-bearing males hover to either side of her bold lotus halo. Directly above Durgā's head, a single lotus grows from the peak of the relief ground.

The pointed apex and the position of the foliage on the base of the relief make it likely that this Durgā was intended for a sanctum; perhaps as a secondary and complementary image placed behind a liṅga of Śiva. This view is substantiated by looking at an approximately contemporary image of a goddess[2] originally in the sanctum of the Jarai-kā-Maṭh, a goddess temple at Barwasagar in Uttar Pradesh, datable by its architecture to about A.D. 900. Indeed, the similar composition and level of detailing on the Barwasagar sculpture helps confirm the late ninth-century attribution of this Durgā.

Although lacking provenance, this statue conforms to a certain extent in style with figures found in ancient Madhyadeśa, the general region of the imperial Pratīhāra capital city of Kannauj[3] in Uttar Pradesh, and we can attribute it to this region by assuming the continuity of craft tradition (Nos. 33, 35).

The rectangular face as well as features such as the wide, fleshy mouth abutting a straight, flaring nose or the open, horizontal eyes with defined lids and cordlike arching brows are particularly characteristic of certain ninth- and early tenth-century images from Madhyadeśa. Also characteristic is the short-waisted torso with gentle but distinct rolls of flesh beneath spherical breasts. In earlier ninth-century female figures from this region, these rolls tend to be larger, reaching to the waist in continuous bands. In later images the bands contract and separate and tend toward a smoother expanse from waist to breast.

Unfortunately, due to accessibility to later iconoclastic as well as random destroyers, virtually no standing temples remain in Madhyadeśa. Enough fragments with definite find spots do remain, however, to enable future scholars to determine the various regional idioms found in the historically crucial Ganges-Jumna valley and the role played by patrons in the powerful court at Kannauj.

1. The presence of two lions may indicate that this is Durgā in her benevolent form as Kṣemaṅkarī ("conferring peace"). See M. A. Dhaky, "Kṣemaṅkarī: The Cult Image of the Ambikā Temple, Jagat," *Vishveshvaranand Indological Journal*, vol. 6 (1968) pp. 117–120. However, according to other scholars, the identifying feature of this aspect of the goddess, rather than lions, is four arms with one of them in *varadamudrā*, the pose of conferring boons, where the hand hangs downward with the palm out. See, for example, T. A. Gopinatha Rao, *Elements of Hindu Iconography*, vol. 1, pt. 2 (1914–1916; reprint, New Delhi: Motilal Banarsidass, 1985) p. 342.

2. The base of that image, which has similar foliage and the right foot positioned on a small lotus, remains in situ. Other fragments, including the torso and right leg (to the ankle) of the goddess seated on a larger lotus base with stem, are in the nearby collection of the Rani Laxmi Bai Palace Sculpture Collection, Jhansi.

3. See for comparison the earlier *mātṛkā* panel in the Kannauj Archeological Museum, published in Chandra, *The Sculpture of India: 3000 B.C.–1300 A.D.*, no. 43.

70.
Viṣṇu
Probably sanctum interior
Provenance unknown, probably Mathura region, Uttar Pradesh
(Śūrasena)
About late 9th century
Sandstone; 114 x 96.5 cm
Frank C. Russek Collection/Novel Art

It is often impossible to determine whether an elaborate iconic relief from the developed "medieval" temple came originally from the central offset *bhadra* niche of an exterior wall or from the sanctum of a main shrine or subshrine. At times independent reliefs were even erected on the main axes of the hall interior as well as in niches interrupting the basement moldings. Sometimes there are clues, but usually iconic sanctum images utilize the same stepped base, the same minor figure composition, and even the same rectangular format as images intended for placement in the exterior *bhadra* or basement (*jagatī*) niches.

The peaked top leads toward an identification of this image as having been intended for a sanctum, but even this form can at times be set into a rectangular exterior niche. Sanctum images still in situ do tend to be more elaborate and more carefully carved than their exterior counterparts. However, without knowing the original temple context, it is impossible to compare them and determine the relative level of elaboration.

The main figure in this relief is the four-armed iconic form of Viṣṇu, appropriate for the sanctum as well as the *bhadra* niche, especially opposite the temple entrance. Viṣṇu stands in the symmetrical *samapādasthānaka* (position with feet planted together). He wears his usual elaborate conical crown, large earrings, and a long garland of buds. In one right hand is the mace (*gāḍha*), with sprouting foliage. The upper left hand holds the *cakra*, while the other carries a conch shell. The final right hand is held downward in the wish-dispensing posture (*varadamudrā*), with a small, round lotus flower on the palm.[1]

Two worn *nāgas* support the god's lotus pedestal, while tiny devotees or attendants kneel with water pots along the base and support garlands to either side of the god's feet. Above these stand male and female fly whisk-bearers. Like the umbrella, fly whisks held by attendants indicated royalty in India from an early date, and these bearers emphasize the ultimate royal stature of the god. Garland-bearers, backed by stereotyped clouds, soar overhead. At the apex sits a figure in meditation, possibly Viṣṇu in his contemplative form as Yoganārāyaṇa.

Around the perimeter of the relief are placed Viṣṇu's most common manifestations: the "ten descents" or "incarnations" (*daśāvatāras*). In the upper left corner is Matsya, the fish. Opposite is the tortoise, Kūrma, with whose aid the gods and demons (*asuras*) churned the primordial ocean to produce ambrosia and other good things. Here the narrative is minimally reenacted with two small figures pulling the rope that turns the mountain/churning stick braced on Kūrma's back.

On the next level on the left stands boar-headed Varāha (No. 71) and opposite him the lion-headed Narasiṃha, who rips the entrails from the demon Hiraṇyakaśipu. The portly dwarf Vāmana holds his umbrella halolike behind his head on the level below Varāha, while Paraśurāma ("Rāma of the Ax"), at right, hefts his mighty weapon. Level with Viṣṇu's thighs stands Rāma with his long bow crossing his chest, on the left, and Kṛṣṇa, beneath a beneficent serpent's hood, on the right.

Finally, Buddha, displaying the long smooth robe, elongated ears, and cranial protuberance but not snail curls of the familiar iconic form, stands with one hand raised in gesture of assurance (*abhayamudrā*) on the lower left. In general, Hinduism retained its strength in the subcontinent through the constant absorption rather than denial of conflicting sects. Thus Buddha became just one of Viṣṇu's manifestations, retaining his distinctive iconographic traits but losing his primacy and power in the process. Indeed, Viṣṇu is said to have

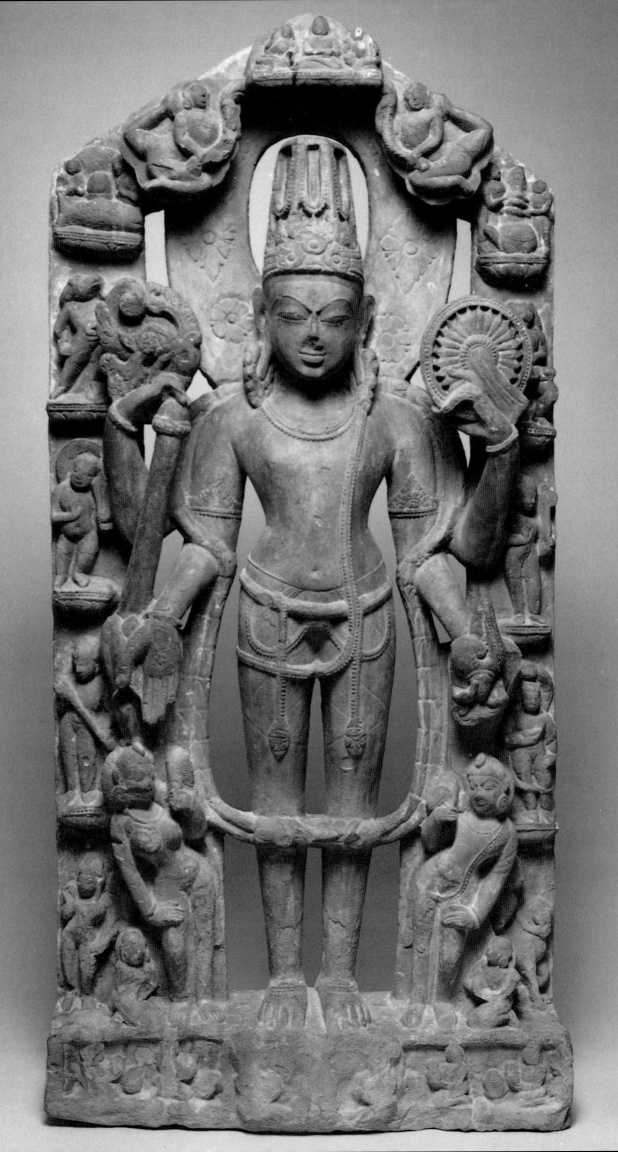

manifested himself in the form of Buddha to delude the *asuras* into abandoning the sacred texts and so forfeiting their power as warriors.

Across from Buddha is Viṣṇu's last and future incarnation, the equestrian Kalkin, who cleanses the world at the end of the *kaliyuga*—the age of darkness and final of the four recurring phases of creation.

The *avatāras* project on lotus bases from the perimeter of the relief. Within this surround, the relief plane is pierced so that Viṣṇu seems to stand free of his stone matrix with his flat oval halo suspended behind him. The form of halo and relief as well as the sharp sideways bend of the attendants are reminiscent of contemporaneous images from Madhyadeśa and Dāhaladeśa to the east. The smooth planes and almost concretelike texture of the carving, however, together with details of anatomy (pinched waist, tapering but tubular legs) and particularly the very oval faces with narrow slanting eyes and receding chins link the piece with images known to have originated around the city of Mathura in southwestern Uttar Pradesh (No. 28).[2]

1. The four-armed standing Viṣṇu is considered to have twenty-four aspects (*caturviṅśatimūrti*), distinguishable by the order in which his four attributes are held. The configuration of this Viṣṇu identifies him as Trivikrama, but does not relate him to the Trivikrama of the *daśāvatāra* set (the giant form of the dwarf Vāmana). Certain texts [see Rao, *Elements of Hindu Iconography*, vol. 1, pt. 1, pp. 235–36] state that each class of person should worship one of these twenty-four forms. For example, men of the Vaiśya or merchant class should worship Trivikrama. However, there are other, more esoteric reasonings for the *caturviṅśatimūrti*.

2. See also the Agni in the Denver Art Museum, Acc. No. 1973. 83; illustrated on p. 25 of Denver Art Museum, *Denver Art Museum: Major Works in the Collection* (Denver, 1981).

71.
Viṣṇu in His Boar Incarnation

Probably from a sanctum or subshrine
Provenance unknown, probably northern Rajasthan (Mārudeśa)
About A.D. 1000
Schist; 83.8 x 43.8 cm
Asian Art Museum of San Francisco, The Avery Brundage Collection; B62 S15

Varāha, the boar, is one of the ten earthly incarnations or descents (*daśāvatāras*) of the God Viṣṇu (No. 70). As with most of his other incarnations, Viṣṇu took the form of Varāha to rescue the world from a particularly horrendous demon. In this case the demon, Hiraṇyākṣa, had imprisoned the earth, Bhū, personified as a woman, beneath the ocean. Viṣṇu manifested himself as a great boar and dove into the water to root the earth free from the muddy deep. The parallel between the boar's rooting and the act of plowing led Varāha to be seen as an embodiment of agriculture. Varāha is also considered to be Aniruddha, one of the four aspects (*caturvyūha*) of Viṣṇu.

Like the four-armed form of Viṣṇu (Nos. 70, 72), Varāha carries Viṣṇu's most typical attributes: the *cakra* (lower right), *gāḍha* (upper left), and conch (upper right). He places his final hand (lower left) on his hip with a snake's tail looped over his thumb. His left leg rests on an a lotus pedestal supported by intertwined *nāga* and *nāginī*. They are the primordial serpent Ananta (Śeṣa, No. 72) and his wife. Two more *nāgas*, those omnipresent, auspicious, and chthonic water spirits, flank Varāha and honor him.

The small figure of Bhū, the earth, perches on the god's upraised left elbow, her hand gently touching his snout. Varāha's lower body is in human form. He wears a short garment with a dagger tucked into his belt. Lotuses, indicative of water, grow up the back of the relief. One shelters him like an umbrella, as it does the river goddesses on the lower portions of doorways (Nos. 51–53). Behind Varāha are small icons of the other trinity members seated on lotuses: Brahmā on the left and Śiva on the right. Even the halo (*prabhāmaṇḍala*) behind Varāha is more than the usual stylized lotus. Stamens are delineated, and a thick winding stem forms a naturalistic circular border surrounded by cursory flames.

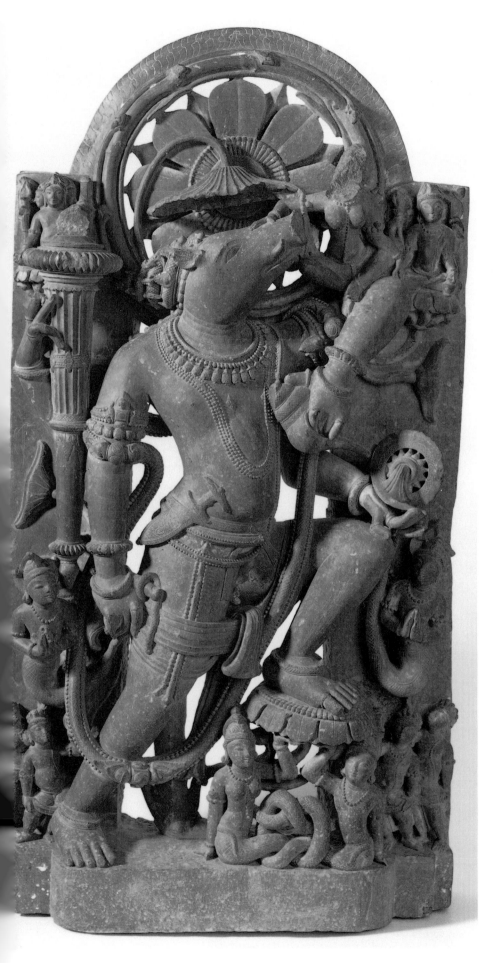

There are numerous images of Varāha still in situ on temples in western and central India dating from the end of the tenth and first half of the eleventh century with virtually the same iconographic characteristics as this image. In terms of regional style, however, certain features of the anatomy indicate an origin in northern Rajasthan, ancient Mārudeśa. For example, female torsos display a tubular rib area divided by a ridge at the waist to begin a gently bulging but narrow belly and hips. The long male torso with defined diaphragm is also indicative of contemporaneous monuments in the region. It has been the common wisdom that reliefs with pierced backs are typical of central and not western India; however, they do appear in northern Rajasthan.

Although half a century earlier than our image, the figures of the Nīlakaṇṭha Mahādeva temple at Kekind (Jasnagar) in the Nagaur district of Rajasthan, midway between Jodhpur and Jaipur, bear some relationship to this piece, even though the delicacy of the limbs of figures at Kekind link them to the Cāhamāna idiom of the neighboring Jaipur and Sikar districts. The late tenth-century subshrines at the site of Osian, north of Jodhpur, may be more comparable.

During the "medieval" period, Varāha became one of the most common iconic forms of Viṣṇu, found frequently on exterior *bhadra* niches of Vaiṣṇava temples. However, this image of Varāha is carved of schist rather than the sandstone typical of temple bodies in northern Rajasthan. This indicates that it was most likely carved for a sanctum, probably the sanctum of a subsidiary shrine in a Vaiṣṇava temple complex. Dark schist or serpentine/metasiltstone was often utilized in western India for sanctum images. The finer grain allowed for a level of detailing not possible with coarser sandstone (quartz or quartzite arenite).

Reference: Lefebre d'Argence and Tse Bartholomew 1969:70, no. 30.

72.
Viṣṇu Asleep on the Serpent Ananta
Sanctum interior
Rectangular temple south of the tank, Baroli, Rajasthan
(Uparamāla)
About A.D. 925–950
Sandstone; 50.8 x 91.4 cm
Kota Archeological Museum

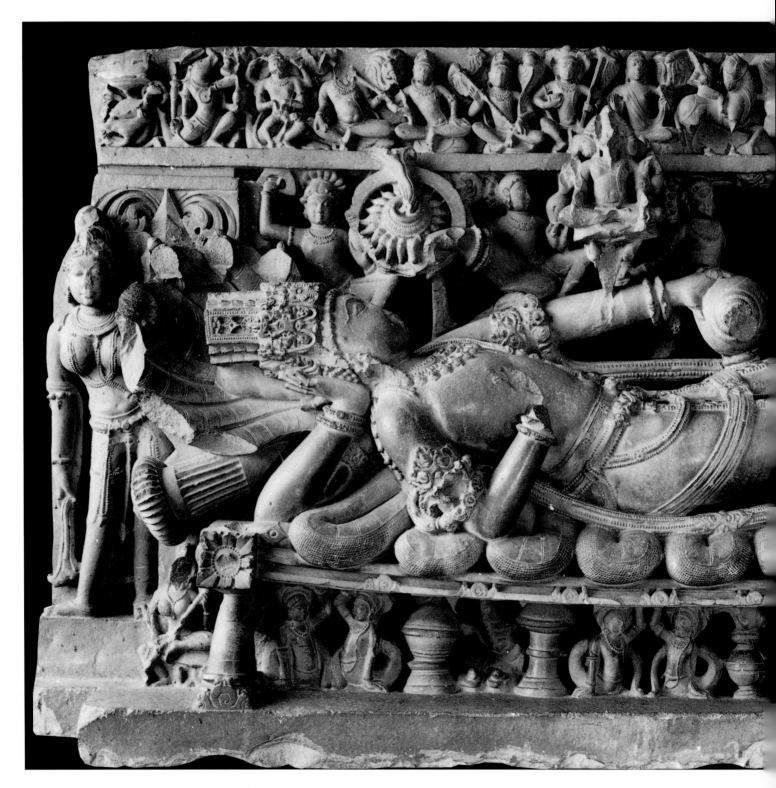

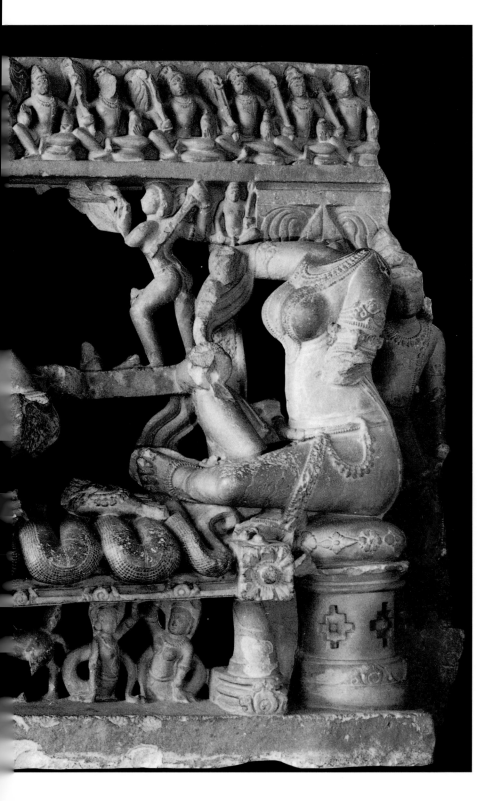

A royal husband lies on a couch that bows under his weight, its form resembling the simple wooden charpoys found in homes throughout north India. His sandals are abandoned below, and his wife tenderly massages one foot. The image seems a peaceful domestic tableau, yet it is a domesticity bursting with cosmogonic significance. The husband is the Lord Viṣṇu. Ananta,[1] the endless or infinite one, cushions the god with his thick coiled serpent body and shelters the divine head in multiple cobra hoods. Tiny water beings (*nāgas* and *nāginīs*) uphold the couch. Together with Ananta they represent the ocean on which the god reposes. It is the cosmic ocean, the ocean of eternity, from which all emerges and to which all returns.

The god sleeps on the ocean; the universe rests, unmanifest. Then the god meditates. From his navel, as from the lacustal depths, sprouts a lotus. It grows and opens to reveal the Lord Brahmā, his four heads surveying the endless vista and revealing the godhead. Brahmā then brings into being the manifest world, initiating a period of active engagement. When the allotted time elapses, this manifest world dissolves again into the quiescent godhead. The cycle of creation, preservation, and dissolution continues without end, *ananta*.[2]

Four-armed Viṣṇu holds a *cakra* and conch shell and props his crowned head with one hand while his mace lies behind the serpent's hood. His front right arm, now broken, would once have held the fourth familiar attribute, a lotus flower (No. 70). His consort, Śrī Lakṣmī, the fecund earth, rests on a round cushioned stool at the foot of the couch. Behind her stands a graceful male attendant balanced, at the head of the couch, by a female. A small seated woman, perhaps the goddess Sarasvatī, plays a *vīṇā* (stringed instrument) at the lower left.

As background to these central figures, the relief is divided into three tiers. Indian cosmology divides the universe into three layers: the earth and waters below, the heaven above, and the space between.[3] Like the doorway to the shrine (No. 51), the tiers carved on images of Viṣṇu on Ananta from "medieval" north India reflect these cosmic divisions.

Below are the waters.[4] In the center, the realm of human existence, warriors battle, their violent activity contrasted with the divine repose. Above, as on the overdoor, sets of celestial figures appear. Although both

navagrahas and *mātṛkās* (Nos. 51, 62) can appear, this relief shows, on the left, the ten *avatāras* of Viṣṇu (No. 70) followed by the eight guardians of the directions (Nos. 1, 7).

The *avatāras* begin at the left with Viṣṇu's fish and tortoise forms and end with the equestrian Kalkin, savior of the future.[5] The *dikpālas* follow the usual order,[6] beginning with Indra holding his thunderbolt. But apparently the sculptor slightly miscalculated, for only seven of the eight guardians sit together. The final *dikpāla*, Īśāna with his trident, is inserted below, squeezed between the pilaster capital and a swordsman.

In north India, particularly the westerly regions of Gujarat and Rajasthan states, icons of Viṣṇu on Ananta frequently occupy a niche in the wall of temple tanks or the large habitable wells (Fig. 85)[7] that dot the region, a literal translation of the story. This Viṣṇu also originally rested in the proximity of a temple tank but was sheltered by its own small shrine.

Today at the site of Baroli, nine temples remain, divided into two groups by a stream (No. 45). On the bank farthest from the road stands the main group of shrines including the exquisite Ghateśvara. On the near bank, approached first from the road, the visitor encounters a square tank filled year-round with water. In the center of the tank, an open shrine shelters a Śiva *liṅga*. Three other small shrines surround the tank. Two show the square sanctum standard for temples throughout north India, but the third, at the southwest corner, is constructed with a rectangular *garbhagṛha*[8] to house this image of the reclining Viṣṇu.

Where images remain in place, it is clear that the shrines at Baroli were focused around the worship of Śiva. This temple to Viṣṇu appears most understandable when the frequent association of the specific iconic type and water is remembered.

Within the rectangular sanctum, a plinth remains, its face replicating the lower binding moldings of the shrine itself. Two small fly whisk-bearing female attendants appear at the center of the plinth flanked, on the recessed sides, by a pair of seated women playing *vīṇās*. The upper surface of the plinth is indented to accommodate this sculpture in its original placement. The temples at Baroli seem to range in date from the early tenth century through the eleventh.[9] From the shape of the moldings, the shrine that housed this image dates from approximately the first half of the tenth century.[10] The carving of the images makes it likely that the shrine dates toward the later part of this period and a date of A.D. 925–950 seems reasonable.

References: "Remnants. . ." 1959:14, 17; M. M. Shastri 1961:26, no. 269, pl. VI; L. K. Tripathi 1975:7–9, 65–67, pl. XXVIII B; Parimoo 1983: fig. 27.

1. Or Śeṣa, "remainder."

2. For an excellent and comprehensive discussion of this image type and its textual roots, see Ratan Parimoo, *Sculptures of Śeṣaśāyī Viṣṇu: Survey, Iconological Interpretation, Formal Analysis* (Baroda: Maharaja Sayajirao University, 1983).

3. Ibid., p. 42.

4. For a discussion of the vessels, conch, and horse, see ibid., pp. 44–45.

5. Matsya, Kūrma, Varāha, Narasiṁha, Vāmana, Paraśurāma, Balarāma, Kṛṣṇa, Buddhavatar, Kalkin.

6. Indra, Agni, Yama, Nirṛti, Varuṇa, Vāyu, Kubera, Īśāna.

7. These range from simple tanks to extraordinarily elaborate constructions of multiple subterranean pavilions filled with sculpture. See Kirit Mankodi, *The Queen's Step Well at Patan* (Bombay: Project for Indian Cultural Studies, 1992) and Jutta Jain-Neubauer, *The Stepwells of Gujarat in Art-Historical Perspective* (New Delhi: Abhinav Publications, 1981). Besides the images of Viṣṇu on Ananta mentioned in these publications and Parimoo, op. cit., numerous others can be found in the tanks of western India. Some, such as the tank by the Viṣṇu temple near Ekalingji, Rajasthan, are datable to the tenth century.

8. For rectangular sanctums, see Michael W. Meister, "Geometry and Measure in Indian Temple Plans: Rectangular Temples," *Artibus Asiae*, vol. 44 (1983), pp. 266–96.

9. See L. K. Tripathi, *The Temples of Baroli* (Varanasi: Amitabha Prakasana, 1975). See also No. 45.

10. For a discussion of the *vedībandha* in western India, see Dhaky, "The Genesis and Development of Māru-Gurjara Temple Architecture." Although they are not the primary focus of his discussion, the rounded down-sloping pot molding (*kalaśa*) and tall shoulder molding (*kumbha*) conform to "Mahā-Gurjara" style dating to approximately the first half of the tenth century.

73.

Five-headed Śiva *Liṅga*

Sanctum interior

Provenance unknown, possibly Uttar Pradesh

(Madhyadeśa)

About early 9th century

Sandstone; H. 38.7 cm

Cincinnati Art Museum, Bequest of Mary M. Emery, by exchange;
 1982.123

(*Note: Photograph is on following page.*)

In the exact center of the *garbhagṛha* of the majority of Śiva temples throughout India appears a thick, short pillar with rounded top embedded into a base from which a spout projects (Fig. 24). This is the *liṅga* ("mark") of the God Śiva, his aniconic representation and a concretization of complex and profound philosophical and religious concepts. In origin, the *liṅga* is the erect phallus of the deity, the earliest examples replicating the natural appearance of the erect human phallus.

Mythological explanations of the *liṅga* throughout the centuries stress the multivalence of the image: it is the generative organ of the God, yet it is erect, the seed pulsating within, drawn up and contained by mental control. It is the power of generation harnessed and is the infinitely expanding, infinitely diversifying, yet ultimately featureless universe. Śiva is the great ascetic; for Śaiva devotees he is also the origin of all and the absolute reality to which all returns.

Yet this image clearly is not a simple aniconic pillar. On the shaft below the rounded tip appeared four large faces (three are extant). They represent Śiva in a variety of forms or moods. Their emergence from the smooth shaft is the divine in the very act of taking manifest form. God emerges in all the directions of space, including the apex, for this type of image is often termed a *pañcamukhaliṅga,* or five-faced *liṅga,* a fifth uncarved head thought to face upward. As Stella Kramrisch writes, it is "a lighthouse for the manifestations of deity."[1] In other stories about the God, the *liṅga* itself is seen as infinitely expanding on the vertical axis.

On this image, the central head of the remaining three shows the god with matted hair (*jaṭāmukuṭa*) neatly piled and ornamented. A prominent third eye appears in his forehead above a serene countenance. His simple beaded necklace is perhaps formed of the *rudrākṣa* beads used as an ascetic's rosary.

It is the form of Śiva as Mahādeva, the great and all-pervading Lord who creates the world through the extraordinary power of his physical and mental control.

When complete, the rear head would likely have had features similar to Mahādeva, but showing Nandī, the guardian. The face to the left displays the bulging eyes and skull ornament of Śiva as Bhairava, the *ugra*, or angry and destructive aspect, although the beauty and serenity of the style (Nos. 41, 54) quell his terror. The opposite face, shows the elaborate female coiffure and gentle face of Umā (Pārvatī). She is not only Śiva's consort but also an aspect of the androgynous, all-pervading godhead itself.[2]

References: Cincinnati Art Museum 1984:46; Walter Smith 1989:48–51.

1. Kramrisch, *Manifestations of Shiva*, p. xi.

2. For a fuller explanation of the many levels of symbolism associated with these four types, see Gerd Kreisel, "*Caturmukhaliṅga* and *Maheśamūrti*: The Cosmic Aspects of Śiva," *Tribus* (Linden-Museum Stuttgart), vol. 36 (December 1987).

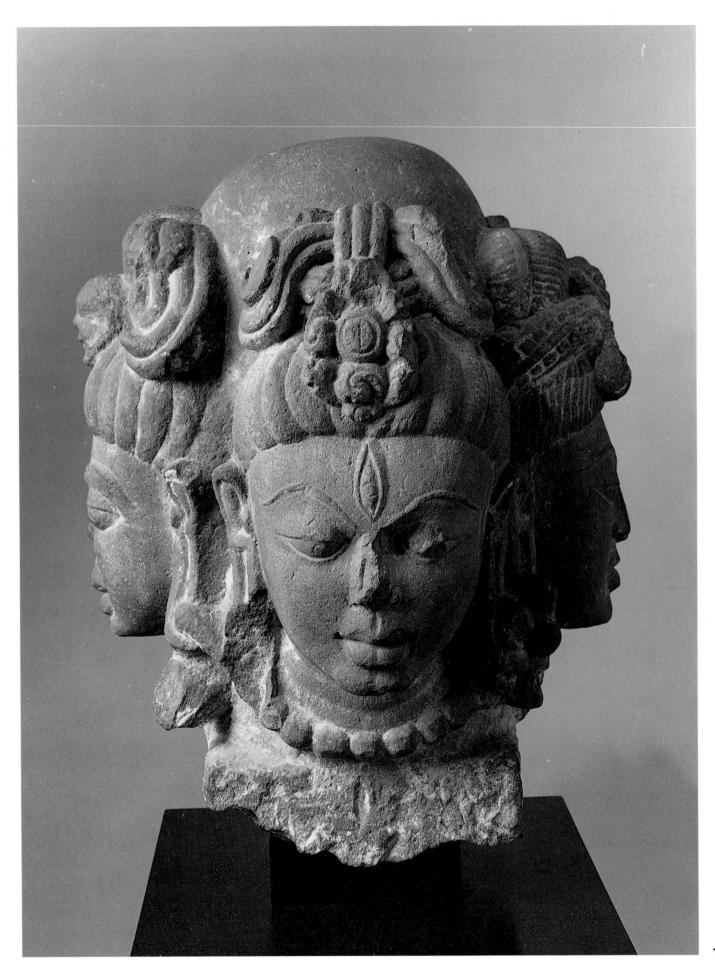

◀ 73

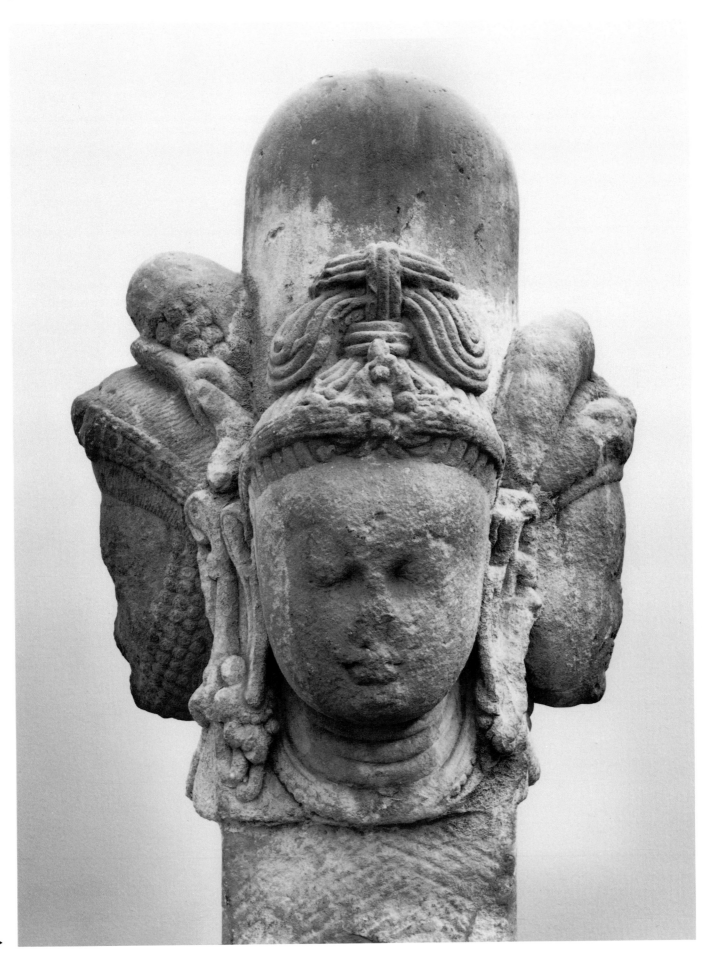

74.
Five-headed Śiva *Liṅga*

Sanctum interior
Provenance unknown, probably Uttar Pradesh or central
 Madhya Pradesh
(Madhyadeśa or Daśārṇadeśa)
About 9th century
Sandstone; H. 73.7 cm
Private Collection
(*Note: Photograph is on previous page.*)

Despite or perhaps because of its abraded condition, this monumental *liṅga* of the god Śiva (*pañcamukhaliṅga* or *caturmukhaliṅga*, No. 73) projects its power in all the directions of space. The upper rounded portion of the shaft is tall and plain, the heads' full forms growing from it.

The lower square portion of the shaft is roughly finished. In its original setting, only the upper portion (according to texts, the upper third) of the *liṅga* would have been visible, the lower segment encased within a spouted pedestal that was either round or a square inscribed with a circle. The pedestal is at times called *yoni* (vulva), and the two form an abstract depiction of coitus that speaks of the female energy (*śakti*, Nos. 19–21) as the spark that ignites the quiescent absolute. The spout, projecting to the north and connecting with a drainage channel and exterior spout (No. 6), would have carried off excess lustral liquids like the milk and water with which the *liṅga* is anointed.

Like the previous piece (No. 73), the front head depicts Śiva as Mahādeva. That on the left, with curled beard and bun and grinning mouth, is Bhairava, while Umā, her soft hair delicately etched in gentle waving strands, appears opposite. On the rear, almost indistinguishable from Maheśvara, is the personified Nandī.

Despite the similarity of Maheśvara and Nandī, however, there is no question about the orientation of the *liṅga* within its original sanctum setting, for the four faces are clearly associated with directions in space. The central head of Mahādeva would have faced east, that of Bhairava, south, and that of Umā, north. Thus they coincide with the organization of images in the *bhadras* of the temple exterior wall. The east is the door that reveals the sanctum image, the south is frequently a vengeful or terrible (thus protective) appearance of the deity (Nos. 17, 22) and the north is usually the goddess

(Nos. 1, 19–21).[1]

The *pañcamukhaliṅga*, then, parallels the temple itself in many ways. From its undifferentiated center, its "ground of being," the god manifests and expands, proliferating in the six directions to fill the universe with divine potency.[2]

1. See the essay by Darielle Mason.
2. See the essay by Michael Meister.

Appendix: Regional Classification of Sculptures

All works in the exhibition have been classified here according to the ancient region (see map on pages 16–17) from which they came or to which they show a stylistic affiliation. The order within each regional grouping is approximately chronological. Where regional stylistic affiliation is uncertain or ambiguous, works appear under more than one regional category and are identified with an asterisk.

Dāhaladeśa

17
Twenty-armed Gaṇeśa
Probably central-eastern Madhya Pradesh
About early 10th century

49
The Solar God (Revanta) and His Entourage
Probably central-eastern Madhya Pradesh
About second half of the 10th century

36
Flying Celestial
Attributed to the monastery at Candrehe, Madhya Pradesh
A.D. 973

61
Śiva as the Cosmic Dancer
Central-eastern Madhya Pradesh
About early 11th century

50
Nursing Mother
Shāhadol District, Madhya Pradesh
About early 11th century

27
Viṣṇu
Probably central-eastern Madhya Pradesh
About early 11th century

3
Lion Subduing an Elephant
Reputedly Kari Talai, Madhya Pradesh
About first half of the 11th century

Daśārṇadeśa

4★
Crouching Lion
Probably western Madhya Pradesh
About 8th century

22
Śiva Slaying the Demon Andhaka
Southern Uttar Pradesh or neighboring Madhya Pradesh
About second half of the 8th century

29
Ambikā Yakṣī
Possibly Ujjain region, Madhya Pradesh
About late 8th to early 9th century

9★
Dancing Celestial Woman
Probably Rajasthan or Madhya Pradesh
About A.D. 800

51
Door Frame
Probably central Madhya Pradesh
About A.D. 800–850

53
The River Goddess Yamunā
Probably central Madhya Pradesh
About early 9th century

74★
Five-headed Śiva Liṅga
Probably Uttar Pradesh or central Madhya Pradesh
About 9th century

41★
Celestial Woman Beneath a Mango Tree
Possibly southern Uttar Pradesh
About mid-9th century

54★
River Goddess
Possibly southern Uttar Pradesh
About mid-9th century

57
Overdoor with Viṣṇu and Goddesses
Probably central Madhya Pradesh
About mid-9th century

60★
Śiva as the Cosmic Dancer
Probably western Madhya Pradesh or eastern Rajasthan
About late 9th century

7
Guardian of the Southeast, Agni
Probably central Madhya Pradesh
About early 10th century

66
Marīcī
Probably central Madhya Pradesh
About first half of the 10th century

65
Sūrya Parikara
Possibly central Madhya Pradesh
About late 10th century

44
Celestial Woman Beneath a Flowering Branch
Attributed to Surwaya, Madhya Pradesh
About late 10th or early 11th century

68
Ambikā Yakṣī
Attributed to Onkar Mandata, East Nimar District, Madhya Pradesh
Dated A.D. 1034/35

2
Śiva Dancing in a Circular Frame
Udayapur, Madhya Pradesh
A.D. 1080

15★
Mythical Beast (Vyāla)
Probably western Madhya Pradesh
About late 11th century

Gopādri

1
Small Shrine
Gwalior, Madhya Pradesh
About A.D. 750–775

15★
Mythical Beast (Vyāla)
Probably western Madhya Pradesh
About late 11th century

32
Pillar
Gwalior, Madhya Pradesh, or vicinity
About late 11th to early 12th century

63
The Trinity and Goddesses
Probably near Gwalior, Madhya Pradesh
About 12th century

273

Glossaries

Adapted from: Liebert, Gösta. *Iconographic Dictionary of the Indian Religions: Hinduism, Buddhism, and Jainism.* 2d ed. Delhi: Sri Satguru Publications, 1985.

Meister, Michael W., M. A. Dhaky, and Krishna Deva, eds. *Encyclopaedia of Indian Temple Architecture.* 2 vols. Princeton: Princeton University Press, 1988.

Glossary of Selected Divinities and Religious and Iconographic Terms

abhayamudrā: Pose indicating freedom from fear, reassurance; one hand (usually the right) raised palm outward with the fingers pointing upward.

ācārya: Spiritual guide or teacher; temple priest.

āgama: Traditional doctrine.

Agni: NP. (name proper) of the Vedic god of (the sacrificial) fire; *dikpāla* of the southeast. His *vāhana* is a ram.

Ambikā Yakṣī: NP. of an attendant female divinity of a *jina,* specifically of Neminātha, twenty-second *tīrthaṅkara.*

Ananta: "Endless, infinite"; NP. of the world snake on which Viṣṇu lies in his form as Anantāśāyana.

Anantāśāyana: Epithet of Viṣṇu resting on the cosmic ocean atop the world snake, Ananta.

Andhakāsura(vadha)mūrti: Representation of Śiva as the slayer of the demon Andhaka.

añjalimudrā: Pose indicating reverence, salutation, or adoration; slightly cupped hands held together near the chest, fingers upward, palms facing each other.

aṅkuśa: Hook, especially of an elephant driver; attribute, especially of Gaṇeśa and Indra.

apsaras: Female semidivinity, beautiful female celestial being with no specific identity.

araṇya: A wilderness, desert, or forest.

Arjuna: NP. of the spiritual son of Indra and hero of the epic *Mahābhārata.*

aśoka: A type of tree belonging to the leguminous class with magnificent red flowers.

aṣṭadikpāla(s): Eight guardians or regents of the directions or quarters in space.

asura: Demon, titan.

avatāra: "Descent"; divine incarnation, especially of Viṣṇu.

Bhairava: "Terrible"; NP. of a terrifying (*ugra*) form of Śiva.

bhakti: "Devotion," worship.

Bhṛṇgi: NP. of an ascetic attendant of Śiva.

Bhū: "Earth," NP. of the goddess earth.

bhūmi: "Earth"; earthly and cosmic reality.

bīja: "Seed."

bindu: "Point, dot."

Brahmā: NP. of the divine priest, god of sacrifice and worship; a member of the *purāṇic* trinity, associated with creation.

brahmān: The all-pervading formless, the absolute, self-existent reality.

brāhmaṇa: Member of the priestly class (Brāhmin).

Brahmāṇī: NP. *śakti* of Brahmā, one of the Saptamātṛkās.

Buddhī: "Knowledge"; NP. of a consort of Gaṇeśa.

Budhāvatāra: NP. of Buddha as an incarnation of Viṣṇu, ninth of the *daśāvatāras.*

cakra: "Wheel, disk"; attribute, especially of Viṣṇu.

cakravarti(n): World ruler; in Jainism a great man subordinate to the *tīrthaṅkara.*

cāmaradhāriṇī: Attendant woman who carries a fly whisk.

Cāmuṇḍā: NP. of a form of the Goddess Durgā; epithet of Kālī; one of the Saptamātṛkās.

caturbhuja: "Four-armed"; epithet of Viṣṇu.

caturmukhaliṅga: "Four-faced *liṅga*"; *liṅga* representing four aspects of Śiva as projecting heads, same as *pañcamukhaliṅga.*

caturviṅśatimūrti: "Twenty-four forms of Viṣṇu"; arrangements of four-armed Viṣṇu with his four typical attributes, each arrangement considered an aspect of the God.

Caturvyūha: A group of four manifestations or aspects of Viṣṇu; epithet of Viṣṇu.

ḍamaru: Double drum shaped like an hourglass and struck with a bead on a string, used by dancers; attribute, especially of Śiva as Naṭeśa.

dāna: Gift, offering.

darśana: Act by which divinity can be seen by the worshiper; seeing.

daśāvatāra: The ten divine incarnations of Viṣṇu.

deva: Deity, god.

devadāsī: "Female slave or servant of gods"; female temple servant and entertainer.

devagṛha: "House of gods"; temple.

digambara: "Clothed in the sky"; one of the two main Jaina sects, originally characterized by nudity.

dikpāla(s): Guardians of the directions in space.

Durgā: NP. of the great goddess; a *śakti* of Śiva.

dvārapāla: Door guardian or keeper.

dvija: "Twice born"; a man of any one of the first three classes.

ekamukhaliṅga: Śiva *liṅga* with one face.

gadā: Mace, club; attribute.

Gajāsuramardin (Gajāsura[saṃhāra]mūrti): Representation of Śiva as slayer of the elephant demon.

gaṇa: Member of Śiva's troupe; usually shown as an obese dwarf.

Gaṇeśa: NP. of the elephant-headed God of Wisdom and Good Fortune, Remover of Obstacles, a son of Śiva and Pārvatī.

Gaṅgā: The river Ganges; NP. of the Ganges personified as a goddess.

Garuḍa: NP. of Viṣṇu's *vāhana* represented as part man and part bird.

Gaurī: "Shining, Golden One"; epithet of Pārvatī.

guru: Teacher, patriarch.

haṃsa (haṅsa): "(Wild) gander"; a semidivine bird, *vāhana* of Brahmā.

Harihara: NP. of a conjoined form of Viṣṇu and Śiva.

Hiraṇyākṣa: NP. of a demon killed by Viṣṇu in his Varāhāvatāra.

Indra: NP. Vedic king of the gods, God of Storms and Clouds; *dikpāla* of the east. His *vāhana* is an elephant.

Indrāṇī : NP. of a *śakti* of Indra; one of the Saptamātṛkās.

Īśāna: NP. of a form of Śiva; *dikpāla* of the northeast. His *vāhana* is a bull.

iṣṭadevatā(s): "Deity chosen (by the worshiper himself)." Generally refers to a family deity.

Jagannātha: "Lord of the World"; epithet of a form of Kṛṣṇa particularly popular in Orissa; NP. of a *yakṣa* attendant of the eleventh *tīrthaṅkara.*

jaina: A religious doctrine rejecting the Vedas and revering twenty-four enlightened beings (*tīrthaṅkaras* or *jinas*).

jaṭāmukuṭa: A headdress formed of piled, matted hair; attribute, especially of Śiva.

jina: "Victorious"; in Jainism, an enlightened being and teacher, a *tīrthaṅkara.*

Kailāsa, Mount: A mythical mountain in the Himalayan range, home of Śiva and Pārvatī.

Kālī : "Power of Time, The Black One"; NP. of the great Goddess in a destructive form; a *śakti* of Śiva.

kaliyuga: "The Kālī Age"; the final and most degenerate age of the world, the present age.

Kalkin: NP. of the tenth incarnation of Viṣṇu, the future world savior who appears on horseback, one of the *daśāvatāras.*

Kāma: NP. of the god of love.

kapāla: Oval cup made of the top of a skull; attribute, especially of deities in their terrifying form such as Bhairava or Kālī.

karaṇḍamukuṭa: "Basket crown"; a conical headdress that resembles a pile of flattened pots, attribute of Gaṇeśa and minor deities.

Kārttikeya: NP. of the god of war, a son of Śiva and Pārvatī, rides a peacock (Kumāra, Skanda).

Kaumārī : NP. of a *śakti* of Kumāra (Kārttikeya), one of the Saptamātṛkās.

kāyotsargamudrā: Attitude of standing with feet together and arms hanging straight at the sides, characteristic of *tīrthaṅkaras.*

Ketu: NP. of the descending node of the moon, one of the *navagrahas.* Often shown as a serpentine tail.

kīrti (kīrtti): "Fame, glory."

Kṛṣṇa (Krishna): "The Dark One"; NP. of the eighth *avatāra* of Viṣṇu, hero of the epic *Mahābhārata.*

Kṣatriya: Member of the military or ruling class.

Kṣemaṅkarī : NP. of a beneficent form of the great Goddess, Durgā.

Kubera: NP. of the god of wealth; *dikpāla* of the north. His *vāhana* is a man.

Kumāra: "A youth"; NP. *See also* **Kārttikeya.**

Kūrma: "Tortoise"; NP. of the second incarnation of Viṣṇu, one of the *daśāvatāras; vāhana* of the Goddess Yamunā.

laḍḍu: A sweet. *See also modaka.*

Lakṣmī : NP. of the goddess of wealth and good fortune; consort of Viṣṇu and other gods.

Lakṣmī-Nārāyaṇa: Representation of Viṣṇu with his consort.

Lakulīśa: "The Lord with a Club"; NP. of a reformer of the Pāśupata cult; considered to be an *avatara* of Śiva.

lalitāsana: A seated posture of relaxation with one leg pendant and one tucked under the body.

liṅga: "Sign, sign of gender"; aniconic, pillarlike form of Śiva, originally his phallus, often placed in a *yoni*-shaped base.

Mahādeva: "The Great God"; epithet of Śiva.

Mahāvīra: "The Great Hero"; NP. of the twenty-fourth Jaina *tīrthaṅkara;* founder of Jainism who lived about 540(?) to 477 B.C.

Maheśvara: "The Great Lord"; epithet of Śiva.

Māheśvarī : NP. of the *śakti* of Śiva as Maheśvara, one of the Saptamātṛkās.

Mahiṣāsuramardinī : Representation of the Goddess Durgā as slayer of the buffalo demon, Mahiṣāsura.

makara: A mythical composite sea creature.

maṇḍala: A diagram often used as an aid to meditation or as the basis for an architectural plan; a two-dimensional representation of the cosmos.

Marīcī: NP. of a *ṛṣi.*

Marīcī : NP. of the Buddhist goddess of the aurora who rides a chariot drawn by swine.

maṭha: Cloister, monastery.

Matsya: "Fish"; NP. of the first incarnation of Viṣṇu, one of the *daśāvatāras.*

māyā: "Illusion."

Meru, Mount: A mythical mountain in the Himalayan range, center of the world, location of Indra's heaven.

mithuna: "(Loving) pair," couple in erotic posture and gesture.

modaka: A (usually round) sweet, attribute of Gaṇeśa. *See also laḍḍu.*

mudrā: An attitude of the body, especially of the hands; a hand position with specific religious meaning.

muni: A sage, seer.

mūrti: A manifestation or anthropomorphic representation of a deity; a sculpture.

nāga: "Snake" (m.); attribute of a snake; a snake deity or spirit.

nāginī : A female snake deity or spirit.

Nandī : "Rejoicing"; NP. of the bull *vāhana* of Śiva.

Narasiṅha (Nṛsiṁha): "Man-lion"; NP. of the fourth incarnation of Viṣṇu, half man and half lion, one of the *daśāvatāras.*

Naṭeśa: "Lord of Dance"; epithet of Śiva as the cosmic dancer.

navagraha(s) (navagṛha): The nine planets, including the sun (Sūrya), moon (Chandra) and the ascending and descending nodes of the moon (Rāhu and Ketu).

Nemīnātha: NP. of the twenty-second Jaina *tīrthaṅkara.*

Nirṛti: "Misery, dissolution"; NP. of the *dikpāla* of the southwest. His *vāhana* is a corpse.

Pañcāgnitapas Pārvatī: Epithet of the ascetic Pārvatī performing the penance of standing amid five fires.

pañcamukhaliṅga: "Five-faced *liṅga*"; *liṅga* representing four aspects of Śiva as projecting heads, the fifth and final as the *liṅga* itself. Same as *caturmukhaliṅga.*

Paraśurāma: "Rāma with the Ax"; NP. of the sixth incarnation of Viṣṇu, one of the *daśāvatāras.*

Pārśvanātha: NP. of the twenty-third Jaina *tīrthaṅkara,* shown shaded by *nāga* hoods.

Pārvatī: "Daughter of the Mountain"; NP. of the consort of Śiva.

Pāśupata: A Śaiva sect.

prāsāda: Palace, temple.

prasāda: The food presented to a god and the remnants returned to the devotee; propitiatory offering.

praśasti: Eulogy.

pūjā: Honor, reverence; the acts performed to worship a divinity.

purāṇa(s): "Old"; texts recording stories about the gods.

Rāhu: "Seizer"; the ascending node of the moon, depicted as a severed head, one of the *navagrahas*.

Rāma: NP. of the seventh incarnation of Viṣṇu, one of the *daśāvatāras*; hero king of the epic *Rāmāyaṇa*.

Rāvaṇa: "Roaring"; NP. of a multiheaded, multiarmed demon king; chief villain of the epic *Rāmāyaṇa*.

Revanta: NP. of a son of Sūrya, a huntsman.

Riddhi: "Abundance"; NP. of a consort of Gaṇeśa.

Ṛṣabhanātha: NP. of the first Jaina *tīrthaṅkara*, depicted with long hair and a bull.

ṛṣi (risi): Sage, seer, inspired poet.

Rudra: NP. of a Vedic storm god; Śiva.

śakti: "Energy"; energy of a god in its personified form as a female counterpart.

śālabhañjikā: "Breaking a branch of a *śāla* tree"; posture of a woman standing near and grasping a tree.

samapādasthānaka: "Holding the feet even"; posture of standing symmetrically with legs straight.

śaṅkha: "Conch shell"; attribute of Viṣṇu.

Śāntinātha: NP. of the sixteenth Jaina *tīrthaṅkara*.

Saptamātṛkā[s]: "Seven mothers"; personifications of the energy of certain gods.

Sarasvatī: NP. of the goddess of learning, speech, and music.

Śeṣa: "Remainder"; epithet of the world snake. *See also* **Ananta.**

Siddhi: "Attainment"; NP. of a consort of Gaṇeśa.

Śiva: NP. of one of the major Hindu gods appearing in many forms, often holding a *triśūla*; a member of the *purāṇic* trinity associated with destruction.

Skanda: NP. *See also* **Kārttikeya.**

Sūrya: "Sun"; the sun god, depicted with boots and armor and holding two lotuses.

sūtradhāra: Architect, carpenter.

Śvetāmbara: "Clothed in white"; one of the two main Jaina sects, originally characterized by white garments.

tantra: Doctrine emphasizing the symbolism of the female, often esoteric and magical.

tarjanīmudrā: Pose indicating anger and threat; the hand is held in a fist with the index finger pointing upward.

tīrtha: "Bathing place"; a holy place, pilgrimage site.

tīrthaṅkara: "Ford finder"; a Jaina *jina*, one of twenty-four for the present cycle of time.

tribhaṅga: "Three bends"; a standing posture with the body following an **S** curve.

triśūla: Trident, attribute, especially of Śiva.

ugra: A violent, vengeful aspect of a god, especially Śiva.

Umā: Epithet of Pārvatī.

Umā-Maheśvaramūrti: Representation of Śiva with his consort.

Uṣas: "Dawn"; NP. of a consort of Sūrya.

vāhana: Vehicle, mount, or complementary creature of a deity on which he/she rides or by which he/she is accompanied.

Vaiṣṇavī: NP. of a *śakti* of Viṣṇu, one of the Saptamātṛkās.

Vaiśya: Member of the merchant class.

vajra: "Thunderbolt"; attribute, especially of Indra.

Vāmana: NP. of the fifth incarnation of Viṣṇu, the dwarf, one of the *daśāvatāras*.

varadamudrā: Hand pose indicating the conferring of boons; hand hangs loose with palm outward.

Varāha: NP. of the fourth incarnation of Viṣṇu, the giant boar, one of the *daśāvatāras*.

Vārāhī: NP. of a *śakti* of Viṣṇu as Varāha, one of the Saptamātṛkās.

varṇa: "Color"; caste, class.

Varuṇa: NP. of the Vedic god of the waters; *dikpāla* of the west.

Vāsuki: NP. of a *nāga*-king; attribute of Śiva.

Vāyu: NP. of the Vedic god of the winds; *dikpāla* of the northwest.

vidyādevī(s): "Goddess of Knowledge"; one of a group of sixteen female Jaina deities.

vidyādhara: "Bearer of Knowledge"; mythical air-space being in human form having magical knowledge.

vihāra: Monastery.

Vikrama-Saṁvat: "The year of Vikrama"; beginning in B.C. 58.

vīṇā: A long stringed musical instrument, attribute, especially of Śiva as Vīṇādhara and Sarasvatī.

Vīṇādhara: Epithet of Śiva as lord of music.

Vināyaka: Epithet of Gaṇeśa.

Viṣṇu: NP. of one of the major Hindu gods appearing in many forms, often holding a *cakra* and *śaṅkha*; a member of the *purāṇic* trinity associated with preservation.

vyāla: A mythical lionlike animal having horns and a variety of facial features.

yakṣa: Local nature deities; Jaina semidivine attendants of the *tīrthaṅkaras*.

yakṣī: Female counterpart of a *yakṣa*.

Yama: NP. of the god of the dead; *dikpāla* of the south.

Yamunā: The river Jumna; NP. of the Jumna personified as a goddess.

yantra: A geometric diagram that aids meditation and concentration, often magical.

Yoganārāyaṇa: Epithet of Viṣṇu as yogin.

Yogeśvara: Epithet of Śiva as yogin.

Yogeśvarī: "Lady of Yoga"; sometimes one of the Saptamātṛkās.

yogin: One who practices certain meditation exercises (yoga), especially a Śaiva monk.

yoginī: A female minor deity.

yoni: "Vulva"; symbol of the female principle; the circular or square base in which a *liṅga* is placed.

Glossary of Selected Architectural Terms

āmalaka: "Myrobolan fruit"; ribbed, doughnut-shaped stone crowning the *nāgara śikhara.*

aṇḍa: "Egg," spirelet.

anekāṇḍaka: Multispired; *śikhara* with multiple abutting towers or spirelets.

antarāla: Vestibule, connecting space between *maṇḍapa* and *garbhagṛha.*

antarapaṭṭa: Recess between projecting moldings.

ardhamaṇḍapa: "Half *maṇḍapa*"; portico, entrance porch.

aśvapīṭha: Basement molding with a frieze of horses.

bhadra: Central wall offset or projection.

bhūmija: Variation of the *nāgara śikhara* showing vertical bands of spirelets.

brahmasthāna: Central square within the *garbhagṛha.*

caitya: A holy spot often associated with relics; a barrel-vaulted hall; a circular window shape.

candraśālā: Ogee-shaped dormer window form used as a decorative device, in many locations on the temple, from superstructure to floor.

chādya: Awning; eave.

devakulikā: Subsidiary shrine.

devālaya: "House of gods," temple.

drāviḍa: South Indian temple type.

ekāṇḍaka: Single-spired *śikhara.*

gajapīṭha: Basement molding with a frieze of elephants.

garbhagṛha: "Womb chamber"; sanctum.

ghaṇṭā: "Bell"; bell-shaped decorative device; ribbed, bell-shaped finial in a pyramidal roofing configuration.

ghaṭapallava: Vase-and-foliage decorative device and pillar type.

grāsapaṭṭi (grāsapaṭṭamālā, grāsapaṭṭaka): Band of *kīrtimukhas.*

jāḍyakumbha: Lotuslike curved basement molding.

jagatī: Plinth, raised terrace.

kakṣāsana: Sloping seat back and balustrade.

kalaśa: "Pot"; pot-shaped decorative device; torus molding; pot finial.

kapilī: Wall connecting hall and sanctum, wall enclosing the *antarāla.*

kapota: Roll cornice; cyme molding.

karṇa: Angle; corner.

karṇikā: Knife-edge molding.

kīrtimukha (kīrttimukha): "Face of glory"; horned, lionlike face used as a decorative device.

kumbha: "Pot"; tall base molding with a curved shoulder.

kuṇḍa: Temple tank, step well, *vāpī.*

lalāṭabimba: Crest image, figure placed in the center of the overdoor.

latā: "Creeper"; vertical band of the *śikhara* covered in a mesh of intertwined *candraśālā* motifs.

latina: *Śikhara* covered in *latās*; single-spired curvilinear *nāgara śikhara.*

mahāmaṇḍapa: Large enclosed hall fronting and attached to the shrine, often with interior pillars and lateral window projections.

mahā-stambha: Freestanding dedicatory pillar.

makara-toraṇa: Arch composed of a garland emerging from *makara* springers.

maṇḍapa: Attached or detached hall fronting a temple.

maṇḍapikā: Temple type with pillared walls and flat roof.

mandira: Temple.

nāgara: North Indian temple type.

nāgaśākhā: Doorjamb of intertwined snakes.

narapīṭha: Basement molding with a frieze of human figures.

navāṇḍaka: *Śekharī śikhara* showing nine attached spirelets.

pañcāṇḍaka: *Śekharī śikhara* showing five attached spirelets.

pañcāyatana: "Five-shrined," a temple with four surrounding subshrines.

pañjara: "Cage," a pillared structure; decorative device showing the front of an apsidal shrine; central band of a *latina śikhara.*

parikara: Image frame.

pedyā: Lower portion of a doorjamb, usually carved with river goddesses and door guardians.

phāmisanā: "Wedge"; layered cornice roof type having a pyramidal profile.

pīṭha: Molded base or basement.

pratiratha: Intermediary wall offset flanking the *bhadra.*

pūrṇaghaṭa: Vase-of-plenty decorative device.

raṅgamaṇḍapa: Dance hall; open, pillared hall type.

rūpaśākhā: Doorjamb of human figures.

sabhāmaṇḍapa: Assembly hall; open hall type.

śākhā: Decorative band surrounding a door; doorjamb.

salilāntara: Vertical recess between wall offsets.

saṁvaraṇā: Tiered roof type of concentrically arranged units, each topped by a *ghaṇṭā.*

śekharī: *Śikhara* of a central curvilinear tower with multiple abutting and subsidiary spires.

śikhara: "Mountain peak"; tower; spire.

stūpa: Solid, hemispherical structure containing a relic.

toraṇa: Gateway, arch.

udgama: Pediment of intertwined *candraśālās.*

udumbara: Raised threshold.

uttaraṅga: Overdoor; door architrave or lintel.

uttaravedī: "Upper altar"; crowning slab of a curvilinear *śikhara.*

valabhī: Temple type with barrel-vaulted superstructure.

vāpī: Temple tank, step well, *kuṇḍa.*

vāstupuruṣamaṇḍala (vāstumaṇḍala): Grid used as conceptual basis of a structure.

vedī: Altar.

vedībandha: Binding moldings around the lower portion of the wall.

vīrastambha: "Hero pillar."

Select Bibliography

This bibliography is based on specific works cited by the authors of this book. It does not include all of the references that may be pertinent to the general study of Indian sculpture or architecture.

A

Ackerman, James, ed. "On Rereading 'Style.' " *Art and Archaeology.* Englewood Cliffs, NJ: Prentice-Hall, 1963.

Agrawala, R. C. "Rāvaṇa Uplifting the Kailāsa: An Unpublished Stone Relief from Rajasthan." *Bharatiya Vidya* 16, nos. 3, 4 (1956).

———. "Sikar." *Mārg* 12, no. 2 (1959).

———. "A Newly Discovered Sun Temple at Tusa." *Bharatiya Vidya* 22 (1963).

———. "Inscriptions from Jagat, Rajasthan." *Journal of the Oriental Institute, Baroda* 14 (1965).

———. "Unpublished Temples of Rajasthan." *Ars Asiatiques* 11 (1965).

Agrawala, Vasudeva S., tr. *Devī-Māhātmya: The Glorification of the Great Goddess.* [Section of the *Mārkaṇḍeya Purāṇa.*] Varanasi: All-India Kashiraj Trust, 1963.

———. rev. and ed. *Samarāṅgana-Sutrādhāra of Mahārājadhirāja Bhoja, The Paramāra Ruler of Dhārā.* Baroda: Oriental Institute, 1966.

Altekar, A. S. *The Rashtrakutas and Their Times.* Poona: Oriental Series, 1934.

Alvarez, Sergio Meliton Carrasco. "Brahmanical Monastic Institutions in Early Medieval North India: Studies in Their Doctrinal and Sectarian Background, Patronage and Spatial Distribution." Ph.D. Dissertation. Jawaharlal Nehru University, 1990.

Annual Report on Indian Epigraphy (1957–58).

Annual Report on the Workings of the Rajputana Museum, Ajmer for the Year Ending 31st March 1924. Simla: Government of India Press, 1924.

Appadurai, Arjun. "The Status of Brāhman Priests in Hindu India." *South Asian Anthropologist* (1983).

Archaeological Survey of India Report 2 (1864–65).

The Art of India. Minneapolis: University of Minnesota, 1969.

Arts Council of Great Britain. *In the Image of Man: The Indian Perception of the Universe Through 2000 Years of Painting and Sculpture.* London: Weidenfield and Nicolson, 1982.

The Asia Society. *Masterpieces of Asian Art in American Museums.* New York, 1960.

———. *Archives of Asian Art* 21. New York, 1967–68.

———. *Archives of Asian Art* 22. New York, 1968-69.

———. "Art of Asia Acquired by North American Museums, 1977–1978." *Archives of Asian Art.* New York, 1978.

———. *Handbook of the Mr. and Mrs. John D. Rockefeller 3rd Collection.* New York, n.d. [1981].

———. *Guide to the Mr. and Mrs. John D. Rockefeller 3rd Collection of Asian Art.* New York, n.d. [1982].

———. "Art of Asia Acquired by North American Museums, 1984." *Archives of Asian Art.* New York, 1984.

———. "Art of Asia Acquired by North American Museums, 1990." *Archives of Asian Art* 44. New York, 1991.

Asopa, J. N. *Origin of the Rajputs.* Delhi-Varanasi-Calcutta: Bharatiya Publishing House, 1976.

Atherton, Cynthia Packert. "Levels of Meaning: The Harṣamātā Temple at Abaneri." Association for Asian Studies 42d Annual Meeting, 1990.

B

Bachhofer, Ludwig. *Early Indian Sculpture.* 2 vols. New York: Pegasus Press, 1929. Reprint (2 vols. in 1). New York: Hacker Art Books, 1972.

Bakker, Hans. *Ayodhyā.* Groningen: Egbert Forsten, 1986.

Banerjea, Jitendra Nath. *The Development of Hindu Iconography.* 2d ed. Calcutta: University of Calcutta, 1956. Reprint, New Delhi: Munshiram Manoharlal Publishers Pvt. Ltd., 1985.

Banerji, R. D. *The Haihayas of Tripurī and Their Monuments, no. 23, Memoirs of the*

Archaeological Survey of India. Calcutta: Government of India, 1931.

Basham, A. *The Wonder That Was India.* London: Fontana, 1971.

Belvakar, S. D., ed. *Pṛthīvirājavijaya-mahākāvya.* Calcutta: The Asiatic Society, 1914.

Bhandarkar, D. R. "Ghaṭayālā Inscriptions of Kakkuka: Saṁvat 918." *Epigraphia Indica,* vol. 9. Reprint. New Delhi: Archaeological Survey of India, 1981.

Bhattacharya, P. K. *Historical Geography of Madhya Pradesh from Early Records.* Delhi: Motilal Banarsidass, 1977.

Bhavnagar Archaeological Department, comp. *A Collection of Prākrit and Sanskrit Inscriptions,* n.d.

Bird, Virgil H., et al. *A World View of Art History: Selected Readings.* Dubuque, Iowa: Kendall/Hunt Publishing Co., 1985.

Brown, Percy. *Indian Architecture (Buddhist and Hindu Periods).* 3d ed., rev. and enl. Bombay: D. B. Taraporevala Sons and Co., 1956.

Bruhn, Klaus. *The Jina Images of Deogarh. Studies in South Asian Culture Series.* Edited by J. E. van Lohuizen-de Leeuw. Vol. 1. Leiden: E. J. Brill, 1963.

Bühler, Georg. *The Life of Hemacandrācārya.* Translated by Manilal Patel. Singh Jain Series, no. 11. Santiniketan: Singhi Jaina Jnanapitha, 1936.

Burgess, J., and H. Cousens. *Architectural Antiquities of Northern Gujarat.* London: T. Rubner & Co., Ltd., 1903.

C

Chakravarty, Kalyan Kumar. *Gwalior Fort: Art, Culture and History.* New Delhi: Arnold-Heinemann Publishers, 1984.

Chandra, Pramod. "The Kaula-Kapalika Cults at Khajurāho." *Lalit Kalā* 1–2 (1955–56).

———. *Stone Sculpture in the Allahabad Museum.* Poona: AIIS, n.d. [1970].

———. *On the Study of Indian Art.* Cambridge and London: Harvard University Press, 1983.

——. *The Sculpture of India: 3000 B.C.–1300 A.D.* Washington, D.C.: National Gallery of Art, 1985.

Chattopadhyaya, B. D. "Trade and Urban Centers in Early Medieval North India." *The Indian Historical Review* 1, no. 2 (1974).

——. "Origin of the Rajputs: The Political, Economic and Social Processes in Early Medieval Rajasthan." *The Indian Historical Review* 3, no. 1 (1976).

——. "Political Processes and Structure of Polity in Early Medieval India: Problems of Perspective." Presidential Address, Ancient India Section, Indian History Congress. Forty-fourth session, at Burdwan, 1983.

——. *A Survey of the Historical Geography of Ancient India.* Calcutta: Manisha Granthalaya, 1984.

——. "Markets and Merchants in Early Medieval Rajasthan." *Social Science Probings* 2, no. 4 (1985).

——. *Aspects of Rural Settlements and Rural Society in Early Medieval India.* Calcutta: K. P. Bagchi & Co., 1990.

——. "The Making of Early Medieval India." Forthcoming.

Cincinnati Art Museum. *Masterpieces from the Cincinnati Art Museum.* Cincinnati, 1984.

The Cleveland Museum of Art. *Handbook of the Cleveland Museum of Art.* Cleveland, 1958.

——. *Handbook of the Cleveland Museum of Art.* Cleveland, 1966.

——. "Golden Anniversary Acquisitions." *Cleveland Museum of Art Bulletin* 142 (September 1966).

——. *Cleveland Museum of Art Bulletin* 54 (December 1967).

——. *Handbook of the Cleveland Museum of Art.* Cleveland, 1978.

Codrington, K. de B. *Ancient India.* London: Ernest Benn, Ltd., 1926.

College Art Association. *The Art of India.* Loan exhibition of Indian Sculpture. New York, 1935.

Coomaraswamy, Ananda K. *Yakṣas.* 2 vols. Washington, D.C.: Smithsonian Institution Press, 1928.

——. *History of Indian and Indonesian Art.* Reprint. New York: Dover Publications, 1965.

——. "An Indian Temple: The Kandariya Mahādeo" and "Svayamātṛṇṇā: Janua Coeli." In *Traditional Art and Symbolism: Coomaraswamy 1, Selected Papers.* Edited by Roger Lipsey. Princeton: Princeton University Press, 1977.

Courtright, Paul B. *Gaṇeśa: Lord of Obstacles, Lord of Beginnings.* New York and Oxford: Oxford University Press, 1985.

Cousens, Henry. "Somanātha and Other Mediaeval Temples of Kāthiāwād." *Archaeological Survey of India. New Imperial Series*, 45. Calcutta: Government of India, Central Publication Branch, 1931.

Czuma, Stanislaw. "Mathura Sculpture from the Cleveland Museum of Art Collection." *Cleveland Museum of Art Bulletin* 64, no. 3 (March 1977).

D

Dasgupta, S. B. *An Introduction to Tāntric Buddhism.* 3d ed. Calcutta: University of Calcutta, 1974.

Davis, Richard. "Indian Art Objects as Loot." Paper presented at the Annual Meeting of the American Committee of South Asian Art, at Richmond, Virginia, 1988.

The Dayton Art Institute. *Fifty Treasures of the Dayton Art Institute.* Dayton, 1969.

De Casparis, J. G. "Inscriptions and South Asian Dynastic Tradition." In R. J. Moore, ed. *Tradition and Politics in South Asia.* New Delhi: Vikas Publishing House Pvt. Ltd., 1979.

Dehejia, Vidya. *Yoginī Cult and Temples: A Tāntric Tradition.* New Delhi: National Museum, New Delhi, 1986.

de Lippe, Aschwin. *Indian Medieval Sculpture.* Amsterdam and New York: North-Holland Publishing Company, 1978.

de Mallmann, M. T. *Les enseignements iconographiques de l'Agnipurāṇa.* Paris: Presses universitaires de France, 1963.

Denver Art Museum. *Denver Art Museum: Major Works in the Collection.* Denver, 1981.

Department of Archaeology, Gwalior State, *A Guide to the Archaeological Museum at Gwalior.* Gwalior, n.d.

Desai, Devangana. "Art Under Feudalism in India (c. A.D. 500–1300)." *The Indian Historical Review* 1, no. 1 (1974).

——. *Erotic Sculpture of India: A Sociocultural Study.* New Delhi: Tata-McGraw-Hill Ltd., 1975.

——. "Placement and Significance of Erotic Sculptures at Khajurāho." *Śiva Symposium.* Philadelphia: University of Pennsylvania Press, 1985/1986.

——. "Social Dimensions of Art in Early India." Presidential Address, Ancient India Section, Indian History Congress. Fiftieth session, at Gorakhpur, 1989.

——. "The Patronage of the Lakshmana Temple at Khajurāho." *The Powers of Art: Patronage in Indian Culture.* Barbara Stoler Miller, ed. Delhi: Oxford University Press, 1992.

Deva, Krishna. "Kachchhapaghāta Temples." *The Researcher.* Directorate of Archaeology and Museums, Government of Rajasthan, Jaipur, 1963/64.

——. "Bhūmija Temples." In *Studies in Indian Temple Architecture.* Edited by Pramod Chandra. New Delhi: American Institute of Indian Studies, 1975.

——. *Temples of Khajurāho.* New Delhi: Archaeological Survey of India, 1990.

Deviprasād, Munshi [and F. Kielhorn]. "Ghaṭayālā Inscription of the Pratīhāra Kakkuka of [Vikrama] Saṁvat 918." *Journal of the Royal Asiatic Society* (1895).

Dhaky, M. A. "The Date of the Dancing Hall of the Sun Temple, Modhera." *Journal of the Asiatic Society of Bombay* 38 (1964).

——. *The Vyāla Figures on the Medieval Temples of India.* Varanasi: Prithivi Prakashan, 1965.

——. "Kiradu and the Māru-Gurjara Style of Temple Architecture." *Bulletin of the American Academy of Benares* (1967).

——. "Kṣemaṅkarī: The Cult Image of the Ambikā Temple, Jagat." *Vishveshvaranand Indological Journal* 6 (1968).

——. "Some Early Jaina Temples in Western India." *Shrī Mahāvir Jaina Vidyālaya Suvarṇamahotsava Grantha.* 2 vols. Bombay: Shrī Mahāvir Jaina Vidyālaya University, 1968.

——. "Prāsāda as Cosmos." *The Adyar Library Bulletin* 35 (1971).

——. "The Genesis and Development of Māru-Gurjara Temple Architecture." In *Studies in Indian Temple Architecture.* Edited by Pramod Chandra. New Delhi: American Institute of Indian Studies, 1975.

——. *The Indian Temple Forms in Karnata Inscriptions and Architecture.* Delhi: Abhinav, 1977.

Dhaky, M. A., H. P. Shastri, and J. D. Bhattacharya. *The Riddle of the Temple of Somanātha.* Varanasi: Bharata Manisha, 1974.

281

Dhal, U. N., ed. *Ekāmrapurāṇa*. Delhi: Nag Publishers, 1986.

Dikshit, R. K. *The Candellas of Jejākabhukti*. Delhi: Motilal Banarsidass, 1977.

Dikshit, S. K. *A Guide to the State Museum, Dhubela, Nowgong (BKD.), Vindhya Pradesh (1955–1957)*. Chhatarpur: State Museum, 1955–57.

Dirks, Nicholas B. *The Hollow Crown: Ethnohistory of an Indian Kingdom*. Cambridge: Harvard University Press, 1988.

Dvivedī, Harihar Nivās. "Gopakṣetra ke kacchapaghāta." In *Gvaliyar darśan*. Gwalior: Gwalior Research Institute, 1980.

Dwivedi, V. P. "An Unusual Devī Image from Kanauj." *Oriental Art* 17 (1971).

E

Eck, Diana L. *Darśan, Seeing the Divine Image in India*. Chambersburg, PA: Anima Publications, 1981. 2d revised edition, 1985.

Entwistle, A. W. *Braj: Centre of Krishna Pilgrimage*. Groningen: Egbert Forsten, 1987.

Epigraphia Indica. 1888–. Calcutta and Delhi.

Eschmann, A., H. Kulke, and G. C. Tripathi. *The Cult of Jagannath and the Regional Tradition of Orissa*. Delhi: Manohar Publications, 1978.

Evans, Bruce H. "Two Early Medieval Indian Sculptures." *Dayton Art Institute Bulletin* 25, no. 1 (September 1966).

F

Fergusson, James. *History of Indian and Eastern Architecture*. 2 vols. Vol. 1, London: John Murray, 1876; Vol. 2, New York: Dodd, Mead and Co., 1891.

Frédéric, Louis. *The Art of India: Temples and Sculpture*. New York: Harry N. Abrams, n.d. [1959].

Fry, Roger Eliot. "Indian Art." In *Last Lectures*. Cambridge: Cambridge University Press, 1939.

G

Gangoly, O. C., and K. N. Dikshit. "An Image of Sarasvatī in the British Museum." *Rupam* 17 (January 1942).

Gazette des Beaux Arts (February 1968).

Geertz, Clifford. *The Predicament of Culture: Twentieth-Century Ethnography, Literature, and Art*. Cambridge: Harvard University Press, 1987.

Goswamy, B. N. *Rasa: les neuf visages de l'art Indian*. Paris: Galeries Nationales du Grand Palais Association Francaise d'Action Artistique, 1986.

Grabar, Oleg. *The Mediation of Ornament*. Princeton: Princeton University Press. In press.

Granoff, Phyllis. "When Miracles Become Too Many: Stories of the Destruction of Holy Sites in the *Tāpī Khanda* of the *Skandapurāṇa*." *Annals of the Bhandarkar Oriental Research Institute* 72 (1991).

——. "Worship as Commemoration: Pilgrimage, Death and Dying in Medieval Jainism." Paper delivered at the Association of Medieval Scholars in Kalamazoo, Michigan, 1992.

Gupta, Chitrarekha. "The Writers' Class of Ancient India—A Case Study in Social Mobility." *The Indian Economic and Social History Review* 2, no. 2 (1983).

H

Hague, Enamul. *Bengal Sculptures: Hindu Iconography Up to c. 1250 A.D.* Dhaka: Bangladesh National Museum, 1992.

Halder, R. R. "Samoli Inscription of the Time of Siladitya; [Vikrama-Saṃvat] 703." *Epigraphia Indica*, vol. 20 (1929–30). Reprint. New Delhi: Archaeological Survey of India, 1983.

Handa, Devendra. *Osian: History, Archaeology, Art and Architecture*. Delhi: Sundeep Prakashan, 1984.

Hardy, Friedhelm. "Ideology and Cultural Contexts of the Śrīvaiṣṇava Temple." In *The Indian Economic and Social History Review* 14, no. 1 (1972).

Harle, James C. "An Early Indian Hero-stone and a Possible Western Source." *Journal of the Royal Asiatic Society* (1970).

——. *Gupta Sculpture: Indian Sculpture of the Fourth to Sixth Centuries A.D.* Oxford: Clarendon Press, 1974.

——. *The Art and Architecture of the Indian Subcontinent*. New York: Viking Penguin Inc., 1986.

Harle, James C., and Andrew Topsfield. *Indian Art in the Ashmolean Museum*. Oxford: Ashmolean Museum, 1987.

Havell, E. B. *Indian Sculpture and Painting*. London: John Murray, 1908.

——. *The Ancient and Medieval Architecture of India: A Study of Indo-Aryan Civilisation*. London: John Murray, 1915.

Hawking, Stephen W. *A Brief History of Time from the Big Bang to Black Holes*. New York: Bantam Books, 1988.

Heeramaneck, Alice N. *Masterpieces of Indian Sculpture*. Verona, Italy: Privately published, 1979.

Heifetz, Hank, tr., *The Origin of the Young God: Kālidāsa's Kumārasambhava*. Berkeley: University of California Press, 1985, 1990 paper.

Hollis, Howard. "An Indian Pillar." *Bulletin of the Cleveland Museum* (January 1939).

Huntington, Susan. *The Art of Ancient India: Buddhist, Hindu, Jain*. New York: Weatherhill, 1985.

Husain, Mahdi. *The Reḥla of Ibn Baṭṭūṭa (India, Maladive Islands and Ceylon). Translation and Commentary*. Baroda: Oriental Institute, 1953.

I

Inden, R. "Hierarchies of Kings in Early Medieval India." *Contributions to Indian Sociology*, New Series, 15 (1981).

——. *Imagining India*. Oxford: Basil Blackwell Ltd., 1990.

Indian Antiquary. Title varies. 1872–. Bombay.

"Indian Art Abroad." *Design* 2, no. 7 (July 1967).

Indiana University Art Museum. *East and West on Art: Ancient Indian Sculpture and Painting*. Indiana: University of Indiana Press, 1965.

J

Jain, Jyotindra, and Eberhard Fischer. *Jaina Iconography*, pt. 1. Leiden: E. J. Brill, 1971.

Jain-Neubauer, Jutta. *The Stepwells of Gujarat in Art-Historical Perspective*. New Delhi: Abhinav Publications, 1981.

Jain, V. K. *Trade and Traders in Western India (A.D. 1000–1300)*. New Delhi: Munshiram Manoharlal Publishers Pvt. Ltd., 1990.

Jayakar, Pupul. "Medieval Sculpture: 11. Paranagar (Alwar)." *Mārg* 12, no. 2 (March 1959).

Jha, D. N. "State and Economy in the Early Medieval Himalayan Kingdom of Chamba." Paper presented at the 52d session of the Indian History Congress.

——. ed. *Feudal Social Formation in Early India*. Delhi: Chanakya Publications, 1987.

K

Keith, J. B. *Preservation of National Monuments; Gwalior Fortress*. Calcutta: Superintendent of Government Printing, 1883.

Kennedy, Richard. "The King in Early South India as Chieftain and Emperor." *Indian Historical Review* 3 (1976).

Kielhorn, F. "The Sāsbahu Temple Inscription of Māhipāla of Vikrama-Samvat 1150. *Indian Antiquary* 15 (1886).

——. "Harsha Stone Inscription of the Chahamana Vigraharaja: The [Vikrama] Year 1030." *Epigraphia Indica* 2 (1894).

——. "Inscriptions from Khajurāho." *Epigraphia Indica*, vol. 1. Reprint. New Delhi: Archaeological Survey of India, 1971.

——. "Siyadoni Stone Inscription." *Epigraphia Indica*, vol. 1. Reprint. New Delhi: Archaelogical Survey of India, 1971.

——. "Two Chandella Inscriptions from Ajaygadh." *Epigraphia Indica*, vol. 1. Reprint. New Delhi: Archaeological Survey of India, 1971.

——. "Khalimpur Plate of Dharmapāladeva." *Epigraphia Indica*, vol. 4. (1896–97). Reprint. New Delhi: Archaeological Survey of India, 1979.

Kosambi, D. D. *An Introduction to the Study of Indian History*. Bombay: Popular Book Depot, 1956.

Kramrisch, Stella. *Indian Sculpture. The Heritage of India Series*. London: Oxford University Press, 1933.

——. *The Hindu Temple*. 2 vols. Calcutta: Calcutta University Press, 1946; Delhi: Motilal Banarsidass, 1976.

——. "The Four-Cornered Citadel of the Gods." *Journal of the American Oriental Society* 75 (1955).

——. "Indian Sculpture Newly Acquired." *Philadelphia Museum of Art Bulletin* 52 (1957).

——. *Indian Sculpture in the Philadelphia Museum of Art*. Philadelphia: University of Pennsylvania Press, 1960.

——. "The Temple as Puruṣa." In *Studies in Indian Temple Architecture*. Edited by Pramod Chandra. New Delhi: American Institute of Indian Studies, 1975.

——. *Manifestations of Shiva*. Philadelphia: Philadelphia Museum of Art, 1981.

——. *The Presence of Śiva*. Princeton: Princeton University Press, 1981.

——. "An Image of Aditi-Uttanapad." *Artibus Asiae* 19 (1956). Reprinted in *Exploring India's Sacred Art: Selected Writings of Stella Kramrisch*. Edited by Barbara S. Miller. Philadelphia: University of Pennsylvania Press, 1983.

Kreisel, Gerd. "*Caturmukhaliṅga* and *Maheśamūrti*: The Cosmic Aspects of Śiva." *Tribus* (Linden-Museum Stuttgart) 36 (December 1987).

Kulke, Hermann. *The Cidambaramāhātmya*. Weisbaden: Otto Harrassowitz, 1970.

——. "Kṣetra and Kṣatra: The Cult of Jagannātha of Puri and the 'Royal Letters' of the Rajas of Khurda." In *The Sacred Centre as the Focus of Political Interest*. Edited by Hans Bakker. Groningen: Egbert Forsten, 1992.

L

Lal, Rai Bahadur Hira. "The Sirpur Stone Inscription of the Time of Mahasivagupta." *Epigraphia Indica* 11. Calcutta: Archaeological Survey of India, 1911–12.

Lanius, Mary. "Rajasthani Sculpture of the Ninth and Tenth Centuries." *Aspects of Indian Art*. Edited by Pratapaditya Pal. Leiden: E. J. Brill, 1972.

Lannoy, Richard. *The Speaking Tree: A Study of Indian Culture and Society*. London: Oxford University Press, 1971.

Lascarides-Zannas, Eliki. "The Big Śukanāsa of Udayeśvara Temple at Udayapur, Madhya Pradesh." *Madhu: Recent Researches in Indian Archaeology and Art History*. Shri M. N. Deshpande Festschrift. Edited by M. S. Nagaraja Rao. Delhi: Agam Kala Prakashan, 1981.

Lee, Sherman. *Asian Art: Selections from the Collection of Mr. and Mrs. John D. Rockefeller 3rd, pt. 2*. New York: The Asia Society, 1975.

Lefebre d'Argence, Rene-Yvon, and Terese Tse Bartholomew. *Indian and South-East Asian Stone Sculptures from the Avery Brundage Collection*. Pasadena and San Francisco: The Pasadena Art Museum and the San Francisco Center of Asian Art and Culture, 1969.

Lerner, Martin. "Some Unpublished Sculptures from Harshagiri." *Bulletin of the Cleveland Museum of Art* (December 1969).

Liebert, Gösta. *Iconographic Dictionary of the Indian Religions: Hinduism, Buddhism, and Jainism*. 2d ed. Delhi: Sri Satguru Publications, 1985.

M

Madan, T. N., ed. *Religion in India*. New Delhi: Oxford University Press, 1991.

Majumdar, R. C., ed. *The History and Culture of the Indian People*. 11 vols. Bombay: Bharatiya Vidya Bhavan.

Majumdar, R. C., and K. K. Dasgupta, eds. *A Comprehensive History of India*, vol. 3, pt. 1 (A.D. 300–985). Delhi: Peoples Publishing House, 1981.

Mallison, Françoise. "Development of Early Krishnaism in Gujarat: Viṣṇu-Raṇchoḍ-Kṛṣṇa." In *Bhakti in Current Research 1979–1982*. Edited by Monika Thiel-Horstmann. Berlin: Dietrich Reiner Verlag, 1983.

Mankodi, Kirit. "A Paramāra Sculpture in the British Museum: Vagdevī or Yakshī Ambikā?" *Sambodhi* 9 (April 1980–January 1981).

——. "Scholar-Emperor and a Funerary Temple: Eleventh-Century Bhojpur." *Royal Patrons and Great Temple Art*. Edited by Vidya Dehejia. Bombay: Mārg Publications, 1988.

——. *The Queen's Step Well at Patan*. Bombay: Project for Indian Cultural Studies, 1992.

Maxwell, T. S. "Nānd, Parel, Kalyānpur: Śaiva Images as Meditational Constructs." In *Discourses on Śiva*. Edited by Michael W. Meister. Philadelphia: University of Pennsylvania Press, 1984.

Meister, Michael W. "The Hindu Temple: Axis and Access." In *Concepts of Space, Ancient and Modern*. Edited by Kapila Vatsyayan. New Delhi: Indira Gandhi National Centre for the Arts and Abhinav Publications.

———. "Detective Archaeology: A Preliminary Report on the Śiva Temple at Kusumā." *Archives of Asian Art* 27 (1974).

———. *Form in the North Indian Temple: A Field Survey.* Ph.D. Dissertation, Harvard University, 1975.

———. "A Field Report on Temples at Kusumā." *Archives of Asian Art* 29 (1976).

———. "Jain Temples in Central India." In *Aspects of Jaina Art and Architecture.* Edited by U. P. Shah and M. A. Dhaky. Ahmedabad: L. D. Institute, 1976.

———. "Phāṁsanā in Western India." *Artibus Asiae* 38 (1976).

———. "Construction and Conception: Maṇḍapikā Shrines of Central India." *East and West* 26 (1978).

———. "The Śivaite Sūrya Shrine Near Tusa." *Journal of the Indian Society of Oriental Art.* 2d of Moti Chandra Commemoration volumes (1978).

———. "Altars and Shelters in India." *aarp* (Art and Archaeology Research Papers) 16 (1979).

———. "Juncture and Conjunction: Punning and Temple Architecture." *Artibus Asiae* 41 (1979).

———. "Maṇḍala and Practice in Nāgara Architecture in North India." *Journal of the American Oriental Society* 99.2 (1979).

———. "Dārra and the Early Gupta Tradition." In *Chhavi II, Rai Krishna Dasa Felicitation Volume.* Edited by Anand Krishna. Banaras: Bharat Kala Bhavan, 1981.

———. "Display as Structure and Revelation: On Seeing the Shiva Exhibition." *Studies in Visual Communication* 7, no. 4 (1981).

———. "Muṇḍeśvari: Ambiguity and Certainty in the Analysis of a Temple Plan." In *Kalādarśana. American Studies in the Art of India.* Edited by Joanna G. Williams. New Delhi: Oxford & IBH Publishing Co., 1981.

———. "Analysis of Temple Plans: Indor." *Artibus Asiae* 43 (1982).

———. "Bīthū: Individuality and Idiom." *Ars Orientalis* 13 (1982).

———. "Geometry and Measure in Indian Temple Plans: Rectangular Temples." *Artibus Asiae* 44 (1983).

———. "The Udayeśvara Temple Plan." In *Śrīnidhih, Perspectives in Indian Archaeology, Art and Culture.* Shri K. R. Srinivasan Festschrift. Madras: New Era Publications, 1983.

———. "Śiva's Forts in Central India: Temples in Dakṣiṇa Kośala and Their 'Dæmonic' Plans." In *Discourses on Śiva.*

Edited by Michael W. Meister. Philadelphia: University of Pennsylvania Press, 1984.

———. "Historiography of Temples on the Chandrabhāgā, Reconsidered." In *Indian Epigraphy, Its Bearing on the History of Art.* Edited by G. S. Gai and Frederick S. Asher. New Delhi: Oxford & IBH Publishing Co., 1985.

———. "Measurement and Proportion in Hindu Temple Architecture." *Interdisciplinary Science Reviews* 10 (1985).

———. "Symbol and Surface: Masonic and Pillared Wall-Structures in North India." *Artibus Asiae* 46 (1985).

———. "The Hero as Yogin: A Virastambha from Chittor." In *Dimensions of Indian Art.* Edited by Lokesh Chandra and Jyotindra Jain. Delhi: Agam Kala Prakashan, 1986.

———. "On the Development of a Morphology for a Symbolic Architecture: India." *Res, Anthropology and Aesthetics* 12 (1986).

———. "Regional Variations in *Mātṛkā* Conventions." *Artibus Asiae* 47 (1986).

———. "Temple: Hindu Temples." In *The Encyclopedia of Religion,* vol. 14. Edited by Mircea Eliade. New York: Macmillan Publishing Co., 1987.

———. "Prāsāda as Palace: Kūṭina Origins of the Nāgara Temple." *Artibus Asiae* 49, no. 314 (1988–89).

———. "Reading Monuments and Seeing Texts." In *Sastric Traditions in Indian Arts.* 2 vols. Edited by A. Dallapiccola. Stuttgart: Franz Steiner Verlag, 1989.

———. "Temples, Tīrthas, and Pilgrimage: The Case of Osiāñ." In *Ratna-Chandrikā.* Edited by D. Handa and A. Agrawal. New Delhi: Harman Publishing House, 1989.

———. "De- and Re-constructing the Indian Temple." *Art Journal* 49 (1990).

———. ed. *Ananda K. Coomaraswamy: Essays in Early Indian Architecture.* Delhi: Oxford University Press, 1992.

———. "Seeing and Knowing: Semiology, Semiotics, and the Art of India." Proceedings of the 15th Annual Colloquio, Mexico: Instituto de Investigaciones Esteticas. Forthcoming.

Meister, Michael W., M. A. Dhaky, and Krishna Deva, eds. *Encyclopaedia of Indian Temple Architecture.* 2 vols. Princeton: Princeton University Press, 1988; New Delhi: American Institute of Indian Studies [AIIS] and Oxford University Press, 1991.

"Messrs. Luzac's Collection of Indian Sculpture." *Rupam* 11 [1922].

Mirashi, V. V. *Inscriptions of the Kalachuri-Chedi Era. Corpus Inscriptionum Indicarum* 4, pt. 1. Ootacamund: Department of Archaeology, India, 1955.

———. "Gwalior Museum Stone Inscription of Pataṅgaśambhu." *Journal of the Madhya Pradesh Itihas Parishad* 4 (1962).

———. "Three Ancient and Famous Temples of the Sun." *Purāṇa* 8 (1966).

Mishra, Ram Swaroop. *Supplement to Fleet's Corpus Inscriptionum Indicarum, Vol. III 1888, Inscriptions of the Early Gupta Kings and Their Successors.* Varanasi: Benares Hindu University, 1971.

Mishra, S. M. *Yaśovarman of Kanauj.* Delhi: Abhinav, 1977.

Misra, Krsna. *Prabodhacandrodaya of Kṛṣṇamiśra.* Sanskrit text with English translation by S. K. Nambiar. Delhi: Motilal Banarsidass, 1971.

Misra, R. N. *Sculptures of Ḍāhala and Dakshiṇa Kośala and Their Background.* Delhi: Agam Kala Prakashan, 1987.

Mitra, Debala. *Buddhist Monuments.* Calcutta: Sahitya Sansad, 1971.

Mitra, S. K. *The Early Rulers of Khajurāho.* 2d ed. Delhi: Motilal Banarsidass, 1977.

Mittal, A. C. *The Inscriptions of the Imperial Paramāras (800 A.D. to 1320 A.D.).* Ahmedabad: L. D. Institute, Series 73, 1979.

Mitter, Partha. *Much Maligned Monsters: History of European Reactions to Indian Art.* Oxford: Clarendon Press, 1977.

Mookerjee, Ajit. *Ritual Art of India.* London: Thames and Hudson, 1985.

Mosteller, John F. "Texts and Craftsmen at Work." *Making Things in South Asia: Proceedings of the South Asia Seminar, University of Pennsylvania.* Edited by Michael W. Meister. Philadelphia: Department of South Asia Regional Studies, 1988.

Mukhia, H. "Was There Feudalism in Indian History?" *The Journal of Peasant Studies* 8, no. 3 (1981).

Munshi, K. M. *Somanātha, the Shrine Eternal.* Bombay: Bharatiya Vidya Bhavan, 1976.

Museum of Fine Arts, Boston. *Asiatic Art in the Museum of Fine Arts, Boston.* Boston, 1982.

———. *Selected Masterpieces of Asian Art 1890–1990, Museum of Fine Arts, Boston.* Tokyo: Nihon Hoso Shuppan Kyokai, 1991.

N

Nandi, R. N. *Religious Institutions and Cults in the Deccan.* Delhi: Motilal Banarsidass, 1973.

Nanvati, J. M., and M. A. Dhaky. "The Ceilings in the Temples of Gujarat." *Bulletin of the Museum and Picture Gallery, Baroda* 16–17. Baroda: Museum and Picture Gallery, Baroda, 1963-64.

The Nelson-Atkins Museum of Art. *Nelson-Atkins Handbook.* Kansas City, Missouri, 1959, 1949, 1941.

Newman, Richard. *The Stone Sculpture of India: A Study of the Materials Used by Indian Sculptors from ca. 2d century B.C. to the 16th Century.* Cambridge, MA: Center for Conservation and Technical Studies, Harvard University Art Museums, 1984.

O

O'Leary, B. *The Asiatic Mode of Production: Oriental Despotism, Historical Materialism and Indian History.* Oxford: Blackwell Ltd., 1989.

P

Pal, Pratapaditya. *The Divine Presence: Asian Sculptures from the Collection of Mr. and Mrs. Harry Lenart.* Los Angeles: Los Angeles County Museum of Art, 1978.

———. *The Ideal Image: The Gupta Sculptural Tradition and Its Influence.* New York: The Asia Society in association with John Weatherhill, 1978.

———. *The Sensuous Immortals: A Selection of Sculptures from the Pan-Asian Collection.* Los Angeles: Los Angeles County Museum of Art, 1978.

———. ed. *American Collectors of Asian Art.* Bombay: Mārg Publications, 1986.

———. *Indian Sculpture 700–1800, Vol. 2, A Catalogue of the Los Angeles County Museum of Art Collection.* Los Angeles and Berkeley: Los Angeles County Museum of Art and University of California Press, 1988.

Palloting, Massimo, ed. *The Encyclopedia of World Art.* 15 vols. New York: McGraw-Hill, 1959.

Panikkar, K. M. "Presidential Address." Indian History Congress. Eighteenth session, at Calcutta, 1955.

Parimoo, Ratan. *Sculptures of Śeṣaśāyī Viṣṇu: Survey, Iconological Interpretation, Formal Analysis.* Baroda: Maharaja Sayajirao University, 1983.

Patil, D. R. *The Cultural Heritage of Madhya Bharat.* Gwalior: Department of Archaeology, Madhya Bharat Government, 1952.

Pollock, Sheldon. "The Theory of Practice and the Practice of Theory in Indian Intellectual History." *Journal of the American Oriental Society* 105 (1985).

———. "Mīmāṁsā and the Problem of History in Traditional India." *Journal of the American Oriental Society* 109 (1989).

Prabhācandrācārya. *Prabhāvakacarita.* Edited by Jina Vijaya Muni. Ahmedabad, 1940.

Prasad, R. B. P. *Jainism in Early Medieval Karnataka (c. A.D. 500–1200).* New Delhi: Motilal Banarsidass, 1975.

Progress Report of the Archaeological Survey of India, Northern Circle (1905–06).

Progress Report of the Archaeological Survey of India, Western Circle (1906–07).

Puri, B. N. *The History of the Gurjara-Pratiharas.* New Delhi: Munshiram Manoharlal Publishers, 1986 (reprint).

R

Rabe, Michael. "Royal Portraits and Personified Attributes of Kingship at Mamallapuram." *Journal of the Academy of Art and Architecture, Mysore* 1 (1991).

Rahman, Ali. *Art and Architecture of the Kalacuris.* Delhi: Sundeep Prakashan, 1980.

———. *Pratīhāra Art in India.* Delhi: Agam Kala Prakashan, 1987.

Rājaśekharasūri. *Prabandhakośa.* Vol. 1 of Singhi Jain Series. Edited by Jina Vijaya Muni. Santiniketan: Singhi Jaina Pitha, 1935.

Ramesh, K. V., and S. P. Tewari. *A Copper-Plate Hoard of the Gupta Period from Bagh, Madhya Pradesh.* Delhi, 1990.

Rao, Gopinatha T. A. *Elements of Hindu Iconography.* 1914–1916; reprint, New Delhi: Motilal Banarsidass, 1968, 1985.

Ray, Niharranjan. "The Medieval Factor in Indian History." General President's Address, Indian History Congress. Twenty-ninth session, at Patiala, 1967.

Ray, Hem Chandra. *The Dynastic History of Northern India.* 2 vols. Calcutta: University of Calcutta, 1931–36.

"Remnants Shored Against the Ruin, Rajasthani Sculpture." *Mārg* 12, no. 2 (March 1959).

Renou, Louis. "The Vedic Schools and the Epigraphy." In *Siddha Bharati.* 2 vols. Edited by Vishva Bandhu. Hoshiarpur: Veshvarananda Vedic Research Institute, 1950.

Rocher, Ludo. *The Purāṇas, A History of Indian Literature.* vol. 2, fas. 3. Wiesbaden: Otto Harrassowitz, 1986.

Rosenfield, John. *The Arts of India and Nepal: The Nasli and Alice Heeramaneck Collection.* Boston: Museum of Fine Arts, Boston, 1966.

Rowland, Benjamin. *The Art and Architecture of India. Buddhist, Hindu, Jain.* Reprint. Harmondsworth, Middlesex: Penguin, 1970.

The Royal Academy of Arts. *The Art of India and Pakistan, A Commemorative Catalogue of the Exhibition Held at the Royal Academy of Arts.* London, 1947–48.

S

Sahni, D. R. "Ahar Stone Inscription." *Epigraphia Indica,* vol. 19 (1927–28). Reprint. New Delhi: Archaeological Survey of India, 1983.

Salomon, Richard, and Michael Willis. "A Ninth-Century Umāmaheśvara Image." *Artibus Asiae* 50 (1990).

Sankalia, H. D. "Gurjara-Pratīhāra Monuments: A Study in Regional and Dynastic Distribution of North Indian Monuments." *Bulletin of the Deccan College Research Institute* 4 (1942–43).

Śaṅkara. *Upadeśasahasrī, A Thousand Teachings.* Tokyo: University of Tokyo Press, 1979.

Sankaranarayan, S. "Nanana Copperplates of the Time of Kumārapāla and Ālhaṇa." *Epigraphia Indica,* vol. 39, pt. 1. Reprint. New Delhi: Archaeological Survey of India.

Sastri, K. A. Nilakanta. *The Cōḷas.* Madras: Madras University, 1955.

Schopen, Gregory. "The Buddha as Owner of Property and Permanent Resident in Medieval Indian Monasteries." In *Journal of Indian Philosophy* 18 (1990).

Seidel, Linda. *Songs of Glory: The Romanesque Facades of Aquitaine.* Chicago: University of Chicago Press, 1981.

Shah, U. P. "Sculptures from Śāmalāji and Roda." *Bulletin of the Baroda Museum and Picture Gallery* special number (1960).

——. "Some Medieval Sculptures from Gujarat and Rajasthan." *Journal of the Indian Society of Oriental Art* special number (1965–66).

——. *Jaina-Rūpa-Maṇḍana* (Jaina Iconography). Vol. 1. New Delhi: Abhinav Publications, 1987.

Sharma, D., ed. *Rajasthan Through the Ages*, vol. 1 (*From the Earliest Times to 1316*). Bikaner: Rajasthan State Archives, 1966.

Sharma, R. K., ed. *Art of the Paramāras of Malwa*. Delhi: Agam Kala Prakasham, 1979.

Sharma, R. S. *Indian Feudalism, c. 300–1200*. Calcutta: Calcutta University, 1965.

——. *Social Changes in Early Medieval India (c. A.D. 500–1200)*. Delhi: Peoples Publishing House, 1969.

——. *Urban Decay in India (c. 300–c. 1000)*. Delhi: Munshiram Manoharlal Publishers Pvt. Ltd., 1987.

Shastri, Ajay Mitra. *India as Seen in the Bṛhatsaṁhitā of Varāhamahīra*. Delhi: Motilal Banarsidass, 1969.

Shastri, M. M. *Catalogue and Guide to the Government Museum, Kota*. Jaipur: ASI Rajasthan, 1961.

Singh, Tahsildar. "Jaina Mahāstambhas at Deogarh." *Sambodhi* 10, nos. 1–4 (April 1981–January 1982).

Sinha, Nandini. "Guhila Lineages and the Emergence of State in Early Medieval Mewar." M. Phil. Dissertation, Jawaharlal Nehru University, 1988.

Sircar, D. C. "Stray Plates fron Nanana." *Epigraphia Indica*, vol. 33. Reprint. New Delhi: Archaeological Survey of India.

——. *Select Inscriptions Bearing on Indian History and Civilization*. 2 vols. Calcutta: University of Calcutta, 1965.

——. *Indian Epigraphical Glossary*. Delhi: Motilal Banarsidass, 1966.

——. *Studies in the Geography of Ancient and Medieval India*. Delhi: Motilal Banarsidass, 1971.

Sivaramamurti, C. *Nataraja in Art, Thought and Literature*. New Delhi: National Museum, New Delhi, 1974.

——. *The Art of India*. New York: Abrams, 1977.

Smith, V. A. *Early History of India, From 600 B.C. to the Muhammadan Conquest, Including the Invasion of Alexander the Great*. 4th ed. Revised by S. M. Edwardes. Oxford: Oxford University Press, 1924.

Smith, Walter. "Object of the Month: *Pañcamukha Liṅga*." *Orientations* 20, no. 2 (February 1989).

Sontheimer, Gunther-Dietz. "Religious Endowments in India and the Juristic Personality of Hindu Deities." In *Zeitschrift für vergleichende Rechtswissenschaft einschliessende ethnologische Rechtswissenschaft* 67 (1965).

Stadtner, Donald M. "The Śaṅkaragaṇa Panel in the Sāgar University Art Museum." In *Indian Epigraphy: Its Bearing on the History of Art*. F. M. Asher and G. and Gai, eds. New Delhi: American Institute of Asian Studies.

——. "A Central Indian Monastery." *Discovery: Research and Scholarship at The University of Texas at Austin* 6, no. 2 (Winter 1981).

——. "Nand Chand and a Central Indian Regional Style." *Artibus Asiae* 43 (1981–82).

Stein, Burton. *Peasant State and Society in Medieval South India*. Oxford: Oxford University Press, 1980.

Stoddard, Whitney S. *The Sculptors of the West Portals of Chartres Cathedral: Their Origins in Romanesque and Their Role in Chartrain Sculpture*. New York: W. W. Norton & Company, 1952.

Survey of India Map 45 D.16.5.

Survey of India Map 45 I.II.7.

Sutton, Denys. "Editorial: The Search for Perfection." *Apollo* 118, no. 261 (November 1983).

T

Taggart, Ross E. *Those Beguiling Women*. Kansas City, Missouri: The Nelson-Atkins Museum of Art, 1983.

Taggart, Ross E., George L. McKenna, and Marc F. Wilson, eds. *Handbook of the Collections in the William Rockhill Nelson Gallery of Art and Mary Atkins Museum of Fine Arts Kansas City, Missouri*. vol. 2. Kansas City: Nelson-Atkins Museum, 1973.

Tandon, Pratap Narain, ed. *Kannauj: Archaeology and Art*. Kannauj: Archaeological Museum Kannauj, n.d. [1978].

Thakore, S. R. *Catalogue of Sculptures in the Archaeological Museum*. Gwalior: M. P. Gwalior, n.d.

Thapar, Romila. "Interpretations of Ancient Indian History." In *Ancient Indian Social History: Some Interpretations*. Delhi: Orient Longman, 1978.

——. "The Mouse in the Ancestry." In S. D. Joshi, ed., *Amritadhara*. Professor R. N. Dandekar Felicitation Volume. New Delhi: Ajanta Books International, 1984.

Tillotson, G. H. R. *The Tradition of Indian Architecture*. New Haven, CT: Yale University Press, 1989.

Tod, James. *Annals and Antiquities of Rajasthan or the Central and Western Rajpoot States of India*. New Delhi: K. M. N. Publishers, 1971.

Trabold, J. N. *The Art of India: An Historical Profile. Selections from the Los Angeles County Museum of Art*. Northridge, CA: Fine Arts Gallery, California State University Northridge, 1975.

Trauber, Henry, William Jay Rathbun, and Catherine A. Kaputa. *Asiatic Art in the Seattle Art Museum*. Seattle: Seattle Art Museum, 1973.

Tripathi, L. K. *The Temples of Baroli*. Varanasi: Amitabha Prakasana, n.d. [1975].

Tripathi, R. S. *History of Kanauj*. Benares: Indian Book Shop, 1937.

Trivedi, H. V. *Inscriptions of the Paramāras, Chandellas, Kachchhapaghātas and Two Minor Dynasties. Corpus Inscriptionum Indicarum* 7, pt. 2. New Delhi: Archaeological Survey of India, 1978.

Trivedi, R. D. *Temples of the Pratīhāra Period in Central India*. New Delhi: The Director General, Archaeological Survey of India, 1990.

Turner, J. S., ed. *The Dictionary of Art*. London: Macmillan. Forthcoming.

V

Vākpati. *The Gauḍavaho: A Historical Poem in Prākit*. Shankar Pandurang Pandit, ed. Bombay: Government Central Book Depot, 1987.

van Lohuizen-de Leeuw, J. E. *Indian Sculptures in the von der Heydt Collection*. Zurich: Atlantis Verlag/Museum Rietberg, 1964.

Varāhamihīra. *Bṛhatsaṁhitā*. Translated by H. Kern. *Journal of the Royal Asiatic Society* 4–7 (1869–74).

———. *Bṛhatsaṁhitā*. Translated by Subrahmanya Sastri and M. Ramakrishna Bhat. Bangalore: V. B. Soobbiah, 1947.

Vātsyayāna. *Kāmasūtra*. Translated by S. C. Upadhyaya. Bombay, 1963.

Vaudeville, Charlotte, tr. *L'Invocation: Le Haripāṭh de Dnyāndeva*. Paris: Publications de l'Ecole Francaise d'Extreme Orient, vol. 73, 1969.

Viennot, Odette. *Temples de l'Inde centrale et occidentale. Étude stylistique et essai di chronologie relative du Vie au milieu du Xe siécle*. 2 vols. *Publications de l'Ecole Francaise d'Extreme-Orient, Memoires Archeologiques*. Paris: Adrien Maison-nueve, 1976.

von Steitencron, Heinrich. "Orthodox Attitudes Towards Temple Service and Image Worship in Ancient India." *Central Asiatic Journal* 21 (1971).

W

Washburn, Gordon Bailey. "The John D. Rockefeller III Oriental Collections," *ARTnews* 69, no. 5 [1970].

Wiesberg, Gabriel P., and H. W. Janson. *Traditions and Revisions: Themes from the History of Sculpture*. Cleveland: The Cleveland Museum of Art, 1975.

Williams, Joanna G. "The Sculpture of Mandasor." *Archives of Asian Art* 26. New York: The Asia Society, 1972–73.

———. *The Art of Gupta India: Empire and Province*. Princeton, NJ: Princeton University Press, 1982.

"Vakataka Art and the Gupta Mainstream." *Essays on Gupta Culture*. Edited by Bardwell L. Smith. Delhi: Motilal Banarsidass, 1983.

———. "Śiva and the Cult of Jagannātha: Iconography and Ambiguity." In *Discourses on Śiva*. Edited by Michael W. Meister. Philadelphia: University of Pennsylvania Press, 1984.

Willis, Michael. "Eighth-Century Miḥrāb in Gwalior." *Artibus Asiae* 46 (1985).

———. "Introduction to the Historical Geography of Gopakṣetra, Daśārṇa and Jejākadeśa." *Bulletin of the School of Oriental and African Studies* 51 (1988).

Winter, Irene. "Change in the American Art Museum: The Art Historian's Voice." In *Different Voices: A Social, Cultural, and Historical Framework for Change in the American Art Museum*. Edited by Marcia Tucker. New York: Association of Art Museum Directors, 1992.

Y

Yadava, B. N. S. *Society and Culture in Northern India in the Twelfth Century*. Allahabad: Central Book Depot, 1973.

Young, Mahorni Sharp. "Treasures of the Orient: A Rockefeller Collection." *Apollo*, New Series, 92, no. 105 (1970).

Z

Zannas, Eliki. *Journal of the Uttar Pradesh Historical Society*, New Series, 18, nos. 1 and 2.

———. *Khajurāho*. The Hague: Mouton and Co., 1960.

Zimmer, Heinrich *The Art of Indian Asia: Its Mythology and Transformation*. 2 vols. Edited by Joseph Campbell. Bollington Series 39. Princeton, NJ: Princeton University Press, 1968 [1955].

Photograph and Illustration Credits

Figs. 1, 9, 24, Nos. 26, 55, Aditya Arya;

Figs. 2–4, 6, 11–13, 15, 23, 25, 28, 29, 59, 74, 76, 81, Nos. 6, 28, 32a, 55a, Vishakha N. Desai;

Fig. 5 (No. 17), Michael Tropea, courtesy of James W. and Marilynn Alsdorf Collection, Chicago;

Figs. 7, 8, Joseph Ascherl;

Fig. 10, N. S. Olaniya;

Fig. 14, courtesy of Michael D. Willis;

Figs. 16–21, Michael D. Willis;

Fig. 22 (No. 25), Nos. 58, 59, Los Angeles County Museum of Art;

Fig. 26 (No. 71), Asian Art Museum of San Francisco;

Figs. 27, 32, 33, 35–38, 40–49, 51, 54–58, 62, 64, 66, 68, 77, 80, 83, 85, 87, No. 6a, Michael W. Meister;

Fig. 30, reproduced courtesy of Bharat Kala Bhawan, Banaras Hindu University;

Fig. 31, reproduced by permission of State Museum, Lucknow;

Fig. 34, American Institute of Indian Studies (AIIS) neg. no. 239.50; Fig. 63, AIIS 103.30; Fig. 72, AIIS 322.15; Fig. 73, AIIS 236.79; Fig. 84, AIIS 604.77; No. 1, AIIS 304.83; No. 1a, AIIS 304.84; No. 2, AIIS 305.54; No. 3, AIIS 80.26; No. 5, AIIS 218.87; No. 32, AIIS 236.17; No. 33, AIIS 486.82; No. 47, AIIS 355.21; No. 49, AIIS 54.33; No. 72, AIIS 646.40;

Figs. 39, 60, 61, 65, 67, 69, 70, 71, 75, 79, 82, 86, Nos. 31a, 31b, 35, Darielle Mason;

Fig. 50, from Krishna Deva, *Temples of Khajurāho*, 1990, reproduced by permission of Archaeological Survey of India;

Fig. 52, Klaus Herdeg;

Fig. 53, from Benjamin Rowland, *The Art and Architecture of India*, 1970;

Fig. 78, Patrick A. George;

Nos. 4, 66, Lynton Gardiner;

Nos. 7, 8, 15, 22, 69, courtesy of The Brooklyn Museum;

Nos. 9, 11, 20, 45, The Denver Art Museum;

No. 10, Rollyn Puterbaugh, copyright The Dayton Art Institute;

No. 12, Philadelphia Museum of Art;

No. 13, M. McLean, copyright The Nelson Gallery Foundation, The Nelson-Atkins Museum of Art, Kansas City, Missouri;

Nos. 14, 68, reproduced by courtesy of the Trustees of the British Museum, London;

Nos. 16, 50, Otto Nelson, The Asia Society, New York;

No. 17 (See Fig. 5 above);

Nos. 18, 27, 53, 60, 61, courtesy of Photographic Services Department, Museum of Fine Arts, Boston;

No. 19, courtesy of Photograph Services, The Metropolitan Museum of Art, New York;

Nos. 21, 51, 63, 74, by kind permission of Spink & Son Ltd., London;

No. 23, Paul Macapia, copyright Seattle Art Museum;

No. 24, copyright The Dayton Art Institute;

No. 25 (see Fig. 22 above);

No. 29, courtesy of Royal Ontario Museum;

Nos. 30, 46, 54, 62, courtesy of Sotheby's Inc., New York;

Nos. 34, 43, 52, The Cleveland Museum of Art;

No. 36, Ron Jennings, copyright Virginia Museum of Fine Arts, Richmond;

No. 37, Victoria and Albert Museum;

No. 38, Ashmolean Museum, Oxford;

Nos. 39, 56, copyright The Art Institute of Chicago;

Nos. 40, 67, Wettstein & Kauf, Museum Rietberg Zürich;

No. 41, courtesy of Berthe and John Ford Collection;

Nos. 42, 57, Doris Wiener, Inc.;

No. 44, Otto Nelson, courtesy of Mr. and Mrs. Nathan L. Halpern, New York;

No. 48, copyright The Nelson Gallery Foundation, The Nelson-Atkins Museum of Art, Kansas City, Missouri;

No. 64, copyright Smithsonian Institution, courtesy of The Arthur M. Sackler Gallery, Washington, D.C.;

No. 65, Seattle Art Museum;

No. 70, courtesy of Frank C. Russek Collection/Novel Art;

No. 71 (see Fig. 26);

No. 73, Cincinnati Art Museum.

Map on pages 16–17 by Joseph Ascherl;

Drawings on pages 141, 151, 165, 193, 225, 251 by Patrick A. George

Cover: M. McLean, copyright The Nelson Gallery Foundation, The Nelson-Atkins Museum of Art, Kansas City, Missouri

Back cover: Michael W. Meister

Photographs on pages 2–3 by C. Basu; on page 5 by Otto Nelson, The Asia Society, New York; on endpapers and pages 6–7 by Vishakha N. Desai